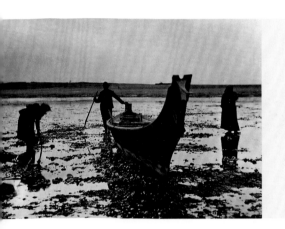

S'abadeb
The Gifts

Pacific Coast Salish Art and Artists

S'abadeb
The Gifts
Pacific Coast Salish Art and Artists

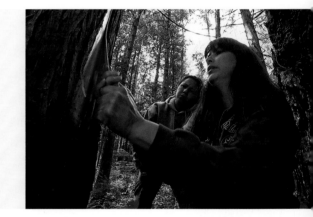

Edited by Barbara Brotherton

Seattle Art Museum
in association with
University of Washington Press
Seattle and London

The Gifts

WHILE THE ART of the Coast Salish Nations of Puget Sound, western Washington, and southern British Columbia has changed over many thousands of years, most perceptively in the last two hundred, the underlying values and worldviews that inform their artistic expression have remained constant. Central to Salish culture is the practice of ritually and artistically honoring the gifts (*s'abadeb*) of the earth, of the ancestors, of the spirit world, of family, and of the artists and culture-bearers who uphold age-old responsibilities of re-presenting those teachings in visual art, story, song, and speech.

The Seattle Art Museum is privileged to organize an exhibition that provides new scholarship and showcases the fine artistic traditions of a living culture, that of the Coast Salish. Since the late nineteenth century, many other Northwest Coast Native communities have been well researched; however, the Coast Salish peoples deserve more attention than they have received to date. This publication and exhibition enhance our

Foreword

The artist appeals to that part of our being . . . which is a gift and not an acquisition—and therefore more permanently enduring.

—Joseph Conrad, *Nigger of the Narcissus*

knowledge and appreciation of the Coast Salish. We are grateful to the many Native and First Nations advisors to this project who have realigned our thinking and, through their generosity of spirit and their knowledge, have brought us insightful interpretations of the rich artistic traditions of the Coast Salish.

In Seattle (named after Chief si?ał) and other areas in proximity to the northwest coast of the United States and across the Canadian border, the presence of indigenous people is imprinted on the landscape and within the urban sphere, attesting to the intimate connection of Coast Salish people with these places. It is most appropriate that the Seattle Art Museum is the organizer of this project as the museum sits upon Duwamish land near the once-thriving Native hub of Elliott Bay, where indigenous peoples came to trade and visit. Through this important book and exhibition, we gratefully acknowledge the gift of being able to present the fruits of a truly collaborative effort among SAM, the Salish Advisory Committee, many community organizations and individuals, and all who supported this project in myriad ways.

Barbara Brotherton, curator of Native American Art at the Seattle Art Museum and a specialist on the Coast Salish, conceived the idea; organized the exhibition, carefully selecting each work; and, in collaboration with many scholars and Native advisors,

wrote and edited the publication. We are sincerely grateful to Barbara for the years of in-depth research and hard work she has devoted to this project. Also deserving of our gratitude is Anna Strankman, currently curator of Native American Art at the Portland Art Museum, who provided invaluable assistance during three years that she spent at the Seattle Art Museum. In the Curatorial Division, Chiyo Ishikawa, the Susan

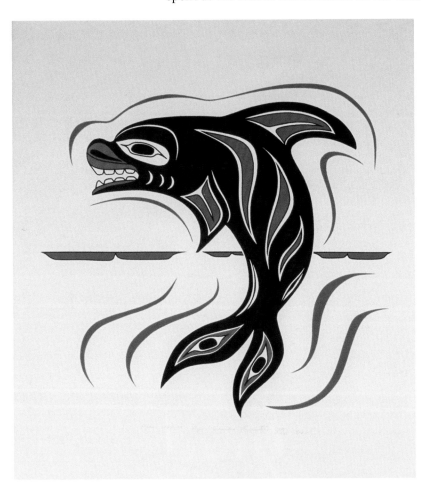

Brotman Deputy Director for Art, offered advice at every stage, and Zora Hutlova Foy, manager of Exhibitions and Publications, skillfully oversaw many aspects of the publication.

We are extremely pleased to partner with the University of Washington Press, co-publisher of the catalogue, as well as with the Heard Museum, Phoenix, Arizona, and the Royal British Columbia Museum, Victoria, Canada, which are sharing the exhibition with us so that it can be enjoyed by a wide audience. Laura Hopkins, development officer/head of exhibition and program support, deserves accolades for tireless fundraising efforts.

Projects of this scale and importance require major funding. We thank the Henry Luce Foundation for their early support and patience; the National Endowment for the Humanities for covering the costs of planning, consultation, and travel; and the National Endowment of the Arts, our nation's supporter of artistic excellence. Other remarkable organizations also stepped forward: the City of Seattle Mayor's Office of Arts and Cultural Affairs, Washington State Arts Commission, Suquamish Clearwater Casino Resort, Humanities Washington, members of the Native Arts of the Americas and Oceania Council at the Seattle Art Museum, U.S. Bancorp Foundation, and Adobe Systems Incorporated. We thank the Thaw Charitable Trust for generous support of this publication.

We express heartfelt gratitude to all, with special thanks to the lenders who so generously parted with their splendid works of art.

Mimi Gardner Gates
The Illsley Ball Nordstrom Director
Seattle Art Museum

This book has been published in conjunction with the exhibition *S'abadeb—The Gifts: Pacific Coast Salish Art and Artists,* organized by the Seattle Art Museum

Presenting Sponsors

Major Sponsors

Adobe Systems Incorporated
Washington State Arts Commission
U.S. Bancorp Foundation
Native Arts of the Americas and Oceania Council
 at the Seattle Art Museum
Thaw Charitable Trust
Charlie and Gayle Pancerzewski
Suquamish Clearwater Casino Resort
Humanities Washington
Kreielsheimer Exhibition Endowment
Seattle Art Museum's Publication Fund
Contributors to the Annual Fund

IT TAKES A VILLAGE to realize a project such as this. The collaboration with the essayists, Native and First Nations advisors, scholars, museums, and collectors has been a productive and memorable endeavor. Each embraced the challenges and rewards of contributing to various phases of the exhibition and catalogue. The University of Washington Press director Pat Soden enthusiastically supported the project from its inception, and Jacqueline Ettinger gave guidance on the initial manuscript. Marilyn Trueblood of UW Press and Brynn Warriner of Marquand Books expertly negotiated all the twists and turns during the editing and composition phases. Designer John Hubbard of Marquand Books applied his keen eye and fine aesthetic sense to the book.

The guest essayists have generously shared their expertise in many subjects, thus laying a foundation for further Salish scholarship. Thanks go to elders Vi Hilbert and Ellen White and to Crisca Bierwert, Steve Brown, Sharon Fortney, Michael Kew, Carolyn J.

Acknowledgments

Marr, Jay Miller, Astrida Blukis Onat, Michael CHiXapkaid Pavel, Qwalsius Shaun Peterson, and Susan Point. We honor the memories and contributions of our late colleagues, Wayne Suttles and Gerald Bruce subiyay Miller, whose work defines a watershed of Salish cultural writings and teachings. Special acknowledgment goes to Cameron Suttles, Wayne's son, for editing his father's essay, and to Michael Pavel for sensitively interpreting some of the teachings of his uncle subiyay Miller, who was a cherished advisor to the Seattle Art Museum. Cecile Hansen, chairwoman of the Duwamish Tribe, and Leonard Forsman, chairman of the Suquamish Tribe, graciously offered welcome statements as representative of the First Peoples of the Seattle region.

Many institutions have rallied around our requests for the loan of art and artifacts and for photography. They deserve special mention, since without their willingness to attend to the complex tasks involved, this book and exhibition would be diminished in quality and presentation. These institutions include American Museum of Natural History, New York; The British Museum, London; Brooklyn Museum, Brooklyn, New York; Burke Museum of Natural History and Culture, University of Washington, Seattle; Canadian Museum of Civilization, Gatineau, Québec; Field Museum of Natural History, Chicago; Heard Museum, Phoenix; IslandWood, A School in the Woods, Bainbridge

Island, Washington; Maxey Museum, Whitman College, Walla Walla, Washington; Museum of Anthropology and the Laboratory of Archaeology, University of British Columbia, Vancouver; National Museum of the American Indian, Washington, D.C.; Peabody Museum, Harvard University, Cambridge, Massachusetts; Perth Museum & Art Gallery, Perth, Scotland; Portland Art Museum, Portland, Oregon; Royal British Columbia Museum, Victoria, B.C.; Tems Swiya Museum, Sechelt Nation, Sechelt, B.C.; Vancouver Art Gallery, Vancouver, B.C.; and the Vancouver Museum, Vancouver, B.C. The National Museum of Natural History, Smithsonian Institution, was not able to lend to the exhibition, but its staff willingly provided images for the catalogue.

Historic photographs were provided by British Columbia Archives, Victoria, B.C.; Burke Museum of Natural History, University of Washington, Seattle; Canadian Museum of Civilization, Gatineau, Québec; Jefferson County Historical Society, Port Townsend, Washington; Museum of History and Industry, Seattle; Special Collections Division, University of Washington Libraries, Seattle; Whitman College and Northwest Archives, Walla Walla, Washington; and Vancouver Public Library, Special Collections, Vancouver, B.C. Steve Brown allowed us to use photographs of canoe-making, and photographer Helen Pope and Shirley Jones, wife of the late Jerry Jones, gave permission to print an image of Mr. Jones carving a canoe. The Musqueam Band Council, Musqueam First Nation, the Saanich First Nation, the Sauk-Suiattle Tribe, the Squaxin Island Indian Tribe, and the Swinomish Tribe each permitted the photography and exhibition of important works by their ancestors.

Many other people have shared their treasures in this book, including living artists and the families of deceased artists. These include Rena Point Bolton, Ed Carriere, Lynn Wilbur Foster, Chief Janice George, Stan Greene, Maynard Johnny Jr., Heather Johnson-Jock, Buddy Joseph, Aaron Nelson-Moody, Marvin Oliver, Dionne Paul, Michael and Susan Pavel, Shaun Peterson, Manuel Salazar, Mary Lou Slaughter, Debra Sparrow and Matika Wilbur; and the families of Simon Charlie, Ron Hilbert Coy, Josephine George, Mary Jane Jackson, Martha James, Gerald Bruce subiyay Miller, Rod Modeste, Mary Peters, and Alice Williams. Alcheringa Gallery, Victoria, B.C., Curtright and Son, Tacoma, Washington; Stonington Gallery, Seattle; and Legacy Gallery, Seattle, facilitated important loans.

Generous individuals opened their collections to us as well. Our thanks to Helen Carlson and Paul Nicholson, Anna Chavelle MD and Christine Knutson, Jack and Jane Curtright, Gloria Lobb, Eugene and Martha Nester, Simon and Carol Ottenberg, Glen and Ann Parker, Kay and William Rosenberg, Ann Stevenson, Bob and Betty Stott, Whale Rider Arts, and anonymous Canadian collectors. Special recognition should be given to the Burke Museum, especially Robin Wright, Rebecca Andrews, and Laura Phillips, who went the extra mile to make so many works available from their fine collections. We would like to extend our appreciation for collegiality to the Royal British Columbia Museum and the Heard Museum, both of which are also venues for this exhibition.

One of the most rewarding and inspiring aspects of preparing the exhibition and catalogue was collaborating with the many scholars, experts, and culture-bearers

whose guidance and advice shaped every aspect of this project. Compelled by a desire to further the aims of Salish scholarship and to have the voices of the ancestors and communities heard, each brought unique insights and ideas, and for that we are very grateful. This endeavor would not have been possible without their stewardship. We lift up our hands to them: elders Ed Carriere (Suquamish), Vi Hilbert (Upper Skagit), and Ellen White (Snuneymuxw), as well as Chief Darren Blaney (Homalco), Keith Thor Carlson, Joey Caro (Hul'qumi'num Treaty Group), Michael Evans (Snohomish), Roger Fernandes (Lower Elwha S'Klallam), Sharon Fortney (Klahoose), Karen Gallegos (Sliammon), Frank E. George (Songhees), Leah George-Wilson (Tsleil-Waututh), Chief Janice George (Squamish), Alexandra Harmon, Heather Johnson-Jock (Jamestown S'Klallam), Joe Kalama (Nisqually), Warren KingGeorge (Muckleshoot), Georgia LeSage (Nisqually), Geraldine Manson (Snuneymuxw), Sonny McHalsie (Stó:lō), Nan McNutt, Bruce Granville Miller, Jay Miller, Kris Miller (Skokomish), Astrida Blukis-Onat, Simon Ottenberg, Dionne Paul (Sechelt), Gordon Planes (T'souke), Tracy Rector (Seminole), Laurel Sercombe, Mary Lou Slaughter (Duwamish), Leona Sparrow (Musqueam), Tom Speer, George Swanaset Jr. (Nooksack), Chief Andy Thomas (Esquimalt), Romayne Watt (Seneca), and Robin Wright.

Seattle Art Museum staff—too numerous to mention—have shown constant dedication to the project. No one exemplifies more our motto of "SAM brings art to life" than director Mimi Gates, who has supported this project through the challenges of meeting the very high standards of scholarship, community representation, and artistic presentation to which the museum aspires. Anna Strankman, now curator of Native American Art at the Portland (Ore.) Art Museum, assisted in every aspect of the project for three years; I owe her a special debt of gratitude for the sensitivity she brought to the job as well as for her friendship. Phil Stoiber, associate registrar, needs to be singled our for the professionalism, dedication, and poise he brought to the monumental task of securing loans and organizing shipping. His deep appreciation for Native art ensured that every work of art was given proper respect. Ellen Oppliger and Monica Guidici oversaw the task of finalizing rights and permissions for the images in the book. I am indebted to Jay Miller, trusty colleague, who shared with us his encyclopedic knowledge of Salish history and language and served as advisor, essayist, reader for this manuscript, and consultant on many other aspects. Kenneth Greg Watson, an artist and educator, provided the expert drawings in the book, and Deborah Reade created the wonderful map.

Heartfelt gratitude goes to my father, David G. Iliff, and to my mother, Marta Strawn, for inspiring curiosity in all eight of their children, to Mark and Ethan for shared adventures, and to Vi Hilbert for many enriching years of being my mentor and friend. *ɫigʷitubuɫəd čəd (I thank all of you).*

Barbara Brotherton
Curator of Native American Art
Seattle Art Museum

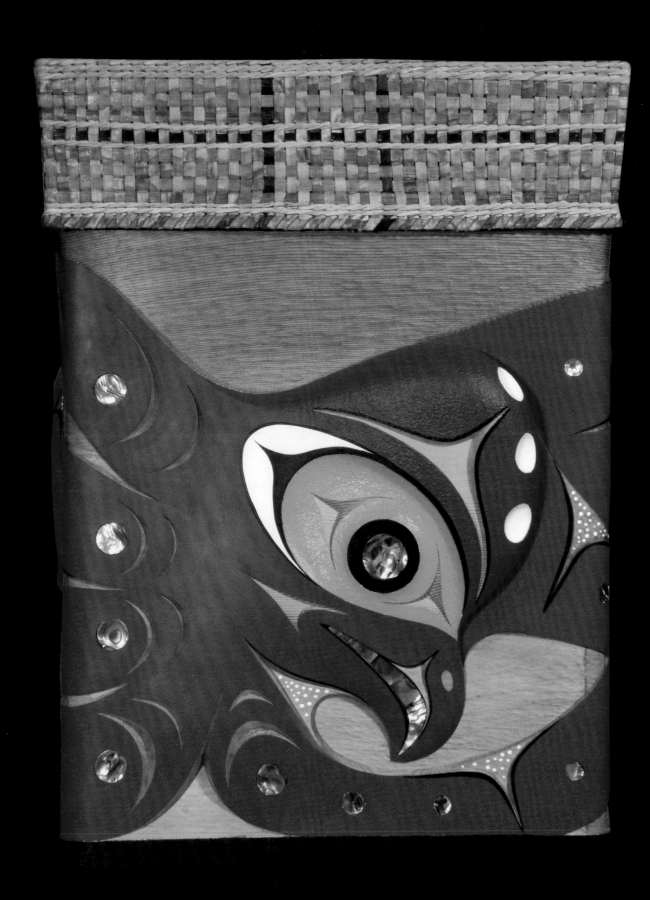

THE DUWAMISH TRIBE gives a warm welcome to all who read this book, *S'abadeb—The Gifts: Pacific Coast Salish Art and Artists.*

We are an alive culture.

The ancestral homelands of the Duwamish Tribe are what is now the city of Seattle and the surrounding area. The Seattle Art Museum sits on Duwamish territory. Our chief was the honorable SEE-ALTH (Sealth, siʔał, Chief Seattle), born on the shore of this homeland. The Duwamish were the stewards of more than 54,000 acres, living in peace, unless our safety was compromised by others. A "welcome" was the traditional way we greeted the first settlers when they arrived in the early 1800s.

Our way of giving and sharing was not reciprocated by the pioneers or by Washington Territorial Governor Isaac Stevens, who came to sign treaties with the Indians

Welcome from the Honorable Cecile Hansen
Chairwoman of the Duwamish Tribe

and with Chief Sealth's people. Our chief gave welcome but the governor was here to take Indian lands. The Duwamish Tribe was the first signer to the Point Elliott Treaty in January 1855. The famous treaty gave us the right to continue to fish in our usual and accustomed places and also set aside land for us to live in peace; provided educational, medical, and housing monies; and, most importantly, assigned monies to pay us for the land ceded. These promises were never realized.

Chief Sealth remained a great leader, welcoming more settlers, standing tall, dignified, steadfast, and determined to give the newcomers the benefit of the doubt. It was not to be; our great chief passed on in 1866 and was not buried on the land ceded to the federal government. He was buried at Suquamish, across Elliott Bay from Seattle, at Port Madison.

The pioneers honored this great man by naming the city after him. Chief Sealth spoke memorable words that are still resonating around the world some 150 years later. His words spoke of the traditional ways—welcoming others, the wisdom of communicating with the earth, and maintaining a respectful relationship with the environment. He said not to take the earth's gifts for granted. Poignantly, he said, "every part of the soil is sacred in the estimation of my people," and we still believe that today.

Today the Duwamish Tribe still welcomes visitors to Seattle and reminds all that the Duwamish people still survive. We are building our first home since 1894, a longhouse. It will be a house of welcome— a place to share our hospitality with all and a cultural building for the sharing of the Tribe's history and rich heritage.

We send a welcome to you here to learn about our artistic traditions and some of the meanings they hold for us, and to celebrate that these traditions are alive and evolving today.

May 2008

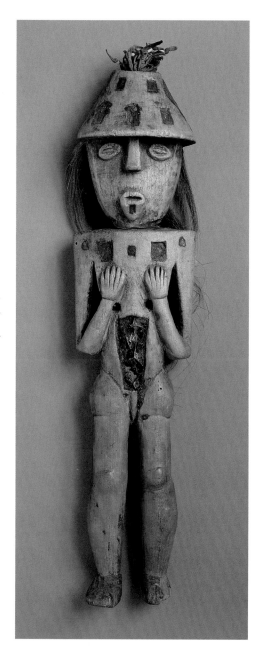

WELCOME TO THE LAND AND WATERS of the Coast Salish people. I am the leader of the Suquamish people of central Puget Sound. I live on the lands of the great Chief Seattle (siʔaɫ), for whom the city was named. The art and the lessons of the elders and ancestors of my tribe, and those of the other great First Nations represented in this important book, are a great testimony to our heritage. We are proud of our way of life. Expressions of our culture are not well known outside of our traditional territories. Our art forms honor ancestral spirits found in our visions through prayer and ceremony. We lost many of these ancient traditions after European contact and settlement. We are regaining much of what we lost through tribal canoe journeys, by traveling to visit and share with our Coast Salish neighbors. Our neighboring relatives helped us regain our songs and our traditional ways. Since the Paddle to Seattle in 1989, we have traveled in our traditional canoes to their winter villages. Since then we have seen a resurgence

Welcome from the Honorable Leonard Forsman
Chairman of the Suquamish Tribe

in Coast Salish art traditions—baskets, canoes, welcome poles, masks, and many other demonstrations of our Salish art traditions abound. I hope you will learn about the Coast Salish people, our expressions of culture and our values, and pass them on to your friends and family.

My hands are up to you in welcome and respect.

May 2008

THE SALISHAN LANGUAGE FAMILY is unique to the Northwest. Its two-dozen languages, with component dialect chains, descend from proto-Salish, spoken near the mouth of the Fraser River thousands of years ago. From there it spread along the coast from British Columbia to Oregon, as well as into the interior as far as western Montana.

Salish languages use about fifty sounds, some very complex, pronounced all around the mouth and throat. Each Salish sound is represented by a single letter with appropriate embellishments. The most complex occur in four-way sets such that it is plain (said much like ordinary English), glottalized (said in the back of the throat along with a raspy pop of air released from the voice box or glottis), and labialized (fronted in the mouth through rounded or pursed lips). Moreover, these articulations can be compounded so that a sound is both glottalized and labialized.

Pronunciation Guide

As distinct sounds, they are indicated by an ordinary letter, a letter under an apostrophe (glottal), a letter beside a raised W (labial -ʷ), or by both the apostrophe and the raised W. For example, K is said unadorned like k̲in, K̓ is "harsh, explosive" [cf gee̲k], Kʷ is said like Q̲ueen, and K̓ʷ combines the last two. Here is the progression:

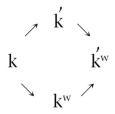

Other fronted sounds that are probably unfamiliar include ł (known as barred-L), a sound used in Welsh and a letter (for a different sound) in Polish, said by pushing air around the tip of the tongue while it is pressed against the roof of the mouth—something like the middle sound in Catholic or athlete, and ƛ̓ (a glottalized barred lambda) said with a click at the back of the throat while tapping the tip of the tongue against the back of the front upper teeth.

Below is the Salish alphabet in four rows, top to bottom, portraying sounds that are 1) plain, 2) glottalized, 3) palatalized, and 4) both glottalized and palatalized:

a	b	c	č	d	dᶻ	e	ə	f	g	i	ǰ	k	l	ł	m	n	ŋ	p	q	s	š	t	θ	u	w	x̣/x̌	y	1
ʔ	b̓	c̓	č̓									k̓	l̓	ƛ̓	m̓	n̓		p̓	q̓			t̓			w̓		y̓	2
					gʷ							kʷ							qʷ							x̣ʷ/x̌ʷ		3
												k̓ʷ							q̓ʷ									4

Distinctive sounds, their names, other spellings, and > an English word example are shown below:

c	Salish C	tS	>	cats
c̓	TS		>	glottal ts
č	c-wedge	cH	>	church
dᶻ	d-raised z	dZ	>	kids
ə	schwa		>	sofa, but
ł	barred-L	hL	>	athlete
ƛ̓	glottalized barred lambda	TL	>	athlete said harder
ŋ	tailed-N, eng		>	sing
š	s-wedge	sH	>	shirt
θ	theta	th	>	thin
x̣/x̌	dotted X, X-wedge for same sound		>	raspy breath in the throat
' ʔ 7	glottal stop		>	catch in the middle of uh'oh

Coast

Nuxalk (Bella Coola)

Central
 Comox
 Pentlatch
 Sechelt (Shíshálh)—Sliammon
 Squamish
 Halkomelem
 Island (hə́lq̓əmin̓ə́m̓) Cowichan—Chemainus—
 Nanaimo
 Delta (hən̓q̓əmin̓ə́m̓) Musqueam (xʷməθkʷəy̓əm)—
 Tsawwasen—Katzie
 Upriver (hɛlq̓əmɛyləm) Matsqui—Sumas—
 Chilliwack—Chehalis—Tait

Straits
 Lummi—Samish—Semiahmoo—Songish—Saanich—
 Sooke (T'Sou-ke)
 Klallam (S'Klallam)

Nooksack

Lushootseed (Puget)
 North (dxʷləšutsid) Skagit—Duxwaha—Sauk—
 Suiattle—Swinomish—Stillaguamish—
 Snohomish—Skykomish
 South (Whulshootseed, (t)xʷəlšutsid) Suquamish—
 Snoqualmi—Duwamish (Muckleshoot)—
 Puyallup—Steilacoom—Nisqually—Sahewamish
 (Squaxin)

Twana—Skokomish

Tsamosan
 Quinalt
 Chehalis
 Cowlitz (sǎ́púlmixq)

Tillamook—Siletz

Salishan Languages

Interior

North
 Secwepemc (Shuswap)
 Nlaka'pamux (Thompson)
 Stl'atl'imc—Lillooet (Lil'wat)

South
 Coeur d'Alene
 Flathead (Selish)—Kalispel—
 Spokan
 Lakes—Colville—Sanpoil—
 Nespelem—Okanagan
 Columbia (Sinkiuse)—Wenatchee
 (Pəskʷaws)—Entiat—Chelan—
 Methow

* dialect chains indicated by a dash

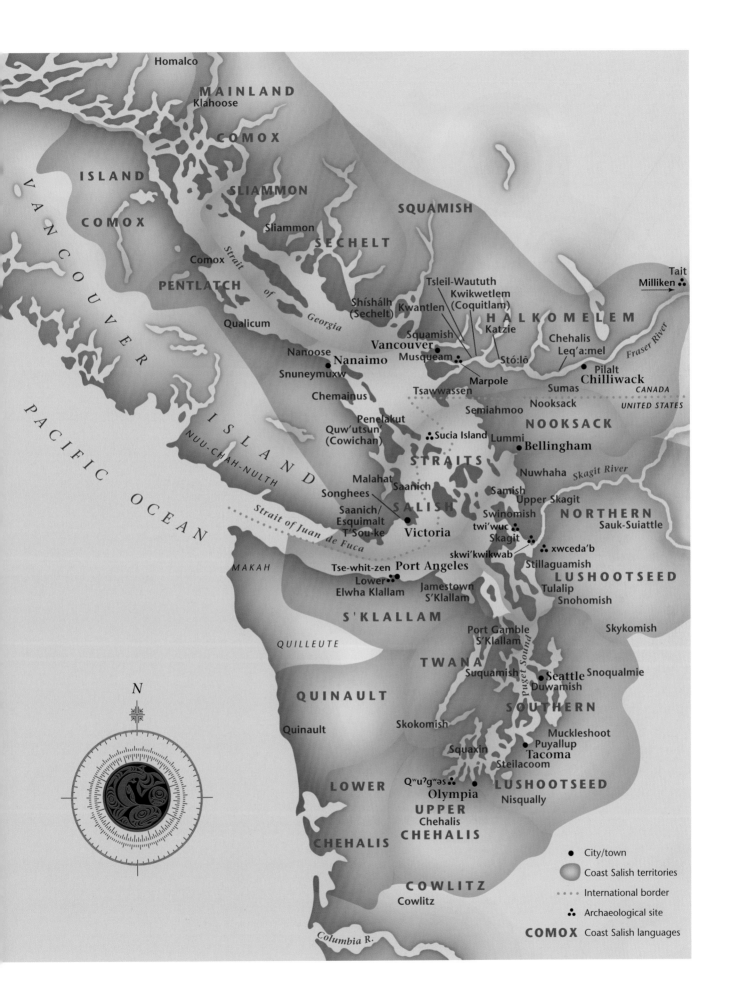

Homalco

MAINLAND
Klahoose

COMOX

ISLAND

SLIAMMON

COMOX

SQUAMISH

SECHELT

Sliammon

PENTLATCH

Comox

Strait

Tait
Milliken

Qualicum

of

Shíshálh
(Sechelt)

Kwantlen

Tsleil-Waututh
Kwikwetlem
(Coquitlam)

HALKOMELEM

Georgia

Squamish

Katzie

Chehalis
Leq'a:mel

Fraser River

Nanoose

Vancouver
Musqueam

Stó:lō

Pilalt

Nanaimo

Snuneymuxw

Marpole

Chilliwack

Chemainus

Tsawwassen

Sumas

CANADA

Semiahmoo

Nooksack

UNITED STATES

Penelakut

NOOKSACK

Quw'utsun'
(Cowichan)

Sucia Island

Lummi

STRAITS

Bellingham

Malahat

Nuwhaha

Skagit River

Songhees

Saanich

Samish

SALISH

Upper Skagit

NORTHERN

Saanich/
Esquimalt
T'Sou-ke

Swinomish

twi'wuc

Victoria

Skagit

Sauk-Suiattle

skwi'kwikwab

xwceda'b

MAKAH

Stillaguamish

LUSHOOTSEED

Tse-whit-zen
Port Angeles

Lower
Elwha Klallam

Jamestown
S'Klallam

Tulalip

Snohomish

S'KLALLAM

QUILLEUTE

Port Gamble
S'Klallam

Skykomish

TWANA

Suquamish

Seattle
Duwamish

Snoqualmie

QUINAULT

SOUTHERN

Quinault

Skokomish

Muckleshoot

Squaxin

Puyallup
Tacoma

Steilacoom

Qʷuʔgʷəs

Olympia

LUSHOOTSEED

Nisqually

LOWER

UPPER

Chehalis

CHEHALIS

CHEHALIS

COWLITZ

Cowlitz

Columbia R.

VANCOUVER

PACIFIC OCEAN

NUU-CHAH-NULTH

Strait of Juan de Fuca

Puget Sound

N

● City/town

⬭ Coast Salish territories

∙∙∙∙ International border

∴ Archaeological site

COMOX Coast Salish languages

xix

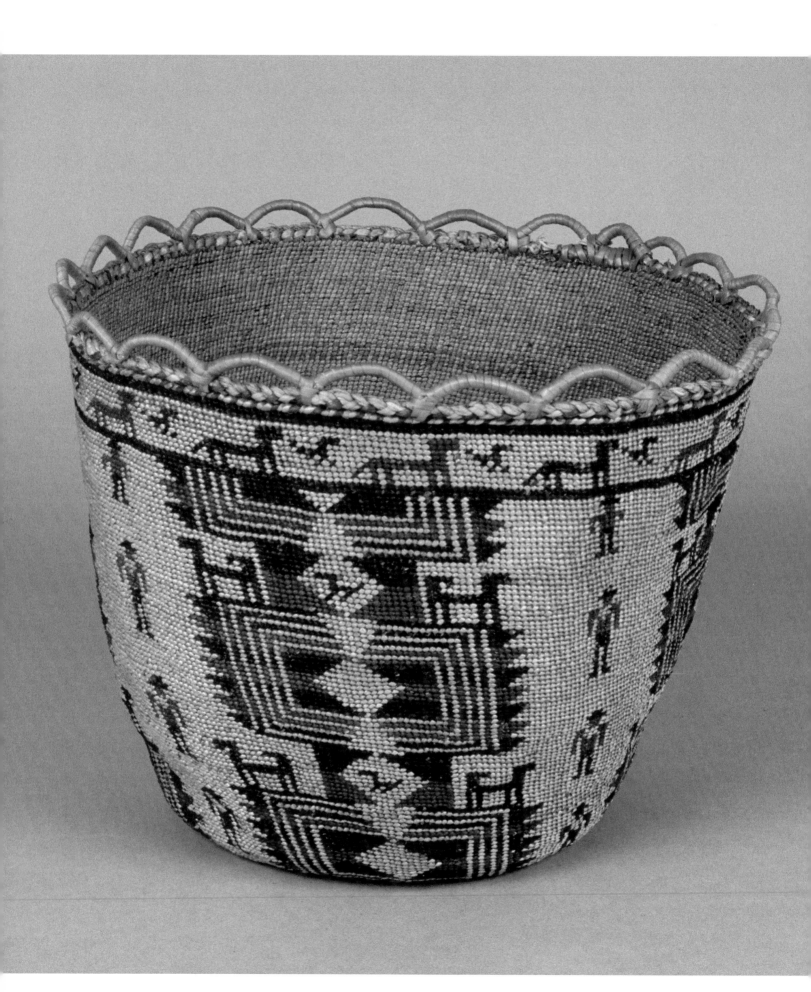

ALTHOUGH SALISH-SPEAKING PEOPLES have contributed significantly to the cultural landscape of the Seattle–Vancouver–Victoria region that makes up the core of their ancestral homelands, there has been a dearth of public recognition of their culture and artistry. There are many reasons why this is so—and these are explored in this book—but a significant factor has been the rapid urbanization and forced disruption of Native lifeways. Vestiges of the dislocation from homelands and the resultant erasure of time-honored means to communicate knowledge about such things as food gathering, spirit associations, orally transmitted family histories, and artistic styles are still being felt today in Native communities and courtrooms, and even within public institutions like museums and universities. Salish art and culture are best seen from broad analytic perspectives, ones that commingle aboriginal concepts with scholarly analysis and ones that squarely place aboriginal people at the center of the collaborative dialogue. This

Introduction

book has asked several writers from many disciplines and perspectives (and from across the Canadian–U.S. border) to share their thoughtful analyses of significant issues in Salish studies—identity, historical change, and cultural revival, to name a few—using Salish visual art as the pivot point. As we will hear, art makes visible the aspects of culture that are intangible and foundational, and artists, with their creations, guide us to acknowledge the links between past, present, and future. Nowhere is this more prevalent than in the stalwart determination of an earlier generation of artists to recapture Coast Salish aesthetics and in the versatile creativity of the current generation of artists, who embrace new materials, methods, and visions.

The theme of "the gifts" as a guiding principle for the exhibition and the book serves as a searching and potent metaphor, revealing core aspects of Salish philosophy, and was the suggestion of the Native advisors. The word *s'abadeb* signifies a wide range of beliefs and actions, in a field that encompasses both the flexible give-and-take of daily cooperative human interaction and the serious responsibilities implicit in ceremonial roles. It lives in the cultural wisdom passed between elder and youth, teacher and student, master artist and apprentice, and in the generational bestowal of names and privileges, as well as within the private sphere of human-spirit alliances. Works of art are gifts freely

1

bestowed to inspire, uplift, and instruct and to create lasting legacies for generations to come. In keeping with Lewis Hyde's definition (1979), art is not a commodity but a gift bestowed by another. Throughout these essays, the complex meanings of "gifting" will emerge and convey the gift's expansive connotation as a living quality that joins together the social, spiritual, political, and economic lives of Salish people.

Two of the essayists, Vi taqʷšəblu Hilbert and the late Wayne Suttles, present a wealth of thought based on long careers and productive work that can be said to have laid the groundwork for subsequent Salish research. Dr. Suttles inaugurated the use of a broad holistic framework with which to study Coast Salish cultures that included linguistics, history, archaeology, art history, and—most importantly—extensive work with Native (U.S.) and First Nations (Canada) consultants. In the posthumous contribution edited by his son and collaborator Cameron Suttles, he offers an insightful overview of the academic mind-set he inherited as a young scholar in the 1950s and of how he sought to amend it. Coming to her work a bit later in life—beginning in the late 1960s—Vi taqʷšəblu Hilbert, with the help of linguist Thom Hess, documented the spoken Lushootseed language by transcribing older recordings and by recording the stories and cultural teachings of her own living elders.

Suttles and Hilbert have published numerous books and articles and mentored many students. Each represented their respective disciplines, and indeed propelled them further, while at the same time conveying the value of understanding "the people" behind Coast Salish culture. In 2000, I accompanied Hilbert to the annual conference on Salish and Neighboring Languages, and we had the chance to meet up with Suttles. They were the same age—eighty-two at the time—and were exchanging clever quips about aging (they called each other the "ancient ones"). Vi said, "Well, Wayne, there's still an old Indian inside me," to which Wayne replied, "Yes, Vi, and there is still an old anthropologist inside me." I was awestruck by the moment, realizing that between them they had more than a hundred years of passionately and sensitively documenting the unique lifeways of Salish people, from their own equally authentic mix of scholarly and aboriginal epistemologies.

In the Salish worldview, elders are among the most precious of gifts. Ellen White—elder, storyteller, educator, herbalist, political activist—conveys how the oral traditions teach everything there is to know about life, from one's ancestral origins to how to care for the body, and on to the proper protocols when dealing with the spirit world. Likewise, D. Michael CHiXapkaid Pavel shares with the reader the poignant story of his education at the side of his late uncle, Gerald Bruce subiyay Miller, a gifted artist and spiritual leader of the tuwuduq (Skokomish) people. Pavel offers a glimpse into the synthesizing nature of Salish thought, where the tangible (such as the visual arts) and the metaphysical are enmeshed, lessons he learned from his uncle.

Expansive discussions of specific art practices—like wool weaving and basket weaving—in the essays of Sharon Fortney, Carolyn Marr, and Crisca Bierwert reveal the intimate connection women have to the natural environment from which they gain their

materials, as well as the nuanced ways in which weavers adapted to historic changes. Marr touches on the conditions under which baskets left their communities of origin and are now in world museums, a loss to the aboriginal community that has an ongoing effect and that has prompted weavers to seek out museum storerooms as a new type of classroom. Fortney aptly offers thoughts on ways that basketry is aligned with concepts of identity and knowledge.

My own essay examines the circumstances of the dislocation of objects and the new meanings they take on in the transformation from functional object to fine art. I bring the discussion up to the present because of the complex terrain that contemporary artists often have to navigate. They might produce functional objects (house boards, rattles, drums, prints) as gifts for their own communities or a fine-art piece for sale in a commercial gallery: in other words, they create both "gift" and "commodity."

Since this exhibition and publication are an occasion for bringing art and people together, I asked Musqueam artist Susan Point and Professor Emeritus of Anthropology J. E. Michael Kew to have an unscripted dialogue about several key works in the collection of the Museum of Anthropology and the Laboratory of Archaeology at the University of British Columbia, as well as about some works there on loan from the Canadian Museum of Civilization. Museum director Anthony Shelton generously allowed us to record the conversation in the galleries with the artwork close at hand. Both Kew and Point have been trailblazers in bringing public prominence to Coast Salish art: Kew, in his important publications and exhibition of Salish art ("Visions of Power, Symbols of Wealth," 1980), and Point, as perhaps the most accomplished artist working in Salish style, together with Stan Greene, Charles Elliott, Marvin Oliver, and others who are the force behind the current "Salish renaissance." The result is a refreshing and insightful awareness of how Salish art can speak to us on several levels: as a series of technical and aesthetic problems to be solved, as keys to unlock cultural knowledge, and as a sophisticated and masterful world art tradition.

When I asked an elder what her understanding of ancient artifacts was she said that they are "what the ancestors left behind for us to think about and learn from." Salish archaeology has undergone changes (in some respects similar to those in the fields of anthropology and art history), in part because of a wide range of new protocols concerning cultural material and also because of the role of scholars as expert witnesses in court cases involving Native fishing and harvesting rights (see B. G. Miller 2007). Archaeologist Astrida Blukis Onat has parlayed her expertise to those ends, but for this volume has chosen to take the role of the elder and to deliberate about a group of enigmatic figural sculptures and what they might mean. Rightfully for our theme, she casts them as characters within the framework of family ceremonial interactions, the potlatch and the gifting of special presents to people within the web of social exchanges, a concept of utmost importance for Salish people.

Steve Brown reminds us that of all the physical "gifts" present in the Salish sphere none is more significant than the canoe. This "Cadillac of the waterways" allowed people

the mobility to gather food, visit relatives, and trade and—in recent times with the modern canoe journeys—has been a symbol of Native pride and personal accomplishment. As a canoe carver in his own right, Brown introduces the reader to the different types of canoes and the particular qualities that make them perfectly adapted to the features of fresh and saltwater environs.

The evocative photographs of Edward Curtis taken in Salish territories parallel Curtis's own views about Native people: in peaceful coexistence with nature, as seen in the views of coastal people with their canoes in calm water, on the beach, or, in the case of the empty canoe, as a relic of the past. For artist Qwalsius Shaun Peterson the canoe conjures up a much different image. As a canoe puller himself, Peterson tells us that when they are in the canoe, the crew must be of one mind and one body, perfectly aligned together and ready for the unexpected. This metaphor becomes, in his essay, a reflection on his own journey as a contemporary artist and "urban Indian." While it is an exciting time for Salish artists, the role of emerging artists is a complex one. While they must be knowledgeable about their own heritage, they often have to go outside the community for art training, even finding it in museums and archives. A desire to experiment with new forms and materials may or may not win them favor among their peers and kin or in the commercial marketplace. And because of the visibility of the artist's work, he or she may unwittingly become a spokesperson for the community, tribe, or Native people as a whole. Urban artists living outside the reserve might have the added burden of "not being Indian enough." Within these schizophrenic extremes, Peterson advocates for pulling one's life and art within a singular focus.

We at the Seattle Art Museum have been greatly enriched by the collaboration with the community advisors, scholars, artists, and elders who have guided us in this project: it has been a gift of unimaginable proportions.

Barbara Brotherton
Curator of Native American Art
Seattle Art Museum

S'abadeb
The Gifts
Pacific Coast Salish Art and Artists

STORIES ENLIVEN THE WORLDS OF NATIVE CULTURES, and the arts beautify them. They are both gifts, as indicated by the Lushootseed title of this exhibition. The word *s'abadəb* is based on the root *ab* (meaning "to extend, stretch, reach out the arms and legs"); plus the *s-* prefix, to mark a noun and to freeze-frame the action; *ad,* to show direct action; and the ending *-əb,* to indicate committed involvement in the action. Taken together, the words in the title suggest "extended, expansive, radiant gifts." These gifts are timeless yet are set in specific places in tribal homelands. Like the earth itself, they have adapted to new conditions and to various audiences in a multitude of languages. At their most traumatic and creative, they live on even as their original tellers pass "to the other side" after suffering devastating disease and despair. Though a Boeing plant or housing development may now occupy the site of a mythic

Storied Arts
Lushootseed Gifting
Across Time and Space

Vi taqʷšəblu Hilbert and Jay Miller

episode, the imaginations of both storyteller and audience can ignore these intrusions onto a storied landscape.

Stories, as oral literature, are one of the many facets of artistic expression among the Native peoples of the Puget Sound Basin, who are known as Lushootseeds.[1] Today, despite heroic efforts in classrooms, the Lushootseed language has few fluent speakers and soon will survive only in a written or literary form. Its influences, however, remain both covert and long-lasting. Lushootseed has two chains of close dialects in the north or the south, dividing at Whidbey Island.[2] Most telling, each has a distinct word for "story": *sx̌ʷiʔab* in the south, and *syəhub* in the north (Bates, Hess, and Hilbert 1994: 271).

Overall, the subtleties of creativity, in the verbal as well as other fine arts, are well represented in specific word roots. Lushootseed (based on *lush* [ləš], meaning Puget's inland salty sea) is a language that uses roots or lexicals (grammatical segments) at the core of each word. The closest the language comes to a word for art is *ləcuqʷal* (pronounced letsu-qual) to indicate something done habitually over time at some place. Three roots in particular illustrate nuanced meanings: *x̌al* is the general term for "mark,

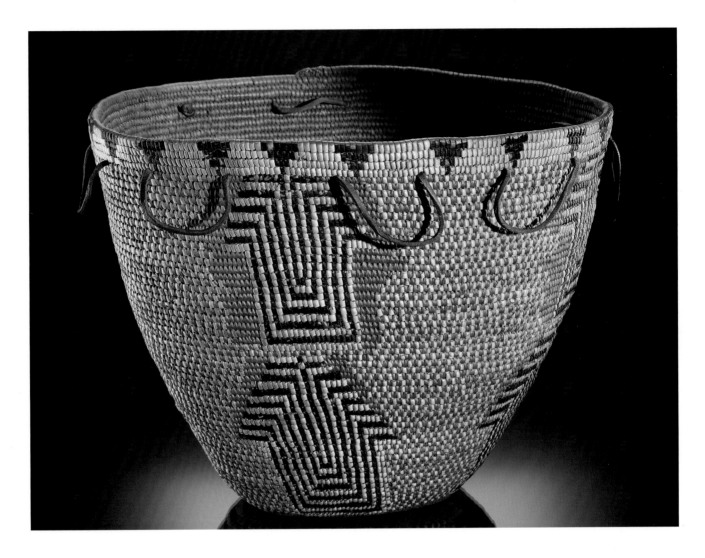

Figure 1.1
Basket, Duwamish, twentieth century, cedar root, bear grass, horsetail root, 16 × 15 in. (40.64 × 38.1 cm). Collected by T. T. Waterman in 1920. National Museum of the American Indian, Smithsonian Institution, 097649.

The knowledge, patience, and skill necessary for creating utilitarian and fine basketry was instilled in girls during their puberty instruction and provided a sound foundation for a girl's development as a young woman. There are many stories within the oral traditions in which baskets teach about the natural and spiritual worlds, as well as about human character (Thompson and Marr 1983: 11).

write, randomly leave a trace"; *q*ʷ*al* is to "mark with a purpose or intent, to paint"; and *k*ʷ*al* is to "mark with texture," or to "weave, braid, twine." Women wove over a dozen kinds of baskets: hard—made of coiled cedar roots; soft—made of interwoven bark strips; or open work—made with regular gaps to drain off shellfish and other watery foods. Women also wove blankets of mixed fibers derived from cattails, ducks, and, most prestigious of all, mountain goats (the wool specially collected in the mountains), or the hair of a special breed of woolly dogs carefully raised by their owners.[3]

A design can be referred to as -*us,* the lexical for "face" (flattish expanse), derived from *s'acus,* which is made up of *s-* to indicate a noun, *'ac* for something centered, and -*us.* Each template is inspired by some object, with typical patterns named star, fern, net, and dog. In addition to the arts of wood, fiber, baskets, clothing, architecture, and language, body decoration was applied to women, who were traditionally tattooed with bands around their ankles, knees, wrists, and elbows.[4] A few had facial tattoos. Traders had standard lengths tattooed along their inner arms for use in measuring strings of valuable shells. Everyone still paints their faces for ceremonial and other festive events, generally in black or red depending on their links with saltwater or mountain spirits. Jewelry, especially of dentalium (tusk shell), was worn in the ears and nose. Rings of bone, shell necklaces, and wooden combs enhanced one's appearance.

Carving, especially of cedar, includes the word *p̓ayəq,* which provides the root for the word for "adze" (*p̓ayəqəd*). The ending -*təd* refers to a tool (an implement with which to do something). For finer carving there is *čuqʷ,* "whittle, carve, chip off, finish." Nor is the human component of art ignored, since an artist is said to have *sk̓ʷədači,* or "blessed, empowered hands," from the root -*ači* for "hand." Family-owned privileges, ancestors, and other evocations of power were carved and painted on house posts but kept covered with mats or skins, except when the extended family hosted a public event and revealed them to all the guests. During finely crafted speeches, attention was directed to these images, validating family claims before honored witnesses to make them legal throughout the region.

Roots for "tell, say, talk" are highly specific and include *yəc-,* "report, inform"; *cut-,* "tell, say"; *tul̓,* "interpret, translate"; and *təɬ,* "something real, true." The addition of the ending -*alikʷ* implies that an activity is done with finesse. Much of the understanding of a phrase or oration in Lushootseed is intuitive, but the language has been graced by a community of scholars and insightful speakers, especially Elder Vi Hilbert, who have been able to tease out connotations. This work remains ongoing.

In some cases, the larger community of comparative Salishanists, linguists who meet annually to share research on the many languages that make up the Salish linguistic family, are able to provide a broader perspective reaching back to the proto-language (as Latin is for the family of Romance languages) of the fourteen Coast and seven Interior Salishan languages. The thousands of Native languages of the Americas share this type of grammar, built up of logical, precise roots, inflected or modified to produce even greater nuance.

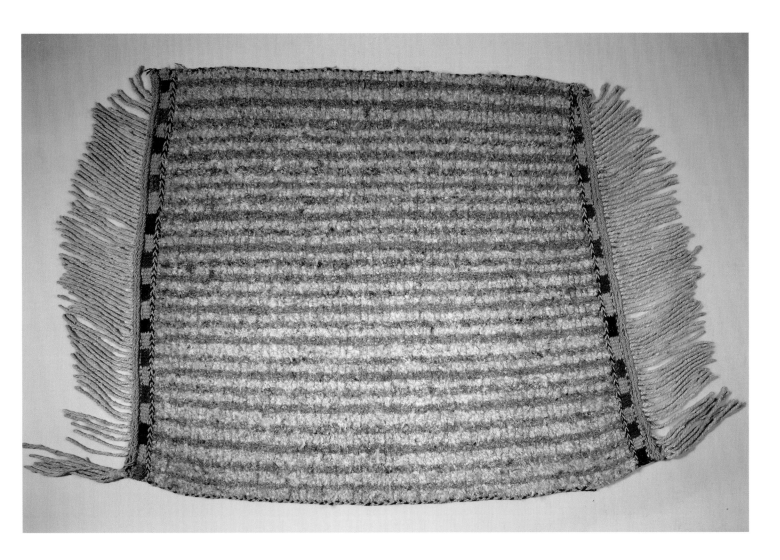

Figure 1.2
Robe, before 1841, mountain-goat wool, vegetal fiber, birdskin, 59¹³⁄₁₆ × 60⅝ in. (151.9 × 153.9 cm). Collected by Lt. Charles Wilkes in 1841. Department of Anthropology, Smithsonian Institution, 1894.

Women were experts on the collecting, processing, and use of myriad materials in the weaving of prestigious robes (often referred to as "blankets"). The special robe here is twined from the down of ducks and geese mixed with the hair of the mountain goat and maybe that of a special dog bred for this purpose. The colorful border is twined with goat wool tinted by dyes from plants and plant fibers, possibly fireweed cotton or nettle. Commercial wool and cotton cloth became available beginning in the early nineteenth century, contributing to the eclipse of the handwoven garments, although the high regard for them never waned.

Over thousands of years, Lushootseed developed dialects specific to the rivers draining into Puget Sound.[5] Each drainage was distinct, with its major village at the mouth. In addition to welcoming ceremonies for the First Salmon and other foods, the major regional ceremony took place in midwinter when a crew of Native doctors (shamans, religious specialists) symbolically went to the afterworld to assess the spiritual health of the community and to retrieve any lost souls detained there. Though shamans usually worked alone, this was a cooperative rite that drew men and a few women doctors from a wide region.

Three objects served as insignia of this Soul Recovery, Redeeming, Spirit Canoe, or Shamanic Odyssey: effigies, planks, and poles. Stuck into the floor of the house were

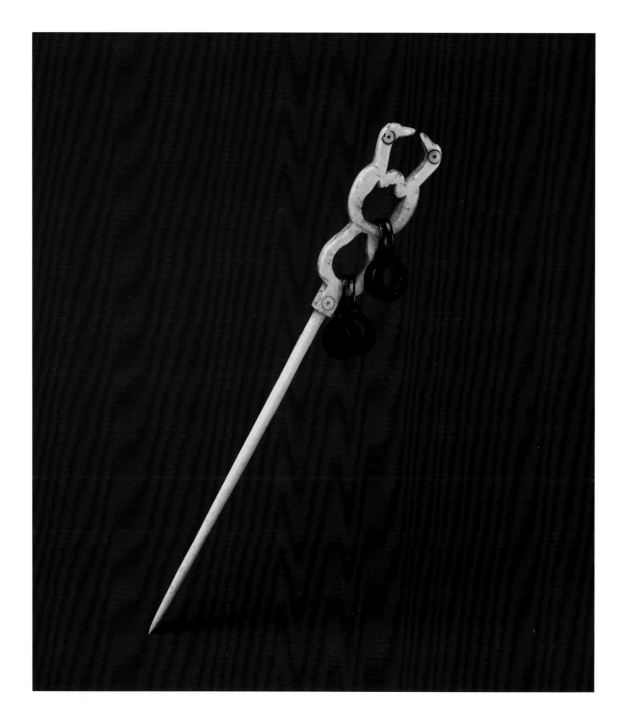

Figure 1.3
Blanket pin, attributed to Skokomish, 1893, bone, brass, 5⅛ × ¾ in. (13 × 1.9 cm). Collected by Rev. Myron Eells. Maxey Museum, Whitman College, WHIT-E-0407.

Elegant, simple carving applied to small-scale sculpture is a hall-mark of Coast Salish art. This lovely bone pin has the same delicate carving that is seen on bone combs, jewelry, and small figures (see figs. 7.3–7.5). The contemporary robe pin made by Skokomish artist D. Michael CHiXapkaid Pavel in this exhibition calls up an ancient story about a conflict between humans and animals at the beginning of time, and perhaps this one once had a story about the symmetrical, quadruped, weasel-like animals depicted on it. The collector, Myron Eells, did not furnish any details about this piece when he acquired it, probably from the Skokomish, for the Chicago World's Columbian Exposition in 1893. He was familiar with the customs of Puget Sound Natives since he lived among them from 1874 until his death in 1907 (see Castile 1985).

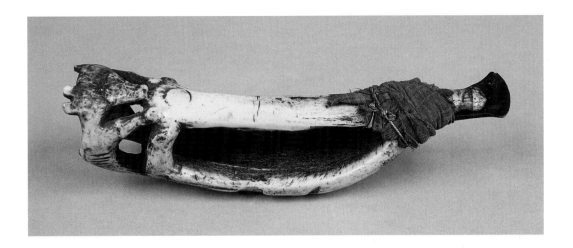

Figure 1.4
Straight adze, southern Puget Sound, nineteenth century, elk antler, steel, cotton cloth, 9½ × 2⅓ × 2 in. (24.1 × 5.8 × 5.1 cm). Burke Museum of Natural History and Culture, Seattle, 4588.

The fine-grained wood of the western red cedar was worked with few tools, but those that were used were ever efficient, like this straight adze made of elk antler. The carver's toolbox would include several types of adzes (see figs. 5.25, 5.26, and 11.3), wedges, straight- and crooked-bladed knives, and, later, metal blades, chisels, and saws. Before Natives had access to metal via salvage from oceangoing vessels or trade, adze blades were made from finely sharpened stone, and knives from shell or beaver teeth. The straight adze was employed on the southern Northwest Coast and along the Columbia River (Holm 1987: 34). Often there is a human or animal on the butt: here, it might be a mountain goat or an elk.

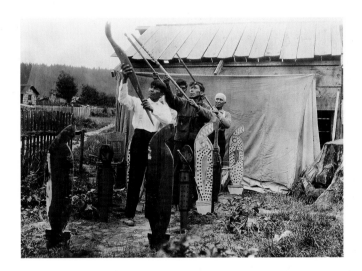

Figure 1.5
Lifting the Daylight. Photographed on July 12, 1920, by J. D. Leechman at Tolt (now Carnation), Washington; pictured are Jerry Kanim, Tommy Josh, Ed Davis, and Gus James. Burke Museum of Natural History and Culture, Seattle, L3911/3.

This photograph shows a reenactment of an important Puget Sound Native healing ceremony called *spəłtədaq*, or Soul Recovery, which had ceased to be practiced at the time the photograph was taken. Soul Recovery was undertaken by an experienced group of ritualists who painted flat boards and spirit figures (as instructed by their supernatural helpers) to ferry them to the land of the dead. Illness and even death could result from the loss of the soul, which could become dislodged or stolen by spirit forces. In a ceremony staged within the traditional plank house, and with the patient's family and others in attendance, the ritualists pantomimed the dangerous journey that their supernatural helpers underwent while traveling in the land of the dead in hopes of recovering the lost soul.

11

knee-high carvings of humanoids representing the "Little Earths" who made the actual journey. Figure and doctor stood before a six-foot cedar plank whose outline shape was distinctive of that river and whose center panel was painted with a vague image of a powerful protector. Each curer carried a carved staff that served as an all-purpose tool, ranging from paddle to spear.

Prior to the present age, before the world "capsized" to create present conditions, lived the Animal People, who were immortal proto-humans. Some had the outer cloak of their species, either plant or animal, while others turned into a "natural condition" such as a river, mountain, or echo, or a mineral such as flint. These beings also shared human values, emotions, and foibles. Some were heroic, like Star Child; some were tricksters, like Mink; and others were people of ordinary abilities and assets. They had homes in certain places, though some traveled with the seasons as later humans did. Each being had one or more inherent ability that was shared with a later human. Each type of Salmon expressed its preference for ways of being caught and preserved as food. Spider taught weaving; Cedar taught the use of its bark and roots for baskets, as well as its wood for canoes, boxes, and house planks. Beaver and Woodpecker taught particular techniques, one for marine applications of woodwork and the other for carpentry.

Respect is accorded all fellow beings, even the most annoying. In her storytelling, Susie Sampson Peter, a superb Upper Skagit narrator, used different voices for each character, as in modern cartoons. She heightened their emotions, in a range from pathos to an all-inclusive empathy, as when she became a ripe berry hoping to be picked and enjoyed.

Vi Hilbert's signature story, because it encapsulates so much of the humor and irony of the culture, is Lady Louse, who provides a key negative example. In Native society, no one should live alone (especially in a huge house that is not a lively home), nor be unclean (both physically and spiritually); no one should be kinless and friendless, nor vanish without someone expressing concern. That Louse is female is understood, though nowhere specified in the telling (because pronouns lack gender in Lushootseed; it is implied by the context of what is being said).

<div align="center">

Louse lived there in a huge house

All alone by herself

She had no relatives or friends

She took it up

And she swept

This huge house

Full of dirt

At the middle of the house

She disappeared

Thus ended Lady Louse.

</div>

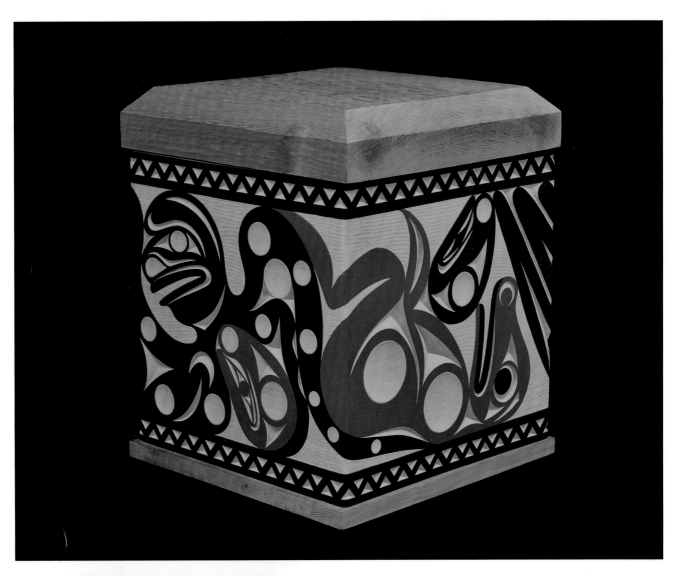

Figure 1.6
Thunderbird Saves Killerwhale, Andrea Wilbur-Sigo, Squaxin, 2006; red cedar, yellow cedar, paint, 18 × 18 × 22 in. (45.7 × 45.7 × 55.9 cm). Collection of Glen and Ann Parker.

This stunning bent-corner box by a new-generation artist, Andrea Wilbur-Sigo, retains the ethos of the older cedar boxes yet moves the design beyond its function as a storage container to one that conveys a Salish story in Wilbur-Sigo's personal style. As the legend is orally recounted, Thunderbird saves Killerwhale and his people from starvation by creating loud noises and bright flashes at the mouth of the Skokomish River, scaring the sea creatures who were blocking the fish from entering. The reciprocal agreement was that the Killerwhale people would never waste this precious food source.

As a warning against loneliness as well as a postmodern commentary on the hollowness of greed, Lady Louse translates across time and space, as comfortable in a Native household of today as in Seattle's symphony hall. Such is the power of a well-crafted story that it is able to withstand the ever-homogenizing forces of globalization. Lady Louse, though a dejected spinster, holds her own for herself and for her community.

Most long stories, however, have moral, educational, and spiritual purposes that fuse a being, place, ability, and power. Certain families had and have special relationships with these places and their spirits, renewed every generation. Once, by fasting and questing in remote areas of shore or peak, youths personally gained this renewed link. More often today, through special initiation, these patron spirits are passed down along family lines. Leading families have bonds with more powerful spirits, who provide them with ample supplies to assure their generosity as hosts. Doctors, curers, or shamans bond with spirit immortals that stay close to them at all times, unlike career patrons, who come close in winter but travel away in summer, when humans are busy storing up food.

All the sensitive distinctions of rank, class, birth, and pedigree are played out in the stories, featuring impostors as well as inherent nobility and base slavery. Place names are embedded in accounts of travel so that listeners can visualize the country both as it is now and as it was in the distant past. Named characters populate stories, with the names themselves passed on as family treasures, complete with attributes and locales that are also claimed by family lines.

Where, how, and when these links were forged was the content of private family teachings. For the community at large, moreover, there were tales, anecdotes, and stories that featured these Animal People teaching moral lessons, often by negative example. Humor was sparked by the role of Raven, an inept braggart, devoid of the occasional noble deeds of his counterpart in Alaskan and Siberian Native epics.

Prior worlds were destroyed by fire or flood, or both (as in volcanic eruptions), only to be reconstituted by beings known as Changers or Transformers. In specific tribal territories, teams of Changers (often brothers) prepared the world to be as it is today, leaving permanent, obvious landmarks as "proofs" of their intentions and successes. Certain abilities, however, were lost at each destruction. One ancient loss was a common language. In one tale, the sky dropped too low and everyone had to learn the word *yuhaẃ* to push it back up in unison. Other beings in the lowered sky did not get the warning and so remain in the sky as named constellations. As a consequence, the explanatory power of these stories, both in Puget Sound and throughout Indian Country, is cosmic in scope.

The arts provide a steadying influence in an unsteady world. For Natives, Puget Sound has been remade many times, revived after some catastrophe caused by human arrogance, greed, or hostility. Overpopulation often tips the balance that leads to

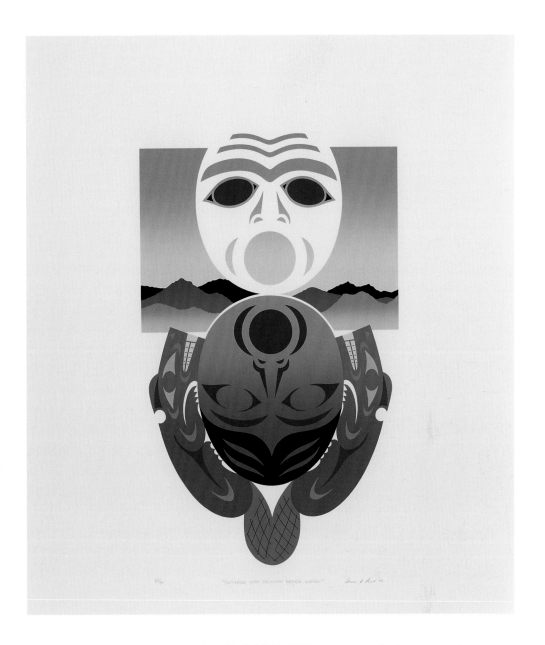

Figure 1.7
Southwind with Mountain Beaver Woman,
Susan Point, Musqueam, 2004; serigraph,
24 × 20 in. (61 × 50.8 cm). Gift of the
Point Family, Musqueam, in honor of
the 75th anniversary of the Seattle Art
Museum, 2007.52.

Arthur C. Ballard (1876–1962) was a recognized expert on the
language and oral traditions of Puget Sound tribes. Beginning
in 1916, Ballard recorded the folklore of the Duwamish, Muckle-
shoot, Snoqualmie, and other tribes in their Native languages
and translated them into English. Versions of the myth of the
battle between the Northwind and the Southwind were recorded
by Ballard around 1924 (Ballard 1929). In 1992, Susan Point was
commissioned by the King County Arts Commission to create a
series of concrete and cedar Spirit Planks at the site of this mythic
battle in south Seattle. She also made a limited edition series of
prints that depict scenes from the story. This epic story explains
the climatic differences in Duwamish territory, as well as the
origins of modern-day Duwamish people. Mountain Beaver
Woman ensures that the Duwamish lineage will continue.

destruction, making room for coming generations. Only a few are saved. Among them are teams of Changers who go about (re)fixing the world.

Art, because of its spiritual links with the immortal, often initiates a re-creation. In the most famous example, the Changer known as Swanaset painted his face with red ocher in a pattern of sloughs and ditches to drain the Pitt Meadows along the Fraser River. Lifting his right hand, he prayed to the deity above and instantly the design was transferred from his face to the meadow itself, creating an ecological balance where all could thrive.

Along the Skagit River, the team of Changers consisted of a protective guardian known as *sgʷədiličˇ* (sgwud-ee-litch), along with beings named Knife, Fire, and Baby (though Progeny would be a better translation). Each has a modern embodiment. Somewhere along the river, they encountered another being known as *tustəd,* a guarding power for the inside of the house. As their names imply, Fire taught cooking skills, as well as the virtues of steaming shellfish for food or softening wooden planks to bend into boxes. Knife taught the preparation of foods, as well as the skills of carving wood. The *sgʷədiličˇ* taught songs, dances, and music to protect kin and resources. Baby placed certain abilities and privileges about the landscape where youngsters with proper training, discipline, and pedigree could inherit them through their efforts of fasting, praying, and working toward the greater good.

Many of the river-based dialects, spoken by communities now called tribes, have their own national epics, extolling the work of their own Changer to make their climate and terrain as it is today. Each includes proofs left on the landscape, or, where massive construction has damaged the homeland, is featured in "story poles," which are the Lushootseed equivalent of the totem poles of the central and northern Northwest Coast. There once were standing figures, carved of cedar, at the approach to Native villages, but these poles are a reaction to the invidious comparisons made by settlers who assumed wrongly that the Canadian-Alaskan tradition of decorated poles was pan-Indian.

For the Duwamish living around Seattle, the War of Winds, a story set where Boeing Plant #2 now sits, explains the milder local climate there. Brutal North Wind slays the other Winds but a child (Storm) is hidden, to grow up and take revenge at a final battle at Yeomalt on Bainbridge Island. The weir blocking the Duwamish is smashed, allowing salmon to spawn upriver. An important female character in this epic is Mountain Beaver, a mammal famous for elaborate tunneling and making "baseballs" gnawed out of the packed dirt.

Both Skagits and Snoqualmies trace their chiefly lines back to the marriage of human girls to Star beings—the parents of Star Child and Diaper Boy, who remade the world after a catastrophe. They burned up all the debris that remained and used the ashes to re-create all that was and is useful for the people to come. They also left physical evidence, or proof. For Skagits, the rope that fell from the sky became Big Rock on Route 9, while the petrified Snoqualmie rope coil near Issaquah has been half quarried away.

At Swinomish, when Robe Boy re-created the world, he first trapped small animals and made a blanket of their pelts, which he waved over debris from the flood that had destroyed the prior world while praying to the deity. He revived foods and then peoples, who soon scattered because they did not share a language. Later, when an epidemic was laying waste to this entire region, Lahalbid saved his community, across from La Conner, by gathering the people together to pray and sing until the disease passed over. Thereafter, the names of these heroes have been passed on, the sites of their triumphs honored, and their carved and painted portrayals now adorn the insides of ceremonial buildings based on the ancient plank longhouse homes.

In south Puget Sound, the recounting of ancient epics was overshadowed by the efforts of John and Mary Slocum to found the Indian Shaker Church near Olympia in 1882. John died, visited God, and returned to preach a message of salvation that was distinctively Native, gifted by a special type of songs. Mary, mourning for her husband, received the special gift of "the shake" that heals and cures the afflicted. Today, their church has taken on a vital role in the treatment of substance abuse.

Among the Lushootseed peoples of Puget Sound, art is everywhere. It enhances the lives of all because it is the most direct link with the eternals of spirit and beauty. Not surprisingly in this highly varied terrain, the Lushootseed word for "beautiful" referred to a far vista where one can both see and be seen. This compound for "beautiful" (to see) is *ʔadzalus* (derived from *ʔadz*, "sharp, bright, good," along with the *-us* ending for "face"). Its intent is an emotional jab that heightens sensibilities in all ways.

Art is a lens into the immortal universe and is a link that is reciprocal across time, space, beings, and generations. Compassionately, it involves all, not just humans, in a community that is timeless and pan-species. A wise leader makes decisions to involve more than just kin, so as to include everything, known and unknown, far and wide, across the universe. Environmental degradation of the landscape might be ignored for the moment in favor of the long-minded view encompassing a timeless totality devoted to enhancing all qualities of a good life.

Notes

1. The vast literature on what was once known as Puget Sound Salish has been summarized in the works of Lushootseed Press and in publications by Jay Miller, working with Vi Hilbert and other elders, especially *Lushootseed Culture and the Shamanic Odyssey: An Anchored Radiance* (J. Miller 1999).

2. Lushootseed has northern and southern dialect chains, each link based along a river or inlet (see Salishan Languages, p. xiv). Each has its own words for story, important foods such as salmon species, pattern numbers (4 in the north, 5 in the south), and word accent (first or second syllable of the root word). Under strong pressure from English and other languages, Lushootseed sounds that had been intermediate nasals (m, n) became fixed bilabials (b, d) so that the mountain every local Native person knows as Takoma is pronounced in Lushootseed as *taqʷoba*.

3. After years of speculation about this special breed of dogs, based on a Paul Kane painting with a pup in it (see fig. 5.14), the full hide of "Mutton," the woolly dog owned by George Gibbs, has now been located in the mammal collection at the Smithsonian Institution.

4. Haeberlin and Gunther (1930: 39) report the word for "tattoo" as *sL!e'L!tc*, but it has yet to be confirmed and updated by a Native speaker. A gooseberry thorn was used to jab charcoal just beneath the skin to leave a dark design.

5. Lushootseed belongs to the larger grouping of Central Salishan languages spoken contiguously from Comox on Vancouver Island, inland to the crest of the Cascade Mountains, and on the coast south to the Chehalis River. Far separated ends of the whole Salishan Family are Nuxalk (Bella Coola) to the north, Tillamook to the south, and Flathead (the source of the term "Salish") in Montana.

17

OUR PEOPLE, THE COAST SALISH, were taught to pass on the teachings of our elders through storytelling. This is how we pass on the teachings of the old ones. The traditional stories were handed down to me from by Granny Mary Rice Xalunamut and her only brother, Tommy Piell Quyupulenuxw. The elders always say, "We didn't make this up—we got this from the old ones. We got it from our great-grandparents and it comes from thousands of years ago. We were trained to connect with the energies of the Universe."

The Creator told us, "This is how you will be as human beings. You will not let the future generations forget where they came from. How they got here. Who made them. How to speak to their bodies."

Kwulasulwut Teachings of the Past, Treasures of the Future

Ellen White Kwulasulwut

It is said that the soul introduces itself to the new body it is going to be in, and then this body introduces the soul to the next generation. That is why we must never forget our ancestors. Our ancestors tell us: "Never forget where you came from," and in this way the younger generation will pass this on. When the stories were told to us over and over again, we'd say, "We already heard that story." Granny would say, "If you are smart, you will be listening for the words that are added from the last time the story was told."

The stories were very easy in the beginning when we were young, and then the stories became more involved as we got older. In this way the lessons were reinforced. Can we use these stories that were told a long time ago to better our lives today? Can we learn how to connect with the universal energies to understand where we came from? The stories pave our way to a healthier, more stable life. These are support systems for our future generations to come. That is why it was so important for us to learn them through the stories. The stories teach us how to call upon our helpers. They teach us that we must never forget to pass this on to the younger generation. We might wonder if these stories can be used today. The answer is yes.

Figure 2.1
Snuneymuxw elder
Ellen White Kwulasulwut.

Ellen Rice White (Kwulasulwut) has devoted her life to continuing the language and oral traditions of her Snuneymuxw people. She is also widely recognized for her knowledge of traditional herbal healing, Native foods, and Coast Salish dance and music. "Auntie Ellen," as she is affectionately called, has dedicated her life to education, social change, and community development, working to build bridges between her community and the Nanaimo region. In 2006 she received an Honorary Doctorate of Laws from Malaspina University-College, Nanaimo, British Columbia.

One of the stories passed on to me is about the boys who became a killer whale. In this story, one of the younger boys hid in the longhouse to listen to his elders speak because he wanted to hear how the older boys and girls were being taught. The younger children felt left out and they were very angry about this. The young boy told the other children what he had learned from the teachings: he had learned how to make the gray whale skin become a killer whale. He said that if they could do this, the older ones would have to believe that they are knowledgeable and then maybe they would be included in the teaching time.

He told them that if they were going to make the gray whale skin into a killer whale, it was very important that they only use objects that were "spoken to" by the elders. These objects could only be made by knowledgeable people who spoke to the objects to imbue them with power. So the children started to steal these objects, such as the black paint, the white paint, the red ocher, the cedar, and the long pole that was going to become the fin of the killer whale. They gathered clamshells for the eyes and for the teeth of the killer whale. From the grandfather they stole the firekeeper that was to be used to create smoke when the whale surfaced.

The children prayed to the Creator while they worked on the skin. "We will become one with the skin, help us to become one." When they finished their work and entered

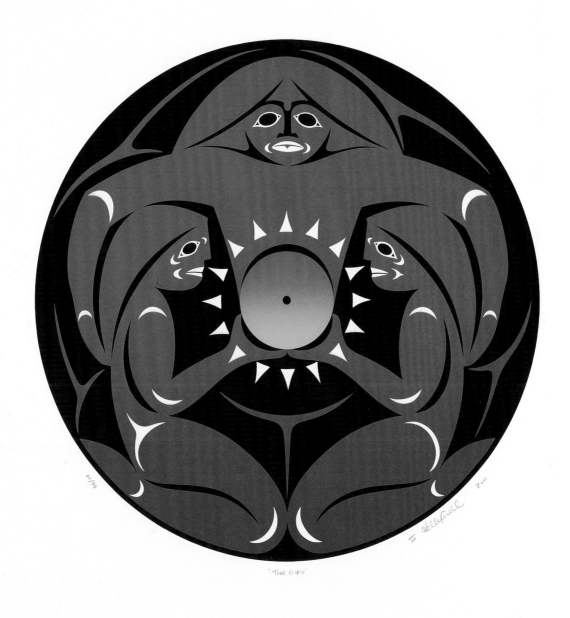

Figure 2.2
The Gift, Kelly Cannell, Musqueam, 2001; serigraph, 25.2 × 25.2 in. (64 × 64 cm). Burke Museum of Natural History and Culture, Seattle, 2004-2/379.

According to the artist, the imagery here represents the passing of knowledge from teacher to student and was created for a school fundraising effort. The title of the piece refers to qualities that educators impart to their students, such as the gifts of enlightenment, empowerment, pride, and strength, in order to keep the circle strong for future generations. Kelly Cannell uses elements drawn from traditional Central Coast Salish design, which she learned from her mother, artist Susan Point.

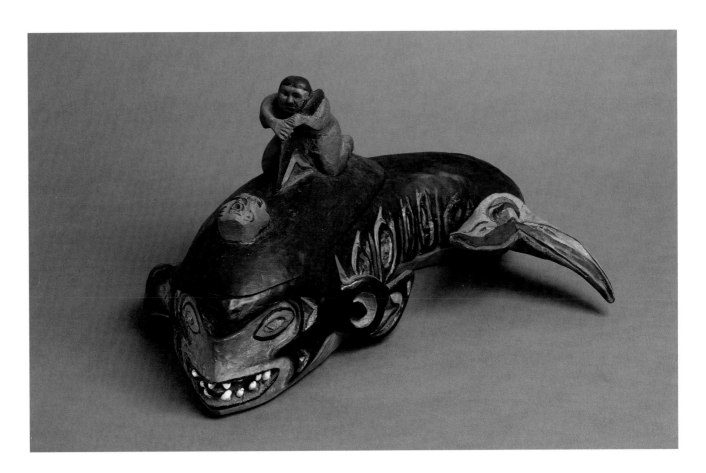

Figure 2.3
Woman and Killer Whale, Simon Charlie, Cowichan, 2003; red cedar, acrylic, 10½ × 18½ × 10 in. (49.5 × 40.6 × 45.7 cm). Collection of Simon Charlie Family.

Well-known sculptor Simon Charlie (1919–2005) carved this piece late in his career, using his unique expressive style that includes bold sculpture and vibrant color. Charlie was raised with the traditional stories that he often expressively depicted in his work. He has been credited with the revival of the Coast Salish style.

the whale skin, they were honored by the energies of the Universe to do just that—they became "one" with the skin. The whale came to life with the boys inside. The boys became frightened when they saw the men from the community approaching them with spears, but they couldn't escape from the whale skin.

The grandfather realized that something wasn't right. He was listening to his "inner knowing" as he had been taught to. He asked the whale, "Are you my grandchildren?" The answer came back, "Yes, grandfather, we can't get out of the whale—we are one now." The message from the Creator embedded in that story is that you must teach all children, even when they are very young. The stories must start when the children are three or four years old, and become more involved as the children age. As they grow, it is time for more in-depth teachings of how to connect with the energy of the Universe and the importance of respecting the teachings. As the stories become more involved, this paves the way for more teachings in the future.

The Little Flea

In another story, the Creator heard crying and it was very sad. He followed the crying and it led him to a little flea. The flea was rolling around on the ground crying. He had dirt and sand on his face and his knees and he was saying to the snail lady, "Stay away from me. Every time you come close to me your slime gets on these things that I drag all the time. I don't know what they are useful for." "Those are your legs you are dragging, but you don't know how to use them," the Creator said. The snail lady looked at the Creator and said, "You are our Father. We called for you so you could help our little brother." The Creator said to the little flea, "You are dragging your legs; you have to use your legs to stand up and you will be taller." "I can't stand; my feet are sore," the little flea cried. The Creator said, "Those are not your feet, those are your knees. You are supposed to be using your legs to jump."

The flea kept crying and said, "You are big and strong, why can't you help?" "Then it will be for me and not for you. But I can show you how to use your own energy and your own energy will help you. See the *sxa'enxwen,* the plantain: go and get some," the Creator said. The little flea said, "Why don't you get it for me?" The Creator said, "Then it would be for me. You need to do it. You need to do it for yourself." The flea was still complaining that the Creator would not help him. He cried, "The plantain is dirty. I don't want to use it." The Creator directed the little flea, "Ask the plantain to help you. Shake it off and put it in your mouth and chew it. You can swallow a bit, but put the rest in your hands and rub your knees with it. Ask your knees to come alive. Ask that the bone disappear and ask that the skin cover the bones. Ask the rest of your body, the breath of your body, to energize the feet below your knees. Ask the plantain to help you and it will."

The flea didn't want to, but he did it. He was in so much pain that he didn't want to do it. It was too much. The Creator told him over and over again to do this to help himself. The little flea began to apply the plantain to his knees and then he started to believe. He was so excited. "I can feel my toes, my toes are moving. I can't see the bones anymore. Look, Father, the bones are disappearing, the bones are being covered with skin." The Creator asked the flea to get up and stand. The little flea slowly got up on his legs and he wobbled and then fell down. The Creator said, "Now hop around, use your legs, you are a flea. You have to think of the words you are using." The flea prayed, "Help me, help me. Please be a part of me—all of me. Help me to be complete—all of me."

The flea jumped over the branch and then he jumped over the log and he started to holler, "I can do it! I can do it! I am using my legs! I am jumping!" The flea was so happy that he disappeared into the bushes, hopping to find his friends. The Creator watched the little flea jumping into the bushes and he said, "*hychqa*—thank you." His hands went to his chest and he disappeared.

This story was told to young children to help them believe in themselves. I like this story because it teaches us how we can support our total body by loving it and understanding what each part is used for. It teaches us how to think, how to believe. The thought is important because you have to believe that you can do something before you actually do it. It is the thought before the action. We believe that we can help ourselves by knowing ourselves. We can ask our own bodies to be strong, to be whole. Can we use the energies of the Universe to do this today? Yes, we can. We believe that young people can become strong and learn how to direct their path through the teachings.

THIS ESSAY FEATURES THE TEACHINGS OF SUBIYAY with regard to Coast Salish art. The teachings come from the written archive of subiyay (hereafter referred to as Uncle) left at his death to his sole heir, CHiXapkaid, and conversations that he had with his nephew concerning the deep meaning and purposes of Salish art. This essay starts with an understanding of Uncle's belief that artists were the first historians and draws upon Uncle's insights regarding art appreciation and the search for immortality. The discussion continues with a recounting of what Uncle had to say about validation and why it is an essential outcome of ceremony and ritual. It is important as well to present some of Uncle's teachings regarding the Coast Salish worldview. He would say that by understanding Salish art one can find meaning and purpose and engage in a deep philosophical orientation to life. Added to this are his thoughts regarding the value

Traditional Teachings about Coast Salish Art

Gerald Bruce subiyay Miller and D. Michael CHiXapkaid Pavel

of oral tradition as recorded in art, with emphasis placed on the concept of knowledge acquired through one's imagination and through the mythological characters shown on the art featured in this catalogue. From a Native viewpoint, mythological characters are reality, or become a reality, and hence serve as a valuable teaching resource for creative imagination and holistic learning.

This essay will then turn to the elements of Salish form and design, which are often referred to as the circle, crescent, and trigon, including the outline element that delimits the boundary of the design field, a feature not often mentioned in analysis of Coast Salish style. Uncle explained that the traditional Salish artist would first conceive the outline form as it would define the space and boundaries of the overall design. Without boundaries, he said, it would be difficult to detail the other elements. The circle was incorporated within the traditional Salish design because of its supreme characteristic: to represent unity and centrality, important concepts to Salish people. "Crescent" is, in fact, a simplistic term that is better understood as traditionally representing phases— phases of the moon, phases of the seasons, and phases of life. The "trigon" is also a

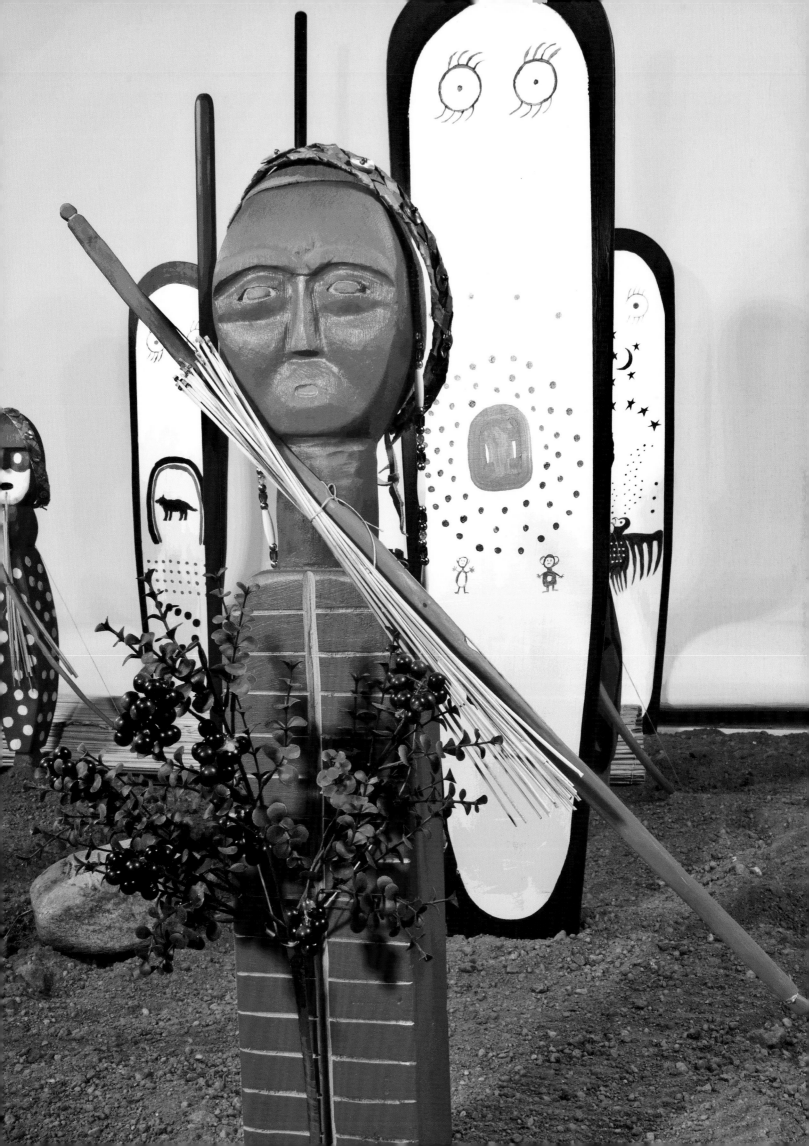

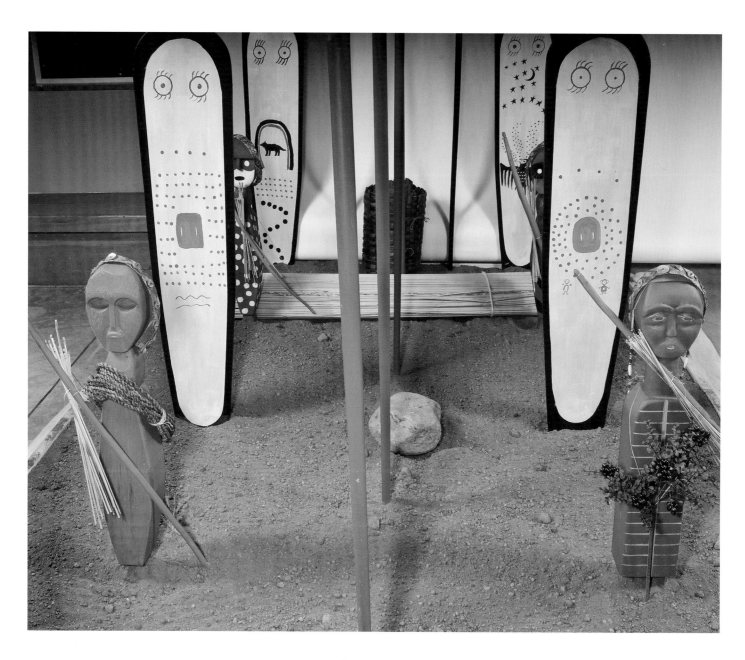

Figure 3.1
Soul Recovery Ceremony, Gerald Bruce
subiyay Miller and D. Michael CHiXapkaid
Pavel, Skokomish, 2005; wood, paint,
cedar bark, grass, imitation huckleberries;
six boards each 60 × 10 × 1 in. (152 × 25 ×
2.5 cm), four figures each ca. 30 in. high
(76.2 cm), four bundles of grass arrows
each 12 in. long (30.48 cm), four bows
each ca. 36 in. long (91.44 cm), one cedar
mat 120 × 36 in. (304.8 × 91.44 cm),
cedar bark rope 360 in. long (914.4 cm),
one rock. Collection of D. Michael
CHiXapkaid Pavel.

This shows a detail of *SHtSa'b* (Soul Recovery Ceremony)
paraphernalia during a break in the ceremony. Those who
had *sb3t3da'q* (soul recovery power) would rest and leave things
dormant on occasion during a three- to four-day ceremony to
and from *a'hLqW3hL* (first land of the dead).

Figure 3.2 (preceding page)
Detail of 3.1

This is a *t3bta'baxW* (earth drawf), an entity that grants soul
recovery powers to a highly trained *b3swa'dasH* (one who possesses
shaman power). There were different types of *t3bta'baxW,* and this
one might be considered from the family of *shuyaXad* (edge-of-
the-earth beings). However, intimate knowledge of the items of the
Soul Recovery Ceremony is considered the private property of the
owner and is not publicly or widely known.

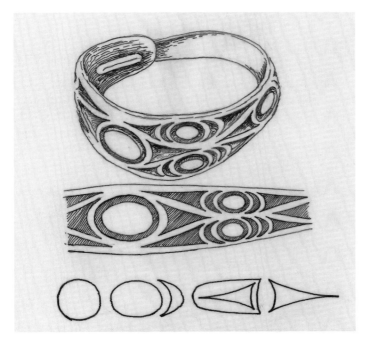

Figure 3.3
Coast Salish design elements.
Drawing by Kenneth Greg Watson,
2008.

As one examines the countless ways in which Coast Salish design is engraved onto wood, stone, and bone sculpture, it is surprising to learn that only a few foundational elements are used, just as they have been for the last two thousand years. The outlines or profiles of humans, animals, and supernatural creatures are the "positive" aspects of the engraved design, while the circular, crescent, and three-pointed U-shapes (often called trigons) are carved out to help define the anatomical features of the subjects. These features—such as their feathers, eyes, ears, beaks, bones, and other body parts—are the "negative" design elements (see Kew 1980; Feder 1983; Brown 2005). The artist can employ a few of the elements, creating a simple yet elegant visual effect, or the artist can choose to use complex combinations of the core shapes to create varying dimensional depth, visual puns, and dynamic compositions.

misdefined term more correctly explained as an element that has four points (three surface points and a fourth inner point), and Uncle referred to the inner one as simply a deep cut or fourth element.

Art Appreciation and Immortality

Uncle felt deeply about the role of artists in the quest for immortality, and he was known to express the sentiment that aboriginal artists maintained the oldest teachings and were the first historians. This role of culture-bearer was one that Uncle assumed in his short life. He liked to pose philosophical questions like "What is art?" coaxing you to look at art from both universal and human perspectives and to ponder the impact of art on humanity. He wanted you to think about the art that you created, and encouraged you to share what you enjoyed about it. Uncle always took pleasure in artists and work that was authentic and culture-oriented.

Uncle would have you, as a viewer of the art featured in this book, consider your own definition of art and what you visualize when you think of the word "art." He found

Figure 3.4
Cedar mat, Gerald Bruce subiyay Miller and Karen Skyki Reed, Puyallup/Chinook, 2003; 74 × 53 × 1½ in. (187.96 × 134.62 × 3.81 cm). IslandWood, a School in the Woods, Bainbridge Island, WA.

Gerald Bruce subiyay Miller learned the traditional methods for harvesting cedar bark from his elder relatives, including Emily Miller, a basket weaver and doll maker. Because he believed that it is vital to pass on different teachings and skills to each of his apprentices, he taught Karen Skyki Reed and some others the art of working cedar bark. Reed's Puyallup ancestors were expert basket makers; she also learned from her grandmother Hattie Cross (Skokomish), Beatrice Black (Quileute), and Anna Jefferson (Lummi) and was inspired by the work of Hazel Pete (Chehalis) (see Blanchard and Davenport 2005).

that many people identify with particular forms and that art helps us validate our own personal identities. Visual styles unique to cultural groups also allow indigenous people to identify with their group, a particularly important concept. Furthermore, Uncle visualized and defined art as connected to immortality. In Coast Salish oral traditions, as in many others around the world, the Creator brought forth the first humans to exist in this world as perpetual living entities—as immortal. They were provided with everything they needed in order to survive, and they could live without knowing what it would be like to want for anything. All that was required was that they be satisfied with what was given them and respect the laws laid down for their benefit. In some stories, the first human people could not appreciate what they had because they had never been without. The laws were disregarded, and as retribution the Creator took eternal life from them. Since that time, the human people have searched for ways to circumvent their eventual deaths and leave something of themselves behind. There were many ways that this might be done. Some individuals handed down ancestral names to their children, while some chose to become storytellers and oral historians. Still others would become proficient at a craft or become song composers, culture heroes, or renowned leaders. In some circumstances, the choice was to become an artist.

With the advent of written languages, people's names and other textual graffiti were left in places occupied by human people. Before written languages, we bear witness to hand prints, cave paintings, and petroglyphs created by early humans to record their presence as they lived, hunted, or passed through on their way to some destiny. Art thus gives humans a means of immortality. Twenty thousand or more years ago, an artist left an image on a large rock, and although the artist's mortal remains are long gone, the expressions he or she made intrigue us today and will do so long into the future. Likewise, entire ancient cultures that have long since vanished leave behind what anthropologists call "material culture" and provide us with a glimpse into their physical appearance, beliefs, ceremonies, and social organization. So it is that these ancestors become immortal. Uncle would ask you to think about what

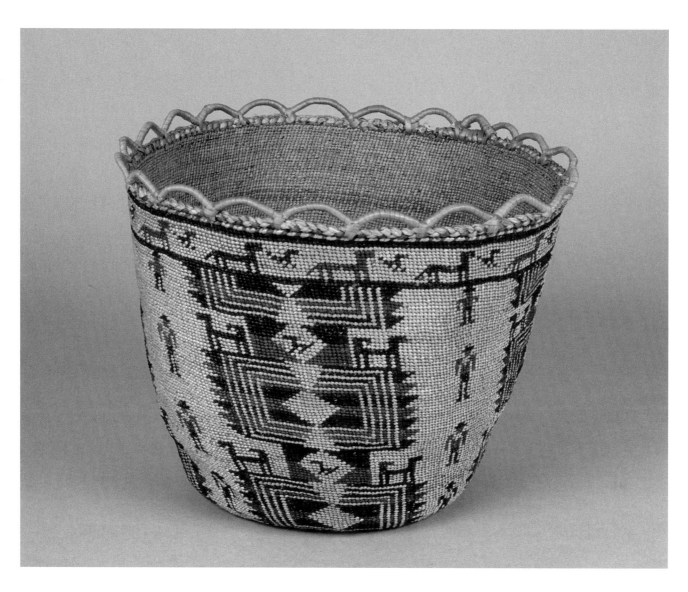

Figure 3.5
Basket, Twana (Skokomish), nineteenth century, cattail leaves, bear grass, cedar bark, 11 × 11¾ in. (27.94 × 29.84 cm). Burke Museum of Natural History and Culture, Seattle, 1-507.

Twined of cattail leaves and decorated with dyed bear grass and cedar bark, this Twana basket employs a distinctive and masterful combination of geometric and figurative motifs that begs the viewer to contemplate its message. While the design elements seen here are recurring—humans with top hats, dogs with upturned tails, wolves with downturned tails, merganser waterfowl, and rectangular shapes accented with alternating colors—no two Twana baskets are alike. The designs were the prerogative of families of weavers and were derived from natural features of the environment (the diamond-shaped flounder caught in a container), oral legends ("crow's shells," the triangular motifs that flank the rectangular boxes), or modern features of life (the man with Euro-American clothing and top hat). The rectangular shapes are puppy pens, perhaps referring to the areas used to contain the prized wool dogs.

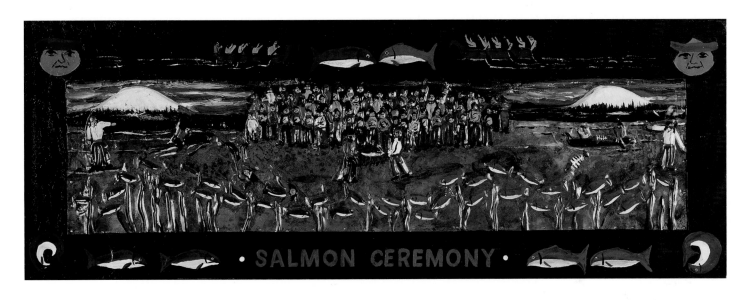

SALMON CEREMONY

Figure 3.6
First Salmon Ceremony, Ron Hilbert Coy
čadəsqidəb, Tulalip/Upper Skagit, 1978;
wood, acrylic, copper, 25 × 15 × 3 in.
(63.5 × 38.1 × 7.62 cm). Gift of Vi Hilbert,
in honor of the 75th anniversary of the
Seattle Art Museum, 2005.175.

Ron Hilbert Coy's painted copper piece depicts the honoring of the salmon, the principal food for Coast Salish people. The scene pictured here cleverly merges the sequence of events: songs sung to welcome the first salmon of the season; the salmon carried in a cradle of cedar boughs; and the ceremonious return of the salmon to the water so it could tell its relatives of the reverential treatment given it by humans. Because of cultural repression and the struggle to maintain subsistence fishing, this and other community celebrations were curtailed but have been revived again in more recent times. The First Salmon Ceremony was reinstated among the Tulalip in 1979, and the First Salmon and First Elk Ceremonies were revived at Skokomish with the assistance of Gerald Bruce subiyay Miller.

immortality means to you and how you would feel about the possibility of never being remembered.

Artists intended for ancestral heirlooms to be handed down through the generations and preserved along with their stories. In this way art connects the past with the generations of today. If the recipients remember the stories, our ancestors will remain immortal. If the heirlooms are conserved and respectfully displayed, we can better understand our ancestors' own quest for immortality.

To aid your visual analysis, Uncle would prompt you to look, say, at a basket as being more than just a basket. What story does the basket tell? Look at the examples of basketry in this book. Compare what you see. How many clues can you identify? Look again and compare the designs that you are able to identify. What does the maker of this basket want you to know? Think about the fact that artists, like the basket-maker, might be the only conduit of precious information by which Coast Salish people today remain connected to their ancestors.

Validation through Ceremony and Ritual

Many of the artworks in this book are ceremonial and ritual in nature. Ceremonies and rituals offer validation by allowing us to acknowledge and honor one another in a culturally accepted manner. They can include song, dance, feasting, storytelling, and gift-giving. These acts validate our existence by being performed with community participation and thus receive group recognition. Our lives are also dominated by personal rituals that involve an intimate giving of thanks for the Creator's gifts, or that we rely on when we experience misfortune or prosperity.

As a true validation and recognition for both individual transformations and group achievements, ceremonies bring people together and demonstrate cultural bonds. They are enacted in order to pass on family privileges, such as property, stories, and regalia; to celebrate marriages; to give ancestral names to children; to honor the deceased; to acknowledge the gifts of plant, animal, and maritime resources; and to highlight achievements. There are even ceremonies to show support for those in need of help as a result of personal misfortune or tragedy. Feasting is an essential component and serves to feed the body, mind, and spirit.

The Rite of Passage

Of the tribal rituals, the rite of passage is probably the most important. All of the art featured in this book was created by people who survived beyond puberty. When the human people, the four-legged people (animals), or the winged people (birds) attain maturity, physical changes drive them to seek challenges that will determine their fate and place within the group. If adults think back to their youth, from puberty to age twenty, they will remember a time of thrill-seeking, risk-taking, and competitive behavior that challenged the status quo. Uncle felt that these energies had to be properly channeled. The rite of passage was a ceremonial rebirth in order to leave the youthful

Figure 3.7
Spoon, Nisqually, nineteenth century, mountain sheep horn, 9 × 5 × 2½ in. (22.86 × 12.7 × 6.35 cm). Harvard University, Peabody Museum, 06-510/66378.

Ceremonial feasting was always an important ingredient of any community or intertribal gathering and still is today. With its social, economic, and religious aspects, feasting on traditional foods—berries, bulbs, shoots, nuts, fish, shellfish, and meat—provides physical as well as spiritual sustenance. Spoons, ladles, dishes, and bowls were carved by specialists, sometimes having simple, elegant shapes and decorations, and other times made with quite elaborate embellishments.

Figure 3.8
Oil dish, Quinault, nineteenth century, alder, glass beads, 12 × 2½ × 1¾ in. (30.48 × 6.35 × 4.44 cm). Collected by Rev. Myron Eells. Maxey Museum, Whitman College, WHIT-E-0150.

Imagine that you are a guest of high standing and are being presented with this extraordinary dish filled with seal oil, into which you will dip your pieces of dried salmon or halibut. During the course of the lavish meal, you might learn about the story associated with the dish—perhaps a long-ago ancestral encounter with a sea monster. The original interpretation of this creature was not collected by Myron Eells when he obtained the dish itself, yet it remains a unique and marvelous piece of sculpture (see Castile 1985).

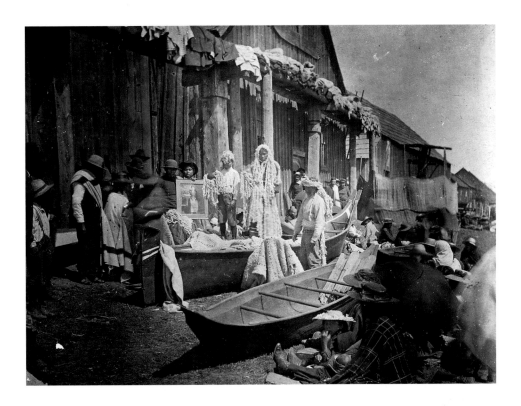

Figure 3.9
Quamichan potlatch (believed to be the last potlatch) and *sxy-whee;* the two children standing represent members of the family who have died. *Sxy-whee* is a dance performed to honor a loved one. Quamichan, British Columbia, about 1913. Photographer unknown. Royal British Columbia Museum, BC Archives, AA-00154.

This photograph shows a boy and girl receiving hereditary names. They are enclosed in spiritually protective goat-wool headdresses while receiving the treasured names of deceased relatives, probably those pictured in the photograph held up for guests to see. The conferring of an ancestral name brings with it a lifelong responsibility to uphold the honor of the name and links one inextricably to one's kin. This naming probably took place during a potlatch at Quamichan village; the blankets folded on the roof of the porch will later be thrown down as gifts to the witnesses below.

life behind and to begin embracing adult roles and responsibilities. It was a ceremonial means of attaining adult status in the culture group. We were taught by our salmon ancestors that to return home and give birth is a strenuous physical challenge necessary to transform us. Only the strong survive. Uncle believed that a person who had never endured hardship or been deprived of the comforts of life could never have the resilience to be a true leader. He felt that a person who had never undergone a rigorous ritual deprivation could not survive in unforeseen circumstances, especially if all security as they knew it was ripped away.

The Salish rite of passage is the Spirit Quest. It requires abstinence from food, sleep, personal comforts, sexual relations, and the security of home and loved ones. It demands rigid self-discipline and self-truth and is a means of positively channeling pre-adult energy. When the challenge is undertaken, the initiate is ritually dressed and prepares to leave an old life behind and to be brought forth to the Creator to bond with a spiritual guardian. The community is called to participate, and witnesses are called to validate the completion of the quest. In this way, the community acknowledges and celebrates the emergence of a new member of the society.

When a rite of passage is lacking in a society, it leaves unfulfilled the ancient drive to take one's place within the social hierarchy. The unchanneled energy of the youth is then prone to develop into dysfunctional behaviors such as juvenile delinquency, gangs, cults, antisocial behavior, and substance abuse. This compelling need to belong is so strong that even gangs have rites of passage that a person must undergo to be accepted. Because the desire to make this transformation has a subconscious element as well as a ritual one, when the rite of passage is not available the challenge to answer its call becomes located somewhere else.

Naming

The public bestowal of a traditional name—a naming ceremony—was another ceremony that carried treasured teachings. An ancestral name like "subiyay" was one of the most valuable forms of wealth that a person could own, and the person holding an ancestral name commanded respect by his or her peers at ceremonial functions. A name was like a garment; it could be soiled and devalued or it could be honored and cared for. One had to earn the right to have a publicly conferred ancestral name. Family elders determined who would become the recipient of a name formerly held by an esteemed ancestor, and they would go to great expense and effort to produce and secure high-class items to be given away to special witnesses and guests. Families often saved for years to put on a ceremonial naming. The value of the ancestral name determined the amount of material wealth that the host family distributed to guests. Some of the items pictured in this volume could have been gifted at such a ceremony, including finely woven robes and baskets and exquisitely carved bowls and boxes. (See, for example, figs. 3.10–3.12.)

Official witnesses known for their integrity and traditional knowledge were called to validate the bestowing of the name on an individual, and publicly offered advice on the responsibility of carrying that name. Extended-family members and guests honored the event through their presence. The recipients of the ancestral names were reminded that their actions from that day on would affect the honor not only of themselves but of their families and their tribal community. A person's improper behavior could sully a name as surely as the physical act of crawling in the mud would dirty one's garment. A name that is disrespected loses its value and the respect of the community. Because the name is connected to a family, that family loses respect as well. The Coast Salish believe that without a name we are destitute and lack resilience. If we have lost the ability to respect ourselves, then we have lost the value of the names that we carry. The need to be recognized is part of the character of being human. When we lose our good name through bad deeds, we lose our self-esteem. When we lose respect for our name, we lose our sense of belonging.

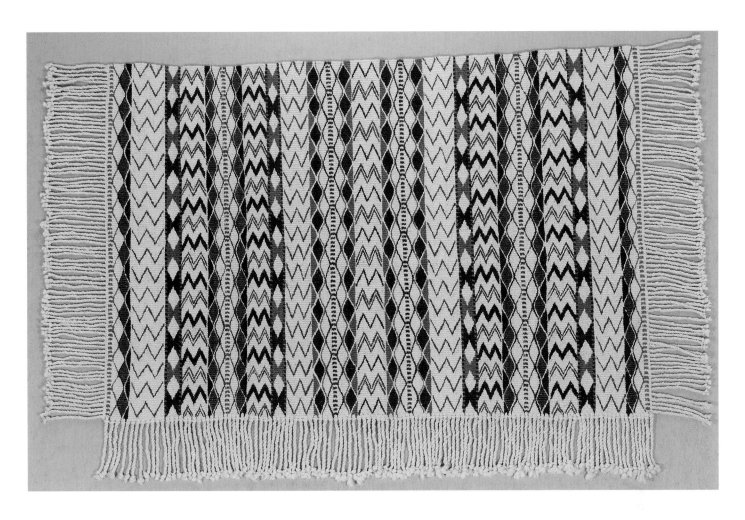

Figure 3.10
du'kWXaXa'ʔt3w3l (Sacred Change for Each Other), Susan sa'hLa mitSa Pavel, 2007; mountain-goat wool, dyes, 55 × 85½ in. (139.7 × 217.17 cm). Gift of Charles and Gayle Pancerzewski, in honor of the 75th anniversary of the Seattle Art Museum, 2007.38.

In 1989, Fran and Bill James created the first twill-weave robe in many generations to be woven of mountain-goat wool. Susan Pavel's robe is the first fully twined robe to be woven of mountain-goat wool for nearly one hundred years. To mark the recent revitalization of Salish weaving and the resilience of this art form against all odds, Salish weavers from near and far were invited in January 2007 to wear their robes to the "naming" ceremony of *du'kWXaXa'ʔt3w3l* at the Evergreen State College Longhouse. According to the weaver, this robe is more than just a garment; it is a feminine entity that has come forth to bring a message of hope and inspiration to all through her teachings. The sacred change referred to in the title notes the resurrection and revitalization of Salish traditional culture. The vertical wavy lines, coupled with horizontal zigzag lines, represent the energy that emanates from all life forms—the life force. The dash motif between the sets of wavy lines is the spine or backbone, reminding us to be strong against life's challenges. The fringes of the robe have tied ends, a lesson about not leaving things undone and unfulfilled.

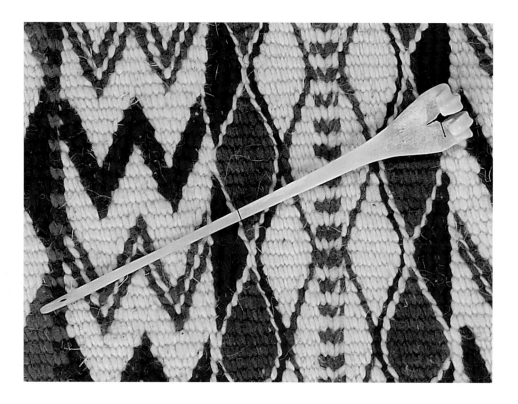

Figure 3.11
Bone blanket pin, D. Michael CHiXapkaid Pavel, Skokomish, 2007; deer bone, 9½ in. (24.13 cm). Gift of Charles and Gayle Pancerzewski, in honor of the 75th anniversary of the Seattle Art Museum, 2007.40.

This pin, carved from the leg bone of a deer, carries an important teaching put forward in a story told by Gerald Bruce subiyay Miller: to honor the gifts of the earth and of people to each other lest they be revoked. Pointed pins hold together the sides of wool and cedar bark textiles when they are worn. Such pins have been found in archaeological sites (see fig. 6.11). Michael Pavel carved this pin to accompany *du'kWXaXa'ʔt3w3l.*

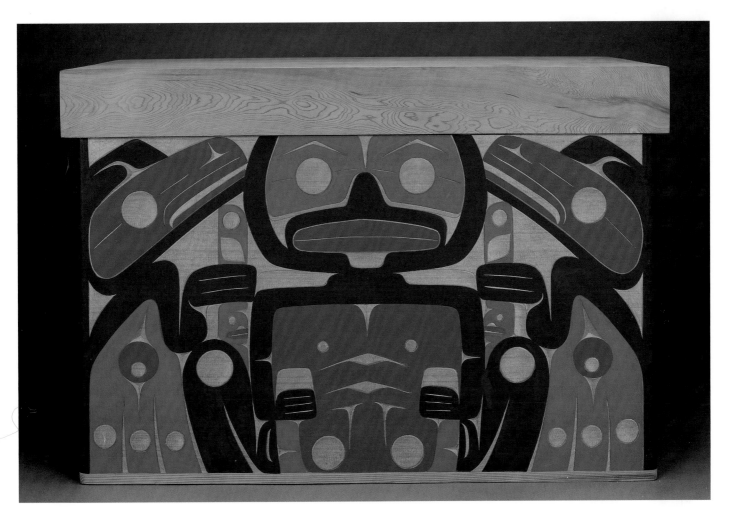

Figure 3.12
The Naming Ceremony, Andy Wilbur-Peterson, Skokomish/Squaxin, 2007; red cedar, paint, 22 × 32 × 19 in. (55.9 × 81.3 × 48.3 cm). Gift of Charles and Gayle Pancerzewski, in honor of the 75th anniversary of the Seattle Art Museum, 2007.39.

Andy Wilbur-Peterson is well known for bent-corner boxes and chests, an art form he and his uncle Peter Peterson revived at Skokomish. He was also taught by weavers Louisa Pulsifer, Emily Miller, and Gerald Bruce subiyay Miller. Like many artists of his generation, he began his artistic career working in Northern Northwest Coast design because there were teachers to learn from and because the style was recognizable to collectors. Growing up in his ancestral homeland, Wilbur-Peterson learned to hunt and fish and preserve Native foods, and he was taught Skokomish history and stories. But it wasn't until he saw museum displays of Salish art forms that the desire to carve in authentic Salish style was awakened in him. He imparts his own bold interpretations of Salish elements to his own designs.

Worldview

Uncle said that probing the deeper meanings that live within art is a search for meaning and purpose in our lives, as well as an engagement in a deep philosophical orientation to life itself. Uncle's teachings help us to think about Salish culture from a holistic point of view that characterizes many, if not all, indigenous values. He said that although values are not always visible, easily articulated, or upheld in every situation, we are subconsciously and consciously influenced by them when making choices, when identifying who we are and to whom we belong, and when defining our worldview.

According to Uncle, Salish artists accept the responsibility to transmit the history of their people and to convey traditional teachings through the story that each artwork holds. Each entity that evolves from the artist's realized inspiration or request through hereditary channels is a sense of life brought forth to enrich people from generation to generation. There is much more at stake than producing art; artists gain unique spiritual powers by living the values encompassed within the Creator's teachings.

Values play an important part in our introspective view, individually and collectively speaking. Uncle explained that values and philosophy go hand in hand. Philosophy is a search for a general understanding of values and reality by chiefly speculative means; it is an overall vision of life as well as the purpose of life. Philosophy plays an integral role in how and why we view ourselves as a part of the whole. Within this philosophic view of self and others, most of us see ourselves from a holistic perspective. People with this perspective conceive of the universe, of living nature, and of themselves in terms of interacting wholes that are more than just the mere sum of elementary particles. In conducting our traditional ceremonies and rituals, this is often called "to work in one mind and in one spirit."

Value of Oral Tradition Recorded in Art

Conveying knowledge and experience through visual art enables the Coast Salish to record teachings through the use of oral traditions. The artworks illustrated in this book carry stories relevant to the lives of Coast Salish people. In turn, the more we know about their lives, the more we might become familiar with the teachings and the more we might develop an interest in participating more comfortably in the teachings of the stories. One result of participants taking an active part in relating to our stories is that ultimately they will communicate with us in ways that are respectful and that convey appreciation for our teachings.

Knowledge acquired through one's imagination should be given credence, according to Uncle. Imagination, in its basic form, means creating images that are beyond the five senses. The mythological characters found on Salish artworks (little people, animals, birds, or spirits) stimulate the imagination. From the traditional viewpoint, mythological characters are reality, or become a reality, and hence serve as a valuable teaching resource for creative imagination and holistic learning. Imagination, if utilized creatively, can be a valuable tool for self-discovery, for exploring the realities of our

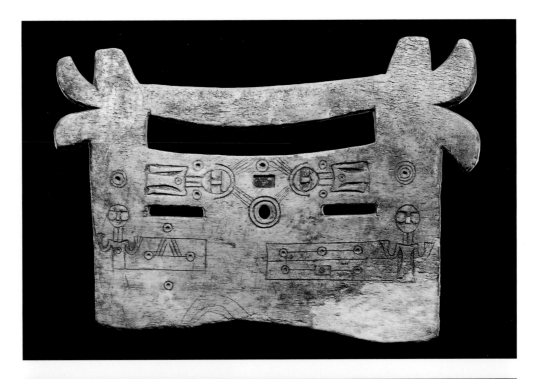

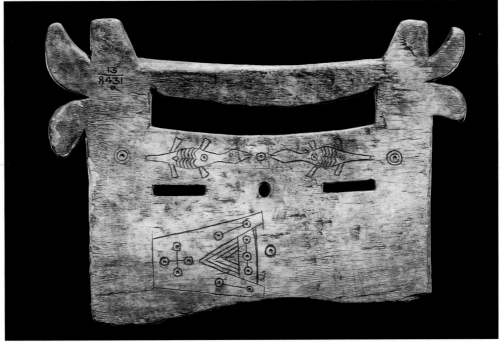

Figure 3.13 a and b
Bark shredder, Quinault, late nineteenth century, bone, 8½ × 6 in. (21.59 × 15.24 cm). Collected by F. W. Skiff in 1925. National Museum of the American Indian, Smithsonian Institution, 138431.

This shredder has the oft-seen features of unidentified animals on the sides flanking the handle. Unusual features are the engraved human and quadrupedal creatures, perhaps associated with shamanism, shown in a graphic style of the Lower Columbia River tribes. Nucleated circles are frequently engraved on Columbia River horn bowls and tools and are painted or engraved on Southern Salish–style wood sculptures. Among the Salish, these are sometimes referred to as "song dots" and may have served as mnemonic devices for remembering words, songs, or chants. The meaning of the graphic elements seen here and their relationship to the bark shredding tool are not known.

Figure 3.14
Rattle, Cowichan, ca. 1860, mountain sheep horn, wood, sinew, buttons, 14 × 6½ × 2 in. (35.56 × 16.51 × 5.08 cm). Gift of John H. Hauberg. Seattle Art Museum, 83.236.

Made from steamed mountain sheep horn, these special rattles are carried by families who have the ancestral right to use them in healing rituals. They are kept out of public view and their meanings are never revealed to outsiders. Special words activate their power. The horn chamber is filled with rattling agents and is fastened to a wooden handle, but this rattle is missing its long rovings of mountain goat wool.

With a great sensitivity for the oblong design field, the artist depicts the profiles of two birds that surround a human or spirit face, indicating eye, ear, and feather forms with deeply carved crescents, and three-point U-shapes (also called trigons). The wood handle terminates in a sculpted bird head with an incised bird face below it. On the Northwest Coast, birds are often considered to be special spirit helpers of the shaman.

world intuitively, and for teaching people how to develop the right hemisphere of their brain. In this regard, oral histories recorded in art are indeed valuable because they contain another form of reality relevant to modern society and human experience.

Delving into the meanings represented in Salish imagery can teach a person how to effectively use imagination in order to think more holistically. For example, oral histories recorded in art reference certain phenomena in Nature. This knowledge can and does open our unconscious minds to rare forms of natural knowledge concerning our Earth, Universe, culture, heritage, and even our own souls. Art teaches us ancient ancestral knowledge and can therefore reveal secrets to us that modern science has not yet discovered or learned to verify appropriately as a natural reality. But more importantly, art serves to bind us to the Earth, a necessity for our survival as a species, which is an integral part of Nature itself.

Our oral histories serve to apply the knowledge inherent in our cultural worldview. In this way, art forms, especially when used in ritual, transmit important cultural beliefs, thus promoting social solidarity and cultural continuity. Oral histories recorded in art provide an opportunity for the society to learn together, especially if ritual and art are connected.

Many ceremonial items, such as the ones seen in this book, can serve to teach a person how to move from the cosmic consciousness to the individual consciousness, and then into group collective consciousness. For example, you need to understand the historical and spiritual significance of a sacred rattle if it is to be used to induce the cosmic consciousness where spirit helpers intervene in human affairs. You experience individual consciousness by learning how to hold the rattle properly so as to bring it to life with your life force. Group collective consciousness occurs when the rattle is used in ceremonies and rituals involving other people who have shared core values and teachings.

Uncle professed that the symbols in the subconscious minds of Native children are culturally based and archetypal. He also believed that the basis of the language is unique for Native people, as are cultural beliefs, practices, values, behavior patterns, and ways of thinking. Native children, on and off the reservation, are influenced, consciously and unconsciously, by their genetic mind/brain complex. Uncle theorized that even the more assimilated Native child is influenced by a genetic cultural patterning and inherited symbolic mind/brain complex. If this is true, then the symbols and archetypes recorded on Salish art become an even more vital learning tool for Native children and would serve to activate the child's latent potentials.

Art Elements: Outline, Circle, Crescent, and Fourth Element

Uncle explained that the traditional Salish artist first conceived the outline form to define the conceptual space and boundaries of the overall design. In essence, the outline form would become the way to interconnect all the other elements. Coast Salish people view themselves as being interconnected with and part of everything, and this is reflected in our art. We see ourselves and our world from a holistic perspective and believe that humans, all of the natural world, and the Universe form a whole entity that is more than just the mere sum of its parts. Uncle made it clear that the interconnectedness of all things, living and non-living, is central to our belief system. The idea that human beings are but a small part of the larger fabric of the universe is a theme frequently heard in many tribal oral traditions.

The circle was described by Uncle as a prominent design element in traditional Coast Salish art because it represents unity and centrality. The circular form is seen throughout Nature, for instance, in the sun, moon, and sky. Birds make their nests in the form of a circle. We see the horizon as a great circle. The seasons of Nature and of human life are cyclical: birth, childhood, adolescence, adulthood, and old age are a kind of circle. The philosophy behind the circle is one of closure, completion, and empowerment. For tribal peoples, all important decisions are made within a circle and vital information is imparted in a circle.

We use expressions such as "social circle," "circle round," "come full circle," and "talking circle." To get to the conclusion of a problem we must return to the beginning—another circle. Within this philosophy everything is related and linked, like the ripple

Figure 3.15
Spindle whorl, ca. 1800, wood, diameter 8 in. (20.32 cm). Department of Anthropology, Smithsonian Institution, E221179E.

The sinuous creature delicately carved into the darkened wood (perhaps maple wood) bends a flexible body around the circular whorl to catch his tail in his mouth. The series of crescent and trigon shapes that might represent his spinal anatomy drive the flow in a circular direction, imparting a perceptible sense of motion or activity. Both the economy of carving and the particular structure of the eye are reminiscent of older styles, suggesting a much earlier date of manufacture (ca. 1800) than the time this piece was collected—at the turn of the twentieth century (Brown 2005: 11).

effect. Our personal actions influence others, beginning with our immediate families, then our friends, our community, and finally our tribe. What we do to the earth will be done to us. In the philosophy of the circle it is important to consider how your actions affect yourself, your people, and the generations yet to come. So to do positive (or negative) things to oneself is to do them to others.

The crescent is better understood by traditional Coast Salish people as phases, such as phases of life or phases of the moon. Uncle characterized this as marking the passage of time in seasons rather than weeks, months, or years. The passage of a day was not marked by seconds, minutes, or hours but by the position of the sun and the moon, by the tides, and even by our internal senses. Social time shared in common is important. Rather than marked by years with numbered names, history is recorded by a sequence of major events. For instance:

> The time the Northerns attacked us,
> the treaty time,
> the year of the spotted sickness,
> the time a volcano erupted,
> the time of so-and-so's potlatch, and
> the year the trees exploded in the cold.

Personal time is marked by:

> My puberty ceremony,
> my vision quest,
> when I got my name,
> when I married, and
> when I got my first deer.

The seasons do not occur on specific days of the year, like March 21; instead, they begin when Nature chooses. Uncle recorded this transition in one of his weavings, entitled *Frog Snow Robe* (fig. 3.16). When the snow melts, the frogs croak, thus awakening the salmonberries. Ancestral teachings do not occur with the turn of the calendar page but begin when the energy is right, not at a specific minute in an hour.

The evening hours are considered to be the most productive time to teach and counsel. By that time of the day the body has expended its excess energy and the mind is more willing to contemplate the meanings embedded in the oral teachings. The nighttime fire serves as a tool for visualization as the flames display the myriad forms of the modified crescent. The shapes of the flames are mimicked in the repeated crescent shapes of Coast Salish art and serve as an aid to focus the mind's eye on the information being visually conveyed. When important teachings are presented at night, they are the last thing we hear before going to sleep. This is why we remember bedtime stories well into our adult years. Nighttime was when the stories came out that taught us about

Figure 3.16
Frog Snow Robe, Gerald Bruce subiyay Miller, Skokomish, 2003; sheep wool, natural dyes, 47 × 60 in. (119.38 × 152.4 cm). Collection of Anna H. Chavelle, MD, and Christine Knutson.

Gerald Bruce subiyay Miller saw his art as inextricably connected with his life. He was a storyteller who used the earth's materials to craft the stories that were so dear to him and in which he believed. Art was a means of teaching and, in this case, teaching about the cycles of nature and how the entire web of life is linked to cyclical change. According to him, in the late winter when snow is still in the air, the frogs announce the impending change to spring and the emerging salmonberry sprouts. A fine, end-of-season sleet comes, making way for the salmonberry blossoms. This sequence of events and the transition from winter to spring are masterfully revealed in this textile. The white color corresponds to the snow of winter—frog snow—while the gray represents sleet and rain. The green color on the border signifies the salmonberry shoots, and the red color, the salmonberry blossoms.

morals, often through the activities of culture heroes like Mink and Raven who, through their behaviors, provide models for character development.

The only training considered to be proper for daytime was physical activity and hands-on participation that would help to develop life skills. It is believed that in the daytime our psyche and soma energy are too hyperactive to focus on and retain important intellectual information.

Uncle did not want to provide a technical definition for the fourth prominent element in Coast Salish design: the trigon. If anything, he would say that it reflects light. What was most important to him was that this design element had four points, three surface points and a fourth inner point. This quadripartite aspect was central to our teachings because four is a ritual number: there are four major directions, four seasons, and four stages of life. Sacred gifts are offered to the four directions, and they are offered four times. The medicine wheel is divided into four parts, which represent the four aspects of human nature—the physical, the mental, the emotional, and the spiritual. Ceremonies were aimed toward maintaining or regaining harmony by incorporating each of these four aspects of human nature. Among other Native peoples, similar ideas may be expressed as the four grandfathers or the four winds, each possessing a different teaching attribute.

Conclusion

Together, the four aspects of Coast Salish design—the outline form, circle, crescent, and the fourth element—enable the traditional artist to create a spiritual map. Whether they depict people and animals, or environmental features such as water, or the celestial realm, all traditional Salish designs share a common characteristic of being a map or guide to a spiritual domain that defies the earthly laws of physics, particularly concepts of time and space. When done properly, the object becomes a vortex that can usher one into the supernatural realm, or open a pathway for spiritual entities to enter the corporeal realm.

The beautiful artwork presented here is a legacy that shows our pride and identity as Coast Salish people. To Uncle, an artist put his "living breath" within his work and, thus, became immortal. As an artist, Uncle put his "signature" on everything he made, and created a memory we have of him that will last until the end of time.

The items shown in this book represent a rich repository of educational materials. Uncle taught us that the plant and animal people were the first teachers. They appear often in the art. Whether the artist is making an implement for everyday use or a ceremonial item, it is important to recall the teachings while gathering and preparing the materials for these sacred resources, such as cedar wood and bark. We are told that plants were created first and their purpose was to hold the earth together for others who would eventually come along in the future. They were instructed to develop the strongest method of teaching possible, and that is called teaching by example. Teaching by example means to show or demonstrate a teaching, and that is what the plant people do

Figure 3.17
Kimberly Miller stripping cedar bark
on the Skokomish Reservation.

Basket weaver Kimberly Miller shows Winter Strong how to pull
cedar bark from a tree. Each weaver has his or her own prayer for
approaching the tree and asking for its beneficence. Bark is taken
in spring when the sap is present, making it easier to get a long,
unbroken strip. Only a small piece is removed from the living tree
so that the tree can survive. The coarse outer bark is then separated
from the inner bark, which will be seasoned before it is split into
smaller strands for weaving.

if we are willing to learn. In our traditions, the animals were the next to be created. They were told by the Creator to live through all the trials and tribulations of life. The various events that animal people experienced are told through the stories of their struggles of survival and are carved or woven into the art. The oral and visual stories serve as teachings for the human people who are yet to come. The powerful teachings embedded in these stories brought forth the moral and ethical values that would guide humanity. Even today we invoke comparisons to animals, their behaviors, and their characteristics when we say things like "She is clever like Raven." Animals set forth the basis for human reasoning and give us a connection to the beginning of time.

Oral teachings were considered to be so important that a Skokomish tribal elder once stated to Uncle that the written word is just a mere shadow of the spoken word. An eloquent speaker can bring a story to life with his inflections, innuendoes, nuances, and pauses. He can paint a vivid picture using his words for the paint and our minds for the canvas. Uncle was such a gifted orator and his words live on in our memories and in recordings made of him.

As you look at these artworks, remember that the Coast Salish also value the contemporary ways in which our artists tell our stories. While it may seem tragic that the old art style and the traditional role of the artist underwent radical changes, we have persisted. In honor of all the artworks and artists featured in this book, Uncle would have said that people will see, feel, and dream about the Coast Salish in a way that reflects the good work the artists have done and the teachings conveyed through their art.

The following is a previously unpublished paper, presented by my late father, ethnographer and linguist Wayne Suttles (1918–2005), at the 1998 Northwest Coast Art Symposium at the Otsego Institute for Native American Art History. This is the text as written by my father in 1998, with the exception that I have integrated revisions in his thinking expressed in a brief paper he presented a year later at a Native American Art Studies Association conference. I've also made edits throughout for clarity, revised Native names and words to reflect currently accepted spellings, and identified artists and artifacts included in the accompanying exhibit.

—Cameron Suttles

The Recognition of Coast Salish Art

Wayne Suttles

TODAY PROBABLY MOST ADMIRERS of Northwest Coast art would recognize a Coast Salish spindle whorl, mask, or rattle. They might even recognize a particular piece as Central Coast Salish or Halkomelem in provenience and one carved in a distinctive incised style identified by Norman Feder (1983) and Michael Kew (1980). But this has not been true for very long. Northwest Coast art, at least Northern Northwest Coast art, has been known to anthropologists since Franz Boas's publications of the 1890s and to the art-viewing public since around 1940. But to the south, Coast Salish art in general and this style in particular did not gain recognition until about 1980, nearly ninety years after Boas's initial work.

In his 1897 work on Northwest Coast art, Boas took all of his examples from the Northern Northwest Coast, except for four Kwakwaka'wakw house fronts, and there was no mention of Bella Coola (Nuxalk), Nootka (Nuu-chah-nulth), or Salish art. In his *Primitive Art* (1927: 281–89), Boas considered some Coast Salish pieces in connection with Kwakwaka'wakw and Nootkan pieces that he believed predated Northern influence. He commented on the importance of triangular incisions "analogous to the

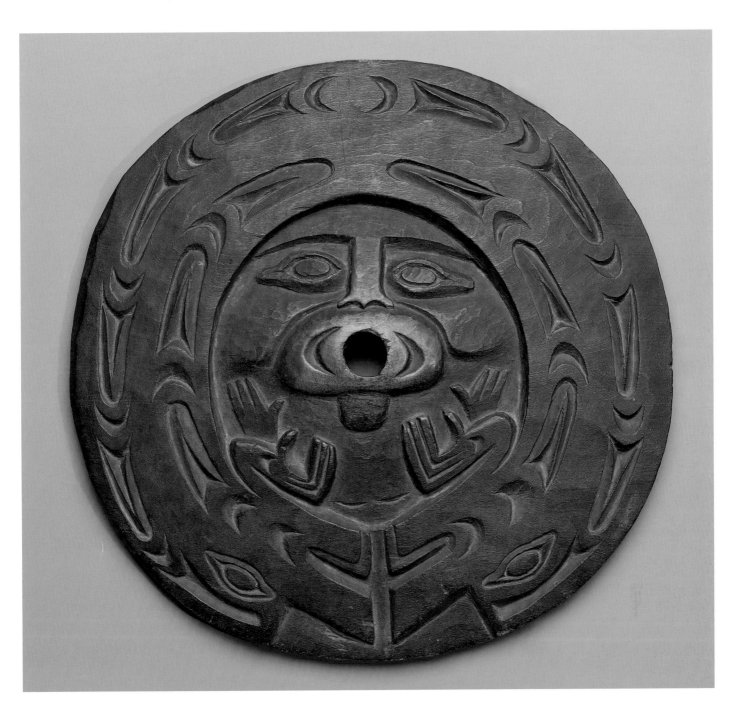

Figure 4.1
Spindle whorl, Chemainus, before 1905, wood, 8¾ × 8¾ × ¾ in. (22.2 × 22.2 × 1 cm). Collected by C. F. Newcombe. Museum Expedition 1905, Museum Collection Fund, Brooklyn Museum 05.588.7382.

This is one of a group of seven spindle whorls that Stewart Culin, curator of ethnology for the Brooklyn Museum, acquired from C. F. Newcombe in 1905, while on a collecting trip to the North-west, California, and the Southwest (see Fane 1991). A frequent configuration for the design on spindle whorls is a human face or figure occupying the central position (with the spindle hole doubling as the mouth of the being) with flanking birds, serpents, or quadrupeds around the perimeter. Newcombe defined the creature as "a two-headed monster" (Fane 1991: 256). It might represent a supernatural fisher or mink, called *sxwemecen* in the Halkomelem dialect; these enigmatic creatures are also carved on house posts and mortuary boxes (see figs. 6.3 and 6.4). Imagery on whorls purportedly alludes to the spirit powers of the weaver.

'Kerbschnitt' [notch-cut] of northern Europe," and did acknowledge the existence of a regional style, "differing in character from the style of the Northwest Coast." Clearly, in 1927 he was identifying the Northern Northwest Coast as the Northwest Coast.

In the first few books published on Northwest Coast art there are a few Coast Salish pieces illustrated. Douglas and d'Harnoncourt (1941: 164–65) showed a Cowichan *sxwayxwey* mask and a Quinault shaman's staff. Inverarity (1950) showed a few spindle whorls, with a good description, and a rattle, which he could not identify. About this time the art historian Paul Wingert published a book on Coast Salish wood sculpture (1949a) and an article on Coast Salish painting (1949b), but he did not consider any spindle whorls or rattles; he missed seeing the set of house posts from Musqueam at the American Museum of Natural History illustrated in *Coast Salish Essays* (Suttles 1987: 121–22) and later copied by Musqueam artist Susan Point, and he did not recognize the incised style. But to be fair to Wingert, I should point out that he did not have the advantage of Bill Holm's analysis of the Northern style (1965), which may be a prerequisite to the recognition of a Central Coast Salish style.

But why did it take so long to look seriously at Coast Salish art? One reason must be that there were simply fewer examples of it—and of Southern art generally—than of Northern art in museum collections, and so there was less to say about it. The causes of this were probably historical and cultural: earlier European exploration and collecting on the northern coast leading to the development there of art produced to sell; the Northern tradition of producing art for public display versus the Coast Salish tradition that some kinds of art are for very limited public display; earlier white settlement in Coast Salish country, which may have resulted in a faster loss of Native technology but which, I believe, also gave some protection against the tyranny of agents and missionaries and allowed the Coast Salish to continue their traditional ceremonialism, which in turn kept ceremonial objects in use and out of collections (see also Macnair 1993: 56; Brown 1998: 56–57); and also the search for the purely aboriginal, which took Boas north to the Kwakwaka'wakw, who seemed to be less affected by European settlement than people to the south.[1]

The collection and recognition of Coast Salish art may also have been delayed by the stereotypes and values of North Americans of European origin. Coast Salish country was where most came, and by the middle of the nineteenth century many had the image of the Northern tribes as physically and intellectually superior to the local Natives. This was in part pure racism. On the Northwest Coast, as in Europe, people in the north were on average taller and lighter skinned than those in the south, and for northwestern Europeans this made them superior. It was probably in part the usual ambivalence about Indians—the noble savage versus the degraded savage. The two images can be held in the same mind if separated by time or space: the noble was in the past, the degraded in the present; or, the noble is somewhere else (maybe in the north) and the degraded around here. But as images of the Native peoples developed, the stereotype became something else.

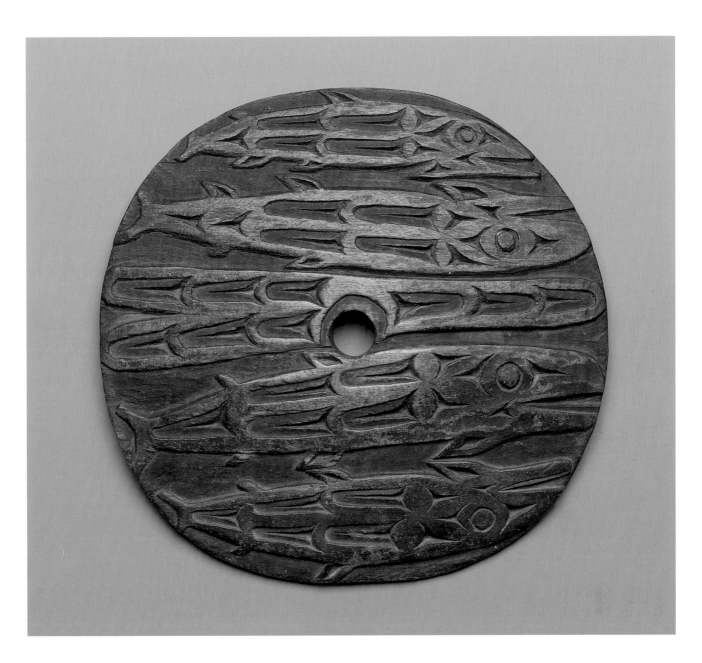

Figure 4.2
Spindle whorl, Chemainus, nineteenth century, wood, 7¼ × 7¼ × ¾ in. (18.4 × 18.4 × 1.9 cm). Collected by C. F. Newcombe. Museum Expedition 1905, Museum Collection Fund, Brooklyn Museum, 05.588.7383.

The unique character of Coast Salish engraving is well demonstrated here. The repetitive use of negative elements, like the engraved U-shapes or trigons, crescents, and circles carved in varying depths into the wood, serves to create the definition of the positive forms, in this case, four whales and an abstract design in the center. Salish designs are not always symmetrical, and the positive forms (whales) appear to float on the background. This free approach to configuring the design field in Coast Salish carving is a style distinct from the formline system used by Northern groups, where all the elements—negative and positive—are systematically applied to a (usually) symmetrical grid of predictable forms that create an interlocking web of design elements.

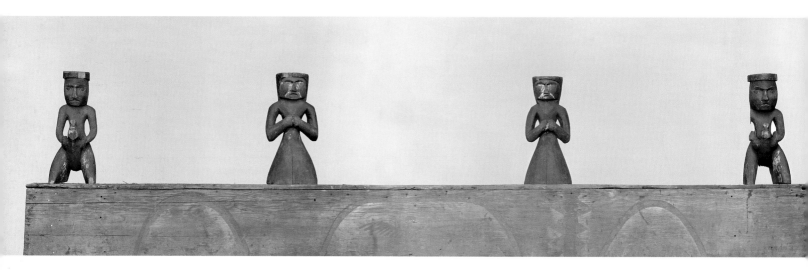

Figure 4.3
Plank drum, Cowichan, nineteenth
century, wood, paint, length 11 feet
(335.28 cm). Collected by C. F. Newcombe
in 1903. The Field Museum of Natural
History, Chicago, 85491.

This unique drum might be the only one of its kind in museum
collections. It is made of nailed planks with four 19-inch carved
figures attached: two male figures holding fishers and two female
figures. Geometric shapes and patterns are painted on the sides.
When tapped with wood sticks, the hollow chamber would reso-
nate. Suttles suggests that the drum may have been used for the
sxwayxwey ritual (Suttles 1987: 112). Wood box drums, wood plank
drums, handheld skin drums, carved wooden rattles filled with
pebbles or shot, or wooden staffs adorned with deer hoof rattlers
are used to accompany singing. Songs, like stories, form a complex
genre of oral expression and have certain musical features, like
tempo, beat, balance, tone, and melodic cadence. Repetition of key
phrases—usually four or five times—is common, although there
can also be improvisation. At times songs may consist of words
mixed with vocables (sounds) or be made up entirely of vocables.

The Recognition of Coast Salish Art

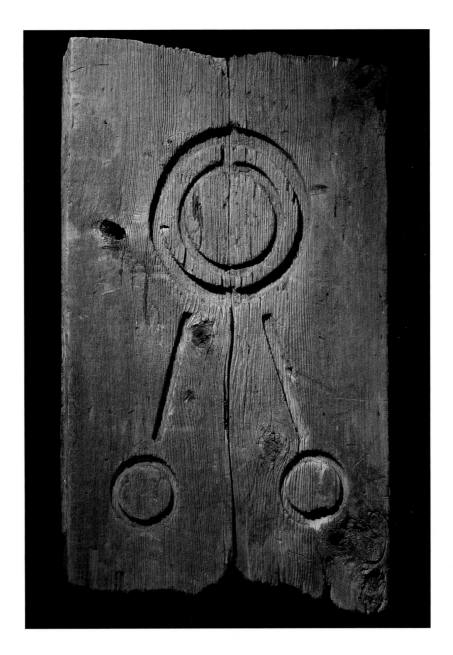

Figure 4.4
House post, Lummi, early nineteenth
century, wood, 59¾ × 35¾ × 6½ in.
(151.8 × 90.8 × 16.5 cm). Whatcom
Museum of History and Art, x.4242.1.

The seemingly abstract design on this interior house post (one of a
pair) belonging to a Lummi leader named Chowitsut, the wealthi-
est man at Lummi in the early 1850s, was described as representing
one of his spirit powers—"the sun carrying two valises of expensive
things." Suttles acquired this information in the 1940s from a
Lummi elder (Suttles 1987: 125).

While we profess democratic values, we are still moved by the pageantry of aristocratic societies. And while we profess a distaste for warfare and violence, we still admire the warrior. So we may be thrilled by the image of the haughty Northern chief leading a great canoe filled with warriors far to the south to raid the poor Salish for slaves and returning to put on his tall hat and his Chilkat blanket for a magnificent potlatch. Though slave raiding no doubt occurred, this image is almost certainly a myth. But it has appealed to whites and, I suspect, to Northern Natives. The Coast Salish were, on the one hand, too egalitarian to appeal to those in love with the pageantry of aristocratic societies but, on the other hand, perhaps not democratic enough to appeal to those in love with the egalitarian noble savage.

However, the status of Coast Salish art in the mid-twentieth century, when Northwest Coast art was gaining popular recognition, was not just the result of too few pieces in collections or of popular stereotypes. It seemed to me at the time that Coast Salish art was marginalized and misinterpreted. When I say marginalized, I am referring to statements saying or implying the following: Coast Salish art was not real Northwest Coast art. Insofar as it looked like Northwest Coast art, this was the result of influence from the north. Variation in Coast Salish art simply reflected degrees of Northern influence. Thus it could be generally dismissed as marginal or imitative, or else something altogether outside the Northwest Coast tradition. And when I say misinterpreted, I am referring especially to statements saying or implying that all Coast Salish art portrayed guardian spirits.

Some of the reasons for this view of Coast Salish art lie, I believe, in anthropology. These are: (1) Boas's reconstruction of Northwest Coast culture history, (2) the culture-area concept, (3) the notion of "the Coast Salish," and (4) the notion of "the culture."

Reconstructions of Northwest Coast Culture History

According to Franz Boas (1905: 96, 1910: 15–16), one of the results of the Jesup North Pacific Expedition was the discovery that the Salish-speaking peoples of the coast had recently come out of the interior with a Plateau type of culture and had acquired on the coast some of the features of Northwest Coast culture. He announced this conclusion in his chapter on art added to James Teit's ethnography of the Thompson, one of three Interior Salish peoples Teit described for the Jesup work. Boas included art in his ethnographic evidence for a recent move to the coast:

> This view is corroborated by a consideration of the art of the Coast Salish, whose works are much cruder than those of the northern tribes. They have never adopted to its fullest extent the method of the latter, of adjusting decoration to the decorative field, but adhere more or less to the pictographic style of the interior. (Teit 1900: 388–89; Jonaitis 1995: 152–53)

Of Thompson culture in general he wrote:

> Their whole social organization is very simple; and the range of their religious ideas and rites is remarkably limited, when compared to those of other American tribes. This may be one of the reasons why, in contact with other tribes, the Salish have always proved to be a receptive race, quick to adopt foreign modes of life and thought, and that their own influence has been comparatively small. (Teit 1900: 390; Jonaitis 1995: 154)

The discovery that the Coast Salish had come from the interior, Boas said, was the result of archaeological work by Harlan I. Smith, ethnological work by James Teit, and linguistic work by himself. It was theoretically significant, he believed, because it showed that peoples could go from a simple family organization to a totemic and clan organization, contrary to what was commonly assumed. Boas's conclusion was thus another piece of evidence against the nineteenth-century theory of unilinear social evolution, which held that all human societies went through the same sequence of stages to arrive at a common end, a theory that he vigorously opposed. Boas's conclusion was taken over hesitantly by A. L. Kroeber but enthusiastically by Philip Drucker and Charles E. Borden, among others, and it was current until around 1960 (Carlson 1990: 109).

But in the light of reanalysis and recent work, Boas's archaeological and linguistic evidence disappears (Suttles 1987: 256–64). His ethnographic argument may have been based on an unexamined unilinear evolutionist assumption different from the one he opposed: the assumption that culture always evolves from the simple to the complex. The culture of the Interior Salish seemed simpler and so must be closer to Proto-Salish culture and reflect an earlier stage in the cultural development of the Coast Salish. It was also in one respect wrong: the Coast Salish did not have a totemic and clan organization.

To be fair I must say that, until a few decades ago, archaeologists and ethnologists supposed that the first humans came into the New World by a route that took them across a dry Bering Sea, through the Yukon Basin, and southward east of the Rockies, and so they must necessarily have reached the Pacific Coast from the interior of the continent. Because there was no evidence for early sites on the coast, it had to be supposed that people had arrived no more than a thousand or so years ago. And because the people of the Northwest Coast speak languages of several unrelated families, too different for them to have developed from a common source in the short time it was believed they had lived on the coast, it had to be supposed that the people came in several waves. The problem, then, was to discover the order in which they came.

Today, however, a homeland for the Salish on or near the coast in the Fraser Valley is generally accepted by linguists (Thompson and Kinkade 1990: 30–51) and archaeologists (Carlson 1983b: 13–32). Moreover, it is now clear that people have lived on the Northwest Coast for at least ten thousand years, possibly for a lot longer. There has been time enough for all the groups there in recent times to have been there for millennia

and for any or all the languages spoken there to have had a common origin. We simply do not know how long the ancestors of the Coast Salish have lived on the coast nor by what route they got there.

The Culture Area Concept

The notion that the Native people of North America could be placed in "culture areas" grew out of the work of Otis T. Mason of the Smithsonian's United States National Museum and Clark Wissler at the American Museum of Natural History, as a principle by which they could display the collections of these institutions. But classification of peoples by culture area soon became the basis for organizing research and writing textbooks. In every system there was a Northwest Coast culture area, with an Arctic on the north and a Plateau on the east but varying in how far it extended south.

Boas did not develop any system of culture areas, but in his early work he did distinguish a "North Pacific Coast," identifying it at one point as extending south only as far as the Strait of Juan de Fuca but at another as far as the Columbia River. On the other hand, in his *Primitive Art* (1927: 285) he used "Northwest Coast" to refer to the Northern peoples—the Tlingit, Haida, and Tsimshian—only.

Wissler's "North Pacific Coast Area" extended from Yakutat Bay to southwestern Oregon. He distinguished three subdivisions: Northern (Tlingit, Haida, and Tsimshian), Central (Kwakiutl and Bella Coola), and Southern (Coast Salish, Nootka, and all to the south). The Northern, he wrote, "seem to be *the type*" (1950: 229; emphasis mine).

A.L. Kroeber, who had been a student of Boas, and Philip Drucker, a student of Kroeber, divided the Northwest Coast culture area into subdivisions that played a role in their reconstructions of Northwest Coast culture history. Kroeber (1939: 29–30), who had worked in northwestern California, added that region to the culture area. Considering environmental as well as cultural variables, he distinguished seven "areal types," his "Northern Maritime" being nearly the same as Wissler's Northern subdivision. The Coast Salish, however, were divided among four of the others. For Kroeber, within a culture area there was a culture climax. On the Northwest Coast this climax had been moving northward. Of his areal types, he wrote:

> These areas are far from equivalent in cultural intensity and depth. The climax of the region seems long to have lain in the northern half. The four southern areas are distinctly subclimatic and culturally peripheral. During the last half of the nineteenth century, the climax must be credited to the Northern Maritime tribes, on account of *their aggressiveness and the vigor of their art.* (Kroeber 1939: 30; emphasis mine)

Kroeber goes on to suggest that the climax had been earlier in the Wakashan area and still earlier in the Lower Fraser area, this sequence being the result of the gradual adaptation of a riverine culture to a fully marine environment.

Drucker (1955a: 186–95, 1955b, 1965: 112–13) distinguished four subareas: Northern, Wakashan, Coast Salish–Chinook, and Northwest California. He saw Wakashans as earliest, in touch with ancestors of the Eskimo, with contact broken by the emergence of Na-dene and Tsimshian speakers. Last of all, the Salish emerged, presumably to acquire Northwest Coast culture from the Wakashans.

There is a view that goes back at least to Plato, that the world consists of "types" and that these are real, individuals being only imperfect reflections of their types. This view is what the biologist Ernst Mayr (1959) once called "typological thinking"—as opposed to "population thinking"—and later called "essentialism" (Mayr 1982, 1988, following Popper 1950). Typological thinking or essentialism is the view that types are real and that the variations we see in the world around us are imperfections, while population thinking recognizes that the variation is real and that the types are mere abstractions.

The racial classification once used by physical anthropologists exemplifies typological thinking. The human species was divided into Negroid, Mongoloid, and Caucasoid races; the Caucasoid into Mediterranean, Alpine, and Nordic subraces. Nordics were characterized by blond hair, blue eyes, long heads; Alpines by brown hair, brown eyes, broad heads. It was assumed that there were once homogeneous Nordic and Alpine subraces, and so blonds with broad heads had to be the result of the mixture of Nordic and Alpine. We now understand that these assumptions are unsupportable. The genes responsible for these different traits simply occur with different frequencies in different populations, and the frequencies keep changing. There is no reason to suppose there ever were any homogeneous groups.

In cultural anthropology, thinking about culture areas is essentialist when one or a few tribes are identified as "the type" and others are seen as marginal or imperfect imitations of the typical tribes with the "essential" features of the culture area. Boas warned about essentialist thinking in a critique of the concept of "culture areas" in his article "Methods of Research" in the textbook he edited in 1938. The material culture of peoples in the same geographic area tends to be alike, he explains, and this was useful for museum displays. But other features of culture may not correspond at all. And he goes on to say:

> The establishment of culture areas as units of general validity has also led to the concept of marginal cultures which are liable to be considered as inferior to the centers in which the traits of the culture area are most fully developed. Here also serious misunderstandings arise if we generalize this concept. It may well be that a culture is not so thoroughly institutionalized as another neighboring one and that, at the same time, the material possessions may be less complex. It does not follow that the cultural life of the people is poorer, because it is not so easy for the observer to formalize a culture permitting greater freedom to the individual. (Boas 1938: 671)

Another manifestation of this kind of thinking is the tendency to postulate earlier linkages of race, language, and culture. Drucker's (1955b) subdivisions of the Northwest Coast are an example, finding in each a linkage of groups of possibly related languages, a physical type, and a set of culture traits. If one of these traits was observed in the wrong province, it had to be because it had diffused from its proper place. Thus he argued (1955a: 189): whaling was Wakashan; the Salishans and Chimakuans who practiced whaling must have learned it from the Wakashans; and the Wakashans who did not practice whaling must have done so in the past but given it up. This suggests that there must have been a time when every trait was in its proper place and every type was pure.

The Notion of "The Coast Salish"

Looking at the sort of map that appeared in general works on the Northwest Coast a few years ago, you could easily get the impression that the Coast Salish were a single group with a single language. The Coast Salish seem coordinate with six other "tribes." But this sevenfold division conceals the fact that the Tlingit, Haida, and Bella Coola speak one language each; the Tsimshian, Kwakwaka'wakw and Nuu-chah-nulth speak three languages each; and the Coast Salish are (or were) speakers of fourteen languages. The extent of the Salishan language family and its composition had been established by work by Boas and others, but Boas's use of the term "dialects" for related languages seems to have led some later anthropologists, familiar with the modern usage of the term, to assume that the Coast Salish tribes spoke regional varieties of one Coast Salish language. In fact, the Salishan Family consists of the fourteen Coast Salish languages, Nuxalk, Tillamook, and the seven Interior Salish languages east of the mountains. Adjacent Coast Salish languages may be as different from each other as English is from German.

The early ethnographic work of Boas and Hill-Tout in British Columbia should have alerted later scholars to cultural differences within the Coast Salish area, but by the 1940s this earlier work was largely ignored. More recent work in Washington State was better known, and the Coast Salish of Puget Sound came to be seen as typical, which led to the assumption that all Coast Salish art portrayed guardian spirits.[2]

This assumption was most prominent in the art historian Paul Wingert's work. He was strongly influenced by the anthropologist Marian Smith, who had worked with the Puyallup and Nisqually and found the "guardian spirit complex" to be the center of their religion and ceremonial life. Wingert wrote: "The fundamental concept which lay behind all Salish religious sculpture was that of a partnership between the world of men and the supernatural world" (1949a: 7). And he went on to describe the vision quest. He was aware that among the Coast Salish of British Columbia, house posts and grave posts had "social as well as religious subject matter" (1949a: 12) and that *sxwayxwey* masks were used on social occasions, but he concluded that the animals on the posts and the beings represented by the masks were the guardian spirits of ancestors. Other

Figure 4.5
Seated human figure bowl, ancient (prehistoric), stone, height 10 in. (25.4 cm). Vancouver Museum, Canada, QAD-1692.

This bowl was found in 1956 on the Fraser River near Lillooet, in Interior Salish country (Duff 1975: 176) and is one of about sixty such stone bowls found in northern Washington State, in the Strait of Georgia region, and along the Fraser River. Most have not been associated with datable contexts; a miniature bowl found at the Marpole site is an exception and is thought to be about 1,600 to 3,000 years old (see fig. 6.9). It displays an alert, expressive face with arms, legs, and backbone depicted. Several bowls from the Interior Salish area have protruding "top-knots" and some have perforations for embellishment or possibly to be suspended. Snake imagery is often seen on the bowls, as it is here, and may tie them to the special iconography of the ritualist.

The modeling of the facial features on this and other stone bowls is similar to that of Northern Northwest Coast sculpture, suggesting an early, widespread style that became more regionally differentiated in time. Note the prominent brow and cheek planes, the oval eye with pointed eyelid that is set into a hollowed eye socket, and the bandlike lips.

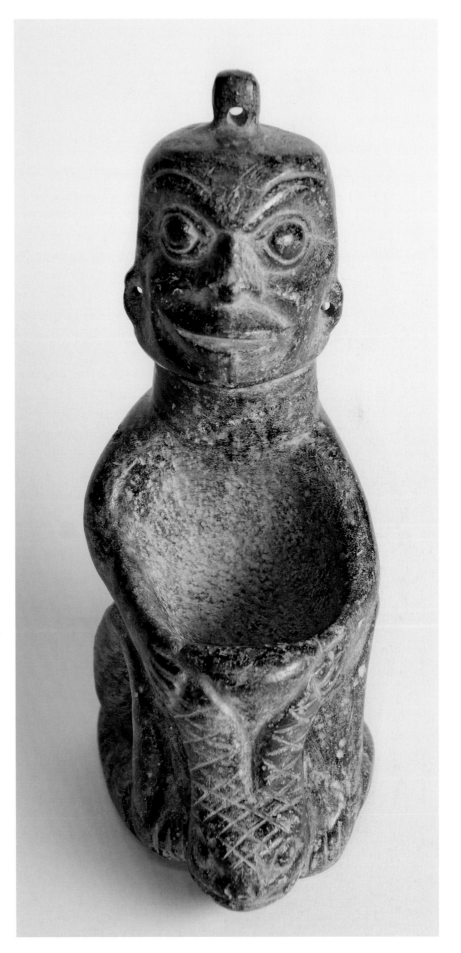

writers continued to identify these animals and masks as "guardian spirits" until fairly recently.

The speakers of the fourteen Coast Salish languages do share a number of features of social organization, and these allowed for extensive intermarriage linking the whole region, extending to non-Salish neighbors, in a social network. However, there were differences in house types, subsistence methods, basketry and weaving, ceremonies, and art. Kroeber saw this when he put them in four of his subdivisions of the Northwest Coast. For the *Handbook of North American Indians,* volume 7, we distinguished four divisions (not the same as Kroeber's)—Northern, Central, Southern, and Southwestern. But the boundaries are fuzzy between these divisions themselves and between the Coast Salish and their non-Salish neighbors.

The vision as a source of power, of extrahuman help, was indeed important for all the Coast and Interior Salish. Adolescents, male and female, went on a quest for a vision, an encounter with some creature in the nonhuman world (some known to Western science, some not). The vision was believed to be the source of success in life and the songs sung in the winter dance. The most powerful visions enabled the men and women who got them to become shamans. Once experienced, the details of the vision had to be carefully guarded. If you told about the experience, it would "spoil it." Or someone could harm you with the knowledge. Thus, representations of the vision were symbolic, only hinting at the identity of the being encountered. I believe this is what we see in the art of the Southwestern and Southern Coast Salish, and I have suggested that the danger of revealing too much of a vision power may have inhibited any representation even on purely secular objects (Suttles 1983). Perhaps you don't want your property decorated with any explicit representation if someone is going to think it is your vision.

In the belief system of the Central Coast Salish, however, there is another source of extrahuman help—the power of the ritual word. Families passed down secret verbal formulas, spells, with the inherent capacity to influence or control all sorts of things, from the splitting of a cedar tree to the affections of a man or woman. The person who knows powerful spells can use them for the benefit of others, working as a "ritualist," something quite different from a "shaman." It is the ritual words, known to the ritualist, that make various "cleansing devices" capable of purifying people experiencing life crises through their use in public performances. These cleansing devices include the performance known as the *sxwayxwey,* the use of the mountain sheep–horn rattle (see fig. 3.14), and others no longer practiced, such as one in which stuffed animals appear to crawl up the bodies of those being purified. Because what is secret about this source of extrahuman help are the spells and songs with spell words that empower these devices, in creating these cleansing devices or representing them on house posts and elsewhere, the artist was free, I believe, to be more explicit in what he portrays than if he were portraying a vision.

Some house posts are said to represent visions, but others represent cleansing devices, as do some grave posts (see fig. 6.3). The *sxwayxwey* mask does not portray a vision or

even an ancestor's vision; stories of the origin of the performance generally simply say it was a gift to an ancestor to be used for purification. I have not learned what is portrayed on a ritualist's rattle nor on the spindle whorls and other implements—looms, mat creasers, combs, bracelets—and I do not expect we will ever know. But I suggest that the artists who created them had more freedom to be explicit because it need not be supposed that they represented visions.

Thus, to begin to understand the art produced by Coast Salish people, we must distinguish different Coast Salish peoples and, among these, sources of extrahuman help and sources of social status. Treating all the Coast Salish as a unit has obscured appreciation of differences in style within the region.

The Notion of "The Culture"

The recognition of the incised style requires us to abandon the label "Coast Salish" or even "Central Coast Salish" or "Halkomelem." As Norman Feder (1983) and Bill Holm (1990) have pointed out, it is found beyond the area of these people. The first sheephorn rattle ever collected was acquired at Nootka Sound and the second in the Lushootseed area. Pieces with elements of the style have also been found in archaeological sites in Interior Salish country. This distribution is similar to that of the stone bowls studied by Wilson Duff (1956a, 1975). Some of these are believed to date back two millennia, but some were in use in historic times. And if we look for antecedents in wood, there is the Skagit River atlatl (see fig. 6.8), radiocarbon dated c. AD 300 (Fladmark et al. 1987).

The occurrence of this style or its antecedents over a wider area in the past need not imply any change in who was living where, nor any change in ethnicity, as archaeologists of a few decades ago would have supposed. To understand the history of any feature of culture in this region, we must ignore boundaries. Placing the Wakashans and the Coast Salish in separate divisions of the culture area has obscured several important features of culture (in technology, social organization, and mythology) that they share. Likewise, the Northwest Coast–Plateau culture area boundary may have drawn attention away from Coast-Interior ties in the Fraser drainage. Language and culture area boundaries were no obstacle to intermarriage and the flow of goods, practices, and ideas.

We must not be seduced by the old image of one society, one language, one culture. The first and best challenge of this image in this region is in W. W. Elmendorf's ethnography of the Twana (1960). He showed that in the middle of the nineteenth century, men in the village of Skokomish got wives from tribes speaking five other Salishan languages and one non-Salishan one; and the Skokomish participated with people to the south, speakers of two other Salishan languages, in intervillage eating contests, and with people to the north, speakers of two other Salishan languages and the Wakashan-speaking Makah, in secret-society initiations. People to the south did not participate in secret-society initiations and presumably knew little about them, while people to the north did not participate in intervillage eating contests. Participation in these activities was independent of language and the peoples were independent of each other.

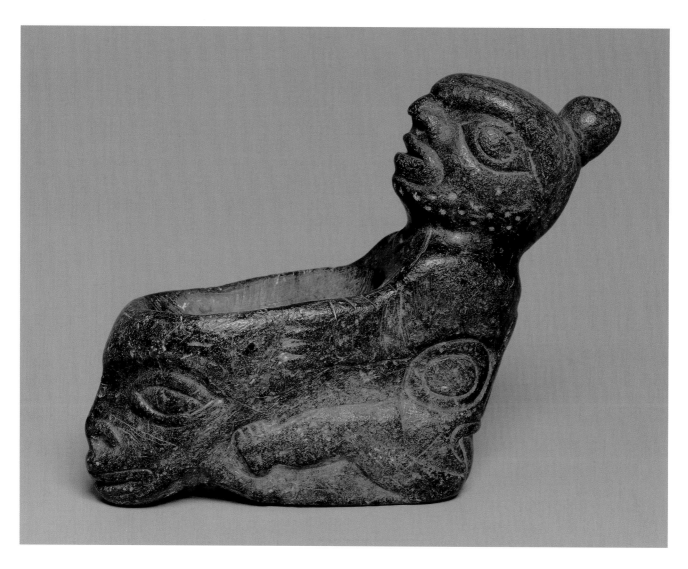

Figure 4.6
Seated human figure bowl, ancient (prehistoric), soapstone, 9 × 7 × 3½ in. (22.86 × 17.78 × 8.89 cm). Collected in 1870; acquired from the Free Museum of Science and Art, 1908. National Museum of the American Indian, Smithsonian Institution, 1/9485.

The incised eye of the main figure is similar to the eye configurations of historic Salish sculpture (see fig. 6.12). This bowl was found in a shell midden—a refuse heap built up over several generations containing waste from daily life, such as shells, animal bones, and household goods. It is not known if it was discarded or purposefully left in place. For aboriginal people, the term "ancient" is preferable to "prehistoric" because they have always been in possession of orally transmitted histories of their origins, ancestors, and territories.

Using genealogies I collected from Lummi and Musqueam people, I mapped the marriage circles of the three groups. They overlap. There were no marriages recorded between the Lummi and the Skokomish, but both married with the Songhees and the Clallam. The Musqueam intermarried with the Saanich, the Saanich with the Songhees, and the Songhees with the Skokomish, and so on. I feel certain that if we had comparable data from villages throughout the region, they would show a social and biological continuum within which there were some pronounced differences in technology, ritual, and art. These differences were not fixed. The secret society, in which the Skokomish were the southernmost participants, was spreading southward. Some kinds of winter dances seem to have been spreading northward. In the past, kinds and features of art associated with ceremonial activities may have ebbed and flowed a number of times, independent of any shifts in language or other features of culture.

Among the reasons it took so long for writers on Northwest Coast art to recognize a Coast Salish style were an early misinterpretation of the region's culture history, a need to define "culture areas," and a tendency to view "tribal culture" as a homogeneous, clearly bounded entity. The evidence today points to a more complex picture, with art influenced by localized practices and a fluid movement of ideas and styles. One of the things that Boas and his students clearly demonstrated was that the culture of every people is an amalgam of culture elements and culture complexes acquired from other peoples throughout their history. I'm sure there are distinctive art styles that originated within one people. But do they extend to all of that group and stay within its limits? I doubt it, and I think that rather than looking for "tribal styles" within tribes, it might be more interesting to look at art styles associated with culture complexes as these spread and adapted themselves to new conditions—as they continue to do today in the works of contemporary Coast Salish artists.

Autobiographical Note

I am neither an artist nor an art historian. I am an anthropologist who has worked with some of the Coast Salish, and I have an interest in Northwest Coast art and in the history of anthropology and how anthropological views have shaped popular perceptions. My interest in Coast Salish art grew out of what I came to see as the denigration and misinterpretation of it in works current when I was a student and beginning to teach in mid-century. As an anthropologist I feel free to criticize my profession and even feel some obligation to do so.

I was introduced to Northwest Coast art in the spring of 1938, when, as a third-term freshman at the University of Washington, I took a course on "Primitive Art" from Erna Gunther. Like three of the other four anthropologists I had courses with, Gunther had been a student of Franz Boas, and of course we read Boas's *Primitive Art* for her class. In the summer of 1939, I went to the San Francisco fair and saw the exhibit of American Indian art that Eric Douglas had put together with Gunther's help on the Northwest Coast material. During the years I was an undergraduate in Seattle, Gunther invited

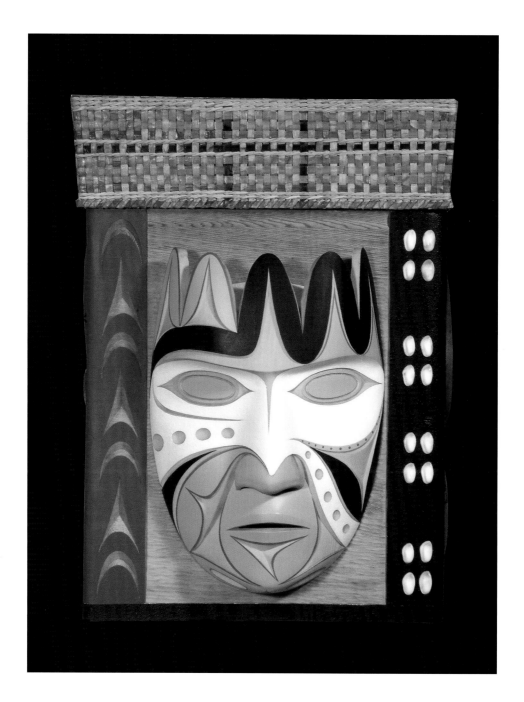

Figure 4.7
The Legend of Octopus Point, John Marston, Chemainus, 2007; cedar, cedar bark, paint, abalone shell, operculum shell, 16 × 12 × 12 in. (40.64 × 30.48 × 30.48 cm). Private collection.

Bent-corner boxes and chests, some with decorated surfaces, are used for storage of household possessions and ceremonial regalia. They are made from a single plank of wood that is steamed to soften the wood, bent at pre-carved notches to form the corners, and sewn or pegged at the corner joints. Bottoms and lids are then fitted onto the container. This extraordinary work shows the inventiveness of this talented artist in the provocative use of the four sides of the box to tell the fearsome story of a brave man, Sum-al-quatz, who conquered a sea monster whose giant maw swallowed canoes. As Sum-al-quatz hurled giant stones at the monster, he created the recognizable landforms around Maple Bay, British Columbia. The movement of the lithesome octopus asymmetrically carved on the box surface is contrasted with the stalwart, iconic face of the hero. Lush colors and textures, including on the woven cedar lid, contribute to its mastery.

The Recognition of Coast Salish Art

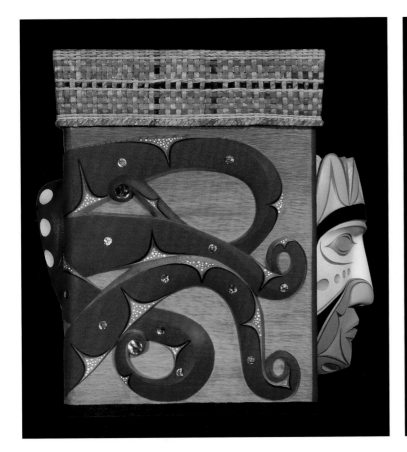
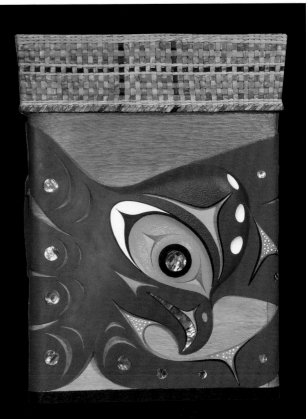

anthropology majors to her home once a month. I remember Bruce Inverarity there several times, as well as Douglas and Ralph Altman, and talk of Northwest Coast art.

Every year on the 22nd of January, Gunther would take a carful of students to a spirit dance on the Swinomish Reservation, where we saw people dancing possessed by the songs that came from their visions. Bill Holm and I must have first met on one of these trips; he was then still in high school and came with Erna's son Kit. During my senior year, a fellow student, Joyce Wike, in her first year of graduate work, stayed at Swinomish and did research on the winter dance. In the summer of 1946, when I had returned from four years in the navy and was about to begin graduate work in anthropology, Erna Gunther directed me to begin ethnographic work with the Native people of the region around the San Juan Islands, where I live today.

Notes

1. But appearances were deceiving. It was an easy but false assumption that when material culture is replaced, all is gone. Homer Barnett (1955: 2), on the basis of ethnographic work around Georgia Strait during the summers of 1935 and 1936 and having seen only three men making canoes and one woman making baskets, could say that "at present the old culture is practically dead." He was evidently wholly unaware of the vitality, among the Cowichans and their neighbors, of the winter ceremonial activities and the continued use of ceremonial paraphernalia. After research on the art nearly fifty years later, Feder (1983: 52) could say: "The old art did not disappear because of a lack of need within the culture. The Central Coast Salish are probably still the most conservative of any Indians on the Northwest Coast, at least in terms of keeping their traditional religion alive."

2. There may also have been a misperception of geography involved. Americans have tended to extend the name "Puget Sound" northward far beyond the waters originally so designated. Even Boas (1927: 288) identified pieces from Musqueam at the mouth of the Fraser as "of the Puget Sound region." And Americans, especially, seeing maps of Washington on one scale and British Columbia on another, might easily get the impression that Georgia Strait is a minor northward extension of Puget Sound.

IT IS A GIFT TO SHARE IN THE RICHNESS of the visual traditions of the Coast Salish First Peoples. And it is through the generosity of the culture-bearers of today that we might learn something of the teachings (x̌ačusədəʔ, in Lushootseed) that lie behind the carvings and weavings that sustained, uplifted, and enlightened their ancestors. Chief Seattle (siʔał) welcomed the newcomers because generosity is a core Lushootseed teaching. His diplomatic actions and wise words paved the way for his people to advocate for basic rights, which they continue to do today.

Bringing together inspiring works of art is a cause for celebration, yet disassociation from them—physically and spiritually—is still painfully felt by Native and First Nations people. Contemporary artists are the stewards of the past and, in their own practices, have set out to reclaim traditional imagery and its meanings. It is good to remember

How Did It All Get There?
Tracing the Path of Salish Art in Collections

Barbara Brotherton

that much of the art you see in this volume belonged to a complex network of social interactions that have been disrupted by colonial collecting attitudes and behaviors. The movement of objects from prescribed contexts has left them in peril of losing their historically situated meanings and philosophical underpinnings. The occasion of bringing a broad range of artworks together affords the opportunity to explore the art from multiple viewpoints.

In 2002, when my attention first turned to the idea of mounting an exhibition devoted entirely to Coast Salish art, I visited two elders who had supported my work in the past. They were Vi taqʷšəblu Hilbert, an Upper Skagit storyteller, linguist, and longtime preserver of Lushootseed oral traditions, and the late Gerald Bruce subiyay Miller, artist, raconteur, plant specialist, and spiritual leader of the tuwuduq (Twana) people. These special individuals—culture-bearers—were doing much to assure that the art, culture, teachings, and languages of Puget Sound peoples played an active role in their and neighboring Native communities. The words they spoke became the foundation from which the concepts, themes, and approaches to *S'abadeb, The Gifts: Pacific*

Figure 5.1

Chief Seattle (Chief Sealth or siʔał), 1864
Photograph by E. M. Sammis, Museum of
History and Industry, SHS 67(1).

This is the only known photographic image of the famed Duwa-
mish/Suquamish chief for whom the city of Seattle is named. siʔał
became leader sometime around 1810 and played an important
role during the first years of white settlement of Puget Sound in the
1850s and until his death in 1866. His most famous speech, prob-
ably delivered in December of 1854 at a reception for Governor
Isaac Stevens, newly appointed commissioner for Indian Affairs for
Washington Territory, was given in the Lushootseed language and
recorded in English by Dr. Henry Smith, who was in attendance,
but not published until 1887 (Hilbert 1991: 259). Delivered on the
eve of the signing of the Point Elliott Treaty, siʔał's speech suggests
that the philosophy that links Native peoples to their ancestors, to
spirituality, and to the earth will be challenged in coming genera-
tions by "the Changers."

Figure 5.2

**Princess Angeline, daughter of Chief
Seattle,** 1880s or 1890s. Photographer
unknown. Museum of History and Industry,
SHS 10,965.

In this photograph, the eldest daughter of Chief siʔał (Kikisoblu,
1820(?)–1896) sits in front of her house on Elliott Bay, below what
is now Seattle's Pike Place Market. Duwamish homelands included
the region that became the Seattle metropolitan area: the Lushoot-
seed name dxʷdəwʔabš means "people of the inside," referring
to the prior Black River outlet of Lake Washington (formerly Lake
Duwamish) before the Ballard Locks and Montlake Cut changed
the flow. During Princess Angeline's lifetime, the Duwamish were
forcibly removed from their lands, some to the Port Madison Reser-
vation, and they struggled to enact the limited guarantees of land,
fishing, and harvesting and the practice of religious beliefs afforded
by the treaties. Early in the twenty-first century, the Duwamish
people are still fighting for federal recognition.

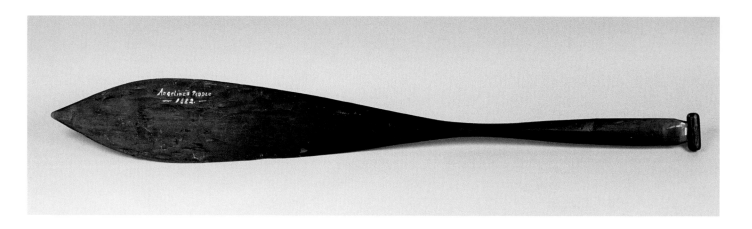

Figure 5.3

Canoe paddle, Duwamish/Suquamish, 1882, wood, paint, nails, 3½ × 59 in. (8.7 × 150.3 cm). Burke Museum of Natural History and Culture, Seattle, 2.5E1556.

The paddle has the name of Princess Angeline, Chief Seattle's daughter, painted on its surface, with the date 1882. In her lifetime, Native canoes were gathered on the Seattle waterfront and used for fishing and visiting and as transport to jobs in the hops and berry fields, canneries, and logging camps. Puget Sound paddles are typically made of maple and are shaped so that they are widest near the center of the blade. Women's paddles, like this one, are smaller and have a rounded diamond shape to the blade, whereas men's paddles have a narrowing tip with an angled point (Holm 1991: 245–46).

Coast Salish Art and Artists unfolded. The role of the artist is important, Vi said, because the Spirit speaks through the heart and hands of the artist, allowing the raw materials to be transformed into items of meaning and beauty. As such, the creations of the artist do not "belong" to him or her, but they do their spiritual work as they pass through the hands of the many who come into contact with them. The words *ʔadᶻalus s'abadəb*— "something beautiful to give"—are at the heart of artistic endeavors. Guidance given by subiyay was in concert with that given by Vi Hilbert. *Iyai* is the spiritual gift bestowed upon artists, subiyay noted, and their work must be shared. *Cəbacəb* are their gifts; the further meaning of the word is "gifts not intended to be kept." Subiyay reminded me that Coast Salish art does not stand independently from other realities, and its meanings must be anchored with philosophy, history, and memory. D. Michael CHiXapkaid Pavel, subiyay's nephew and apprentice, explores these ideas poignantly in chapter 3, while the essay by Vi Hilbert and Jay Miller brings forward the deeper meanings embedded in Lushootseed words as they pertain to art and material production.

During the twenty-five years that I have been Vi Hilbert's student, I have never ceased to be amazed by how close in her memory, and in history, traditional aboriginal culture flourished. Born in 1918, Vi has incredibly sharp recollections of life in the longhouses, canoe travel on the Baker and Skagit Rivers, seasonal travel to pick berries, watching basket makers and wood carvers working, and especially hearing stories recounted in her Lushootseed language. She has related anecdotes about traveling in horse-drawn wagons, raising vegetables in a family garden (her mother loved potatoes), traveling with her father's crew to move shingle bolts down the river, being sent to boarding school, and working at Tacoma's Todd Shipyards during the war, as well as her years as a professor at the University of Washington. Her life history reflects the

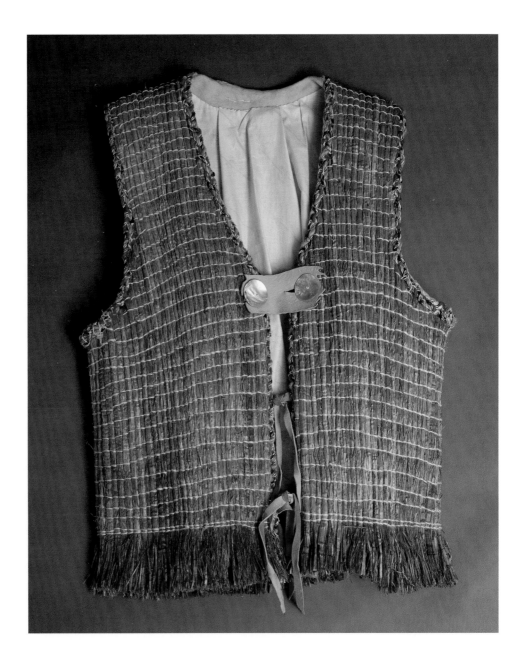

Figure 5.4
Duwamish Vest, Mary Lou "sla'da"
Slaughter, Duwamish, 1995; cedar bark,
wool, flax, cord, leather, abalone shell,
26 × 21 in. (66 × 53.3 cm). Collection
of the artist.

"I learned how to make the pounded cedar bark clothing from master weaver Eddie Carriere [see fig. 9.23]. I pound the hard inner bark, to separate and soften the layers. It is a tedious chore but I really enjoy it because it is like beating a drum! After the bark is pounded, I make cordage to secure it to the edges around the shoulders and neck and down the front. I try to add color with merino wool to make it attractive. I have produced ten of these garments. I feel connected to my heritage when I produce traditional garments and see them worn in dances. The cedar garments were important to our Duwamish Tribe when there was inclement weather; they kept them warm and dry. The people used fish oil on the garments to make them waterproof. Women wore pounded cedar bark skirts and capes. Large blankets were made with the pounded cedar bark and one could wrap oneself up in these soft blankets. I think my Grandfather Sealth and all my ancestors look down on me and are happy with what I have done and continue to do to keep this art form alive." —Mary Lou "sla'da" Slaughter, 2008

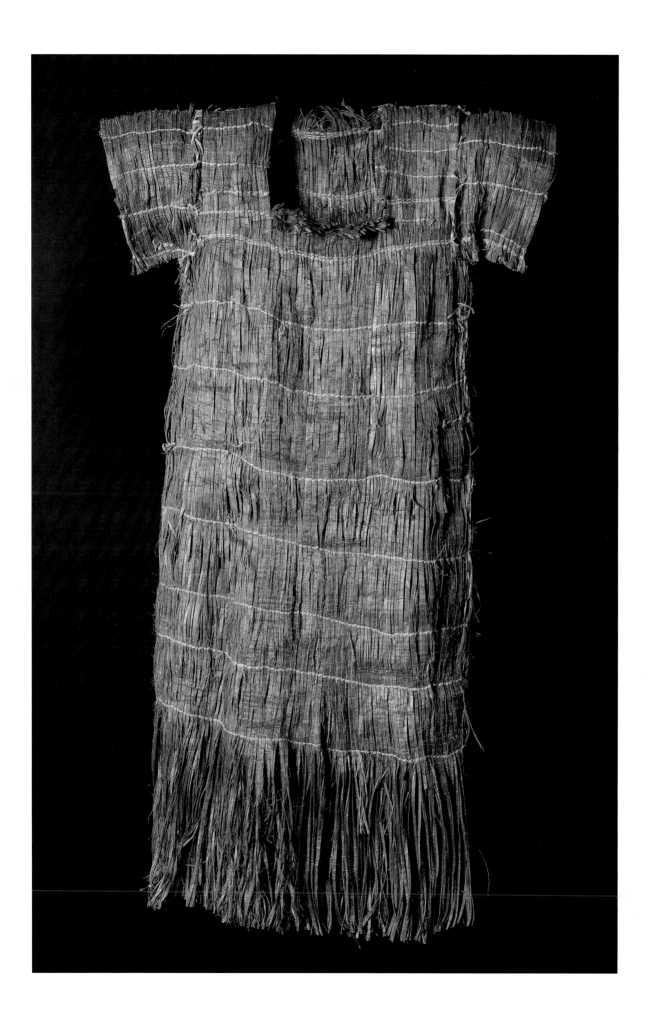

Figure 5.5
Dress, Alice Williams, Upper Skagit, 1985, red cedar bark, raffia, 49 × 27¼ in. (124.46 × 69.22 cm). Seattle Art Museum, gift of Vi Hilbert, 91.206.1.

Alice Williams (1907–1996) was one of the few elders who retained the knowledge of how to work pliable, red cedar bark into dresses. The strong fibers of the inner bark of the red cedar would have to be painstakingly pounded in order to break down the fibers and yield a soft, supple material. This one was a commission from Hilbert, who wanted something traditional to wear when speaking at Native gatherings and public events. Mrs. Williams allowed Vi Hilbert to make a tape recording of her telling traditional Upper Skagit stories (see Hilbert 1985).

profound changes experienced by First Peoples over the last hundred years and the ways in which Native identities have shifted and been transformed to accommodate the changes (see Harmon 1998).

Specialized knowledge of sea and river, coastline and forest, and flora and fauna have sustained indigenous peoples of the southern Northwest Coast for thousands of years—at least 4,000 years in most of the Puget Sound region, and 10,000 years in some other areas. The harvesting of fish, shellfish, roots, plants, and berries, along with the hunting of sea mammals, deer, elk, and wild goats, fully sustained Salish-speaking peoples on what is now the southern British Columbia mainland, lower Vancouver Island, and western Washington State (see map, p. xix). That intimate interaction with the landscape and its bountiful gifts did not cease when Native and First Nations people were forced in the mid-nineteenth century to give up extensive tracts of land and to adapt to a wage-based economy. Indeed, land and subsistence rights continue to be grave issues today, and Native and First Nations groups must negotiate in the courtrooms for their rights to fish, hunt, and gather in their ancestral homelands.

The dislocation from traditional territories and the unique landscapes that have long framed group origin, identity, and history have had devastating effects on the creation of art and material culture, whose meanings and forms have been wholly transformed as they have entered the public realm. This essay will briefly examine the impact of collection and scholarship on the production, collection, consumption, and understanding of Native art since the first encounters. I will present the view, as will other authors included in this volume, that while traditional art forms were subject to influence from changing conditions, many of the values that underlay them have remained the same. Because this publication includes a wide spectrum of Salish arts from collections now in the United Kingdom, Canada, and the United States, it provides an opportunity to trace the movement of Salish arts from their homelands to other venues. Salish people continue to feel the impact of separation from their rich material culture, and in a small way, this project serves to reunite the art with the ancestors of the original makers and audiences.

The art and material culture shown in this book may or may not accurately represent Salish cultures of their time periods. The vagaries of collecting—the personal biases of explorers, tourists, and anthropologists; the fate of specimens while transported or stored; and the lack of adequate recording about them—have insinuated themselves into the art history of Salish peoples. Through research in archaeology, anthropology, art history, museology, ethnomusicology, folklore, and oral history and the expertise of Native culture-bearers, we can piece together a picture of the art history of indigenous Salish nations of western Washington and southern British Columbia.

We are fortunate that objects have been preserved in museums and private collections for study today by scholars and Salish cultural specialists and artists. With the advent of the discipline of ethnology in the late nineteenth century, a decidedly more cohesive approach developed for the collection of not only material culture but also language, folklore, and data about religion, manufacture, economy, subsistence, and

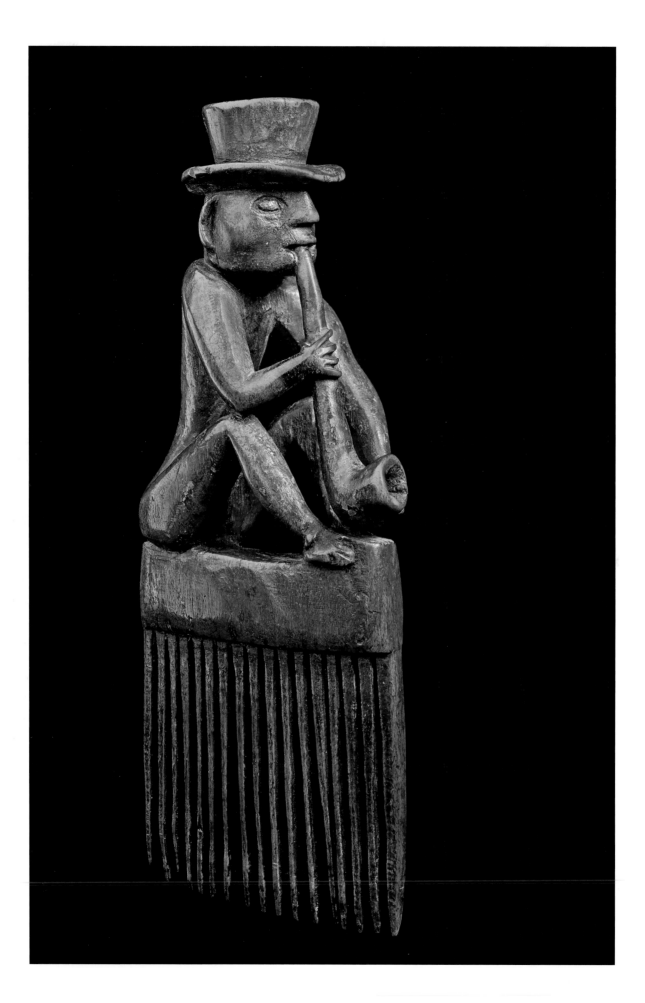

Figure 5.6

Comb, early nineteenth century (?), wood, 6½ × 2⅝ × 1⅜ in. (16.51 × 6.66 × 3.49 cm). The Trustees of the British Museum, Am 1949, 22.46.

This delightful comb depicts a seated man wearing a top hat and grasping a long pipe. The seminaturalistic treatment of the body and head is indicative of sculpture from the Central Coast Salish, specifically house posts from Vancouver Island (see Wingert 1949a: plates 40, 46, 52, 54). The faces are shaped as wide ovals, with small, rounded eyes, straight noses, small lips, and often prominent ears. These features are set within distinctive facial planes: eyes are recessed, cheekbones are displayed and often have carved lines down the sides of the nose, and the chin might be modeled and slightly projected. This comb was in the collection of William Oldman, a London dealer who had assembled rare "souvenirs" brought back to Great Britain from the early explorations that were later located in private collections (see Waterfield and King 2006). While Oldman amassed objects from Africa, the Americas, and Asia, he was best known for his collections of Polynesian art.

social and political structure. Ethnography was a nascent discipline dedicated to salvaging valuable information before traditional cultures gave way completely under the weight of acculturation. So while the mostly well-intentioned collectors searched for "traditional" arts, some ethnologists purposely overlooked the art being made at the time as "tainted" by new materials and influences and by the lure of the tourist trade.

Unlike other regions of North America, the Pacific Northwest was not explored until the late eighteenth century. The purpose of many of the voyages that began in Spain, England, and France was to discover a water route that linked the Atlantic and Pacific oceans. Surveys were taken, maps were created, and territories claimed for their respective countries. While scientific in nature, the potential for finding natural resources for use in Europe and Asia spurred intense competition among those European nations. In 1775, Capt. Bruno Heceta and Juan Francisco de la Bodega y Quadra were the first to encounter the Native peoples of Washington at the mouth of the Quinault River. Because the Coast Salish were socially organized into corporate kin groups who controlled resources and their distribution and had long-established trade practices, maritime encounters included an exchange of goods. Fortunately, the crew members of this first meeting and subsequent encounters kept journals; their records describe the clothing, canoes, and implements the Natives had in their possession, including weapons obtained through trade with non-Natives and copper adornments that indicate widespread trade with other Native groups. It is disappointing that no Salish pieces survive from the earliest Spanish expeditions.

It is believed that British navigator Sir Francis Drake came as far north as Nootka Sound on Vancouver Island in 1579; the Spaniard Juan Perez claimed Nootka Sound in 1774. This was the beginning of tensions between the British and Spanish over land claims in the Pacific Northwest: to avoid serious conflict, each accepted the commercial activities of the other. In 1776, Capt. James Cook departed on his third voyage to North America and the Pacific. Like his previous two voyages, it was conducted to widen existing geographic and scientific knowledge. In 1778, Cook charted the coast of Washington State and anchored at Nootka Sound. Nine years later, Capt. Charles Barkley, commanding a British fur-trading ship, named the Strait of Juan de Fuca, a pivotal waterway for Coast Salish people. British, American, and Spanish fur traders often plied the coastal waters in the following years and enjoyed a robust trade with Native peoples, especially for sea otter skins. The earliest Salish material collected was by Captain Cook, not though direct contact with the Coast Salish but through trade with their neighbors at Nootka Sound, where Cook and his crew wintered in 1778. Cook's third voyage to the Pacific Ocean on the *Discovery* and *Resolution* was the first major European contact with indigenous peoples of the Northwest Coast. The ethnographic material collected on this voyage forms the largest and most significant documented body of artifacts from that time and place (Kaeppler 1978: xiii).

John Webber, the official artist of the voyage, made exacting sketches of the people of Nootka Sound, their surroundings and their technologies. Several of the voyagers,

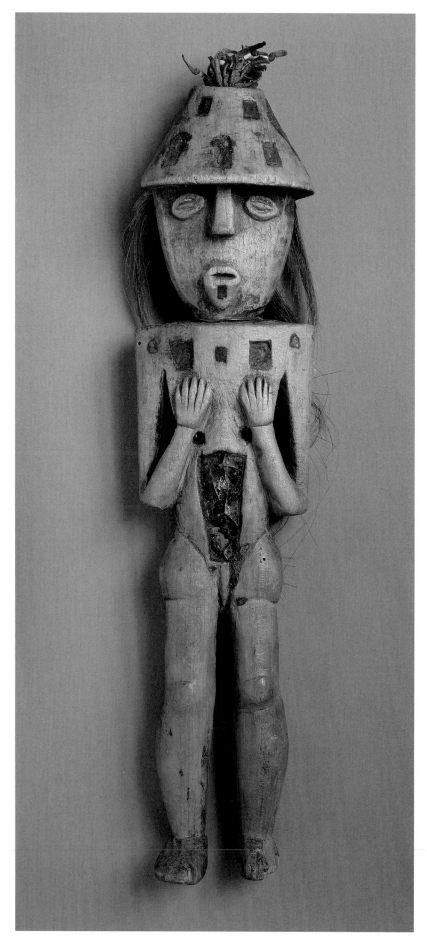

Figure 5.7
Carved figure, Suquamish (?), eighteenth century, wood, hair, leather, glass, dentalium shells, copper, 14 × 3½ × 2⅜ in. (35.6 × 8.9 × 6.1 cm). Collected by George Hewett on the Vancouver Expedition, 1792, Restoration Point. The Trustees of the British Museum, Am, Van 160.

George Hewett's catalogue lists this figure as "Image" and includes it with several other items collected at a village on Restoration Point, such as a wood bowl (fig. 5.8) and goat-horn bracelets (fig. 5.9). It is one of the oldest known fully carved figures from Puget Sound. The softly modeled lower body is in contrast to the more angular upper body. The stylized face with sculpted features set on a flat oval form is a variation of Southern Puget Sound sculpture of the nineteenth century. Inlays once affixed to the torso, shoulders, and hat suggest the figure's importance: copper inlay and shell beads on the hat and remnants of glass or mirror in the abdomen cavity are prized materials acquired through trade. This has been referred to as a "welcome figure," based on the large-scale sculptures of the Makah, Nuu-chah-nulth, and others that were set up in the village on the beach, yet it is more akin to several small figures with upraised hands carved in antler that were found in Salish territory (see the essay by Astrida Blukis Onat, this volume).

including Webber, Lt. James King, David Samwell (surgeon on the *Discovery*), and Sir Joseph Banks, collected ethnographic specimens. The ultimate fate of these objects took many twists and turns that have only in recent decades been sorted out (see Gunther 1972; Kaeppler 1978; King 1999). The London museum of the natural historian Ashton Lever, the Leverian, received collections from Captain Cook's third voyage in 1781, but in 1786 the Leverian holdings were sold off by lottery (Kaeppler 1978: 12) and dispersed far and wide. These items now reside in European museums, mainly in London at the British Museum but also in museums in Cambridge, Dublin, Glasgow, Edinburgh, Göttingen, Florence, Vienna, Leipzig, Cambridge, Berne, and Cape Town, as well as in other public and private collections. One interesting rattle, most likely Salish, now in Cape Town, is made of sheep horn and adorned with wool; it is not engraved on the surface, but in shape and construction it is similar to many sacred rattles known from the nineteenth century and still in use by the Central Coast Salish (Kaeppler 1978: 261). Another rattle of this type was collected on the Vancouver voyage into Salish territory in 1792 (Gunther 1972: 231).

Objects acquired on the voyage of Capt. George Vancouver (1791–95) from western Washington in 1792 are among the earliest collected from this region. Vancouver had claimed for England the territory now known as Washington State and named it New Georgia for the king of England, George III. Several significant works illustrated here were collected at Restoration Point on Bainbridge Island, homeland of the Suquamish Tribe. Most of the extant works were assembled by the surgeon's first mate, George Goodman Hewett (1765–1834), and in 1891 were acquired by curator A. W. Franks for the British Museum, where they reside today (King 1994). These unique works provide insight into the artistic life of the Salish before the time of contact and the subsequent negative impact that non-Native encounters had on Native traditions.

Five of the works noted in the catalogue that Hewett assembled five years after the voyage appear here: a wooden figure (fig. 5.7), a small wood food dish (fig. 5.8), four goat-horn bracelets (fig. 5.9), and a comb (fig. 5.10), all from Restoration Point, and a whalebone club (fig. 5.11) from Port Discovery (Discovery Bay). Unfortunately, Hewett did not provide the names or uses of the pieces he had collected, and while Captain Vancouver noted exchanges between his crew and the Native people in his journal, his brief descriptions shed little light on the specific artifacts connected to the voyage. The use and meaning of the spectacular sculpture of a figure with upraised hands (and others resembling it) have been the subject of speculation (see the chapter by Astrida Blukis Onat, this volume). The figure has upraised hands—a gesture seen in Salish ceremonies today as one of honor and largesse—softly modeled hips and legs, and simplified facial features. The open mouth suggests singing or oratory. The figure's hat, a distinctive type recorded in Spanish drawings in the 1770s, is inlaid with copper and has leather tassels strung with pieces of dentalium shells, trade items suggesting wealth and status. Copper inlay on the shoulders and chest may have indicated a ceremonial tunic, while the missing piece of glass or mirror in the lower torso remains a mystery. The overall

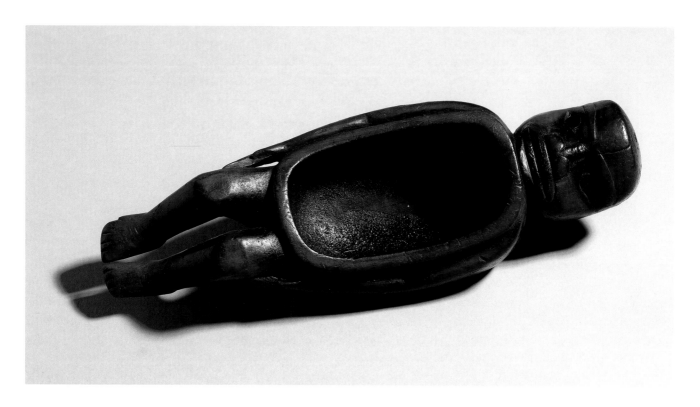

Figure 5.8
Food dish, Suquamish (?), eighteenth century, wood, 4 × 10 in. (10.16 × 25.4 cm). Collected by George Hewett on the Vancouver Expedition, 1792, Restoration Point. The Trustees of the British Museum, Am, Van 161.

Anthropologist Erna Gunther believed that a few of the Hewett-collected pieces from Restoration Point, including this dish, were not of local origin but were traded in from elsewhere (Gunther 1972: 81). Writing that the dish appeared to be of "Northern style," and similar to the Dzonokwa feast dishes of the Kwakwaka'wakw, Gunther did not have the benefit of the analysis of the objects found at the Ozette site (dated to about 500 BP, excavated beginning in 1970) near Neah Bay, some of which share similar stylistic features with this dish. Another dish in the British Museum collection from the Captain Cook voyage has affinities to these dishes (Gunther 1972: 215). The Ozette dish (Kirk and Daugherty 1978: 104) depicts a supine figure with knees drawn up and arms that encircle the cavity of the bowl at the figure's midsection. The rendering of the face is decidedly more naturalistic than the Hewett dish and includes the embellishment of human hair. It is conceivable that such pieces represent an early style of figural sculpture on the Olympic Peninsula, in western Washington, and elsewhere on the coast, although there are too few of them to make a definitive judgment as to provenance, given that a robust Native trade existed long before contact.

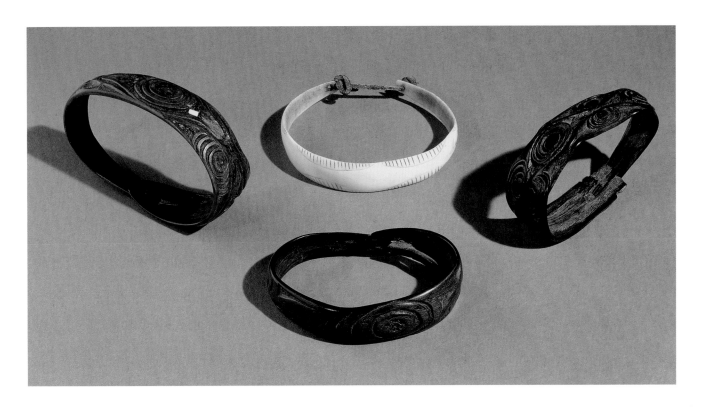

Figure 5.9
Bracelets, Suquamish (?), eighteenth century, mountain goat horn; (a) diameter 3 in. (7.62 cm), (b) diameter 2¾ in. (6.98 cm), (c & d) diameter 2½ in. (6.35 cm). Collected by George Hewett on the Vancouver Expedition, 1792, Restoration Point. The Trustees of the British Museum, Am, Van 210 a–d.

These bracelets are among about twenty known Salish bracelets made from goat horn (see also fig. 5.18), and all were collected during the early historic period of the late eighteenth century. Eight such bracelets (including one of bone) were collected on the Vancouver voyage. Trade in mountain-goat wool and horns afforded the high-status materials needed to create the garments and ornaments for the wealthiest of Salish society. To make the bracelets, the stiff horn was steamed, shaped, and carved with woodworking tools: the tapering end fitted into a notch carved in the basal end to keep the bracelet secured on the wrist. For a younger generation of Coast Salish artists, these works—elegantly engraved with the essential design elements of the circle, crescent, and triangle—have been an inspiration for the rekindling of Salish aesthetics (see fig. 5.44).

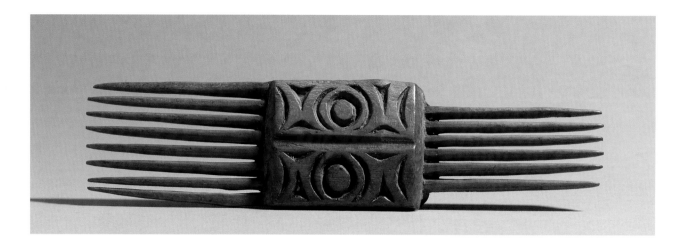

Figure 5.10
Comb, Suquamish (?), eighteenth century, wood, 2 × 7½ × ¹³⁄₁₆ in. (5.08 × 19.05 × 2.06 cm). Collected by George Hewett on the Vancouver Expedition, 1792, Restoration Point. The Trustees of the British Museum, Am, Van 219.

This exceptional comb illustrates the diagnostic features of the Coast Salish art style as it had evolved in the late pre-contact period. As seen here, the circular, crescent, and triangular (also called trigon or wedge) shapes are cut into the wood surface and function as negative designs, thus defining the positive design that flows across the surface. The Salish artist used these few cut-out shapes to create anatomical parts for human and animal beings and, in this case, a pleasing geometric design whose meaning we do not know. The reverse side is also embellished with abstract carved designs.

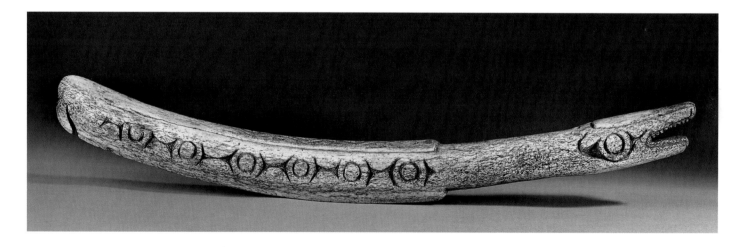

Figure 5.11
Club, Klallam (?), eighteenth century, whalebone, 2 × 21 × 1⅜ in. (5.1 × 53.3 × 3.6 cm). Collected by George Hewett on the Vancouver Expedition, 1792, Port Discovery. The Trustees of the British Museum Am, Van 94.

Several carved wood and whalebone clubs were acquired on the Cook and Vancouver voyages, especially at Nootka Sound. Of the whalebone clubs, most depict a human or bird (or both) on the pommel, with vertical geometric design complexes running down the blade; this club also has interlocking triangular motifs on the top. The serpent shape is a rare variation and may in fact depict a lightning serpent, a creature associated in oral traditions with the thunderbirds shown on many clubs (Wright 1991: 118). Keeping in mind that the cutout circles and wedges are the background of the design, one can trace the flow of the positive circles and U-shapes on the surface that perhaps refer to the serpent's scales.

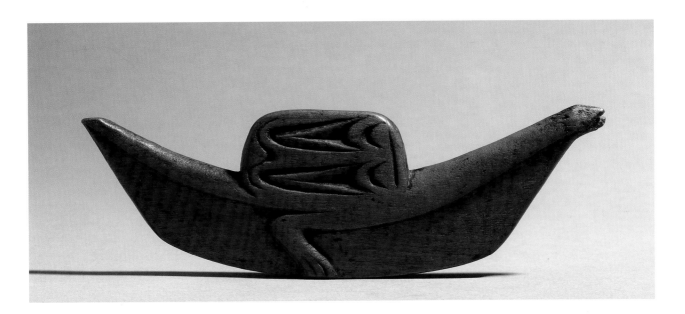

Figure 5.12

Mat creaser, Lower Fraser River, late eighteenth or early nineteenth century, wood, 2½ × 6¾ in. (6 × 17 cm). Acquired from Dr. Peter Comrie, R.N., 1870. The Trustees of the British Museum, Am 6810.

An indispensable tool for making cattail mats, this creaser bears a simply stated abstract bird, with its trailing leg and feathers incised into the surface. Marshes and swamps throughout Salish territory provided an abundance of long, swordlike leaves that when processed yielded materials for the ubiquitous mats, storage baskets, hats, capes, and twine (Turner 1998: 122). Creasers have a distinctive groove carved on the underside (see fig. 6.14) that would be applied on top of the long needle threaded with cord and inserted into the aligned cattail leaves. The action of the creaser as it is rocked over the needle prevents breakage of the leaves. Dr. Peter Comrie, a staff surgeon for the Royal Navy, sold this and eighty-six other objects to the British Museum in 1870.

economy of modeling and the oval face with its rudimentarily sculpted eyes, nose, and mouth are diagnostic features of Salish style into the twentieth century.

While his work is useful, Hewett logged artifacts out of geographic sequence and provided little data about where he obtained particular items (King 1994: 44). Later, in the 1890s, when the collection was catalogued in the British Museum, some non-Vancouver voyage materials were also included. The histories of the Cook and Vancouver collections reveal both the shortcomings and marvels of early thinking about Native objects, which were then referred to as "curiosities." From its inception in 1753 as a museum of ethnography and antiquities, the British Museum continued to develop its ethnographic collections into the nineteenth century. Curator Augustus Franks befriended the wealthy industrialist and collector Henry Christy, who also provided funds for further acquisitions by the museum, including the delicate mat creaser (fig. 5.12) acquired in 1870 from Dr. Peter Comrie. Other significant ethnographic collections were passed on to the British Museum by Lord John Russell, a politician who was twice prime minister of the United Kingdom in the mid-nineteenth century. From 1846 to 1852 he served as Secretary of the Colonies and Secretary of War but likely had not been in the Northwest and relied on others to obtain items for him, mostly from the Cowichan on Vancouver Island and from Native peoples living along the Fraser River. Russell acquired many items associated with weaving—a loom, spindle whorls, and tumplines—including the

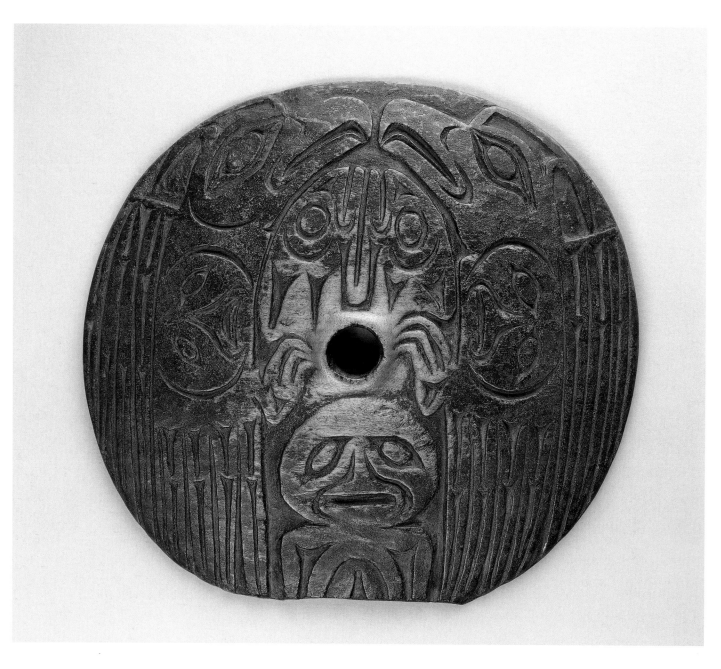

Figure 5.13
Spindle whorl, Cowichan, nineteenth century, maple wood, diameter 6¾ in. (17.14 cm). Acquired from Lord John Russell, 1861. The Trustees of the British Museum, Am 1861.3-12.62.

This is the earliest documented spindle whorl known that depicts a human figure (Feder 1983: 47); the elaborate surface design also shows flanking raptorial birds and fish heads. Within the challenging shape of the circular form, this adept carver constructs a dense design with very little recessed negative area. The central human face (with only a partial body) and the faces within the wings of the birds are defined by the carved eyes, cheek lines around the noses, and down-turned mouths. The wing feathers are relieved by attenuated trigons that, in their repetition, create a rhythmic contrast to the sinuous figural engraving. Note the use of crescent and trigon shapes as they define the areas around eyes and beaks or mouths. Lord John Russell, secretary of state for British Foreign Affairs, donated many objects in 1861 from the Fraser River and Vancouver Island Salish, which he likely acquired from others who brought them to England.

beautifully carved whorl shown here (fig. 5.13). The original catalogue that accompanied the collection included the names of some First Nation artists who made the objects, descriptions of the objects, Native terms for them, and how they were made.

Peaceable trading with Cook, Vancouver, and others encouraged the opening of the maritime fur trade and ongoing contact with aboriginal peoples. After the Spanish established a settlement at Nootka Sound in the 1790s, it was not long before European explorer-merchants came to the Northwest, particularly those affiliated with the fur-trading Northwest Company, such as Alexander Mackenzie, who came in 1793; the American-born Simon Fraser, who explored the Fraser River in the 1790s; and the Canadian explorer and surveyor David Thompson, who arrived in 1812. Both the Columbia and Fraser rivers were significant Native trading areas before contact, and their potential was not lost on the newcomers. Simon Fraser, for whom the river is named, established several forts on the river before reaching present-day Vancouver in 1808. When Thompson reached the mouth of the Columbia River in 1811, he found that the American explorers Lewis and Clark had already claimed the region. John Jacob Astor's American Fur Company was established in the town of Astoria, Oregon, while the rival Northwest Company set up shop at Fort Vancouver (Vancouver, Washington). Just two years later Astor sold his posts to the Northwest Company, which then amalgamated in 1821 with the Hudson's Bay Company. Employees of these enterprises came into close contact with the indigenous peoples, and many important Native artworks were collected through trade. The sketches and later paintings of traveler Paul Kane (see fig. 5.14) in the mid-1840s form an invaluable glimpse of Native life and provide visual context for some of the artworks collected. A self-taught painter of Irish-Canadian descent, Kane embarked on ambitious travels in the Canadian northwest and in Oregon Territory from 1846 to 1848, stopping to visit Hudson's Bay Company forts, including Fort Vancouver and Fort Victoria, where he sketched Native people and their lifeways.

Three remarkable works are among the finest examples of Salish art collected early in the first half of the nineteenth century and are now in the collection of the Perth Museum and Art Gallery in Perth, Scotland (see Idiens 1987). They were sent to Perth by Colin Robertson, who was chief factor of the northern branch of the Saskatchewan District for the Hudson's Bay Company, but they had been collected around Fort Langley on the Fraser River by James M. Yale, who was stationed at Fort Langley from 1829 to 1831 (Idiens 1987: 51). Each bears the unique sculptural and/or surface engraving styles of the Halkomelem-speaking Salish of that region. A rare stone pipe (fig. 5.15) is fully carved to show a quadrupedal creature, perhaps a fisher, with its facial features, ribs, and other anatomical markings incised with crescent and wedge shapes. The unusual club (fig. 5.16) carved in the form of a human figure is a stellar example of two-dimensional Salish design. The arms and torso of the figure are embellished with crescent and U-shapes, and just below the grip is a human head whose hair is represented with a series of U-shapes. It is a prime example of a finely wrought tool that is an item of utility and of beauty and historical importance. The extraordinary Salish model

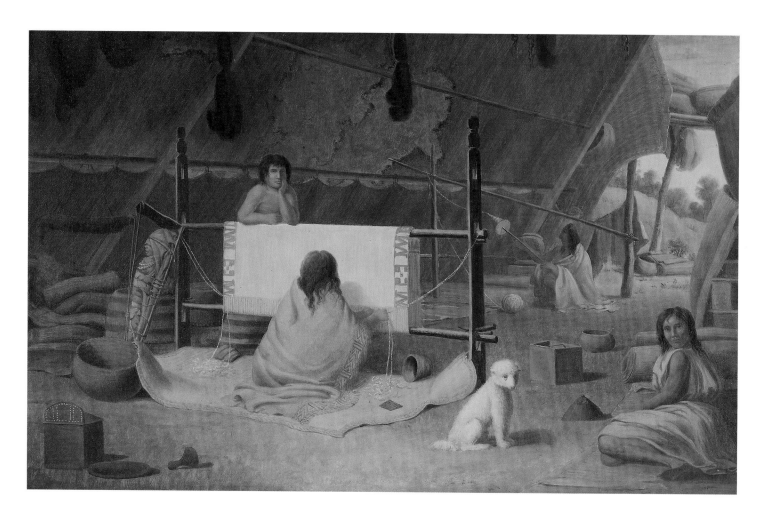

Figure 5.14
Clal-lum Woman Weaving a Blanket,
Paul Kane, Canadian, 1850s; oil painting.
Royal Ontario Museum.

The gifted painter (and observer) Paul Kane (1810–1871) depicts a tranquil moment in the interior of a large cattail-mat lodge used for temporary housing during the busy summer months of fishing, clamming, harvesting camas and wild onion, and picking berries. The two-bar loom where the woman sits weaving a twined, mountain-goat wool robe is accurately re-created, down to the wedges placed in the slots of the uprights where the bars rest, in order to keep tension on the warp threads. A small, whitish "wool dog" pup sits nearby, sporting a short coat, as his has no doubt recently been shorn with a sharpened clamshell. The fiber of the coat, mixed with goat wool, cattail fluff, and nettle or bird down, would be processed into the strong, water-resistant, luxurious wool used for weaving blankets, robes, and other garments. The weaver sits on a cedar bark mat wearing a goat's wool robe, close to the infant secured in the cradleboard. A woman with a shaped head (achieved by gentle pressure on the skull while in the cradleboard) uses a spindle and whorl that twists the wool and vegetal fibers into weaving yarns. A pile of woven mats of cedar or cattail are shown on the left, ready to be put to use as room partitions, mattresses, or tablecloths, or for use in the canoes that would be busily employed during the height of the food-gathering season.

How Did It All Get There?

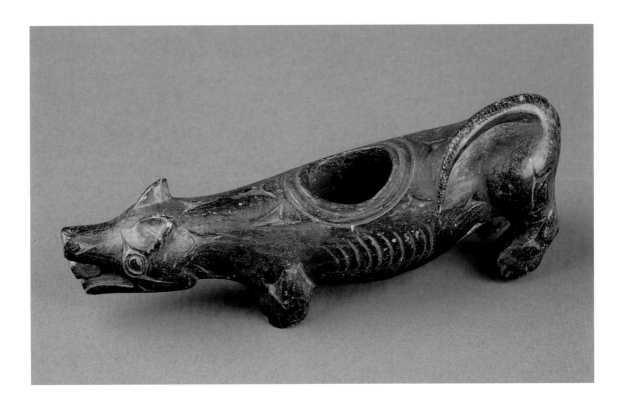

Figure 5.15
Pipe, Lower Fraser River, late eighteenth or early nineteenth century, stone, 1½ × 4¾ in. (3.81 × 12.06 cm). Acquired by Colin Robertson before 1833. Perth Museum and Art Gallery, Perth & Kinross Council, 1978.1761.

Although carved animals in stone, bone, and antler are known, mostly from archaeological sites, this is the only Salish figural stone pipe in existence. It might represent a quadrupedal mammal from the Mustelidae (or weasel) family, having a long, lithe body, small head with short ears, and a tail. Representations of these creatures appear in sculptural and engraved forms on many Salish carvings—house posts (fig. 6.4), grave monuments (fig. 6.3), spindle whorls (figs. 3.15 and 5.23), and combs (fig. 5.19). Colin Robertson retired from the Hudson's Bay Company in 1832 and bequeathed more than fifty-five objects to the Perth Literary and Antiquarian Society the following year (Idiens 1983: vi), of which twenty pieces are extant. They became part of the Perth Museum and Art Gallery in 1914 (Idiens 1987: 47). Robertson did not reside in or travel to the Fraser River region where the Salish objects originated and likely received them from James Murray Yale, who was stationed at Fort Langley from 1829 to 1831 (Idiens 1987: 51).

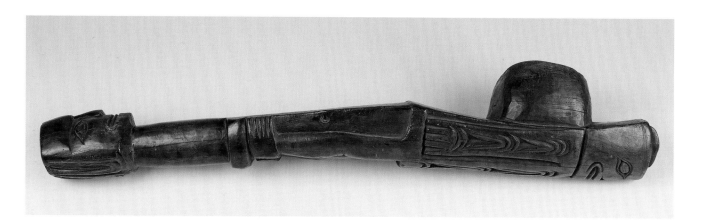

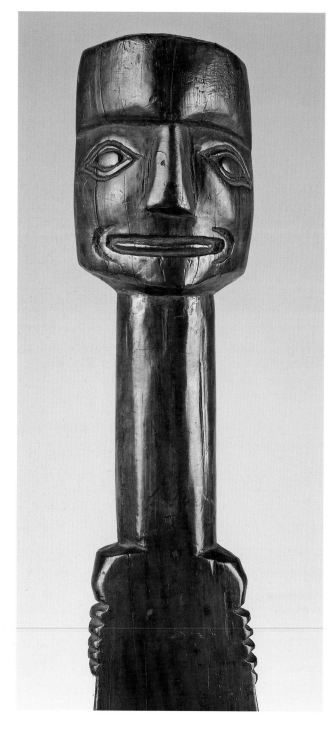

Figure 5.16
Fish club, Lower Fraser River, late eigh-
teenth or early nineteenth century, yew
wood, 23 × 4¾ in. (58.42 × 12.06 cm).
Acquired by Colin Robertson before 1833.
Perth Museum and Art Gallery, Perth &
Kinross Council, 1978.466.

This heavy club with its sturdy handle and formidable
striking knob is made to deliver a powerful blow. It is
also ornamented at the butt with a delicately rendered
human head and a stylized humanlike figure carved on the
rounded surface of the shaft. Unlike wood and whalebone
war clubs, decorated fish clubs are rare in collections.

canoe, the best of its kind, was one of three acquired by Yale around 1830 (see fig. 11.6). Two carved figures sit inside the canoe; one paddles, while the other holds a sturgeon spear. Their faces are animated and contorted as though singing or speaking.

It does not appear that any Salish materials were collected by Lewis and Clark, who wintered in Chinook territory at the mouth of the Columbia River in 1805. George Catlin, the painter of Native subjects, acquired Native artifacts from Clark, who had founded a museum for his personal collection in St. Louis. The elegant bark shredder carved from whalebone and depicting stylized animals (fig. 5.17) came into the Smithsonian Institution in 1884 from the Catlin collection, after it had been exhibited in Europe by Catlin in the 1840s (Wright 1991: 105). There is no documentation by which to ascertain if this was part of the original Lewis and Clark collection. Much of the surviving Lewis and Clark material is in the Peabody Museum of Archaeology and Ethnology at Harvard University; it was received in about 1850 from the personal collection of Moses Kimball, the proprietor of the eclectic Boston Museum. The Peabody ethnographic collections initially were built from private collections and included Native art received from local antiquarian and scientific societies. Two rare goat-horn bracelets (fig. 5.18) of eighteenth-century origin entered the museum from the Boston Athenaeum and the American Antiquarian Society of Worcester, Massachusetts. One of the bracelets and a superb double-ended comb (fig. 5.19) appear to have been collected by Roderic McKenzie (or Mackenzie), a fur trader like his cousin Alexander Mackenzie, who established Fort Chipewyan in Alberta.

The most ambitious exploratory voyage undertaken by the American government was the United States Exploring Expedition (1838–42) under the command of Lt. Charles Wilkes. Its objective—to produce navigational charts for the nation's merchant vessels—took the team to Antarctica, South America, Tahiti, Australia, the Pacific Northwest, Manila, Singapore, and Cape Town. The able crew, which included painter Titian Ramsay Peale, explored the territory in what is now western Washington in 1841. The 2,500 ethnographic and archaeological artifacts that it collected were catalogued by Peale and the naturalist Charles Pickering in the 1840s; 3,000 natural history specimens were collected in addition to the artifacts. The collection was exhibited in the Great Hall of the Patent Office until 1857, when it was transferred to the Smithsonian Institution (the U.S. Exploring Expedition, 2007). More than five hundred of the original artifacts were given to numerous institutions in North America and Europe to help them establish collections, a practice encouraged by founder Robert Smithson and deemed acceptable at the time. The Wilkes collection is rich in textiles, with robes of mountain-goat wool and bird down and many examples of Puget Sound baskets, all beautifully preserved (see figs. 9.9, 9.10, and 9.11; and the essay by Carolyn J. Marr, this volume). A twined robe with complex geometric patterning created from mountain-goat wool colored with native dyes is often referred to as the "classic" type (Gustafson 1980) and is likely the earliest weaving of the several Wilkes pieces (see fig. 10.13). Another very rare type of robe has a typical Salish twined border of geometric design in several colors, but

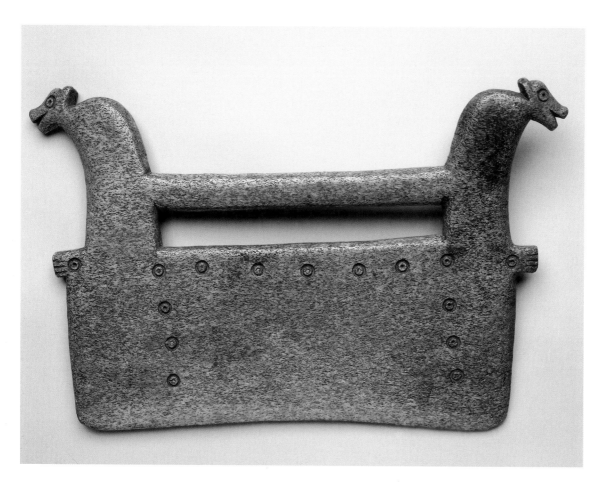

Figure 5.17
Bark shredder, western Washington, nineteenth century, whalebone, 7 × 10 × ½ in. (17.78 × 25.4 × 1.27 cm). Department of Anthropology, Smithsonian Institution, E73290.

This functional tool was used to break down the fibrous inner bark of the red cedar tree to make it pliable for weaving mats, hats, and baskets, or to break down bark from the yellow cedar with which to weave robes, capes, and dresses. Softened bark was also used for bandages, baby diapers, and rope. The dried strips of bark cut in uniform lengths would be laid over a sharp edge—like a canoe paddle—and chopped with the shredder. Many simple, blade-shaped wooden shredders with handles were produced to accomplish this task but only a few spectacular decorated examples exist in museum collections (see also fig. 3.13). On each end, this shredder has identical creatures with open mouths, short ears, and rounded eyes. Each creature's foot, as well as the blade, is decorated with incised circles and dots. The painter George Catlin had this shredder in his collection of Native American art when he toured Europe in the 1840s (Wright 1991: 105).

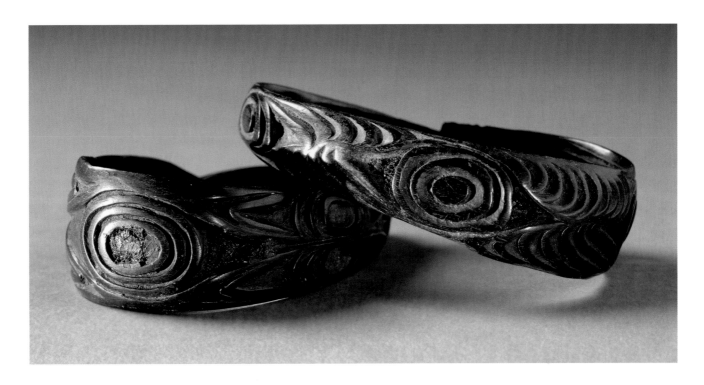

Figure 5.18
Bracelets, eighteenth century, goat horn, each 3 × 2 in. (7.1 × 5.08 cm). Collected by Roderic McKenzie (?). Harvard University, Peabody Museum, 67-9-10/130 and 95-20-10/48405.

These two bracelets—there are only twenty-one in existence—bear the bold geometric carving style of the Halkomelem-speaking people of the Central Coast Salish territory (see map, p. xix). The core shapes that make up the design have their roots in a proto–Northwest Coast design system that remained strong in the art up until the contact period (Brown 2005: 12). Jewelry and adornment were a sign of status and wealth, as the materials had to be obtained through trade. Abalone shell from California, dentalium shells harvested from the deep waters of the Pacific Ocean, goat horns from the Cascade Mountains, and, later, copper, iron, and brass acquired via non-Native trade were prized for their rarity and unique physical properties. Like all of the other goat-horn bracelets, these were acquired early in the historic period—perhaps by Northwest Company fur trader Roderic McKenzie—suggesting that their manufacture dwindled after contact.

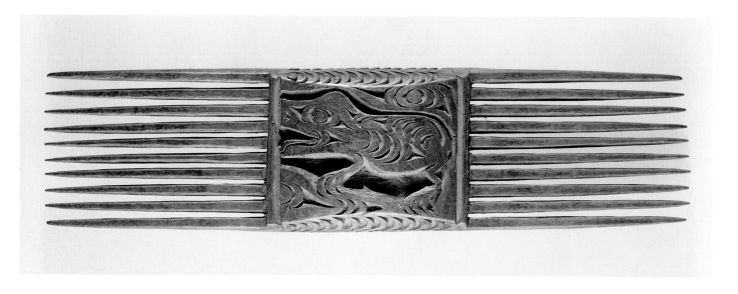

Figure 5.19
Comb, late eighteenth or early nineteenth century, wood, 2 × 8½ × ¾ in. (5.08 × 21.59 × 1.91 cm). Collected by Roderic McKenzie (?). Harvard University, Peabody Museum, 95-20-10/48393.

There are two types of combs: the double-ended type, of which this is an example (see also fig. 5.10); and the vertically oriented, single comb illustrated in figures 5.6 and 5.21. Although they were employed for personal grooming, for combing mountain-goat wool to align the fibers, and for packing the weft during weaving, combs are intriguing sculptures in their own right. Both of the sides are completely carved. This view shows a four-legged creature with a snout and tail that has been completely outlined by the cutaway space around it. Trigon shapes demarcate the nose, eye, and space behind the mouth, while stacked crescent shapes in the body indicate the internal ribcage or, perhaps, the furry texture of its skin. The narrow, flat spaces at the top and bottom provided a surface for the carver to engrave stacked crescent shapes. Repeated elements throughout lend a sense of rhythm and flow to the entire design.

the body of the robe is made from woven strips of natural gray and brown waterfowl down, leaving a lush pile on the surface (see fig. 1.2). Yet another robe (fig. 5.20)—this style called a "nobility robe" and sometimes compared with the Navajo "eye-dazzler" blankets—is an elegant specimen of complex twined weaving. Also in this grouping is a wooden comb carved with a man wearing a top hat (fig. 5.21), perhaps meant to represent a Euro-American.

The British established their first permanent colony in present-day Victoria on Vancouver Island in 1843. When gold was discovered in the lower Fraser Valley of the mainland in 1858, thousands of people flooded in, hoping to become rich overnight. To help maintain law and order, the British government established the colony of British Columbia, and in 1866, the island and mainland colonies were joined. The promise of a rail link between the Pacific coast and the rest of Canada convinced British Columbia to join the Confederation process and become part of the Dominion of Canada in 1871. These events brought significant changes to aboriginal peoples living in southern British Columbia and in Washington Territory.

One could argue that the parallel growth and development of Seattle, Vancouver, and Victoria into major urban hubs were contributing factors to the large-scale destruction of aboriginal life and customs. While the Coast Salish are linked to their northern Northwest Coast neighbors through such pervasive cultural features as food resources, canoe travel, cedar-plank houses, and a hierarchical social structure based on wealth and potlatch ceremonialism (Wright 1991: 22), the Salish were arguably subjected to greater incursions into their territories and ways of life. As Wayne Suttles explains in his essay (this volume), the early and persistent pressures placed on Salish peoples of this region, coupled with a cultural focus on private knowledge and secrecy surrounding the art and ceremonies, have led to fewer scholarly studies and public exhibitions of Salish culture and a general misunderstanding of its artistic heritage. Rapid urbanization has left wide gaps in the archaeological record and knowledge about artistic antecedents as well.

Even before the rail lines built in the 1890s brought thousands of settlers into the Pacific Northwest, traveling microbes in the form of infectious diseases decimated Native populations (Boyd 1999). Because the growing economies of Washington State and British Columbia were based on the utilization of natural resources (as were Native economies), especially fishing and logging, government agencies and entrepreneurs devised strategies to move Native and First Nations communities from their homelands. In Washington alone, tribes were forced to cede 64 million acres through treaties enacted in 1854 and 1855, leading to the establishment of reservations (Wright 1991: 23). Many tribal leaders signed treaties to prevent further violence against Native peoples and to give them access to health care and education. Assurances were made that subsistence hunting, fishing, and gathering were protected, as were rights to practice Native religion. In British Columbia, First Nations were initially recognized as having rights to the land, but by the time of Confederation in 1871, the government retracted its recognition of aboriginal title (exclusive use and occupancy of land), and First Nations were forced onto

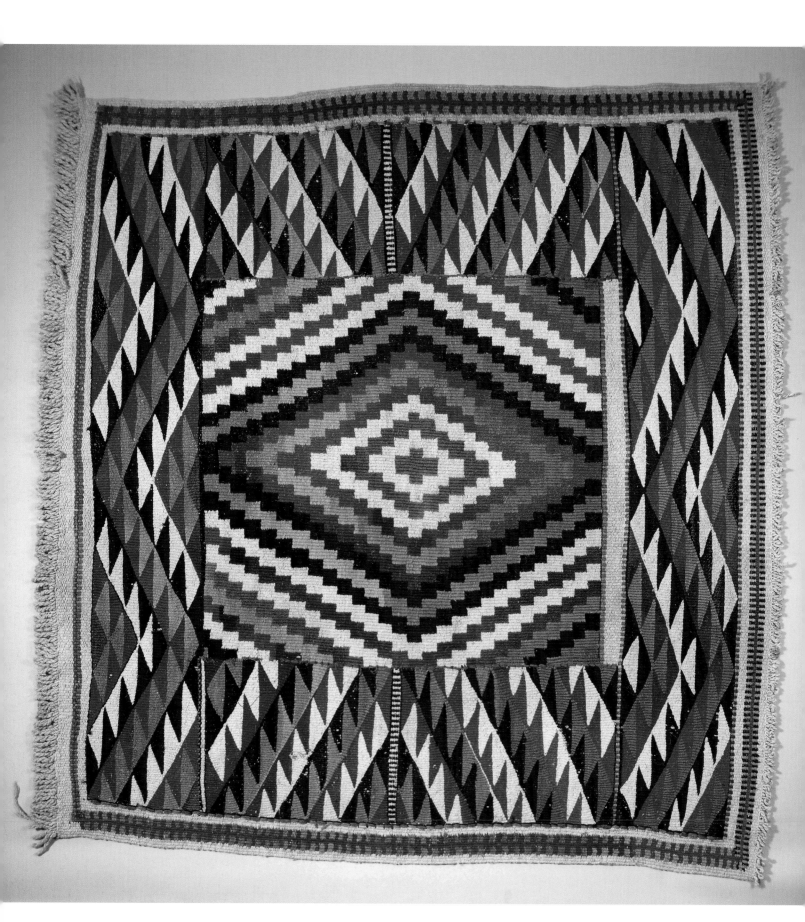

Figure 5.20
Robe, early nineteenth century, mountain-goat wool, dyes, 59¹³⁄₁₆ × 60⅝ in. (150.33 × 153.98 cm). Collected on the U.S. Exploring Expedition, 1841. Department of Anthropology, Smithsonian Institution, E1891A.

Twined and twill-woven textiles of mountain-goat wool mixed with dog wool and plant fiber were woven by women specially selected for this task. Cream-colored twill robes with stripes of colored wool have been found in prehistoric sites and were proudly worn until the early twentieth century (see fig. 10.2). After a hiatus of several decades, wool weaving was revived in the 1960s (see fig. 10.8). Fully twined textiles of dyed mountain-goat wool, such as this one, were referred to as "nobility robes" because only high-status people had the means to commission them. The earliest twined robes (see fig. 10.13) bore intricate combinations of geometric patterns in narrow bands of subtle green, brown, brown-red, rust, yellow, and gold shades created with plant and other natural dyes. Green color was obtained from grasses, and brown and shades of brown from alder or hemlock bark, while yellow and gold were made from wolf moss and the roots of the Oregon grape (Gustafson 1980: 94). By the mid-nineteenth century, bolder colors and patterns were employed, often with a central square in patterns contrasting with the sides, top, and bottom of the weaving.

Figure 5.21
Comb, early nineteenth century, wood, 7¹⁄₁₆ × 2¼ × 1⅛ in. (17.9 × 5.7 × 2.9 cm). Collected on the U.S. Exploring Expedition, 1841. Department of Anthropology, Smithsonian Institution, E2702.

It is interesting to compare this comb with the British Museum example shown in figure 5.6. On both combs, the men wear Euro-American top hats, but one comb is decidedly more naturalistic in its depiction of the human form, while the other employs reductive stylization. It appears from the extant carvings dating to the early contact period (1770–1810) that both styles existed side by side.

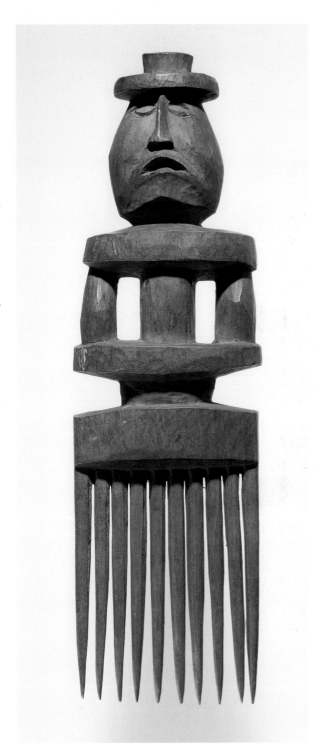

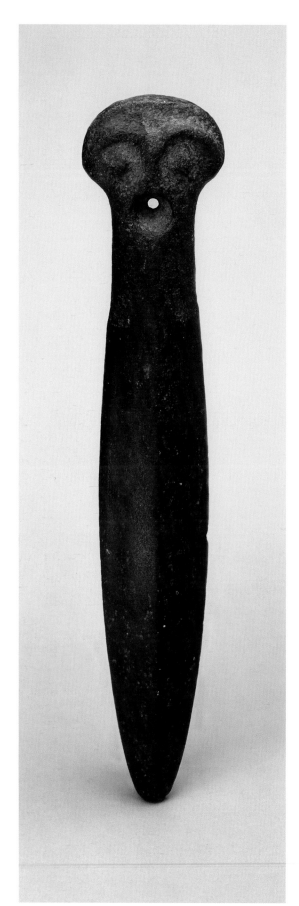

Figure 5.22
Club, Skokomish, ancient (prehistoric), basalt, 15 × 2½ × 1¾ in. (38.1 × 6.36 × 4.44 cm). Collected by Reverend Myron Eells, 1893. Maxey Museum, Whitman College, WHIT-E-0305.

Clubs were used in hunting, fishing, and warfare. Herman Haeberlin reported that war clubs in the Puget Sound area were made of elk horn or hard wood. Nisqually warriors evidently made clubs of black stone, which were sharpened on one side, with a hole in the handle to thread the thong that was tied to the wrist (Haeberlin and Gunther 1930: 14). Bone clubs—and perhaps wooden ones—were used by Salish First Nations in British Columbia, as were stone mauls (or hammers), with a raised nipple on the end (Barnett 2001: 269). This is probably an ancient club; the rudimentary facial features on the handle have affinities with petroglyph images (Hill 1974; Wright 1991: 70). Some of these weapons became famous, with their own names and exploits recalling past military glories.

reserves in 1876 and again in 1912. Only the Douglas Treaties of 1850–54 on Vancouver Island affected Coast Salish people in British Columbia. Beginning in the 1970s, several court cases have confirmed the existence of aboriginal rights, and the exact nature of aboriginal title is being defined through current treaty negotiations in Canada.

With the influx of settlers and entrepreneurs, there also came missionaries who were determined to rid aboriginal peoples of their religion, potlatching, and ceremonial regalia. In Canada, the potlatch was banned in 1884, an act not dropped from law until 1951. The desired effect was to curtail the making of ceremonial regalia and other art, although government officials and missionaries often confiscated and collected these items; many items made their way into private collections and museums.

In western Washington, Rev. Myron Eells, a Congregationalist missionary, collected for museums many of the things he dismissed as "pagan." He was appointed Superintendent of Ethnological Exhibits for the Washington State Pavilion at the World's Columbian Exposition in Chicago in 1893. Working among the Skokomish, Quinault, and Clallam from 1874 to 1907, Eells wrote many essays on the history, religion, and language of the Native peoples of the region, most notably *Twana, Clallum, and Chemakum Indians of Washington Territory,* published in 1889. His collections and archives (see figs. 1.3, 3.8, and 5.22) are housed at his alma mater, Whitman College, in Walla Walla, Washington (see Castile 1985).

Private citizens sometimes gathered extensive collections. The collection of Capt. Dorr Francis Tozier of the U.S. Customs Service was exhibited at the Ferry Museum in Tacoma, Washington, and sold to George Gustav Heye, a wealthy oil heir who owned the largest private collection of Native American objects in the world when he opened his Museum of the American Indian in New York City in 1916. Judge James Wickersham, a probate judge in Tacoma and an amateur ethnologist, amassed an impressive collection of Puget Sound basketry from 1883 to 1898. It was dismantled and sold after his death (see fig. 9.1). Wickersham is best known in the Native community for giving legal protection to the Indian Shaker Church in 1910. Scottish-born physician and passionate natural historian Charles Frederick Newcombe settled in Victoria in 1889 after five years in Oregon. Living in proximity to Coast Salish bands, he developed an interest in aboriginal art and became one of the most knowledgeable and reliable collectors of Northwest Coast Native art. He traveled extensively in British Columbia and assembled impressive items from among all the coastal groups, eventually becoming one of the key players in the development of the British Columbia Provincial Museum collections and of many other Canadian and U.S. museums. His extensive contacts all over the coast—missionaries, storekeepers, collectors, and ethnologists—helped secure major pieces, including many totem poles. He was also able to buy Salish works through the help of a Cowichan man from Chemainus, John Humphreys (Cole 1985: 198). Newcombe and his son William prepared exhibits for the Louisiana Purchase Exposition in St. Louis in 1904. This and other expositions focused on monumental totem

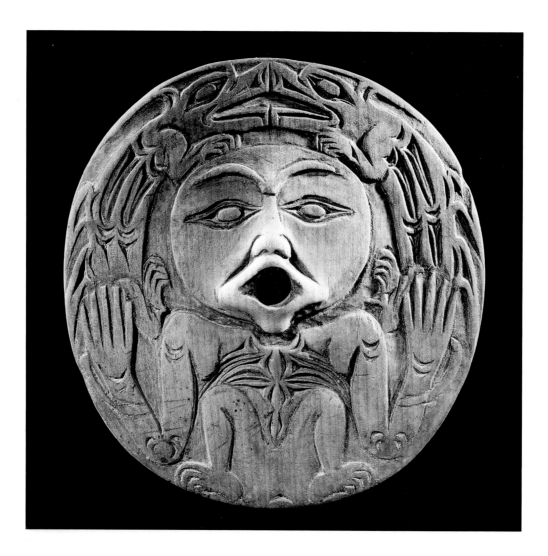

Figure 5.23
Spindle whorl, before 1912, wood,
8⅜ × 8 × ¾ in. (21.27 × 20.32 ×
1.9 cm). Royal British Columbia
Museum, 2454.

This exceptional whorl was featured in the landmark exhibit
assembled by the Royal British Columbia Museum in 1970 called
"The Legacy." Drawing from the Museum's extensive historic col-
lections, the exhibition included modern and contemporary artists
and traveled widely, including to some First Nations centers. A
catalogue by the same title was published in 1980, and again in
1984, and served as the most insightful book of the time on the
persistence and adaptation of British Columbia First Nations styles,
forms, and meanings across time. With artist biographies and pic-
tures, a largely unaware audience was brought face to face with
living traditions and artists, including the late Rod Modeste
(1946–2007) from Malahat (see figs. 5.33 and 5.34). This was the
first museum publication to give credence to Southern Northwest
Coast art styles, including that of the Nuu-chah-nulth and Coast
Salish. This sublime carving depicting a crouching human figure
with animal feet, protected by flanking, snouted animals in mirror-
image, captivated young Salish artists who, without benefit of
formal training, hoped to decipher and re-present the Coast Salish
aesthetic. Stan Greene's and Susan Point's serigraphs of whorl
designs in the late 1970s and early 1980s, which they later trans-
lated into experimental works in glass and wood, brought the
unique features of Coast Salish design to the public. The inspira-
tion of these humble yet forceful tools has become a leitmotif for
a new generation as well (see fig. 5.42).

poles, masks, ceremonial and utilitarian objects, and, sometimes, Native performers, but little attention was brought to Coast Salish art and culture, perhaps because Coast Salish people did not make totem poles or have many types of masks. The general objective of the large public fairs was a nationalistic celebration of America's progress and accomplishments and the arts and industries of "primitive man" showcased within an evolutionary paradigm. Some exhibits even featured the positive "civilizing" effects of government schools on America's aboriginal people (Cole 1985: 126).

Perhaps the most prolific collector on the coast was George T. Emmons, a naval lieutenant stationed in Alaska in the 1880s and 1890s who became a freelance collector after his retirement in 1899. His father was a member of the Wilkes Expedition. Emmons's ethnographic focus was on the people north of Coast Salish territory, and he procured far fewer pieces from the southern region. It would not be an exaggeration to say that every

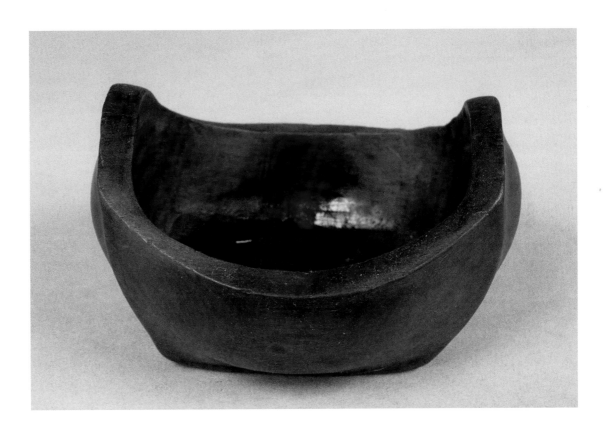

Figure 5.24
Oil dish, Klallam, nineteenth century, wood, 3⅓ × 5 × 4¾ in. (8.46 × 12.7 × 12.06 cm). Burke Museum of Natural History and Culture, Seattle, 219.

Artfully shaped by steaming and carving, this diminutive bowl bears a sticky film of fish or sea mammal oil in the bottom. Tasty oils were used to flavor dried fish and other foods. Small dishes with flaring sides, high ends, and substantial rims were a common type: one variation was an elongated oval shape that is shallow in profile (Waterman 1973: 39). This dish was a gift to the Burke Museum from the Washington World's Fair Commission after the fair ended in Chicago in 1893.

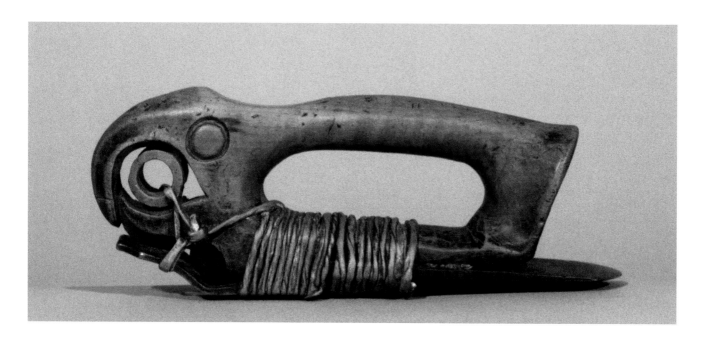

The D-adze is one of the indispensable implements in a carver's
tool chest, along with a straight adze (see fig. 1.4), a short-handle
elbow adze (fig. 11.3), several crooked knives, a chisel, a stone
maul, and yew wedges. Originally adze blades were made of bone,
shell, or stone, but they were quickly replaced by steel blades
acquired through trade and often recycled from pioneer-style axe
heads or chisels, as this one appears to be. Waterman was conduct-
ing an ethnographic survey for the University of Washington dur-
ing the summer seasons of 1918 and 1919, collecting place names
from southern Puget Sound consultants. Curiously, the Burton
Acres Shell Midden—near where Waterman collected this D-adze—
was excavated in 1996 and yielded two antler adze hafts and a
bone chisel dated to approximately 500–600 years ago (Stein and
Phillips 2002: 56, 85–87).

major museum and many smaller museums in Europe, Canada, and the United States
contain Native works collected by him. Franz Boas at the American Museum of Natural
History reportedly relied on Emmons's collecting prowess even while dismissing his
aspirations to be seen as a reputable ethnologist. Yet Emmons's methods suggest other-
wise. He would assemble large collections of specific types of objects—such as Tlingit
shaman implements or jade celts from British Columbia—and sell them as a package to
museums or private collectors, with the idea that a comprehensive grouping had more
scholarly value than works assembled piecemeal.

Emmons provided exacting documentation, designed displays, and contributed no
fewer than fifteen topical articles to anthropological journals and museum publications.
He wrote but never assembled a major monograph on the Tlingit (Emmons 1991). One
of Emmons's patrons was George Heye, who received items on and off from 1905 to
1943. Heye himself made several collecting visits to the Northwest Coast but also relied
on his staff and field collectors to fill in. With his considerable fortunes he was able to

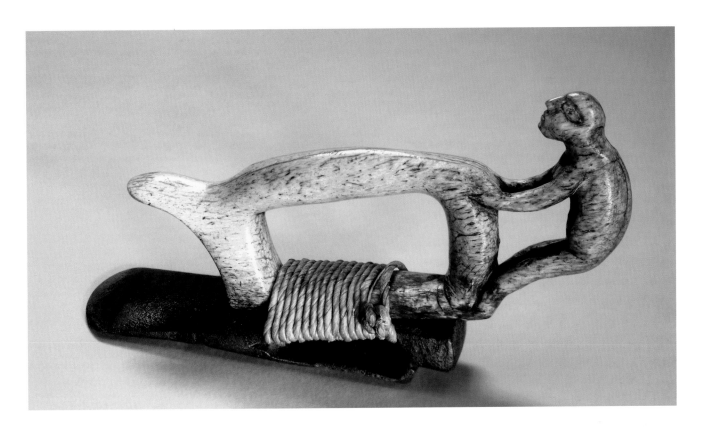

The sensitive carving belies its function as a robust tool used for shaping wood into canoes, house planks, house posts, dishes, spoons, spindle whorls, mat creasers, and a host of other utilitarian and ritual items. Functional and elegant in proportion, it is perfectly constructed to be firmly gripped around the handle, with the thumb placed in the sloping depression. This specimen carved from a single piece of whalebone depicts a large-eyed figure curiously holding on to the hand grip. The axe-head blade is solidly lashed to the haft with rawhide. Anthropologist Ronald Olson reported that among southern Salish peoples this adze type was used by the Quinault, Snohomish, and Lummi (Olson 1967: 15) but likely was employed by many other Salish groups as well, as it is today.

acquire major collections wholesale from others, including the Tozier collection that was stored in Seattle and included Salish material (J. Miller 2005: 77). Additional pieces from Washington State were gathered by ethnologists Leo J. Frachtenberg (1916–18) and Thomas Talbot Waterman (1919–21), whom Heye hired to collect among the Quileute, Quinault, and Makah in 1916–18 and in Puget Sound in 1919–21.

The top Canadian and American institutions called into service independent collectors, creating rivalries and competitions to get the best and the most the field had to offer. C. F. Newcombe, and later his son William, had the advantage of living close to First Nations communities and could procure valuable firsthand documentation about the pieces collected. As we saw with Rev. Myron Eells, field collecting was needed to create displays for fairs and expositions. Grace Nicholson, a dealer and accomplished photographer who had a shop in Pasadena, California, in the early 1900s, was an amateur ethnologist and made several important field collections—a rather unorthodox pursuit for a woman at the time. Although her focus was on California Native

basketry (and Asian arts), she employed buyers at other locations to acquire a broad range of Native pieces. Nicholson traveled to the Puget Sound area in 1907 and 1909, where she likely purchased a Quinault whalebone adze (fig. 5.26) and a Nisqually horn spoon (see fig. 3.7).

The perception that Native cultures were in decline because of disease and displacement sparked visits from anthropologists and independent collectors like Newcombe to salvage what was left of Native language, folklore, and material culture. The era of public museum collections began with the establishment of the Smithsonian Institution in 1846, the Geological Survey of Canada (now the Canadian Museum of Civilization) in 1856, the Peabody Museum of Harvard University in 1866, the American Museum of Natural History in 1869, the British Columbia Provincial Museum (now the Royal British Columbia Museum) in 1886, and the Field Museum of Natural History in 1893. All these institutions vied for prime collections of cultural art and maintained active programs in ethnological and archaeological collecting. Each also relied on the field collecting of individuals outside of museum staff.

By the 1920s the heyday of ethnographic collecting had declined. New forms and materials had long been a part of Native life but had been shunned by collectors in favor of "authentic" cultural objects. The potlatch ban, adjustment to reservation life, the Allotment Act of 1887, residential schools, and the influx of settlers and tourists altered the role of material culture in aboriginal life. Some forms of Coast Salish traditional arts, such as house posts, mountain-goat wool robes, and feasting paraphernalia, had ceased being made, replaced by the items accessible after years of trade. Undeniably, art-making continued for use within the communities and the practice of Native religion never ceased, but the rigorous assimilationist strategies aimed at transforming First Peoples into citizens had chilling effects on Native customs. Boarding school and day school curricula formulated by Indian Affairs sought to teach useful industries and trades, as well as basic education. The boys learned carpentry, farming, and blacksmithing, while the girls learned sewing, cooking, nursing, or office work (Marr 2007). The most devastating initiative was the prohibition against speaking Native languages at school; coupled with mandatory hair-cutting and wearing of Anglo clothing, it caused Native identities to be subsumed and recapitulated. Vi Hilbert explained that while the long periods at residential school in Oregon away from her family were excruciating, she found a new life in the company of hundreds of Indian children like herself. As an only child, having such a big "family" brought her some happiness. For many, the boarding school experience was one of unbearable pain. With shifting attitudes about how to integrate Natives into mainstream society, and the realization that they were not in fact "vanishing races," most boarding schools were closed in the 1920s. Native children then attended public school, and general social reforms allowed aspects of Native culture to coexist within the dominant Anglo culture.

Before the substantial social reforms during and after the Depression, Native art forms were often co-opted by government, civic institutions, and private enterprise as

symbols of the American and Canadian past. Although Coast Salish people did not have a tradition of carving monumental totem poles, civic projects in Seattle, Vancouver, and Victoria seized these prominent forms as expressions of civic identity. One of Seattle's most famous public monuments is the Chief-of-All-Women pole stolen by Seattle businessmen from a Tlingit village in 1899 and erected in Pioneer Square (see Garfield 1996). Similarly, in British Columbia, totem poles were erected on steamship stops to promote tourism, immigration, and financial investment (Hawker 2003: 34). The older, iconic works from the region's past contrasted with the exciting future that was unfolding in the new, urban Northwest. The famous totem poles of Vancouver's Stanley Park were erected for the city's Golden Jubilee on a site that had been a massive shell midden made by the indigenous people of the region, the Burrard (Tsleil-Waututh), Musqueam, and Squamish bands of Coast Salish First Nations. Two Kwakwa̱ka'wakw poles and a Haida mortuary pole, all carved in the late nineteenth century, were installed first. Because of unresolved land issues with the Squamish, the planning committee asked Squamish Chief Mathias Joe to carve a Salish pole for another part of the park, at Prospect Point (Hawker 2003: 104). Joe and other Salish carvers of the time had adopted the use of fully carved and painted poles from their Kwakwa̱ka'wakw neighbors but used creatures and beings from Salish myths. Sculptures in Coast Salish style now appear in Stanley Park with three Salish-style gates carved by Musqueam artist Susan Point, entitled *People Amongst the People*.

Misguided intentions such as these have ultimately contributed to a denigration of Salish aesthetics and reflect an ambivalent social agenda that suppressed the cultural relevance of the art while appropriating the forms as civic symbols. In the 1920s, scholarly factions perpetuated the idea of the Coast Salish region as a "receiver area" whose art was derivative of that of the more robust and inventive styles of their neighbors (B. G. Miller 2007: 2). Because their traditions were not deep and abiding, the argument goes (and because of early non-Native settlement), the Coast Salish had been susceptible to acculturation and left without traditional connections and identities, which made them not worthy of scholarly attention. To be sure, far less Coast Salish art was collected than that of other Northwest Coast groups and, as Wayne Suttles writes in his essay in this volume, it was glossed over or skipped altogether when museum exhibitions brought Native art to public awareness.

Residential schools had selectively promoted certain arts that would provide an economic foundation for students who might otherwise be thrust into unemployment and poverty. In fact, government, religious, and philanthropic economic initiatives aimed at Natives encouraged the making of appealing and saleable handicrafts for public sale. There were well-established curio shops, such as Frederick Landsberg's curio shop in Victoria and J. E. Standley's Ye Olde Curiosity Shop in Seattle. Standley dealt in older materials and sold to museums, but he also contracted with local Natives to produce small-scale totem poles and other portable mementos for the tourist trade. He reportedly showed artists the illustrations in Franz Boas's *Kwakiutl Ethnography* as models for

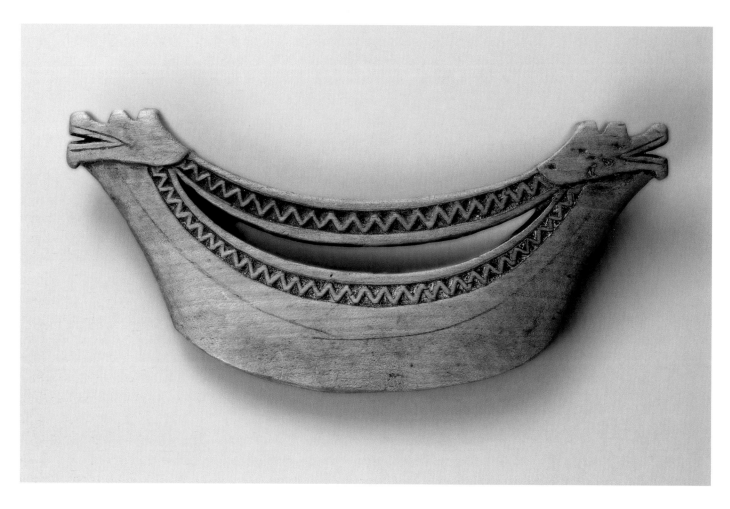

Figure 5.27

Mat creaser, western Washington, nineteenth century, maple wood, 2½ × 7 × ½ in. (6.4 × 18 × 1.3 cm). Rasmussen Collection, Portland Art Museum, 48.3.221. Portland Art Museum, Portland, Oregon, Axel Rasmussen Collection, purchased with the Indian Collection Subscription Fund, 48.3.224.

A striking example of a woman's mat-making tool, this may be of Quinault origin given the zigzag patterns cut into the surface of the body and grip. Compare this with the chip-carved rim of the dish in figure 5.28, which was obtained from J. E. Standley's Ye Olde Curiosity Shop in Seattle in 1931. Perhaps the two creatures are the same as the mysterious "sea-monster" depicted in the Quinault dish (see fig. 3.8) or are intended to show unidentified creatures from the pantheon of the Salish spirit world. This perfectly designed mat creaser from the Rasmussen Collection is used in the making of cattail mats, which served as all-purpose coverings for the ground and for inside the canoe. When placed over lodge poles, these mats created temporary shelter and were an indispensable part of domestic life. Axel Rasmussen (1886–1945) was superintendent of schools for Wrangell, Alaska, from 1926 to 1937, then at Skagway from 1937 until his death in 1945. He amassed a fine collection of Northwest Coast Native art, numbering five hundred pieces, which were acquired by the Portland Art Museum in 1948. He obtained many items from Native owners but also from dealers, like Standley and G. T. Emmons, from whom he acquired the Salish objects (Gunther 1966: 178).

carvings to be sold in the store, thus contributing to the hybridization of art styles for the tourist trade (see Duncan 2000).

Most proponents of adapting Native arts to modern society were concerned not with authenticity but with Native welfare. Depression-era public policy inaugurated by John Collier, commissioner of Indian Affairs under Franklin D. Roosevelt, and the British Columbia Indian Arts and Welfare Society (founded in 1939) sought to integrate Natives into mainstream society while capitalizing on the "positive" aspects of Native culture. The failure of past Indian policy was widely recognized on both sides of the border, especially during the Depression, and resulted in a two-pronged effort to educate the public about Native heritage and to create a commodity market in which Natives could productively participate.

The promotion of national arts programs led to the creation of the Indian Arts and Crafts Board in the United States and the Canadian Indian Arts and Crafts Board, both charged with promoting contemporary Native art and artists. This shift in philosophy (and policy) greatly affected museum activities and exhibitions (Hawker 2003: 71). The aims were clearly stated in a catalogue for the first major exhibition of Native art as fine art, held at the Museum of Modern Art in New York in 1941 and curated by Collier appointee René d'Harnoncourt: "to show that the Indian artist of today, drawing on the strength of his tribal tradition and utilizing the resources of the present, offers a contribution that should become an important factor in building the American of the future" (Douglas and d'Harnoncourt 1941: 2).

In Eleanor Roosevelt's Foreword to the catalogue, the commingling of art and politics is apparent in an apologist tone that offers the potential for Native art renewal as well as a social awareness of the place of the Native heritage within a nationalistic identity. Unfortunately, Coast Salish art was not given much visibility in such exhibitions: the Douglas and d'Harnoncourt catalogue illustrates just two Salish pieces, a *sxwayxwey* mask and a shaman's figure. In 1962, an important exhibition of Northwest Coast Native art was organized for the Seattle World's Fair, along with five other fine-art exhibitions. Erna Gunther, director of the Washington State Museum and a former student of Boas, curated the exhibition (see Gunther 1962). Fifteen world museums and one private collector contributed to this very ambitious undertaking. In what must have been a splendid show, the emphasis appears to have been on assembling works with a wide range of artistic expressions and of high aesthetic quality. Of the 334 works cited in the Northwest Coast publication, only ten were Coast Salish, including loom posts (fig. 10.6) and house posts (fig. 6.4). This paucity of Salish art is puzzling, since Gunther was regarded as an expert on Coast Salish culture and had written a book on the subject, with the help of Herman Haeberlin's field notes, *The Indians of Puget Sound*. It is possible that there were fewer Salish pieces to choose from, however; and based on the exhibition as a whole, there seems to have been favor shown masks and elaborately decorated and painted carvings.

Museums were the principal venues for the public presentation of Northwest Coast art for much of the twentieth century, and permanent collection displays were arranged by anthropologists and a growing field of museum professionals, including Franz Boas, George Dorsey, Harlan I. Smith, Charles Newcombe, and Erna Gunther. All had experience with preparing exhibits for several national fairs and expositions. Boas was perhaps the most strident voice for the scholarly objectives of museum research, fieldwork, and display, while also acknowledging the prevailing emphasis on the role of the museum as educator (Jonaitis 1988: 214). Initially trained as a scientist, Boas was a thoroughgoing professional with ambitious objectives. He challenged the popular anthropological tenet that human societies could be located on a linear evolutionary track—with European culture at the "advanced" end—and that some did not evolve as fast or as far as others (see Suttles chapter, this volume). He openly criticized the display of artifacts at the Smithsonian's United States National Museum, where object types were arranged from the simplest to the most advanced, thus promoting the evolutionary theory of culture (Jonaitis 1988: 126). Based on the belief that a broad scope of material culture could be assembled for each society, Boas's approach opted for intimate cultural groupings that emphasized the historical and social contexts of the works. In the grand installation of the Hall of the North Pacific Peoples that opened at the American Museum of Natural History (AMNH) in 1899 under Boas's direction, an overview of Northwest Coast Native technologies was provided, with most of the hall displaying a wide range of artworks by individual culture groups (Jonaitis 1988: 208).

It is fortunate indeed that the most comprehensive research project on Northwest Native peoples of its day—under the auspices of the Jesup North Pacific Expedition—was directed by Boas, who hired prominent ethnologists to assist in the collection of myth and language, art and archaeology, and, sadly, human remains.[1] Morris K. Jesup, president of AMNH, funded this five-year field expedition of 1897–1901 in order to gather data about the link between Asiatic and New World peoples.[2] The expedition was significant for several reasons: it brought together some of the best scholars and field workers; it made use of Native consultants; it resulted in the publication of important monographs; and it provided for the collection of artifacts and archaeological specimens in this last noteworthy period of collecting. For Coast Salish studies, the combined work of the prominent scholars and individuals who coalesced in the communities is a lasting contribution, including that of Harlan I. Smith, James Teit, Livingston Farrand, and many Native and First Nations consultants. The collections assembled during these years greatly supplemented the Powell-Bishop collection and the Emmons Tlingit collection at the American Museum of Natural History. In regard to Salish art, the Jesup materials filled important gaps from the southern Northwest Coast.

Harlan Ingersoll Smith (1872–1940), with an undergraduate degree from the University of Michigan, worked from 1897 to 1900 with the Jesup Expedition, investigating the archaeology and ethnology of Native peoples in British Columbia and Washington State. He was an assistant curator of the archaeology collections at the American Museum

of Natural History when Boas enlisted him for the expedition (see Thom 2001). Most of Smith's investigations were archaeological and osteological, yet he secured important ethnographic material from Interior and Coastal Salish communities, including eleven monumental Salish sculptures from Comox (see Jonaitis 1988: fig. 84, p. 235 and figs. 62, 63, p. 194), four house posts from Musqueam, and complete *sxwayxwey* dance regalia. A skilled photographer, Smith documented the immediate context for the works he was acquiring (see fig. 6.5), as well as scenes of the people and their communities. Not yet forty years old but with considerable experience under his belt, Smith was asked to join the Geological Survey of Canada as the head of its Archaeology Division in 1911. The findings of this archaeological unit and the ethnographic collections merged to become the Museum of Man, then the Canadian Museum of Civilization (see Vodden and Dyke 2006). Smith returned to British Columbia to investigate archaeological sites, traditional uses of plants, and the cultural customs of the Nuxalk, Dakelh-ne (Carrier), and Chilcotin First Nations. In 1928 he made pioneering ethnographic films in the field of several Northwest Coast groups, among them the film *Coast Salish Indians of British Columbia.*[3] Smith's films break with documentary techniques employed by others in that he shows changes occurring in culture (Wise 2007, pers. comm.). Smith approached his photographic and film work like a scientist, providing such information as the names and family lineages of his sitters. He took measures to assure that his subjects saw the images he took of them.

Boas's legacy at the American Museum of Natural History touched his many colleagues and students. Livingston Farrand (1867–1939), a medical doctor and anthropologist schooled at Princeton, Columbia, and in Europe, was an adjunct professor at Columbia, like Boas, when he was asked to participate in the Jesup North Pacific Expedition. He spent the 1897 field season in Chilcotin and Nuxalk territory and the summer of 1898 on the coast of Washington among the Quinault and Quileute, collecting what linguistic and ethnographic data he could.[4] Although his work was not a central feature of the project, Farrand collected baskets and sculptures (fig. 5.28), including several shamanic pieces (see Wingert 1949: pl. 2, pl. 6a,b; Jonaitis 1988, pl. 84, p. 191), and published a volume on Salish basketry (1900).

Herman Karl Haeberlin (1890–1918), a student of Boas at Columbia, acquired important materials for the American Museum of Natural History from Puget Sound in 1916 and 1917, and he was one of the first scholars to be interested in individual artistic creativity and the role of the artist in Native society (Berlo 1992: 9). He procured about two hundred objects from Puget Salish peoples (including items used in healing and spirit dancing) and notated important supporting data provided by elders and others. This documentation, handwritten in forty-two notebooks, comprised the first systematic research in the Puget Sound region.[5] Especially impressive was the wide range of basketry that Haeberlin documented; his focused attention on this most masterful art form among Puget Sound Natives has provided a basis by which to identify other baskets from the region.[6] Haeberlin circumscribed his area of

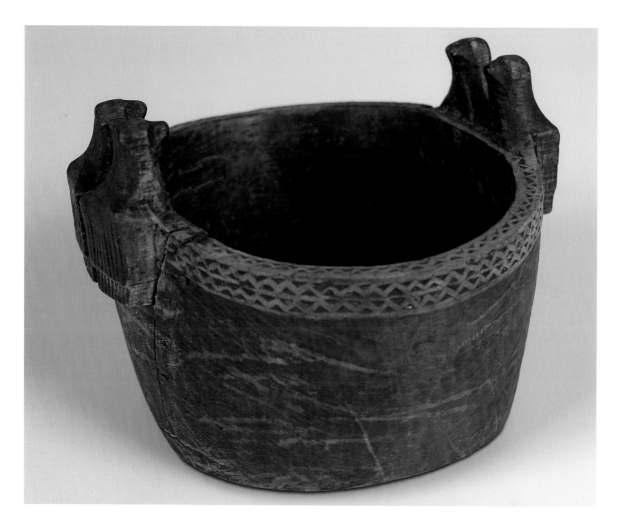

Figure 5.28
Bowl, Quinault, late nineteenth century, wood, 6 × 8 in. (15 × 20.8 cm). Collected by Livingston Farrand for the Jesup North Pacific Expedition, 1898. Division of Anthropology, American Museum of Natural History, 16.4950.

The bird sculptures perched on the rim of this bowl have affinities to a ladle in the British Museum (Wright 1991: 101), probably from western Washington or the Lower Columbia River. Deep, rounded bowls of wood or horn (sometimes called mortars), with decorated raised ends, are also made by the Wasco and Wishram peoples of The Dalles. This rich salmon fishing location on the Columbia River was a busy bartering station for Native groups within a wide radius. Chinook and Coast Salish traded dentalium shells, dried berries, clams, and wapato roots with Interior peoples for hides, horses, camas, bear grass, and nephrite. Lewis and Clark and the Corps of Discovery reached the Wishram village of Nixlúi-dix ("trading place") in October 1805.

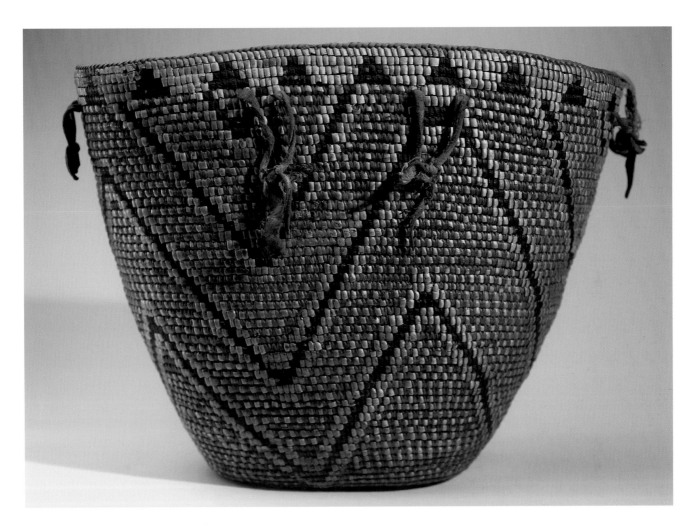

Figure 5.29
Basket, Muckleshoot, late nineteenth century, cedar root, bear grass, horsetail root, hide, 14½ × 9⅜ × 11 in. (36.83 × 23.81 × 27.94 cm). Collected by Herman Haeberlin, 1917. Division of Anthropology, American Museum of Natural History, 50.2/857.

Haeberlin acquired this fine coiled basket on the Muckleshoot Reservation for $4.00 from its maker, Old Anne. In Notebook 32 his handwritten documentation indicates that the design on this basket is called *ts ait,* an Anglicization of *scáyʔt,* meaning "gills" (Miller 2005: 41). Similar upward-pointing triangular designs have also been described as "mountains." A weaver could draw upon a family-owned repertoire of designs but had some latitude in how those might be rendered (Marr 1984: 35). The hide straps attached to the basket indicate that this was a carrying basket used with a tumpline, or pack strap, attached to the basket on either end, with the forehead or the chest bearing the weight of the basket (see Marr 1983: 31).

study by claiming the Puget Sound territory, thus rounding out the interests of Boas's "progeny."[7]

Sadly, Haeberlin died in 1918, while still a young man, of complications from diabetes, yet he left a wealth of scholarship on myth, songs, language, ceremonies, and visual art, from which others would draw. Marian W. Smith, a Boas student with an M.A. and Ph.D. from Columbia University, and later professor of anthropology at Columbia, conducted three seasons of fieldwork among the Coast Salish beginning in 1935. Smith's *Indians of the Urban Northwest* (1949) was a unique contribution to the field because it considered the contemporary Native experience, even if it carried an assimilationist tone. Several prominent scholars contributed essays on a wide range of topics—from painting and basketry to modern community life—many based on fieldwork and Native accounts, including a first-person narrative of Skagit elder John Fornsby, recorded by June Collins, an anthropologist from the University of Chicago who studied the Upper Skagit people (Collins 1974). The volume was dedicated to Arthur C. Ballard, a research assistant in the University of Washington's Department of Anthropology (and an associate of Gunther) who grew up near the Muckleshoot Reservation and recorded valuable information about the oral traditions of southern Puget Sound Natives. Seattle artist Helmi Juvonen (1903–1985) joined Gunther at Native events and incorporated Salish images in her art (Fritzsche 2001).

Others had contributed to documenting Native languages and stories in the early years of audio recording in the field, including Melville Jacobs (1902–1971), another protégé of Boas, whose long career at the University of Washington focused on the languages and folktales of Native people of Oregon and Washington. Thelma Adamson joined Jacobs early in the founding of the Anthropology Department. Jacobs mentored students who worked among the Puget Sound Salish, including Dale Kinkade and Sally Snyder. Snyder recorded oral traditions of the Skagit and Samish people, particularly those of Charley and Louise Anderson, Alice Campbell, Andrew Joe, Joseph Joe, Tom McLeod, Harry Moses, and Lucy Williams (see Snyder 1953–55). Both Adamson and Snyder had medical ailments that curtailed their work, leaving it unfinished. Some outside the academic arena took it upon themselves to record the elder generation of Lushootseed speakers; for example, Leon Metcalf, a Seattle music educator, made numerous recordings between 1950 and 1961, producing the largest source of language materials and songs from the Puget Sound region. Paul S. Fetzer, an anthropology student at the University of Washington from 1948 to 1951, conducted linguistic research among speakers of the Nooksack, Halkomelem, Skagit, and Snoqualmie languages and, in 1950, recorded stories and songs of Native speakers.[8]

Martin Sampson (Swinomish, 1888–1980) had a radio program, worked with local authors, and published booklets (1938, 1972) retelling the epics that inspired artwork at Swinomish. Nels Bruseth (1886–1957) recorded stories, plants, crafts, and arts. Stewart Culin (1858–1929) was not a trained ethnologist, yet he played a role in advancing the field. He was friends with the movers and shakers of the time, including Frederick Ward

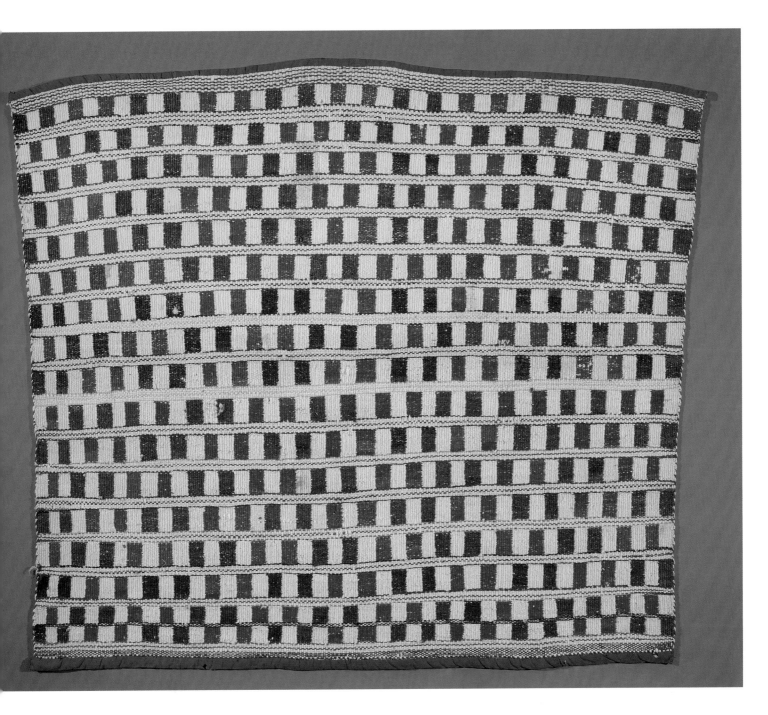

Figure 5.30

Blanket, late nineteenth or early twentieth century, wool, cloth, 47 × 50 in. (119.4 × 127 cm). Collected by C. F. Newcombe, 1911. Brooklyn Museum Collection, X-763.

C. F. Newcombe accompanied Stewart Culin on a collecting trip on the Fraser River, where he purchased several blankets, including this one acquired from Mrs. Billy Sepass at Skau-kail (Skowkale) (Fane 1991: 256). K'hhalserten Chief William "Billy" Sepass was a skilled canoe carver, outdoorsman, and prominent figure of the Ts'elxéyeqw (Chilliwack) people (Carlson et al. 2001: 34). (Eloise Street worked with Chief Sepass to publish a book on Chilliwack legends [Street 1957]). This twined robe is unusual for its all-over geometric patterning and its resemblance to the "beaded" imbricated design used in twined basketry (see fig. 8.11). The relationship between Salish basketry and weaving designs has not been adequately explored.

Figure 5.31
Bracelet, Esquimalt, nineteenth century, silver, diameter 2⅛ in. (5.39 cm). Collected by Harlan I. Smith, 1928. Canadian Museum of Civilization, VII-G-271.

Ornaments of antler and hand-hammered native copper were found at the Marpole site on the Lower Fraser River, dating to 2500–1500 years old (see map, p. xix). Trade copper and iron from Asian shipwrecks were in use before the era of direct outside contact. Early Spanish and British accounts from the late nineteenth century note copper and iron rings, bracelets, neck rings, and earrings in use. Coin silver was the source of most jewelry by the mid-nineteenth century, when the Hudson's Bay Company began to pay its employees in cash rather than barter. Two of Marius Barbeau's consultants told him that Native silversmiths learned jewelry making in Victoria, British Columbia, and that there was considerable exchange of gold for coins that took place around 1858 during the Fraser River gold rush (Bunn-Marcuse 2007: 45). It is curious, therefore, that many more pieces and their documentation exist for the northern Northwest Coast (especially Tlingit and Haida) engraved silver bracelets than for Salish examples. Bracelets were made by softening a silver coin with heat before pounding it into shape, or by melting the silver and pouring it into a mold. This intriguing bracelet has a clasp and is engraved with double killer whales sporting toothed mouths.

Putnam, George Dorsey, Charles F. Newcombe, and George T. Emmons (see Fane 1991). While director of the University of Pennsylvania Museum, he worked with Putnam on the Chicago World's Columbian Exposition. From 1903 to 1929, Culin was curator of ethnology at the Institute of Arts and Sciences (now the Brooklyn Museum) and was instrumental in acquiring and documenting thousands of Native artworks. The Northwest Coast collection he assembled includes about fifty Salish pieces gathered on field trips to the Northwest in 1905, 1908, and 1911. He was accompanied by Newcombe and relied on the Victoria-based collector after that time. Three spectacular works in this volume attest to Culin's selective eye; he also provided detailed documentation of his travels and the specimens he acquired (see figs. 4.1 and 4.2).

On the Canadian side, important pioneering ethnologists included Edward Sapir, who was head of the anthropology department at the Geological Survey of Canada from 1910 to 1925. He hired Harlan Smith, Marius Barbeau (who gave prominence to folklore studies), and Diamond Jenness, a member of the Canadian Arctic Expedition of 1913–18, who became an expert on the Copper Inuit and also conducted fieldwork among Salish groups on Vancouver Island and the Fraser River. Jenness's book *Indians of Canada,* first published in 1932, was the only comprehensive survey of Canadian First Nations at the time (Vodden and Dyck 2006: 48), and *Faith of a Coast Salish Indian* (1955) is still considered an important Salish monograph. Sapir's attention to museum practices resulted in the inauguration of a new artifact numbering system, arranged by culture group (still in use at the Canadian Museum of Civilization), educational programming in the museum and on the radio, and pioneering approaches to exhibit design and conservation under staff member and archaeologist Douglas Leechman (see fig. 1.5).

The next generation of Canadian and American ethnologists were trained or mentored by the old guard who had laid the foundation for the study of Northwest Coast art and culture. The latter include Wayne Suttles, Bill Holm, Pam Amoss, Harry and Audrey Hawthorn, Barbara Lane, Wilson Duff, and Duff's students, Michael Kew and Marjorie Halpin. Most of these scholars have been associated with the University of Washington or the University of British Columbia (see the essays by Wayne Suttles and by Michael Kew and Susan Point, this volume), thus establishing these institutions as leaders in Northwest Coast Native scholarship. Homer Barnett from the University of Oregon contributed a major work on the Coast Salish in 1955, *The Coast Salish of British Columbia.* Of this illustrious group of scholars, only Wayne Suttles, Michael Kew, and Pam Amoss focused their attention on the Coast Salish, with Holm, the Hawthorns, and Kew providing descriptive interpretations of art styles and aesthetic systems. Several significant exhibitions of Native and First Nations art were mounted in Vancouver, Ottawa, and Seattle beginning with *People of the Potlatch,* a survey of coastal art curated by Audrey Hawthorn in 1956 at the Vancouver Art Gallery. Of the 109 works, ten were Coast Salish, including the house posts seen in figure 6.4, a *sxwayxwey* mask, two mat creasers, two baskets, two mortuary figures, a stone bowl, and a spindle whorl (see A. Hawthorn 1956). Interestingly, this exhibition came just five years after the potlatch prohibition

was dropped from the Canadian Indian Act in 1951, and three years after Mungo Martin hosted the first legal potlatch at Wa'waditla, the big house he constructed at the British Columbia Provincial Museum's Thunderbird Park. As mentioned previously, Erna Gunther of the Washington State Museum organized an exhibition of Northwest Coast art in 1962 for the Seattle World's Fair. In 1967, *Arts of the Raven* was hosted at the Vancouver Art Gallery, with selections made by Wilson Duff, Bill Reid, and Bill Holm (Duff et al. 1967). The exhibition was organized to commemorate the 100th anniversary of Canadian Confederation and was significant for several reasons: the intent was to present the work as "art" and not "ethnology"; one gallery was dedicated to the work of a named artist—Charles Edensaw; a selection of contemporary artists was included; and the art was analyzed from contextual, stylistic, and interpretive perspectives. According to the catalogue, "for stylistic reasons, neither the Nootka (Nuu-chah-nulth) nor the Coast Salish are represented, nor is prehistoric stone art included." Presumably, these omissions were because Nootka (Nuu-chah-nulth) and Coast Salish art styles did not fall within the parameters of the formline design that characterized, in various expressions, the other Northwest Coast groups.

It would be some time before the distinctions unique to Salish style would be defined in the literature and, indeed, recognized as a sophisticated expression of aesthetics and cultural meaning. Bill Holm, Wayne Suttles, and Michael Kew were the first to elicit the nuances of the Coast Salish two- and three-dimensional carving and painting styles (Holm 1990a; Suttles 1983; Kew 1980). Kew's insightful synopsis of the Central Coast Salish style elevated it from the perception that it was an inferior version of formline style, one that failed to evolve significantly from an ancient prototype, to suggest that its subtleties were perceptible and tied to cultural imperatives. Suttles offered a reading of the cultural conditions that may have put visual and interpretive limitations on artistic expressions, while Holm suggested that Salish art had regional styles that resulted in different approaches to sculptural composition, relative stylization of figures, and surface decoration. In 1980, Paula Gustafson analyzed Salish weavings in world museum collections, presenting the only systematic account of weaving styles, techniques, and the recent revivals in communities on the Fraser River (see the essay by Crisca Bierwert, this volume). Earlier published reports by Wilson Duff on the stone sculpture of the Fraser River and the Gulf of Georgia and Gulf Islands (1956a and 1956b) yielded to more personal and speculative interpretations of these ancient pieces (and others) in an exhibition, *Images Stone B.C.: Thirty Centuries of Northwest Coast Indian Sculpture,* originating from the Art Gallery of Greater Victoria in 1975, accompanied by a book with drawings and photographs by Hillary Stewart (Duff 1975). This endeavor brought awareness of the antiquity of a group of enigmatic stone bowls, many of them recovered from undatable contexts, which appeared to have stylistic commonalities with wood sculpture of the early historic period.

With few exceptions, anthropological inquiry at mid-century was aimed at salvaging what was practiced and remembered about traditional Native life. Prohibitions on

potlatching (until 1951 in Canada) and the practice of Native religion did not deter communities whose members continued to gather in private homes, community centers, and ceremonial houses in order to transfer ancestral names (namings), for memorials, and for winter spirit dances. Between 1947 and 1950, totem pole salvage programs in British Columbia coincided with official efforts to bring a professional overlay to what had been touristic and social welfare endeavors in the promotion of First Nations art. This was partly achieved by situating prominent anthropologists, such as Harry Hawthorn at the University of British Columbia and Wilson Duff at the British Columbia Provincial Museum, to oversee the pole renovation projects (Hawker 2003: 130). When Mungo Martin was hired as an artist-in-residence to restore old poles and carve new ones, he also provided valuable information on Kwakwaka'wakw songs, stories, art, and ceremonies in the public settings of the university and museum, and he trained a new generation of carvers who in turn, apprenticed others. For the first time, individual aboriginal artists working in an urban setting were recognized as cultural experts and artists in their own right. The carvers' workshop at Thunderbird Park functioned as an art school for younger, mostly Kwakwaka'wakw artists and set the trajectory for an unprecedented vitality of Kwakwaka'wakw arts made for use in the community and for sale in galleries.

During World War II, jobs in aerospace, shipyards, and military industries drew Natives from impoverished reserves into the cities. No longer able to rely on access to the fishing, hunting, and gathering places they had used for generations before the era of reservations, Indians moved to urban centers like Seattle, which offered steady work. After the war ended and the economy declined, the job of mitigating the strife caused by unemployment and homelessness fell to churches and civic organizations like the Seattle-based American Indian Women's Service League (AIWSL). Begun in 1958 by Pearl Warren and a small group of established Native women, the group sought to connect urban Natives with social services, to create a sense of community by offering educational and cultural programs, and to raise awareness in the city-at-large about Native culture and arts. Along with providing practical domestic advice, the AIWSL newsletter promoted the making of crafts (beadwork, basketry, jewelry, and carving) for the organization's store as a way of building public awareness of Native art while providing economic opportunities. The group also supported the professionalization of Native artists through training and promotion, including placement of artists in nationally recognized venues. Morrie Alexander (1916–1973), a Lummi carver of masks and story poles, and Edith Jones, a Lummi basket maker, were invited to participate in the 1968 Smithsonian Folklife Festival. Two years later, Alexander and Al Charles, also Lummi, were artists-in-residence in a unique Ford Foundation–funded project at the Whatcom Museum of History and Art in Bellingham, Washington, near the Lummi Reservation, in which younger Lummis trained in the carving practices that were being kept alive by the older men. The project resulted in an exhibition at the museum of work produced during the apprenticeship program, educational programming, and a publication

(Whatcom Museum of History and Art 1971). Alexander was also artist-in-residence in 1972 for the Washington State Cultural Enrichment Program.

Alexander and Charles were among a small number of carvers who had learned woodworking from their male relatives but who had never made a living from it. They created story poles (between ten and sixteen feet in height) for public places in Whatcom County and for the Lummi Tribe. Activist/artist Joseph Hillaire (Lummi) had followed in the steps of William Shelton, a Snohomish carver (fig. 5.32); and like Shelton, Hillaire created sculptures depicting complex Puget Sound myths. Both men were thrust into the spotlight as "traditional Indians" and were sought after for television and radio interviews, public speeches and performances, and scholarly consultation.

The 1960s saw an invigorated activism on the part of Native peoples regarding the patent apathy toward Native and First Nations education, health care, employment, and rights to fishing and other subsistence activities. The era of human rights brought into focus the neglect of First Peoples and a greater public consciousness about the generational damage caused by loss of homelands, boarding schools, and poor health care. There were many instances of Native and First Nations activists living on reserves and in the cities enacting strategies to survive and to assert self-validation, whether through participation in the Indian Shaker Church or through traditional spirit dancing at summer festivals and powwows, and inside courtrooms (Harmon 1998: 220). Resistance to colonial actions that took lands and natural resources of aboriginal people are well documented since the first non-Native settlements of Washington State and British Columbia. From 1927 to 1951, Canadian laws forbade First Nations from raising money to pursue land claims. More recent victories have been played out in the courts against a backdrop of land, subsistence, and sovereignty issues. The landmark Boldt decision rendered in 1974 (*United States et al.* vs. *State of Washington et al.*) gave Washington treaty tribes one-half of all the harvestable salmon in the state. In 1999, federal courts awarded the same treaty tribes one-half of all the clams, crabs, shrimp, oysters, geoducks, and sea urchins in Washington's inland waters, an important move that clarified and reinforced shellfish harvesting rights under the Stevens Treaties of the mid-nineteenth century. Legal cases defining hunting and gathering rights are likely in the near future. These successes are critical to sustaining traditional ways of life, as well as providing economic solvency and participation in decisions that affect natural resources in the future.

Between 1850 and 1854, James Douglas negotiated fourteen land purchases on Vancouver Island (known as the Douglas Treaties), but Salish First Nations in British Columbia never signed treaties with the Canadian government. The colonial government had effectively extinguished recognition of aboriginal title to lands and reduced the size of reserves. This policy was continued when the colony of British Columbia joined the Dominion of Canada in 1871. Since the early 1970s, First Peoples have forced the definition of aboriginal rights in the courts. Current treaty negotiations with British Columbia tribes are considering political structures by which federal, provincial, and First Nations

Figure 5.32
Snohomish story-pole carver William Shelton, ca. 1925. *Seattle Post-Intelligencer* photograph. Museum of History and Industry, 1986.5G.2783.

Chief William Shelton (1868–1938) of the Snohomish Tribe lived on the Tulalip Reservation, where several of his story poles were made and erected. As a boy he was trained to be a Native doctor but chose instead to go to the Tulalip Mission school. He preserved the old stories by seeking out elders who remembered the "totem" or spirit beings associated with old house post carvings, stories, and personal guardian spirits (Shelton 1913). Shelton held positions in the Indian Bureau and traveled widely to give lectures about Native culture. His family often accompanied him, including his wife, Ruth Sehome Shelton (siastenu), and his daughter, Harriet (see Hilbert 1995b). He carved several remarkable story poles whose purpose was to teach valuable life lessons to children. The Washington State Capitol campus in Olympia is home to a seventy-one-foot story pole by Shelton (dedicated in 1940, two years after his death) that was donated by the Parent-Teacher Association and by schoolchildren who contributed their pennies.

governments can interact and make decisions; the restoration and expansion of reserve lands; access to natural resources within traditional First Nations territories; and protection and access to archaeological sites, heritage sites, and cultural property.[9] One of the likely outcomes will be the large-scale repatriation of art residing in federal and provincial museums and the prospect that more aboriginal museums will be built to display and interpret such cultural properties. Native sovereign prerogatives are far from being redressed, but with political and economic gains have come a resurgence of language, visual arts, storytelling, and ceremonial activities.

Northwest Coast Native and First Nations "art revivals," as they are sometimes called, have evolved since the 1950s, and some significant benchmarks have propelled the aim and scope even further. It is important to note that Native art has never ceased production, as there were needs within the community for dance regalia and potlatch gifts, and a talented cadre of basket weavers, knitters, and carvers continued to supply a commercial market that was decades old. As we saw, civic art projects provided a greater public awareness that art-making was ongoing. Mungo Martin's many contributions stimulated a new generation of urban-based artists to interpret traditional arts in fresh and individual ways.

What Mungo did for a new generation of Kwakwaka'wakw artists at the Thunderbird Park facility in Victoria, Cowichan artist Hwunumetse' Simon Charlie did two generations later for young Salish artists from his workshop near Duncan, British Columbia. Born in 1920, he trained with Henry Hunt, Mungo Martin's son-in-law, at the Provincial Museum. Charlie's artistry issued from his deep knowledge of the language, history, oral traditions, and ceremonial practices of his Cowichan (Quw'utsun') people rather than from copying older examples of the art forms. As a young man he emulated Nuu-chah-nulth and Haida art, but in the 1960s he developed a distinctive, energetic narrative style (see fig. 2.3). This beloved artist and elder, who died in 2005, instructed Jane Marston, Joe Wilson, Cicero August, and Doug LaFortune and inspired many other Salish artists. He was one of the first Salish artists to achieve wide recognition; his totem poles stand in Victoria, Ottawa, New York, Chicago, and Australia, and he received the Order of Canada in 2003.

The reawakening of Salish weaving around 1961 in Sardis, British Columbia, was initially begun as an effort to generate income for First Nations families who had been supported by their knitting work in the early twentieth century. Before the availability of wool blankets, twill and twined robes from mountain-goat wool, dog wool, and plant fibers were esteemed symbols of status, but the availability of wool blankets and European clothing curtailed the labor-intensive process of gathering, processing, and weaving traditional garments. Girls in the mission and boarding schools learned knitting and sewing but not weaving, perhaps in part because of weaving's association with traditional Native life. Some of the women in the Salish Weavers Guild, active in Sardis, were knitters and rug makers who remembered the older weavings (see figs. 10.8 and 10.9). Fran James's Lummi family raised sheep, and her familiarity with wool led her

to knitting and then weaving (see fig. 10.10). She and her son, Bill James, also became proficient basket makers. Gerald Bruce subiyay Miller nurtured the revival of weaving farther south through the Southern Puget Sound Weavers' Guild (see fig. 3.16).

As Crisca Bierwert outlines in chapter 10, memories of the material, social, and sacred aspects of weavings were rekindled during the 1960s. As wool weaving spread to other communities in succession, elders were called upon to share what had lain dormant. Wendy Grant (founder of the Musqueam Weavers) and others from Musqueam went to Chilliwack to take classes at the Coqualeetza Cultural Education Centre and to meet with elder Mabel Dan, who made tumplines and wove with cedar, and Edna Grant, a knitter and basket maker (Johnson and Bernick 1986: 24–25). Musqueam artist Debra Sparrow says that her connection to weaving was immediate once she picked up the wool fibers, and she sought out her grandfather to tell her everything he could remember (Sparrow, pers. comm.). This shared knowledge was lovingly assembled—thread by thread—into one of the most vibrant weaving centers in Salish territory.

Although an old-style apprenticeship system is not in place, weaving, basketry, and carving activities in the modern era are often generated within families, and there are many stories about learning from grandparents, parents, aunts, or uncles (see the essays by Michael Pavel and Sharon Fortney, this volume). Such intimate activity fits precisely with the primacy given by the Coast Salish to family relations and to keeping valued knowledge within the kin group.

By the 1970s, museums were more responsive to seeing the materials in their care as having continued meanings for living Native people. Permanent collection labels, interpretive features in museum galleries, and special exhibitions were undertaken with Native advice. Leading this new wave was the Provincial Museum's exhibition "The Legacy," which underscored the rich inheritance that living artists had in the arts of their ancestors, by mixing historic and contemporary works of First Nations art.[10] Simon Charlie and Rod Modeste were the only named Salish artists included in the exhibition. Modeste, from the village of Malahat, had worked as an apprentice in the museum's carving program in 1978 under Richard Hunt and Tim Paul (Macnair, Hoover, and Neary 1984: 185). Each of these artists was instrumental in the renewal of traditional Salish style: Charlie, through the carving of new versions of *sxwayxwey* masks and in his narrative figural sculptures that illustrated myths; Modeste, through the study of Salish two-dimensional carvings in museum collections. Modeste parlayed Salish design elements into wood carvings (fig. 5.33) and then into his silver engravings (fig. 5.34) from 1979 and later (Macnair, Hoover, and Neary 1984: 185).

Two exhibitions in the 1980s brought prominence to the unique expressions of Salish sculpture and two-dimensional design. "Visions of Power, Symbols of Wealth" was curated by Michael Kew in 1980 for the Museum of Anthropology at the University of British Columbia,[11] and "A Time of Gathering" opened in 1989 at the Thomas Burke Washington State Museum (now the Burke Museum of Natural History and Culture) at the University of Washington. Both shows secured important, rarely seen works from

Figure 5.33
Staff, Rod Modeste, Malahat, 1980, wood,
leather, deer hooves, buckles, 42 × 2 in.
(109.3 × 6.0 cm). Royal British Columbia
Museum, 16627.

Only a small number of Salish artists in the 1970s received formal
training at art schools or through the Provincial Museum's carving
program; most learned about Salish art from elders or from study-
ing examples in museum collections. A skilled carver who was
mostly self-taught, Rod Modeste (1946–2007) expresses the spiri-
tual core of Salish art in this carved wooden staff with hoof rattlers,
the type used by winter-season spirit dancers. From November
to March, dancers honor their personal guardian spirits through
song and dance, using regalia that bears references to the nature
of their spirit connections (Macnair, Hoover, and Neary 1984: 172).
This powerful sculpture depicts wolves and snakes, using Modeste's
masterful command of relief carving and volumetric sculpture.

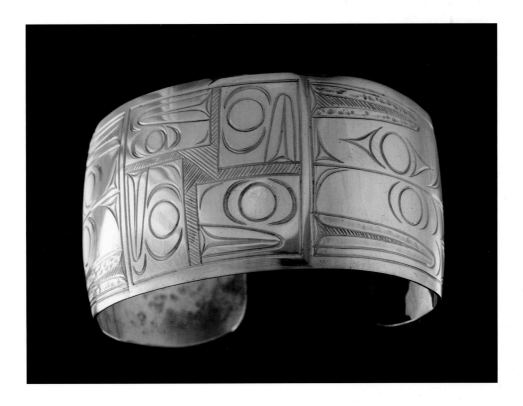

Figure 5.34
Bracelet, Rod Modeste, Malahat, 1981, silver, 2⁵⁄₁₆ × 1⁵⁄₁₆ in. (5.87 × 3.33 cm). Royal British Columbia Museum, 17054.

Rod Modeste made this silver bracelet after only two years of silver engraving. The blunt heads of the salmon are oriented in four directions and make for a rhythmic design. Modeste may have observed a similar design on an old grave monument (see figs. 6.1 and 6.2) on view in the Museum of Anthropology, University of British Columbia, which was made one hundred years earlier. This fine artist was one of the first in the modern era to absorb the unique aesthetic system practiced by his island Halkomelem ancestors and refine it for his own use (compare this bracelet with figure 5.31). Silver jewelry was given as gifts at potlatches, proudly worn by Native men and women, and made for sale to others—and today it functions in much the same way.

European and Canadian collections and provided visitors an opportunity to see Salish art on its own terms. For the Burke exhibition, works commissioned by living artists for the show became part of the permanent collection and heralded a commitment to collecting contemporary Native art. Salish artists Marvin Oliver, Ron Hilbert Coy, Bill James, and Fran James were featured, including the James's robe, the first mountain-goat wool robe woven in several generations (see fig. 10.10).

Some Salish artists accrued skills through study with non-Salish artists, but the lack of training alongside master carvers who understood Salish culture and art hampered the revitalization of Salish art. For the most part, Salish artists in British Columbia and Washington State were self-taught and worked in relative isolation from gallery shows and public art projects. Manuel Salazar and others benefited from community-based art classes and programs, allocated spaces for art-making, and venues for the sale of Salish work, like those at the Quw'utsun' Cultural Centre in Duncan, British Columbia. But there was nothing equivalent to Thunderbird Park and the K'san School of Northwest Coast Art in Hazelton, British Columbia, that could advance the professionalization of Salish art in ways that could give it visibility and validation in the thriving commercial markets for Northwest Coast Native art. In the mid-1990s when I visited Open Pacific Graphics (now Pacific Editions), the premier production workshop for Northwest Coast Native prints, I was told that the familiar Northern-style graphics catered to the tastes of collectors, but that interest was growing in Salish prints like those of Stan Greene and Floyd Joseph. Greene's silkscreen prints in the late 1970s were elegant single-color graphics derived from the enigmatic imagery seen on old spindle whorls (see Blackman et al. 1981: 94). One of Joseph's prints from 1978, *Creation of the Salish People and the First Man*, depicts a seal in perfect Northern formline, with a more naturalistically rendered Salish spirit dancer on its back (Blackman 1981 et. al.: 77); the juxtaposition of the two is poignant. The popularity of the silkscreen print medium in the last two decades and the proficiency of Salish graphic artists in the style of their ancestors have aided artists Charles Elliott, Floyd Joseph, Joe Wilson, lessLIE (Leslie Robert Sam), and Edward Joe in establishing prominent recognition. As well as being commercially viable, prints became treasured potlatch gifts and remembrances of important events; a means to express political viewpoints, especially on social and environmental issues; and a way to raise funds for such causes.

Publications devoted to Northwest Coast art flourished in the 1970s, as did the market for the art. The nascent discipline of Native art history focused on the artists, aesthetics, and styles of First Nations. Bill Holm's seminal analytic study of formline design provided descriptive language for the discussion and evaluation of work of the past and the present (Holm 1965). Under Holm, the University of Washington developed one of the earliest Ph.D. programs for the study of Northwest Coast art history.[12] The Seattle Art Museum's collection of Northwest Native art, given by longtime museum trustee John H. Hauberg, was largely assembled in the 1970s, just as the field was experiencing unprecedented recognition as one of the great art traditions of the world. Hauberg secured rare

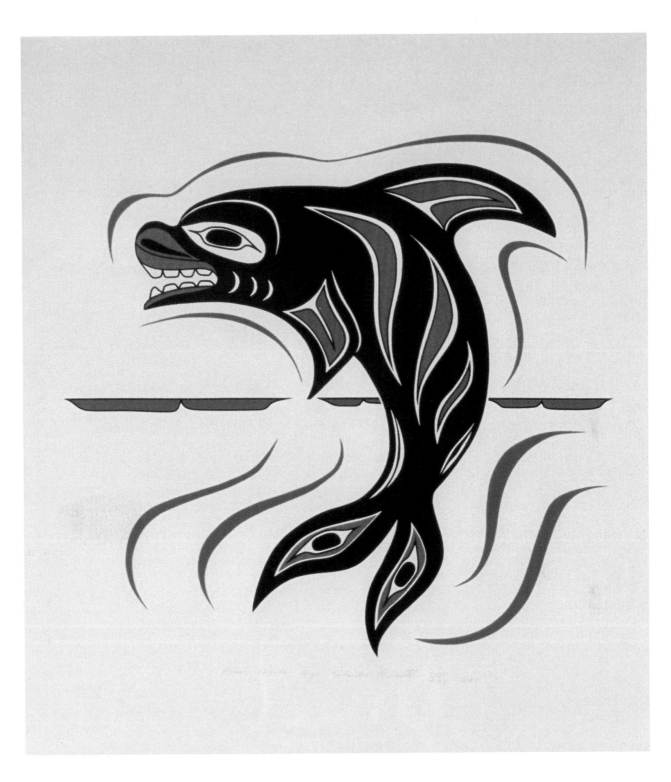

Figure 5.35
Killer Whale, Charles Elliott, Tsartlip, 1980; silkscreen print, 18½ × 16 in. (47 × 40.64 cm). Burke Museum of Natural History and Culture, Seattle, 2.5E1817.

Charles Elliott has worked for nearly forty years to revitalize and encourage the growth of Coast Salish art as both an artist and a mentor for the younger generations. His sculptures and prints consistently express his commitment to use the vocabulary of Salish style as a means to educate and inspire, rather than for personal gain. Recently he has been involved in the resurgence of canoe carving through the Sencoten Canoe Project. Elliott received the Order of British Columbia in 2005. This lively image of a killer whale breaching uses the spare elements of Northwest Coast design from Elliott's artistic perspective.

Figure 5.36

Bear People, Floyd Joseph, Squamish, 1994; serigraph, 24^{15}/$_{16}$ × 22 in. (63.3 × 55.9 cm). Gift of Simon Ottenberg, in honor of the 75th anniversary of the Seattle Art Museum, Seattle, 2005.118.

Floyd Joseph grew up in the homeland of his Squamish ancestors at Capilano, on the north shore of Burrard Inlet (West Vancouver), where he learned about Squamish stories, culture, and arts from his relatives. He studied fine art at Capilano College. Although wood sculpture—masks and painted bowls primarily—is his main medium, he has produced thirty limited edition silkscreen prints. Joseph has won awards and exhibited his work in numerous gallery shows.

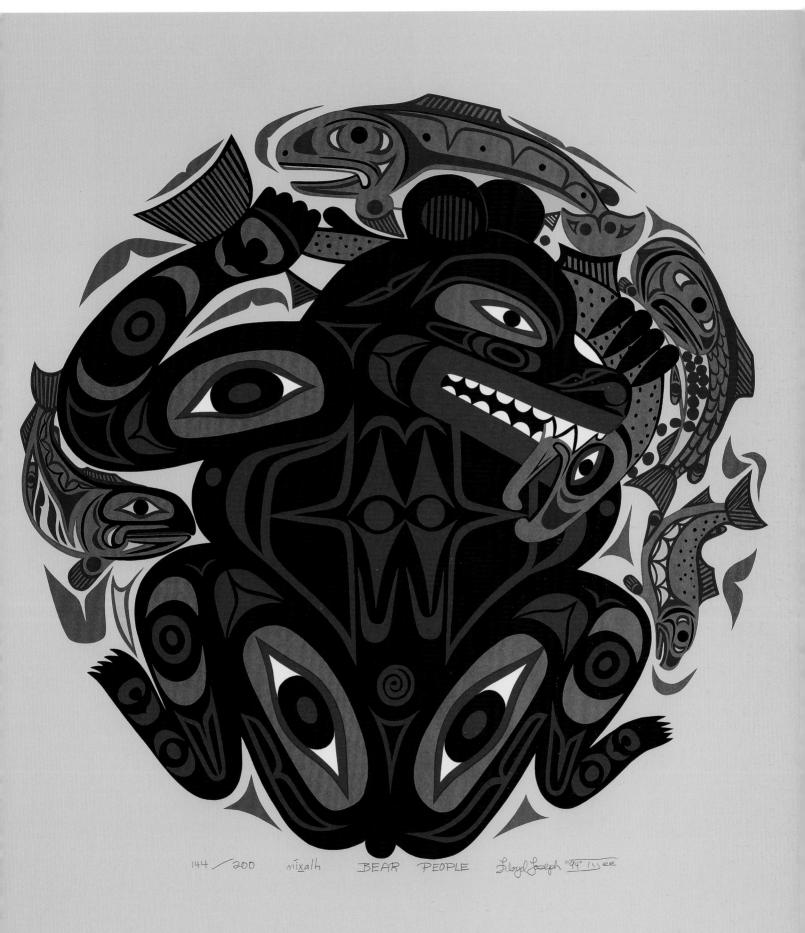

144 /200 mixalh BEAR PEOPLE Lloyd Joseph "94" llyee

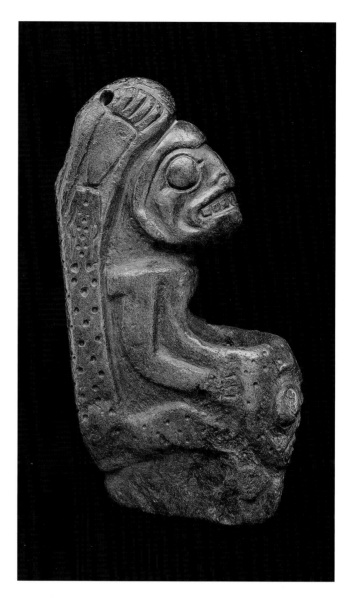

Figure 5.37
Seated human figure bowl, Gulf of
Georgia, pre-1800, soapstone, 14¾ ×
4⁵⁄₁₆ × 7⁵⁄₁₆ in. (37.5 × 11 × 18.5 cm). Gift
of John H. Hauberg, Seattle Art Museum,
83.223.

The Seattle Art Museum is fortunate to have this pre-
contact stone bowl, as fewer than sixty exist. Only the
three found at the Marpole site on the Fraser River (see
fig. 6.9) came from datable contexts. This one was discov-
ered in an eroded bank near a shell midden on the shore
of Shoal Harbour, North Saanich, Vancouver Island. It is
unusual in the rendering of a headdress depicting snake-
skins and human feet (Duff 1975: 173, fig. 34). Little
information has been recorded about the use of these
bowls and the meaning of their enigmatic imagery—
which might include human figures with skeletal
faces, large eyes, headdresses, snakes, and other animal
faces—but there is some indication that they were ritual
vessels used to hold water during female puberty rites
(Boas 1890: 90).

and important works, including a set of four Kwakwaka'wakw house posts, a monu-
mental Tlingit house screen, argillite pieces by Charles Edensaw, a club collected by
Capt. James Cook in 1778, and a rare Salish stone bowl (fig. 5.37). Seattleites Allan and
Gloria Lobb brought together a remarkable collection with stellar examples of basketry
from many Salish groups (see figs. 5.38, 9.7, 9.13, and 9.15). A special publication of this
collection, artfully presented by famed wildlife photographer Art Wolfe, showcased the
woven aesthetics of Salish basket makers (Lobb 1990). Another Seattle resident, Simon
Ottenberg, professor emeritus of anthropology at the University of Washington and a
field-collector of African art, collected contemporary Salish art before it was popular.
He has donated works to the Seattle Art Museum and an extensive print collection to
the Burke Museum (fig. 5.39), including a nearly complete inventory of prints by Susan
Point. Dr. Norman and Patricia Todd of Chilliwack, British Columbia, began assembling
their significant holdings of Simon Charlie's work in 1972; the collection includes sculp-
tures, masks, and rattles and spans more than twenty years of Charlie's career. Selections
from the Todd collection were exhibited at Simon Fraser University Gallery in 1992,
accompanied by a catalogue (Simon Fraser University Gallery 1992).

Figure 5.38
Conical rain hat, Coast Salish or Nuu-chah-nulth, c. 1840, spruce root, red cedar bark, paint, 14 × 6 in. (35.56 × 15.24 cm). Allan and Gloria Lobb Collection.

The basketry arts are held in high esteem in Native communities, but wider interest in them is fairly recent. Notable early focus includes the collection of Judge James Wickersham in the late nineteenth century, and work on basketry designs by anthropologists Livingston Farrand and Herman Haeberlin in the early twentieth century, from the Quileute and Puget Sound tribes, respectively. The same techniques and materials used in the weaving of baskets are employed in hat making—such as twining and plaiting of prepared spruce roots and cedar bark strips. Southern Northwest Coast hats are woven double, then joined together to create an inner and outer hat; in this case, the crown of the inner hat is cedar bark and the outer form is spruce root. Northern hats, once woven, were painted by male artists who were often relatives of the weaver; this might hold true for Southern Coastal traditions as well. In this hat, the black and red painted elements create a stark contrast to the solidly painted lower part. The soft edges of the ovoid, crescent, and trigon shapes, and the relationship of their placement in the design, suggest an archaic form of two-dimensional design (Brown 1998: 63).

Figure 5.39
New Spirit Journey, Roger Fernandes, Lower Elwha S'Klallam, 2002; paper, pencil, collage, 20¼ × 25¾ in. (51.43 × 65.40 cm). Burke Museum of Natural History and Culture, Seattle, 2005-61/1.

"This collage was created to pose the question about the effect money has on the traditional spiritual practices of the Puget Salish people. The piece depicts a fragment of a Native face on one side, and opposite it are spirit figures used in rites such as the Spirit Canoe Ceremony of the Duwamish and Snoqualmie people. Between these elements are poker cards and chips, bingo cards, cigarettes, and fireworks—elements that now drive many tribal economies. Today many tribes have casinos, fireworks, and cigarette revenues, and are making profits that benefit tribal members. While this development has been most meaningful to survival, I have never heard a discussion within the tribes as to the cultural cost of acquiring large amounts of money. I read an interview with a local Native tribal casino manager a few years back and he was quoted as saying, 'Now [with the influx of casino money] we can join the American dream.' I had to wonder if this sentiment is what drove our ancestors. Has this been our goal for the past two hundred years, to become part of the American culture that invaded our lands, made war against our ancestors, and to this day continues its assault on our cultural heritage?"—Roger Fernandes, 2008

Figure 5.40
The Impending Nisga'a Deal, Last Stand, Chump Change, Lawrence Paul Yuxweluptun, 1996; acrylic on canvas, 79 × 96½ in. (201 × 245 cm). Collection of the Vancouver Art Gallery, Canada, Vancouver Art Gallery Acquisition Fund, VAG 96.27.

Lawrence Paul Yuxweluptun (b. 1957) was raised as an "urban Indian" in Vancouver, among the more than 40,000 First Nations people living in the lower mainland of British Columbia (Vancouver Art Gallery 2006). Both of his parents were active in Native organizations and as a youth, Yuxweluptun was initiated into the winter ceremonial and inherited the right to dance with the *sxwayxwey* mask. He uses Western painting modes—notably, surrealism—to call up the injustices perpetrated on aboriginal people, especially concerning land rights and environmental destruction due to logging and mining. This painting was produced at the time of the landmark Nisga'a Treaty, negotiated between the Nisga'a Nation and the governments of British Columbia and Canada, after a century of requests for aboriginal title to traditional lands and resources. Of the three schematic figures constructed from formline design elements, the center two are First Nations people, one pointing to the degraded landscape, the other taunting the figure carrying a suitcase and having raptor's feet—a convention of the artist to identify lawyers and bureaucrats. A *sxwayxwey*-type mask spews water onto a stained and battered earth. The artist aptly opts for a reading of surrealism that invokes the search for an essential truth unmitigated by intellectual analysis and that privileges messages borne from the individual's vision and dream states.

127

Figure 5.41
Rose Paddle, Jane Marston (Kwatleemaht),
Chemainus, 2007; cedar, abalone shell,
copper, paint, twine, 60⅜ × 6 × 1 in.
(153.35 × 15.24 × 2.54 cm). Collection
of Kay and William Rosenberg. Courtesy
of Alcheringa Gallery, Victoria, British
Columbia.

The inventiveness of this artist in the choice of a nonconventional
subject delicately configured on the challenging shape of the verti-
cal canoe paddle attests to the adaptability of Coast Salish design
to contemporary expressions. The buds of the roses carved on the
paddle issue forth from a green life-source, and the innermost fruit
(hips) are inlaid with abalone. Copper strips are inlaid on either
side of the twine-wrapped section that separates the paddle from
the shaft. A meandering trail of vine and thorns graces the length
of the shaft and circular abalone shell inlay marks the juncture
of each node. Three varieties of wild rose are native to Northwest
Coast habitats. The flowers and leaves are gathered in spring and
early summer and the hips are obtained in the fall. Specially pre-
pared rose leaves, branches, and hips make potent spiritual and
physical medicines (Krohn 2007: 141).

Lawrence Paul Yuxweluptun, a graduate of the Emily Carr Institute of Art and Design, has received international acclaim for his large paintings that document critical issues facing aboriginal people (e.g., fig. 5.40): land claims, colonialism, and environmental degradation. His work, a creative mix of Western painting genres and First Nations styles, was featured in two pivotal exhibitions in 1992: "INDIGENA: Contemporary Native Perspectives," an international traveling exhibition originating at the Canadian Museum of Civilization, and "Land, Spirit, Power: First Nations at the National Gallery of Canada," curated for the National Gallery of Canada. In 1995, the Belkin Art Gallery at the University of British Columbia showed a comprehensive retrospective of Yuxweluptun's work ("Born to Live and Die on Your Colonialist Reservations"), and in 2006 his paintings appeared in "75 Years of Collecting: First Nations: Myths and Realities" at the Vancouver Art Gallery. As a modern-day "history painter" who exposes the precarious place of First Nations within the national agenda, Yuxweluptun makes art that does not fit comfortably within the Northwest Coast paradigm, nor is it readily recognizable as Salish in style.

Susan Point and Marvin Oliver have also garnered critical and commercial success (see Blanchard and Davenport 2005). Each has received major commissions for public art projects in the United States, Canada, and abroad. In his capacity as professor of Native studies and art at the University of Washington, Oliver has influenced younger generations of artists. His early work is in northern Northwest Coast style, but as his art has matured and expanded, Salish aesthetics have regularly insinuated themselves into his eclectic style and ambitious experiments. His work sometimes appears to be a paradox. As an urban artist, he is enamored of industrial materials and monumental scale, but his Native aesthetic brings an unexpected spirit and grace to these intractable materials (see fig. 12.6). Susan Point grew up learning the stories and histories of the Musqueam people and Salish references appeared early in her art, which has evolved as a body of dynamic and artistically relevant work. Like other Salish artists, she began by copying pieces in museum collections but quickly developed an impeccable mastery of each medium in which she worked—paper, wood, glass, metal, and polymer (see fig. 1.7). Her broad intellectual and creative range was recently highlighted in a retrospective exhibition and book (Wyatt 2000).

The term "awakenings" most accurately reflects the renewed activities of Salish artists in styles that identify them with their ancestors yet speak to contemporary experiences and issues.[13] An older ethos thrives within today's expressions and each artist is engaged with language, oral traditions, rituals, and artistry of the past. Oftentimes families and relatives nurture cultural connections. Jane Marston (Kwatleemaht), a protégé of Simon Charlie, lives near her ancestral Chemainus home and is a master carver of wooden dolls, masks, poles, and canoe paddles (fig. 5.41). She and her husband, David, also a carver, immersed their sons John (see fig. 4.7) and Luke (fig. 5.42) in artistic expressions of First Nations legends (Blanchard and Davenport 2005: 64). We have already seen the vigor and interest that elders can engender in their younger relations: Fran James and

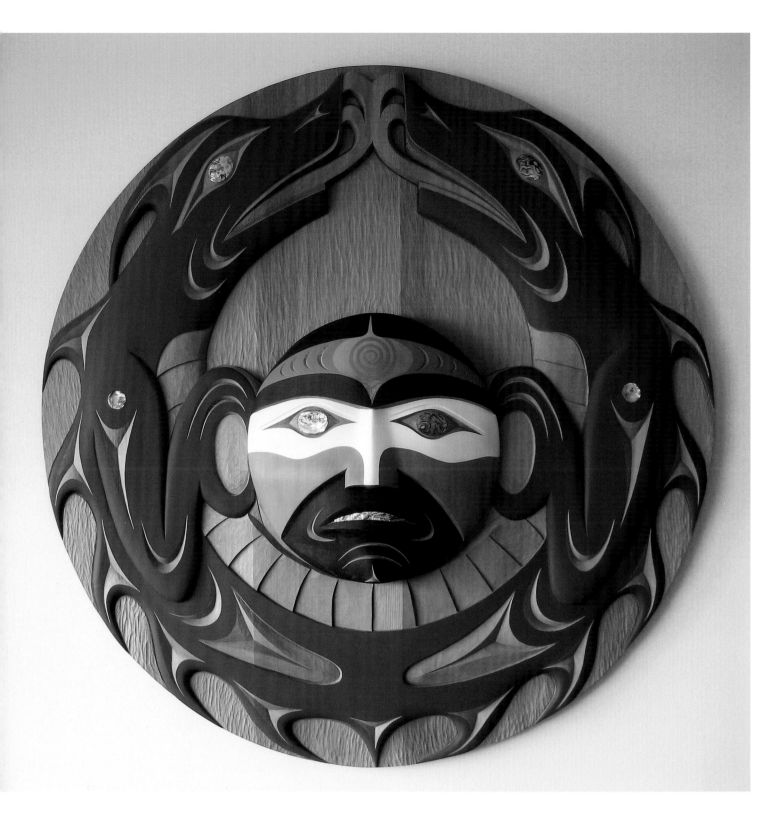

Figure 5.42

Serpent and Moon, Luke Marston, Chemainus, 2007; wood, abalone, paint, diameter 32 in. (81.28 cm). Whale Rider Arts.

The powerful body of this double-headed, feathered snake engraved on the circular perimeter of the sculpture hovers around the human visage (moon), whose face has been painted with traditional designs. The underbelly texture of the creature suggests its part-reptilian nature, while the deeply carved U-shapes and pointed feathers confirm its birdlike attributes. Luke Marston references the spindle whorl shape and the often symmetrical format of Salish design yet invokes a modern approach to visual storytelling.

Figure 5.43
Buddy Joseph Skwetslmeltxw (Squamish) and Chief Janice George Chepximiya siyam' (Squamish) in their studio, Suquamish Reserve, North Vancouver, British Columbia, 2008.

Photographer Eduardo Calderón has been creating elegant portraits of Northwest artists for thirty years. This photograph was taken in Buddy and Janice's weaving studio and shows their work in progress on two looms. A weaving by Anabel Stewart, a key figure in the Salish weaving revival in the 1960s at Sardis, British Columbia, hangs on the wall behind. Buddy is the great-great-grandson of Mrs. George Johnnie, an accomplished weaver who was photographed by Harlan I. Smith in 1928 (Gustafson 1980: 86).

her son Bill James; Gerald Bruce subiyay Miller and his nephew and niece, Michael Pavel and Susan Pavel; Vi Hilbert and her late son Ron Hilbert Coy; Andy Wilbur-Peterson and his daughters Lynn Wilbur Foster and Andrea Wilbur-Sigo, among others.

Family connections were the usual conduit through which art styles and their particular meanings were passed down, yet the boundaries of traditional practices have been widened to include new forms and venues. Buddy Joseph and Chief Janice George (fig. 5.43) are descendants of weavers, and under the tutelage of subiyay, they revived traditional wool weaving and brought it to their Squamish community. In preparation for the building of the 30,400-square-foot Squamish Lil'wat Cultural Centre at Whistler Mountain for the 2010 Vancouver Olympics, Joseph and George led a team that created several large-scale weavings for the facility. Another Squamish artist, Aaron Nelson-Moody, studied the eighteenth-century goat-horn bracelets (see figs. 5.9 and 5.18) and has created elegant silver versions (fig. 5.44) that are worn proudly by First Nations. Tribal communities have recognized the valuable role of the arts in contemporary life, and in the last twenty years, cultural centers have prominently featured the work of living artists, often alongside treasures from the past. Tems Swiya (Our World) Museum, operated by the Shíshálh Nation, features arts representative of the band's rich traditions (see figs. 5.45 and 8.4) and stages cultural performances for the tourist population visiting the Sunshine Coast. Cultural centers offer Native and First Nations programs

131

Figure 5.44
Bracelet, Aaron Nelson-Moody, Squamish, 2007; silver, 1½ × 6 in. (3.81 × 15.24 cm). Collection of Buddy Joseph.

As well as a practitioner of the arts of jewelry making and wood sculpting, Aaron Nelson-Moody is a storyteller, drummer, and singer. He is from the Cheak'mus village of the Squamish Nation, where he has been involved with the Uts'am, Witness Arts and Environment Project. In 2007 he received an award from the Bill Holm Center at the Burke Museum to research Squamish art in that collection. He is in the process of re-creating a nineteenth-century Squamish spindle whorl, which will be on view in the Suquamish Lil'wat Cultural Centre during the 2010 Winter Olympic Games. In his work—including this bracelet—Nelson-Moody seeks to capture the elemental aspects of Coast Salish design.

Figure 5.45
Copper Weave, Dionne Ximiq Paul, Sechelt, 2007; red cedar bark, copper, 24 × 48 in. (61 × 121.9 cm). Tems Swiya Museum, Sechelt Nation.

Dionne Ximiq Paul works as the Sechelt Nation cultural coordinator, a job that includes oversight of the Tems Swiya Museum. She received a bachelor's degree in fine arts from the Emily Carr Institute of Art and Design; in her last year there she had the opportunity to work with Lawrence Paul Yuxweluptun (see fig. 5.40). In this piece, she combines her art training with a deep connection to traditional weaving by creating a woven canvas of cedar and copper strips that is attached to stretcher bars like a picture. Red cedar was the all-purpose "tree of life" to coastal aboriginal people, while copper was an item of wealth and prestige. By bringing these two materials together, Paul asks us to contemplate the precious quality of each.

Figure 5.46

Four Salmon Heads, Maynard Johnny Jr.,
Penelakut/Kwakwa̲ka'wakw, 2008; acrylic
on canvas, each panel 11 × 6 in. (27.9 ×
15.2 cm). Collection of the artist.

A self-taught artist inspired by Robert Davidson, Art Thompson,
Richard Hunt, and Mark Henderson, Maynard Johnny Jr. has
honed his skills in printmaking and acrylic painting. The subjects
of his serigraphs are often animals, birds, and fish that he encoun-
ters around his home of Chemainus on Vancouver Island, rendered
in spare, elegant lines and colors. Recently, he has explored wood
carving, creating compelling painted designs on the surface of
carved, yellow cedar canoe paddles (Blanchard and Davenport
2005: 63).

and ceremonies and create economic benefits for the local communities, but they also provide educational opportunities for the general public.

Through these community-based efforts and the initiatives of individual artists, some of the indifference to Coast Salish art has been overcome, yet it seems these artists are held to a higher standard than other contemporary practitioners. We ask the artists to be at once "traditional" yet not "stuck in the past," seemingly unaware that Salish art has never been static or unchanging. Salish culture has endured precisely because new traditions have persistently been built upon existing ones. The ways in which artists of today steward the past should be left for each to define in accordance with personal experiences and values. While the public admires versatility and inventiveness, experimentation with new materials and technologies can be seen as "unauthentic" or bereft of cultural meanings. Artworks christened within cultural settings have a cachet of authenticity, and when new visions take shape in the foundry or hot shop, destined for gallery shows or as private commissions, we feel a pang of discomfort. We are uneasy with cultural mixings—when the vocabulary of style is altered, augmented, or permeable to the host of outside influences that bear upon modern life. Yet the practitioners are frequently of diverse heritages and varied lifestyles: they reside on reserves, have close ties

Figure 5.47
Chester Cayou, Matika Wilbur, Swinomish/ Tulalip, 2006; gelatin silver print, 16 × 20 in. (40.6 × 50.8 cm). Collection of the artist.

Using black-and-white photography, a medium used in the past to document Native cultures scientifically, Matika Wilbur turns her camera to capture the individual character of Puget Sound Native elders. She is currently working on a book of twenty-five portraits and a series of photographs for exhibitions in Mexico and Paris. Chester Cayou is a respected Swinomish elder and a former member of the tribal senate.

Figure 5.48
Twined hat, Karen Skyki Reed, Chinook/ Puyallup, 2000, red cedar bark, diameter 13½ in. (34.29 cm). Purchased with funds given by Lawrence Christian, Burke Museum of Natural History and Culture, Seattle, 2000-124/1.

This unusual shaped basketry hat was a commission by the Burke Museum, which asked Karen Skyki Reed to replicate an ancient hat unearthed at Wapato Creek in 1976 (see fig. 5.49). Reed's grandmother had lived at Wapato Creek in Tacoma, Washington, which was an ancestral home of the Puyallup Tribe. A gifted basket maker and apprentice of Gerald Bruce subiyay Miller (see fig. 3.4), Reed noted that the old hat was so well preserved that she could puzzle out how the inner hat was made and attached to the outer twined hat (Burke Museum 2000). Contemporary artists revel in the opportunity to re-create older artifacts to determine how they were made and how their forms evolved over time.

to their communities but live away from them, are urban dwellers, and so on. The lack of opportunities on the reserves has meant that artists often have to construct multiple identities in a number of contexts as they search for resources and audiences.

Tribal elders exemplify Salish values through their knowledge of ritual and spiritual practices, language, stories, histories, the environment, and art materials and techniques, and by the pivotal role they play in family life. Younger generations of artists seek them out for advice and validation; and ancestral imagery and narrative, even though couched in modern forms, are used with respect. If there is a common denominator among contemporary artists, it is that each defines him- or herself in relationship to his or her community of origin, through direct participation or by immersion in their

Figure 5.49
Basketry hat fragment, Wapato Creek
(Tacoma, Washington), 400–1,000 BP,
red cedar bark. Burke Museum of Natural
History and Culture, Seattle, 1983-72/1.

This ancient rain hat was discovered in a wet site at Wapato Creek
in 1976, along with remnants of a fish weir and fiber netting.
Water-logged sites preserve perishable materials like basketry,
wood, and wool because saturation prevents decomposition. These
unique occurrences offer a glimpse of ancient artifacts, tools, and
materials that might otherwise be destroyed. This hat, with a
pointed top and sloping body, would have helped to shed water
in the rainy Northwest climate.

histories and expressive traditions. Sometimes the journey takes a long step into the past
as the artist attempts to see through the eyes of an ancient practitioner (figs. 5.48, 5.49),
and at other times it brings the artist to the frontlines of political and social causes.

There is no synthetic perspective from which to critique contemporary Salish art. It
is too soon perhaps, as established artists are just reaching maturity and emerging artists
are just recently finding their voices. If there is an inclusive term to guide an analysis,
it might be "transformative": having the power or character to change wholly without
changing the underlying value. It is instructive to show the art of the past alongside that
of the present: the spirit and ingenuity of living practitioners give nuanced meanings
to the older forms, and the contrast acknowledges the challenges and responsibilities of
keeping cultural practices vibrant, while bringing forth unexplored visual vocabularies
that resonate with personal and collective visions for the present day.

Notes

1. He created uneasy, even hostile, feelings in the course of procuring skulls from graves and attempting to get Natives to agree to have their heads measured and cast for analysis. Smith worked up some of his field notes for publication but these original notebooks were either destroyed or lost. Given the difficulties he encountered convincing Salish people to assist with his objectives, it is likely that he was not able to secure documentation of the ethnographic collections.

2. Osteological samples were taken from graves and plaster casts made of living people from the Northwest Coast and Siberia for comparison. According to Jonaitis, the project was touted publicly as one that would answer the greatest unsolved anthropological question (1988: 157). Boas was more interested in using the opportunity of the fieldwork to bolster his own theories and to create a solid body of data on Northwest Coast and Siberian cultures.

3. Smith filmed Buddy Joseph's great-grandmother Skwetsiya Harriet Johnnie for the weaving segment of the Coast Salish film. George Johnnie, Janice George's great-grandfather, is also featured. Buddy and Janice are weavers (see fig. 5.43).

4. His endeavors were curtailed by the lack of consultants, as most adults were away fishing, and because what he assessed were the effects of conversion to the Indian Shaker Church and the renouncing of traditional customs.

5. See J. Miller 2005; Boas kept #13 at AMNH because it contained lists of the artifacts, while the other notebooks ended up at the National Anthropological Archives in Washington, D.C.

6. Basketry can be particularly difficult to attribute to a specific group because women typically went to live in the village of their husbands, causing diffusion of motifs and styles, and baskets were readily traded between neighboring groups.

7. Some of Boas's other illustrious students included Alfred Kroeber, Robert Lowie, Frank Speck, Edward Sapir, Elsie Clews Parsons, Melville Herskovits, John Swanton, Ruth Benedict, Ruth Bunzel, and Margaret Mead.

8. I am greatly indebted to Dr. Laurel Sercombe, archivist at the University of Washington Ethnomusicology Library, for the information on Metcalf and Fetzer. The Metcalf Native American Collection consists of 75 analog reels and is located at the Burke Museum. Fetzer's original recordings were on 17 aluminum- and glass-based records and field notes recorded in notebooks, now in the Ethnomusicology Library and Special Collections.

9. For information on the treaty process, see the B.C. Treaty Commission website, http://www.bctreaty.net, or the Hul'qumi'num Treaty Group website, http://www.hulquiminum .bc.ca. See also Bruce Granville Miller, *The Problem of Justice: Tradition and Law in the Coast Salish World* (Lincoln: University of Nebraska Press, 2001).

10. "The Legacy" became a traveling exhibition with venues in First Nations communities as well as in the United Kingdom. It featured a host of named artists, such as Charles Edensaw, Mungo Martin, Willie Seaweed, and several artists trained under Mungo Martin, including Henry Hunt and his sons Richard and Tony. Community-based artists Ellen Curley, Charlie Walkus, and others were included, as were a host of emerging artists—Bill Reid, Robert Davidson, Joe David, Art Thompson, Norman Tait—whose mature styles have been celebrated in gallery shows and museum exhibitions. The highly regarded catalogue by Peter Macnair, Alan Hoover and Kevin Neary featured biographies of the artists.

11. About this exhibition, the curator Michael Kew writes: "'Visions of Power, Symbols of Wealth' grew out of many years of my close association with Musqueam First Nation people, participation in their community life and curatorial work with collections of their art at the Museum of Anthropology, University of British Columbia, and the Provincial Museum (now the Royal British Columbia Museum). The exhibition brought together for the first time a substantial array of sculpted and decorated material objects of the several contiguous language groups known as Central Coast Salish (Halkomelem, Squamish, Straits Salish, and Nooksack).

"The title was meant to convey the centrality of wealth and spirit power in Central Coast Salish cultures; power in the broadest sense—personal, social, and political. While preparing for the exhibition, I had visited museums and assembled a large number of images. Several First Nations groups have since then acquired copies for their own resource collections, and the exhibition and images have indirectly played a part in the resurgence of production and use of traditionally inspired art.

"For many Central Coast Salish people, viewing the exhibition cut two ways. Some were uncomfortable viewing the art in a museum setting. Some were resentful of museums and collectors who had had the power to persuade families to sell treasures. Others felt shame for those who had sold such family wealth. Rattles, masks, and costumes were familiar to many as precious and respected objects used in their own community ritual activities, associated with spiritual power and family social status. They were never displayed in their own homes as *objets d'art*. Now they were being transformed into something else for other people's ends. Shortly after the exhibition opened, a group of young people from Musqueam visited the museum and asked that we remove spirit dance costumes whose open display they found offensive. These items, long in possession of the museum, were withdrawn for the duration of the exhibition. Since that time the Museum of Anthropology and others in the Central Coast Salish area have also agreed to the removal from display of objects that evoked similar protests.

"In summary, while attention to traditional art provided welcome information and stimulus for artists and evoked admiration in the wider society, museum exposure threatened sincere religious feelings and also signaled loss of things unique and intimately connected to their old way of life. For some this was a loss as sharply felt as the continuing loss of lands and political autonomy which Salish Nations have experienced in their long damaging association with Canada. The opening of their art to the world was like losing another part of themselves. Museums and tribal leaders might draw a lesson from such ambivalence and view exhibitions not simply for attention brought to qualities of artistic achievement, but also for the opportunities they present for examining history and developing new understanding of the present."

12. The Bill Holm Center for the Study of Northwest Coast Art was established at the Burke Museum in 2003 to continue Bill Holm's legacy as a scholar. The Center supports visiting researchers, lectures, and publications and is dedicated to increasing Native and public access to research resources.

13. For an excellent overview of the Salish art of today, including biographical information on individual artists, see Rebecca Blanchard and Nancy Davenport, *Contemporary Coast Salish Art* (2005). This book accompanied an exhibition held at the Stonington Gallery, Seattle, entitled *Awakenings*.

This interview with Musqueam artist Susan Point and Professor Emeritus Michael Kew, Department of Anthropology and Sociology, University of British Columbia, facilitated by Barbara Brotherton, was video-recorded in September 2007 at the UBC Museum of Anthropology. The Salish objects that Kew and Point discuss are in the collections of the Museum of Anthropology, University of British Columbia, Laboratory of Archaeology, and the Canadian Museum of Civilization, Hull, Quebec. We wish to thank the staff of the Museum of Anthropology who made this discussion possible, especially Director Anthony Shelton.

Kew: You've seen this object many times [fig. 6.1]; there's really not a lot of information that was recorded when it was purchased. There's a story that the main character, who was apparently buried in the box (that is, put away in the box), had been injured

A Dialogue about Coast Salish Aesthetics

Michael Kew and Susan Point

in some way by the lower figure. This shows that the main character prevailed over the one who hurt him. Whether that story is true or not, I don't know. But it was recorded by Harlan Smith when he purchased this in 1929. It comes from West Saanich.

Point: This piece here I really, really love [fig. 6.2]. The actual design is very simple. I depicted it as being salmon or some sort of fish. . . . I did a painting, but [it] was changed drastically, where it had all the rectangular heads. That painting is actually in Switzerland right now at the museum in Zurich. . . . I've used that same rectangular form and created glass modules.

Kew: Why do you think it's such a nice piece? What makes it a nice piece? I'll tell you what I think is nice about it. It's because [the fish are] square. They're hard, rectangular things, and fish are not like that. But it's taking that—depicting that as those hard lines and then showing how it isn't that. The fish has a snout, there. If you look at the negative space in there, it's softening those hard lines of the rectangle. It's as if the artist set himself a problem of making everything square and then relieving it.

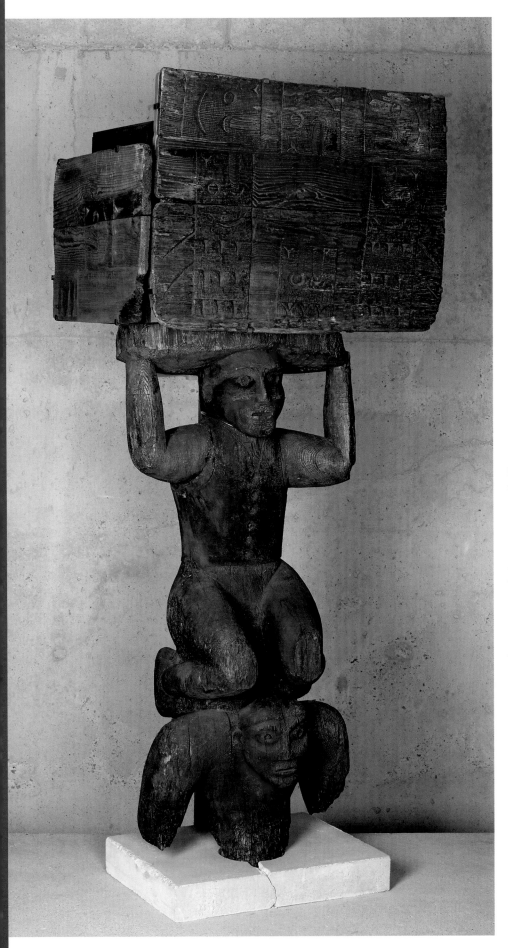

Figure 6.1
Grave monument, West Saanich, late nineteenth–early twentieth century, wood, paint, 54 × 24 × 12 in. (137.16 × 60.96 × 30.48 cm). Collected by Harlan I. Smith, 1929. Courtesy of Saanich First Nation. Canadian Museum of Civilization, VII-G-354.

Elaborate sculptures were erected at family mortuary sites at the time of the memorial for the deceased, usually a year or more after death. Here, Kusha-men, the deceased, is depicted under the box, while the figure on the bottom represents the enemy who killed him. According to Salish beliefs, a soul of the deceased remained near the mortuary site and required food and clothing, which was transmitted by being burned at the time of the funeral and on other occasions (Kew 1980).

Figure 6.2
Grave monument (detail), West Saanich, late nineteenth–early twentieth century, wood, paint, 54 × 24 × 12 in. (137.16 × 60.96 × 30.48 cm). Collected by Harlan I. Smith, 1929. Courtesy of Saanich First Nation. Canadian Museum of Civilization, VII-G-354.

The fish lightly carved into the flat surface of the box are rendered in typical Salish style: round eyes, curved snouts, straight mouths, and sometimes fins and scales. The iconography of Coast Salish art is predominantly that of generic human, animal, bird, and fish forms, yet it is unique in details and in the combinations of creatures depicted. Animals, birds, and fish are often shown in profile, and humans, frontally. The being is outlined with a cut that creates a sharp edge around the form or figure and is thus raised from the surface (Kew 1980). Artists such as Susan Point and Rod Modeste studied this old relief style and incorporated it into their modern works (see fig. 5.34).

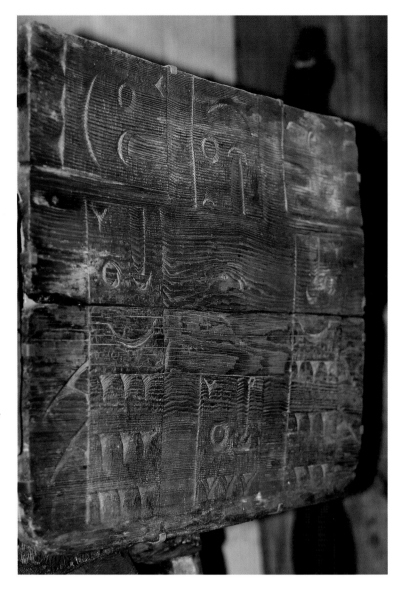

Point: It could also be, though, that the artist or the creator of this piece that carved the front . . . [that it's] the limitation of tools. Years ago they didn't have knives like I use right now . . . it was difficult.

Kew: They would have had a sharp knife, a pointed knife and chisels. It's not carved deeply in between the figures, is it? The curves, beautiful curves. . . . When we look at some other things and look at spindle whorls even, there's some often kind of rectangular outer form to the fish that's relieved with that inner engraving.

Point: Exactly.

Kew: And these have a great mouth. There's always a nice round eye in the fish. I think of this as showing the main features of fish in the engraving style—round eye and these scales, or whatever—relieved in that way, and then fins. And the rounded snout, which is turning this square corner into a curve with that little element.

Point: It's just the element . . . see how it gives that roundness to the snout of the nose as opposed to looking at the overall rectangular image in a square fashion.

Figure 6.3

Grave monument, Musqueam, late nineteenth or early twentieth century, wood, paint, 32⅓ × 77½ in. (85.05 × 196.85 cm). Collected by Duncan Campbell Scott at Musqueam in 1930. Courtesy of the Musqueam Band Council. Canadian Museum of Civilization, VII-G-359.

Diamond Jenness, an ethnologist for the Canadian Geological Survey, recorded that a coffin bearing "four fishers in full relief" was commissioned by a descendant of Seleeptim, leader of a neighboring group of the Musqueam, to show that this family carried the right of the cleansing ritual that made use of the stuffed bodies of fishers. Jenness's knowledgeable consultant, Old Pierre of Katzie, reported that He Who Dwells Above had bestowed this ritual and the prayer that accompanied it onto priests of the Seleeptim family for use during times of mourning "as solace to drive away your tears" (Jenness 1955: 73).

Kew: Yes. If you use this as a block to print and ink that thing, it would show up more vividly. I wonder if it was ever painted? It looks like there's a little dark in the middle.

Point: It looks like a bit of red in the mouth in that one there.

Kew: And a little black on the side. Now the figure below . . . I always liked this figure very much because it seems to me it's depicting not just any human. It's depicting a particular person. It has got a waistcoat on . . . and the face is painted.

Point: Which is quite unusual in Salish art. A lot of it wasn't painted.

Kew: Yes. The art was not painted, but this I think was meant to represent a specific person. It was like a memorial for that person, probably the man in the box. That may have been his particular spiritual way of painting his face.

Point: You mean like in the winter ceremonies?

Kew: Yeah. It is possible because there's black and red. But we don't know that. That's a guess.

Point: Exactly.

Brotherton: How do you make sense of the combination of the naturalistic figure with the very sensitive face and very abstract design on the top? Those two things coexist so beautifully. There's not an abruptness about it at all. It works so convincingly.

Point: I've never really thought of it in that sense.

Kew: Well, I think that particular style of decoration of the engraving for flat surfaces is easier to do on a flat surface. I mean, to do even a low-relief sculpture there you'd have to have a very thick plank to start with. So it was a way of decorating a flat surface. Whether it had any specific meaning for the people who made it or commissioned it, of course, we don't know. I think these were commissioned, by the way. . . .

Point: Commissioned by the individual families?

Kew: Yes . . . These are quite elaborate works of art . . . monuments at grave sites, you know. They would take quite a while to make. I think they were probably commissioned for a memorial service for this person, maybe a year or more after the actual death of the person. For the memorial, the body was removed from its first resting place and rewrapped or reclothed, then put away again. This one [fig. 6.3] was made in the nineteenth century, I guess. We don't have any dates on it, but there were lots of other sculptures like this in some of the Salish cemeteries on Vancouver Island and among the Squamish, Musqueam, and Stó:lō farther up the river. There are very few in museums. This is a rare piece. I think it was commissioned by the family, and they would ask an artist to produce the thing. And they must have talked about what it would be—as one would do before the purchase of a tombstone.

There are so few of these that were ever obtained and purchased for museums and preserved. Left to themselves, they just molder away and disappear. There must have been hundreds of them, literally hundreds of sculptures that were there at one time and have disappeared, I think, that it's entirely unlikely that this was just an ordinary person. The person whose family commissioned this must have been high-standing, respected, and probably wealthy for the day. But there were lots of these sculptures in the Salish area. They were seen by the first visitors to the area. And some of them were photographed and some were recorded in drawings before photography. Are they conservative in style? Are they innovative? I suppose that's all in the way you look at it, isn't it?

Brotherton: I just find that abstract design so intriguing.

Kew: The combination of it with the naturalistic aspect.

Brotherton: And the combination of it and the mind-set that allows that to exist in the same piece to me is just so intriguing.

Brotherton: Can you talk about the house posts [from Quamichan village; fig. 6.4]?

Point: I like how he [the artist] used . . . I don't really know what they are . . . fishers? . . . a form of mink or a marten.

Kew: That's what they say.

Point: It could be something totally different. But anyway, the other thing, too . . . [is that] it [the fisher] was used for cleansing and . . . healing purposes.

Kew: A fisher is larger than a mink but in the same family of animals. Apparently, either puppets or replicas of fishers were used in a cleansing ceremony, but whether these represent that cleansing ceremony, it's not known. They may simply be an animal—a fisher or whatever [animal] that was important to the family that owned the house. That information was not recorded when they were collected. What *was* the significance?

Point: So these were . . . from the inside of a house?

Kew: [Yes.] They would be seen inside the house. They might have been on one side of the house. I think there were more of them, but . . .

Point: Like . . . in the photo?

Kew: [Yes.] Just like that. There was a beam across.

I like the top figures on the house posts [fig. 6.5]. They're facing the others, but they are only partial animals. That's the way this photograph indicates, so I think that's probably the way they were made. These were not necessarily the structural part of the house because they could be moved around, you know. They probably were structural when first made and used, but as house posts rot in time and the people are living in the same house for a long, long time, the posts decay at the bottom. When this happened to posts that were decorated, like these, then they might be set against a new, solid post, like a wall hanging or a plaque that you could move while you renew the post behind it for the structural purpose.

Point: But house posts were actually for structural purposes?

Kew: Originally, yes. But it looks like something has happened. They've either not bothered carving the full animals at the top or they've been cut with a good crosscut saw. And that's what you would do if they were starting to decay and if you wanted to move them. Anyway, they're very nice pieces. They look like they're marching to and fro, those little animals. They're very nice—the features of the face of the animal; the eyes and the little indications of the ears on some of them, and the nose. It's sort of characteristic of that way of sculpting those animal forms. So you see it on the fishers on this box [see fig. 6.3].

Brotherton: Since the boards—and the creatures represented—are one piece, how would these have been made?

Point: Start out with a fairly thick piece of wood or a log. And then . . . take the whole background down and leave relief for it . . . to actually start carving those animal shapes . . .

Kew: That's a high relief. I think you'll see that in some of these Salish sculptures, and you don't see that in the Northwest Coast sculpture farther north. I think that's kind of unique to this area.

Point: It is. It is.

Kew: Really high-relief sculpture.

Figure 6.4

House posts, Quamichan, nineteenth century, wood, 90 × 24 in. (228.6 × 61 cm). Museum of Anthropology, University of British Columbia, A50005 a,b,c.

The four-footed creatures carved in high relief are said to be animals that are members of the Mustelidae family, which in North America includes the mink, ermine, weasel, and ferret. Animals and humans portrayed in Salish sculpture are often generalized and not recognizable as particular animals or as portraits of identifiable people. Mustelids appear on many types of engraved and sculpted art forms, such as house boards and spindle whorls; they are considered powerful and were associated with curing. In the Halkomelem dialect they are referred to as *sxwemecen*.

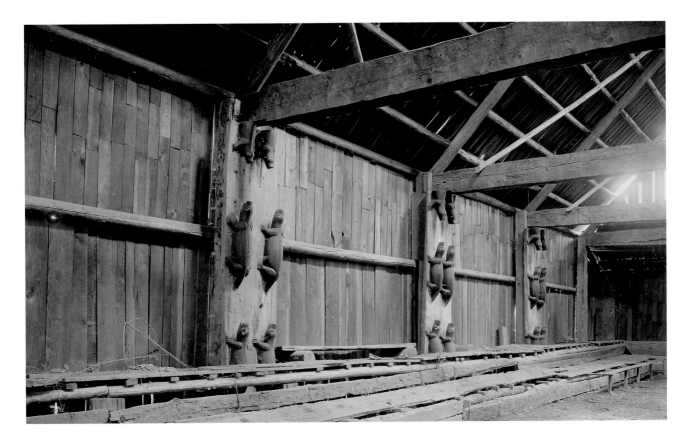

Figure 6.5
House interior at the Cowichan village of Quamichan, showing posts with mustelids. Photograph by Harlan I. Smith, 1929. Canadian Museum of Civilization, VII-G-271, 597-16743.

This photograph shows the house boards in situ within a gable-roof house. In their original position, the boards were architectural members that were positioned in front of weight-bearing posts that held up the crossbeams.

Point: [You see it, too, in] the front board [of the grave box], the back being all removed and leaving the relief of the animal still standing—the animal forms. I think it's quite . . . whoever the artist was, it's excellent. An excellent sculpture.

Kew: They have to have conceived of that thing as a whole and then started the work of excavating, removing the surplus material there. So they must have seen the whole thing first in their heads.

Point: Exactly.

Kew: That's a nice piece. Those are, for all we can tell, the same animals [on the house posts and the grave box], except the lower pair have their tails back over their backs.

Point: With the planks, I noticed . . . I was checking out the tails. You see how they are chopped off into the actual background of the boards there, whereas you have the longer tails here. And whether they're the same animal, it's difficult to interpret.

Kew: Yes, it is, because all of that family of animals have long tails, relatively long tails. But this piece [the box; fig. 6.3], too, has that conjunction of sculpture and the engraving on the flat surface, which is nice. And here it balances the bottom. Part of the engraving in the lower piece is broken off. It looks like the central part.

Point: I think so, because it's referred to as a two-headed serpent.

Kew: What do you think was in the middle part?

Point: It was probably just like how they have the crescents on each of the sides. It probably went right to the center portion. It's like when you look at the bracelets—the goat-horn bracelets [see fig. 5.9]. You know how they had that same element used within, and it was like the circle in the center. You can actually kind of see a part of that circle— I think, I'm not sure—right here. Then it just kind of worked from there.

Kew: When Smith purchased this, he reported that there were three . . . the remains of three people inside the coffin. They were wrapped in blankets and they would have been flexed burials; that is, people closed up, not extended. But I think those were put in at successive memorials. The grave box is made to be able to take it apart. It was tied at the top edges and the bottom fits into a socket so that you could lift the lid off and take the sides out. You could take it apart. They probably added people to it. So it was like a little mortuary house, you know. Mortuary houses were much larger and held many, many people over a long period of time, but they were family owned and family maintained. Members of the same family were put away in them when they died. So that's probably why the box was made like that . . . why there were those three people in there.

Point: That's interesting. Over time as people passed.

Kew: And as they had memorial services for those people. At the memorial service, as you know, they burn food for the dead of the family. It's a way . . . I always thought of it as a very sort of important way of the living people maintaining their obligations to the dead people—to the dead, to the ancestors.

Point: Exactly.

Kew: It's an obligation to help them.

Brotherton: Some of the carving appears to be anatomical features like ribs or feathers. And then some of it on the rim of the box appears to be what we would call decorative [abstract]. Do you know anything about that?

Kew: No, I think that's a good way to describe it. I think that's what it is.

Point: I think it was more decorative as opposed to having a certain meaning.

Kew: It may have had a meaning to the sculptor, but it may have just been a sense of design and balance that someone did that. If you have a nice rim like that on the board, that's the top; it's a big slab of cedar. It just invites an artist . . . it invites you to do something with it.

Point: Right, it does. I know when I'm carving wood, I try to use the space as much as possible.

Brotherton: Now here we have examples, important examples of Salish monumental sculpture with the mortuary pole or the mortuary figure and the house posts. I've read that maybe there are other types of things that we don't know about. Like maybe they had exterior welcome-type figures, maybe house fronts were painted. Things that I've read in the literature may have existed or there's some reference to them. What I'm most familiar with are the house posts and the smaller sculptural figures.

Kew: There certainly was a lot of sculpture in the mortuary areas associated with the mortuary houses, the family-owned huts in which the dead were put away. There certainly was a lot of sculpture associated with that. We know that very firmly from early records of observers and some photographs and some paintings even. But photographs of house posts are fewer. There are some of them, but not a great many. I think most of them were inside the houses, although there are one or two outside. I don't think there's any rule about that. But most of them, I think, were inside and had to do in some way with family history, like the Musqueam posts. There are stories with those posts and they were inside the house, seen from the inside when the family lived there and received visitors. So I think . . . like a piece of fine art in your living room, the post dresses up the place to show to visitors. We're talking about visitors in the dozens and hundreds on some occasions to those family houses. They would make it more impressive and speak to the position, the social position, of the family that lived there.

Brotherton: What about the sculptures we call welcome figures? There is one [outside the museum], carved by Susan [fig. 6.6].

Point: I think basically those figures were used, I assume, outdoors to welcome people into the villages, welcoming individuals to their village. To be honest, there are very few of those kind of welcome figures that I've seen documented, whether in photos or in books.

Kew: Yes, for Salish, I don't think there really are any like that that I've seen in old photographs. But the idea, the act of welcoming visitors, is probably a universal thing, especially if you called for an assembly of people for some family reason, then you would welcome them as they arrived. So the idea of welcoming is universal.

Figure 6.6
Welcome Figure, Susan Point, Musqueam, 1996; cedar, paint, copper, 26 × 4 feet (670.56 × 121.92 cm). Commissioned by the Royal Bank of Canada for the Museum of Anthropology, University of British Columbia.

Welcome figures are better documented for the Kwakwaka'wakw and Nuu-chah-nulth than for the Salish, although the artist Paul Kane sketched a monumental figure outside a Klallam village (see another work by Kane, fig. 5.14). Salish artists carved house posts and mortuary figures in the guises of ancestors, sometimes associated with their inherited spiritual powers, such as holding weasel-like creatures. Point's figure shows an ancestor holding a weasel or fisher—an animal believed to have healing powers. The human figure resembles old-style sculpture of Halkomelem-speaking people, and the circular features at the top and base are done in Salish two-dimensional style.

A Dialogue about Coast Salish Aesthetics

Point: And then I think it's just . . . well, when I use it with the hands raised, it's like a welcoming gesture. A lot of the older Salish house posts, their hands are . . . down. Even still, it can represent welcoming.

Brotherton: Turning to this house post [fig. 6.7]. . . What do you think?

Kew: [The Tsimalano house post] was one of a pair, and they were inside a house. There is a photograph . . . with a post across [them]. So originally they were interior house posts.

Point: Do you know the story behind the man and the bear?

Kew: The man had the name apparently of Tsimalano. That passed on to other people in time at Musqueam. The story that I was told by the older people is that it shows a spiritual power that Tsimalano had to capture or kill bears. There's a bear in a hole in a tree and Tsimalano started a song that had the power to call the bear out. So the bear is coming out to give itself to him, but what he's holding there, the instrument in his right hand, I was told is a rattle. The instrument in his left hand is a dagger. So he's singing his power song, or a power song that he had to call the bear out, and then he's going to dispatch the bear with the dagger. They're not fighting. The bear is giving itself to him.

Point: In a spiritual sense.

Kew: Yes, because of the power, but it's giving himself physically, too. Tsimalano is wearing, again, a garment—and his hair is hanging down behind and it's meant to represent a person who is known. Now he [Tsimalano] may not have been alive when it was made, [but] because that was an important power that he had, an important ability, the post would tell that story to the family.

Brotherton: From an artistic point of view, as an artist, what do you think about . . . just the intensity of that bear and that human confronting each other in that small space between them? It's so riveting. It's so simple, yet so powerful.

Kew: If you think of it as [an image] of antagonism, then it is, of course—you would be facing danger. But if it isn't that and it's not antagonism, then the bear is giving itself to the man. So it's one of receiving the bear.

Point: It does look like . . . a conflict, an encounter of some sort; whereas the real story behind it is not in that sense.

Kew: It's a great pity that we don't have similar stories with which to approach some of the other sculptures.

Brotherton: It is definitely an auspicious moment [depicted] there. You feel that tension even though you [the viewers] are removed from that time and place.

Kew: This is a very nice piece because it's replicating some particular event. That's very different from the Northern crest art, [where] the events that it might depict are far removed in time in the ancestry of the family. This is more imminent, more immediate to the family. It's a person whose name one knows. And the same for the sculptural mortuary art we looked at previously; they are [depicting particular] people.

Brotherton: Not like in myth time but in the historic past.

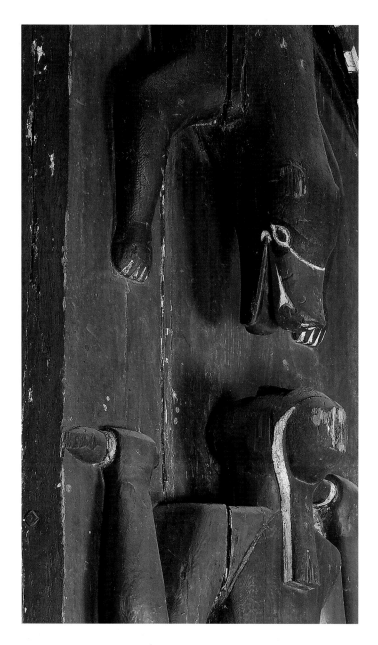

Figure 6.7
House post of Tsimalano, Musqueam,
late nineteenth century, wood, 94 × 28 ×
9½ in. (238.76 × 71.12 × 24.13 cm).
Museum of Anthropology, University of
British Columbia, A50004.

This was the house post of the great-grandfather of Vince Stogan
(d. 2002), who also carried the name of Tsimalano. House posts
bore the designs of the family and were placed at the entrance of
the house in order to proclaim aspects of family histories. Accord-
ing to Stogan, each house had a male and female image on either
side of the main entrance; the female counterpart of this post no
longer exists.

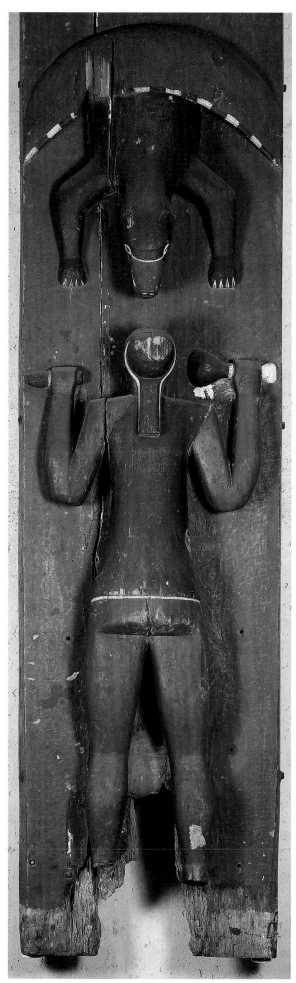

Kew: That's right. It's not myth time. [That is] a difference between Central Coast Salish art and the more Northern art.

Brotherton: Let's look at some of the ancient pieces here, like this atlatl that was found along the Skagit River near Sedro-Woolley, Washington, dated to 1700 BP (before present) [fig. 6.8].

Point: [This ancient piece is] interesting because it's got . . . all the true Salish elements.

Kew: It's got those relief elements in it.

Point: And the eye.

Kew: There's a human face here below the beak or mouth of the bird or animal. It looks like it might have wings here, but maybe a body or a tail—or that may be part of the human here. It's a combined figure . . . animal or bird. It has a beautiful tail, again, with a T-shape form there and crescents. Those engraved elements are like the more recent Salish engraving, but this is a nice sculptural piece as well. The face here—is it human?

Point: In the front . . . is it a human face? But the nose is interesting because in most Salish pieces I've seen they have a long, narrow bridge, and here it's really wide.

Kew: It almost looks like a beak. But it isn't like a beak because it has nostrils. Well, it's a very curious piece, but I think it has elements of Salish art, what we've come to know now as Salish engraved design.

Point: I agree.

Brotherton: Do you think it was functional as an atlatl? It is so detailed in design and aesthetically pleasing . . .

Kew: Well, here we have an atlatl, a spear thrower, an implement for throwing a spear. It's very much like western Inuit atlatls, with a finger hole to grip the thing. And it could be held this way and then turned upside down so that in the throwing position the sculptural form would have been upside down on it. Some atlatls on the Northwest Coast may have been weighted with a stone, and Dr. [Charles] Borden in his excavations in this area found stones, usually nicely shaped stones, that were fitted as if they were intended to be bound to a spear thrower and used as a weight. Some people have argued that those weights gave a little more momentum and power to the throw and so . . . this sculpted figure would be on the tool in the place where a weight might have been. There's a nice weight from Musqueam that was found that had a sculpted head and the base was flat, slightly concave with a hole so that it could be easily bound onto something.

Kew: [This next piece is a] little seated human figure bowl [fig. 6.9]. There are lots of these and they vary in size. Some of them are quite large.

Point: What is this, the material? It looks like steatite or soapstone.

Kew: Yes, a relatively soft stone that you could work with a sharp knife—or you could work it with a piece of sharp bone or a chisel. Not all of the design elements look closely associated with more recent Central Coast Salish . . . maybe the face, a bit. And there are some things not dissimilar, like the round lips and the nose. This is a little tiny

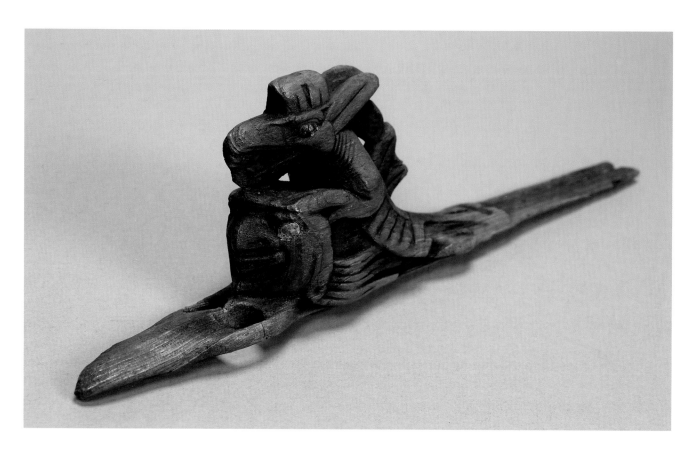

Figure 6.8
Atlatl, Skagit, 1700 BP, yew wood, 4 × 15½ × 2 in. (10.16 × 39.37 × 5.08 cm). Museum of Anthropology, University of British Columbia, A7021.

This phenomenal spear thrower was discovered in 1936 in the Skagit River by a fisherman. It has been described as a sea monster with plumelike crests on top of a human head. Atlatls were used to hunt mammals, birds, and fish. Stone weights—some in the shapes of humans, animals, or abstract forms—were attached to the underside of the throwing board and may have also served as hunting charms.

nostril and a fairly long bridge. The eyes and eyebrows are there, as are elements of the hair.

Point: The indentation or bowl might have been used for grinding paints.

Kew: Nobody knows. There's no ethnographic information collected from [the] users or makers of these things. So I think we're left with guessing. They could have been used by grinding, but you couldn't grind very much in this soft sandstone.

Point: It would just actually wear away.

Kew: I think they were more likely used for some sort of ceremonial or spiritual purpose, perhaps a little water—water figures prominently in Salish rituals; water for cleansing . . . in a spiritual sense as well as physically. So that it might have been a container used to hold a little bit of water, but we don't know. Now the other piece, this little one, that's from the Marpole phase. Do you think it looks Salish?

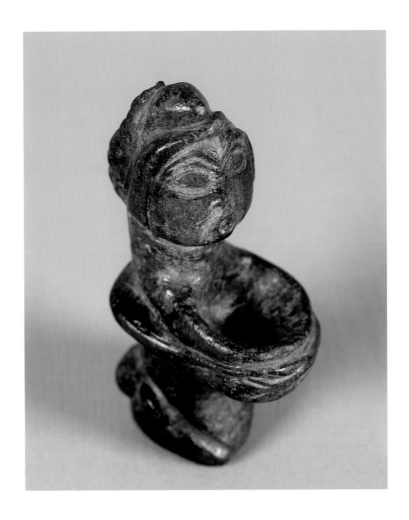

Figure 6.9
Seated human figure bowl, Lower Fraser
River, Marpole site, 350 BC–AD 200, soap-
stone, diameter 4 in. (10.2 cm). Laboratory
of Archaeology, University of British Colum-
bia, DhRs1:9216.

On the north arm of the Fraser River, near its mouth, in present-
day Vancouver, the Marpole phase inhabitants (2500–1500 BP)
produced stone tools, native copper ornaments, fully sculpted
stone bowls, and bone and antler carvings, suggesting a highly
developed ceremonial life. This is the smallest of the approximately
sixty seated human figure bowls that have been found near the
Fraser River and the Gulf of Georgia and in the northern Puget
Sound region. Interestingly, the largest of the bowls is also from the
Marpole site (see also figs. 6.10 and 6.11). Working with stone tools
and a beaver-tooth knife, the artist provides detail to the face and
headdress. Large oval eyes and arching brows protrude from a
hollowed-out eye socket. The nose is small, as is the open mouth
with protruding lips that gives the impression of oratory or sing-
ing. Although small in size and rudimentarily carved, the expres-
sive face and the forceful gesture of the arms encircling the bowl
make it a powerful sculpture.

Point: [This small pestle] looks Salish [fig. 6.10]. It's very simple. It doesn't have all the elements we associate with Salish design, but . . .

Kew: . . . but [it does in] some things; the eye . . . a beautiful form.

Point: The crescent behind the beak is representative of a crane—or a blue heron—with the plumage on the top as well. I think it was a pendant, but it was also a usable tool which could be hung around the neck.

Kew: Dr. Borden [thought] there was evidence that it had been used to grind shells or something like that in a small mortar. It would be tempting to associate it with this stone [bowl discussed above] but I think that would be stretching it a bit!

Point: [Maybe not!] It fits perfectly.

Kew: But it might have been used for paint, for decorative purposes or for face paint.

Point: But see, it's obvious that whoever wore it was using it when they were traveling. If they had something small to grind up, it was handy. It was around their neck. Grind something up for herbs or making tea.

Kew: Or for grinding paint, as for decoration, for cosmetics.

Point: Cosmetics, yes.

Kew: And this is a bone blanket pin [fig. 6.11] from a similar time in prehistory that fits into that Salish style—that treatment of the bird. It would have [originally] been a little longer, used to fasten a blanket. [S]ome . . . similar implements [were] made of some type of bone and are used today by spiritual dancers when they need to scratch their heads.

Point: I know, when you're initiated.

Kew: They carry them on their sash, on a string, so they could take them off and use them. It could have been used like that.

Point: Multipurpose.

Kew: Multipurpose, sure. People in certain phases of life are not supposed to scratch their head with the hand because it might be harmful, and so they used an implement to do that. And not just spiritual dancers, but people who had been bereaved were not to scratch their head. They were vulnerable.

Point: Yes, [my relative] gave me the whole meaning on [what] that is.

Kew: People in danger of dying or transforming, becoming something else or going through a growing-up, a life process [were vulnerable]. Maturity, coming to maturity . . . when you're going through that transition. [S]o it's a condition where people are vulnerable. And you had to be careful and observe all sorts of procedures to protect yourself. One of them was, don't scratch your head with your hand; don't throw your hair around.

Brotherton: I wonder why they would have carved bone instead of wood. Susan, do you ever carve antler or bone? Is it similar to carving wood, or is it just a different procedure altogether?

Point: I've carved goat horn [which is like antler]. I have duplicated a goat-horn bracelet, and initially I had to confer with Mike [Kew]. I didn't know how to start it because I was doing jewelry in silver and using the proper tools, and when it came to actually

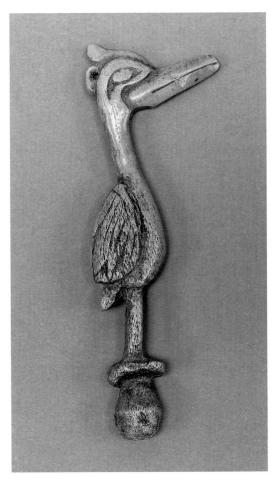

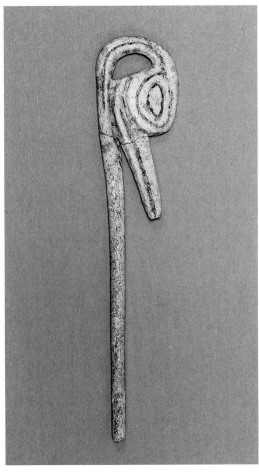

Figure 6.10
Miniature pestle, Lower Fraser River,
Marpole site, 1100 BC–AD 350, antler,
length 4⅜ in. (11.1 cm). Laboratory of
Archaeology, University of British Columbia,
Ma3299.

Figure 6.11
Pin, Lower Fraser River, Marpole site,
1100 BC–AD 350, antler, height 5⅛ in.
(13 cm). Laboratory of Archaeology, Uni-
versity of British Columbia, Ma8182.

Most birds that appear in Coast Salish sculpture are not of a recognizable species, but this bird appears to be a great blue heron (*Ardea herodias*), a wading bird common over most of North and Central America as well as the West Indies and the Galápagos Islands. They live near bodies of water where they feed on small fish and shellfish. The diminutive sculpture captures the distinctive features of this fisher: pointed bill, crested head, elongated neck, and the long plumelike back feathers present at the beginning of breeding season.

Blanket pins are most associated with the late Marpole phase of Fraser Delta prehistory, the Stselax phase dating from about AD 1250 to 1808. This might indicate an increase in the activity of weaving mountain goat and dog wool robes and other garments (Borden 1982: 163). Compared to the bird image on the miniature pestle (fig. 6.10), there is a striking economy of form and stylization of the bird features. The flow of the positive lines from the beak, around the eye and across the head of the bird, differentiated by incised elements, are diagnostic elements seen in later Northwest Coast two-dimensional design.

doing the goat-horn bracelet I didn't know what kind of tools to use. It was hard to carve. So Mike instructed me to wet it down, which I did with a cloth, and let it sit for a tad to soften it. It kind of cuts like butter. Just using my jewelry tools—but then I found, too, that if you get little hairs as you're carving, don't pick it and try and pull it off because all of a sudden it can take the whole thing off. It's stringy. It's very stringy, but when it's wet it's very soft. You can actually kind of scrape it as opposed to even carving it. It's quite different [than working in wood].

Brotherton: How did each of you start looking closely at Coast Salish art and design?

Point: Mike and I were talking about . . . how I really got into [Salish art]. I initially started out doing jewelry and was copying the Northern style. My husband, being a non-Native, [said] to me, "Susan, don't you have your own art form?" I said, "I don't know." That's how it all started. I went to the library and there was very, very little on Coast Salish. I was fortunate that Mike was married to my Aunt Della. I didn't even realize he was a professor specializing in Coast Salish art and culture at that time—and once I knew that, we used to visit together. Mike assisted me in acquiring all of the slides and photos of whatever [Salish artwork] that he had in his teaching collection.

Kew: I was at that time looking at material in preparation for a big exhibit here [at the Museum of Anthropology] . . . in 1980 called "Visions of Power." We talked a bit about [when] I started looking at museum collections . . . how much Salish art there was. It was varied and quite different from Northern art styles [that I had seen in museums]. But most of the Salish art was in American museums or European museums. Much more there than [there was] in Canada. So it was a revelation to me as a student of Northwest Coast cultures to see how much there was of Salish [art], and we shared that understanding when pictures came around. So if there was an influence of me on Susan's art, it was indirect—in the form of passing along a slide or saying, "Hey, go and look at this or that."

Point: But I remember, too, that when I first started out I was doing limited edition prints and . . . I wouldn't say copying, [but] duplicating the old traditional [spindle] whorl imagery . . . not knowing what the actual image was. I would always go to Mike.

Brotherton: Can we turn to these spindle whorls?

Kew: [These are] two of our old favorites [figs. 6.12, 6.13].

Point: The artwork I do now . . . was all inspired from the spindle whorl itself because of the intricate imagery that I found in each of the pieces. That's originally where I did start, and Mike can attest to that. I started all of my work copying from the old images but in my style, refining it . . .

Kew: What is it about the spindle whorl that is artistically challenging or interesting?

Point: Well, because I started out . . . working with the actual circular shape and the imagery of the spindle whorl, it was interesting in a sense that it's got that movement and it's got that motion. So in looking at the designs, it doesn't look like it's just sitting there. It's got an element of motion.

Kew: And, of course, [it] is spun when it's working [to gather] the wool strands into a ball.

Point: Yes, exactly.

Kew: And this side—when it's on the spindle stick—[the] engraved side of the whorl is toward the spinner who's spinning it. But this one [fig. 6.12] is nearly round. I measured a great many in museums, and none of them is really truly round. They are sort of oval in a way.

Point: You're right in that sense, but there are some [that show that] maybe the individual was actually trying to make it round, but with the tools they had it was probably that they couldn't. The whorl wasn't really round, but I always started out doing my images round because that's what I saw in the actual shape of the whorl itself. And then researching and looking at all the slides I found, all of a sudden you get the soft corner— so they weren't necessarily all round or oval. They had the different shapes. I love this here one because of the soft corners.

Kew: This is nearly round. This is rare. And, of course, some of them were used for years and some of them are worn down or cut down, or they'd drop, and since the wood grain runs one way they can splinter and chip. Some of them are cut through. This one is. This inside engraving goes right through the piece of wood. I think over there that's the third level of engraving here on this piece. There's the primary surface here, and then the secondary surface is the back, and then there's a tertiary surface. There are three heights of relief carving here.

Point: There's [often] three levels [of carving] on the spindle whorl. With this one [fig. 6.13], there are only the two levels.

Kew: This one is neat because of the human face and the bird face. It is a bird. And the fish here; beautiful fish.

Point: A good point to mention here is [that] we were looking earlier at the rectangular shape of the salmon on the box. [See fig. 6.2.] If you look at this salmon depicted on the whorl, you see the shape of the roundness on the top of the fish head.

Kew: It's not struggling to fit within a rectangular background there [as on the box]. . . . This is a good example of the bird always [having] a straight leading edge to the wing. It's almost concealed here—but the huge head . . . then the wing back here, and the very short, straight leading edge. That seems to me to be really characteristic of the depiction of birds in this style of engraving . . . working with this very plain space—its round corners—and filling it up with the dynamic movement of those birds.

Point: The interesting thing, too, that I find with the spindle whorl is that the artist that created the piece always uses the negative space as part of the overall design.

Kew: [The design is] a combination of sculpture and engraving. The engraving tends to be this hard line—hard, clean-cut lines—you could ink this and press a paper on that and take off an impression.

Brotherton: Why birds? Why fish?

159

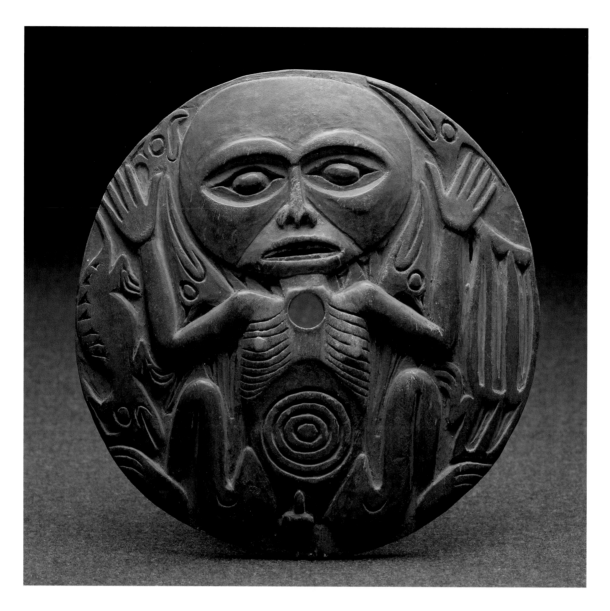

Figure 6.12
Spindle whorl, Cowichan, nine-
teenth century, wood, diameter 8¼ in.
(20.95 cm). Collected by William Fraser
Tolmie in 1884. Canadian Museum of
Civilization, VII-G-6.

This carving was collected by William Fraser Tolmie in 1884 for
the Geological Survey of Canada. Tolmie was a physician, fur
trader, scientist, and politician; he also studied Native languages.
From 1843 to 1859, he was stationed at Fort Nisqually in the
employ of the Hudson's Bay Company, before moving to Victoria,
British Columbia. This is certainly one of the finest examples of the
exquisite skill of the Salish carver in organizing a complex compo-
sition of motifs and elements within the confines of a circular
form. The striking presence of the central human figure carved in
relief is set against the asymmetrical disposition of the other crea-
tures: a beaked bird with bold feather designs on one side, and a
downward-facing quadruped and an upward-facing bird's head.
The mastery of composition and vitality of the carving displayed
on whorls has inspired many artists (e.g., Susan Point, Stan Greene,
Maynard Johnny Jr., and Luke Marston) to adopt the circular for-
mat in their carvings, paintings, and prints.

A Dialogue about Coast Salish Aesthetics

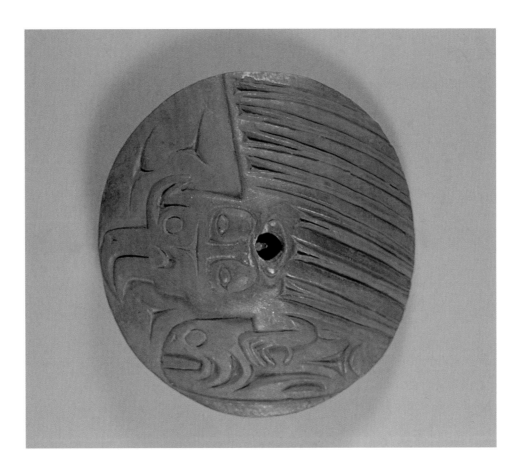

Figure 6.13
Spindle whorl, Chemainus, nineteenth century, wood, diameter 6½ in. (16.5 cm). Collected by C. F. Newcombe in 1905. Canadian Museum of Civilization, VII-G-3.

Humans, birds, fish, and whales are forms commonly engraved on spindle whorls; however, the real meaning of the imagery was not documented. Although the whorls were carved by men, women were the users of these implements, which enabled them to spin the precious fibers of the mountain goat into even strands for dyeing and weaving. It is thought that the creatures are associated with the weavers' vision powers, which nurture their artistry.

Kew: Well, what's in the world? There are humans, there's fish, there's birds, there's animals.

Point: I think the artists . . . looked at their surroundings. I think a lot of that came from their surroundings. The birds, the fish . . . were sustenance for the people along the Fraser River and for many other people as well. In Salish art, you find a lot of the human element, [especially] the face.

Kew: It isn't a naturalistic eagle [seen here on the whorl] because, first of all, eagles don't have plumes and crests on their head . . . its beak . . . is like an eagle. What is that fish?

Point: Generic.

Kew: It's a generic fish. I think that's what is here. It's a fish and bird and human. Now humans and animals—the difference between humans and animals, I think, is an important one. Humans [depicted in the whorls] are associated, or hidden in, or tucked in, or somehow surrounded by either animals or fish. I think that [is] consistent with . . . the Central Coast Salish idea of humans and nonhumans. Humans can receive power, spiritual power, very potent and dangerous power from nonhuman forms. So there is a kind of opposition. These [whorls] are all human products and humans center on themselves, but powers that can come to humans come from those natural forms. So I think it is that basic sense of the position of people in relation to the world—the larger living world—that's important. Powers came to humans not from other humans [but] from the animal forms—from those spiritual powers that are nonhuman.

Point: Exactly. I refer [to] these bird images with a little plumage as thunderbirds because someone . . . referred to them as thunderbirds. What is a thunderbird?

Kew: There is no natural thunderbird.

Point: There are a lot of stories [about] thunder-and-lightning birds.

Kew: What is it? It's a mythical bird. Maybe these are that, but they could be understood to have been thunderbirds or something else. Someone may have associated [these] birds with some power that they themselves had—the artist or the person for whom it was produced.

Point: Right. That's something we've always kind of associated with whoever actually did it . . . Was it their spiritual power that they . . . carve[d] into a piece of wood and gave to their wife or to whomever? Or was it designed for that individual, the certain woman who had . . . that specific power? It's all guessing at this stage.

Kew: Powers were seen in dreams—so that they had a visual sense in a dream. But images may have had significance because of being like dreams. Images could be understood to have a content of power to them. The Central Coast Salish notion of power—spiritual power—is not limited to other living forms, but it can be associated with other sorts of things . . . with places. I suppose it could even be associated with an object like a spindle whorl. But I don't know that that's the case. So I think images are . . . probably tantalizing to people because they might signify some power of someone, not necessarily yourself. You've got to be careful with things like that because images could

have power for someone else and could have a kind of power that reaches beyond the object or the thing that is seen there.

Point: And the other thing you mentioned. Why birds? Why fish? Why the human element? Not all . . . spindle whorl[s] had animal forms or human forms; [some had] geometric [designs].

Kew: Yes, that's right . . . [R]arely in the museums do you find plain spindle whorls . . . there probably were lots of plain spindle whorls, but nobody would collect them. Why buy a plain one, when you could buy the one that's fancy? So the museum collections are not fair representations of the distribution of the form.

Brotherton: What would you say about these decorated tools?

Kew: [These are] little implements for creasing the cattail mat on the needle [figs. 6.14, 6.15].

It's an interesting tool because the functional part is underneath where there's a groove, and that was [for] the needles, which were triangular and long—made out of ironwood or ocean spray. They were run through the fibers of the cattail laid out like this. So the needle was run through the cattail and then this instrument was taken while the needle was still in the cattail and run over, pressing along the top of where the needle was, and it crimped the fibers of the cattail rush so that it was less likely to split—because after you crimped it, you pulled the needle through and pulled the thread through. So the thread sits in that crimped space. So it crimps or bends the rushes. So that's the functional part of the tool. You hold it on the opposite edge. It doesn't matter which way. You run it back and forth with pressure because you want to crimp the rush. But [it could be] carved as any kind of form as long as it has a curved groove and the place to hold it. That's all that you need on these instruments, but they are quite varied and they are decorated. There isn't any standard form for this. They're all different. That's what intrigues me about these, seeing them in the collections. Some of them are really elegant. This is a nice beautiful bird form, but very simple, isn't it? There are no eyes. There's no engraving.

[Some of the designs on the surface] are not really naturalistic forms, as on this other creaser. They're kind of just nice decorative elements.

Point: The notches . . . little chevron notches . . . very nice . . .

Kew: Do you think women made these?

Point: To be honest, no. [They were done by men] for their women, whether it was a wife or girlfriend.

Kew: Or for their mother. Because years ago women did not carve. It was a manly kind of thing. I think that that sort of fits, but I wonder if we sometimes accept some of these assumptions, really, with not much grounding. We should always be suspicious of them.

Brotherton: I've seen a photograph of a woman carrying an adze. So maybe she was using it to strip the bark and make that notch so she'd have an easy strip.

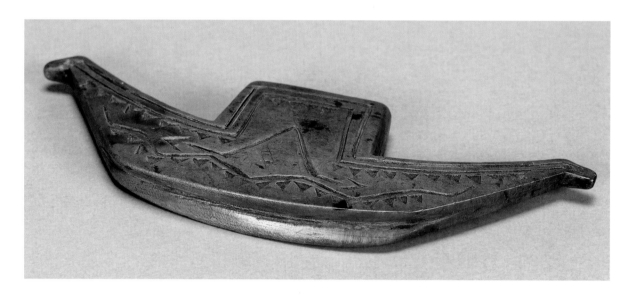

Figure 6.14
Mat creaser, Cowichan, twentieth century, wood, ca. 7⅓ × 2½ × ½ in. (18.62 × 6.35 × 1.27 cm). Museum of Anthropology, University of British Columbia, A17082.

This artist has chosen a more stylized approach to the depiction of double bird or duck forms than that seen in figure 6.15. Only the curved breast and short bill are delineated. The surface of the implement is marked with abstract incised triangles and lines that might be decorative but might reference landscape elements such as mountains or water, like the conceptualizations that appear in basketry designs.

Figure 6.15
Mat creaser, late nineteenth or early twentieth century, wood, 1⅞ × 2⅞ × 7⅜ in. (4.76 × 7.3 × 18.73 cm). Canadian Museum of Civilization, VII-X-1036.

Sleek and spare, the delicacy of this sculpture belies its use as a tool. It is used to make mats from the fibrous, pithy leaves of the cattail plant (*Typha latifolia*), found near edges of lakes, marshes, and ponds. Cattails were also used among the Salish to make baskets and thread; cattail fluff was mixed with wool for weaving, and burned cattail was used to make a charcoal paint (Turner 1998: 122–23). Mats were among the most important and useful household items: they lined cedar-plank houses for insulation; they were used as room partitions, mattresses, eating mats, and canoe liners, and were also used to cover the supports for temporary lodging at summer harvesting sites. Many of these ubiquitous tools are shaped in the form of birds, perhaps because the women picking and processing the cattails would have been in the company of a variety of ducks, gulls, and shore birds.

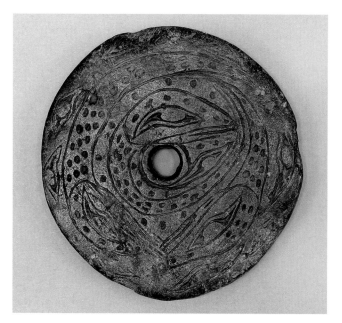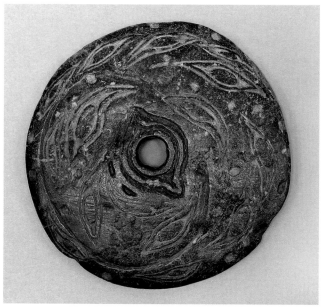

Figure 6.16
Spindle whorl, Milliken site,
AD 1200–1808, steatite, diameter 4½ in.
(11.4 cm). Laboratory of Archaeology,
University of British Columbia,
DjRi3:11.142.

This beautiful weaving implement is engraved on both sides, with snake forms on the front and eye forms on the reverse side, using design elements found on later whorls carved of wood. Its date is a conjecture since this, and other material at this area of the Milliken site near Yale, British Columbia, was recovered from a disturbed context (Borden 1983: 160–61). It is possible that this small whorl was made to spin nettle or plant fiber rather than the bulkier mountain-goat wool.

Kew: There were tools that lay around that were there to be used. Women did a lot of heavy work. If you think about the culture, the wider culture and what was needed, one of the things that is really underestimated is the use of bark twine and rope. . . . [In] all of it, in our conventional understanding of the division of labor, women's work is weaving, making rope, and basketry, and twine. . . . Hours and hours must have been required to produce all those things and women used tools like axes and chisels and so on in the gathering of the material and preparation of it. So the fact that the tools were there and that women used them on occasion, I think it not unlikely that they occasionally chopped a little bit of wood with one of those. But we don't know much about that. . . .

Point: Looking again at these tools . . . there are a lot . . . [of] abstract spindle whorls [and mat creasers].

Kew: I like those very elegant, simple, beautiful curved forms.

I think that's a feature of Salish engraved art in this form that's worth noting—because there is within that range of forms a great range of expressive possibilities. They're not confined by being natural. It's not confined by a set of very specific rules about this or that.

Point: Yes, actually, there is a freedom to Salish art and design that is unique to them. We see it by just looking at these few pieces here, but it is everywhere within the range of Coast Salish arts, in the very old and the very modern.

Figure 6.17
Susan Point, Musqueam, with Seattle Art Museum commission-in-progress, "The First People," 2008.

The traditional homelands of the Musqueam of the Fraser Delta, in present-day Vancouver, are punctuated by fjords and meandering pathways as the Fraser reaches its terminus in the Strait of Georgia. These pathways are the lifelines that yielded salmon and other foods for Salish people. The name Musqueam comes from the hənq̓əmiṅəṁ word for River Grass. The eight faces that connect via flowing tendril forms refer to this grass as well as to the roots of Salish people, and the hereditary bloodlines that connect extended families.

INVITED GUESTS AT TRADITIONAL GATHERINGS in the Skagit River area of the Puget Sound leave with gifts thanking them for taking part. The kind of gift and the value of the gift are appropriate to the importance of the invited person to the sponsor of the gathering and also appropriate to the level of individual participation in the work associated with the event. These gifts serve as a remembrance of the event and continue to commemorate it long after it is over.

Some of the gifts given in the past may have ended up in archaeological sites. I would suggest that four human figures found at four different archaeological sites within or near the traditional lands of the people who now comprise the Swinomish Indian Tribal Community were such gifts.[1] My rationale for this hypothesis is based on the manner in which objects are obtained and assembled for most traditional events and community

Remembrance

Astrida Blukis Onat

gatherings. These four figures may be representative of traditional practices with considerable time depth.

Traditional Gatherings

Today, the traditional community gatherings among the groups that comprise the Skagit area are conducted for a number of reasons. Reasons to host an event are many: for formal naming ceremonies for young family members; for *siown* or smokehouse practices during the winter ceremonial season; for funerals; and for unplanned events. The events are always important to the community at large. The process requires some basic elements:

- A host family that sponsors the event.
- A purpose for the event.
- Speakers who lead various stages of the event.
- The thanking of participants with gifts assembled for the event.
- Witnesses to testify to the conduct of the event.

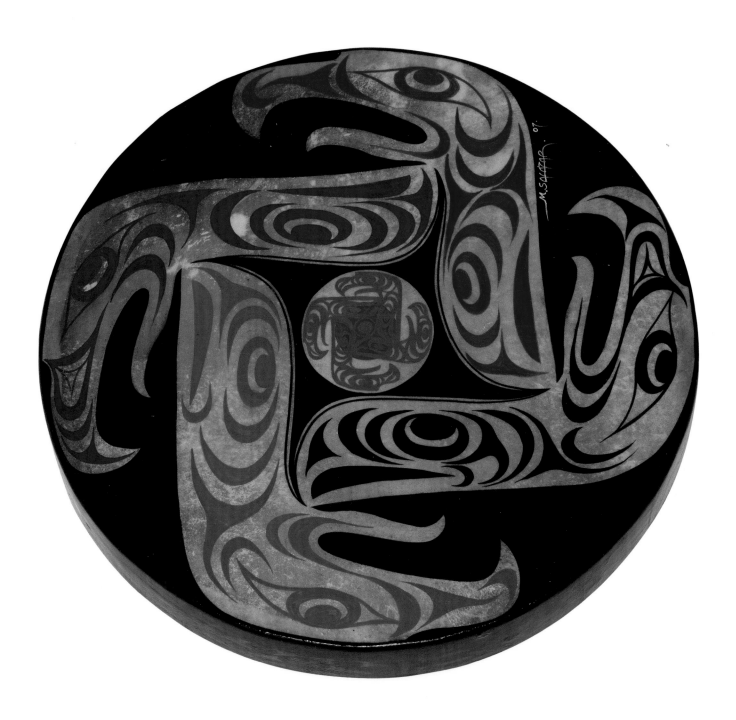

Figure 7.1

Eagle and Salmon, Manuel Salazar, Cow-
ichan, 2007; deer hide, acrylic paint, 20 in.
(50.8 cm) diameter. Collection of the artist

Hand-crafted drums are highly desired potlatch gifts and might be
painted with imagery from stories. This one shows the eagle and
salmon: the eagle as the protector of the people and the salmon
as their primary sustenance. Personal drums often carry images of
visions or personal experiences of the owner. The challenge for the
artist is to create a design within a circular format. Manuel Salazar
has studied with well-known artists and was influenced by the
work of Simon Charlie (see fig. 2.3). He is conversant in the style
of his Cowichan heritage and concentrates on the making of drums
and silkscreen prints.

For the purposes of this essay, I will focus on the gifts that are assembled for the event.

The event as a time to "spread the table" and the purpose of the event are referred to as "work." The term "spreading the table" encompasses preparing for a gathering of community members. It always includes prayers that consider the ever-present spiritual realm. The preparations for spreading the table and the associated "work" for which the community has assembled are of great significance for all participants. Every step of the process is imbued with great care and responsibility for all concerned, and all aspects of the event and the work have a spiritual quality.

Important planned events are announced well in advance. Invitations to major participants who will lead the work at the event also are given well ahead of time. As planning for the event continues, more announcements are made and more invitations are presented. The host family will include relatives from throughout the region and beyond. This extended family will gather needed resources from many locations. Individuals and families sponsoring or hosting the event are assigned duties early in the planning process, which may begin years before the event will take place. Planning for the event takes place at regularly scheduled intervals. It also includes making arrangements and collecting materials for thanking the participants at the event.

Spreading the table operates within a network of linked benefits and obligations that are commemorated with gifts to all invited guests. By the time an event is announced and invitations are given, the family or community sponsoring the event already has been in the process of assembling gifts. Some gifts are meant for specific individuals who have been invited to act as Speakers or Witnesses or have other important roles in the work of the event. As the event nears, the host family makes an accounting of the assembled gifts, and additional gifts are obtained as needed. It is important that all invited guests receive gifts and that these gifts are appropriate.

The process of assembling gifts will vary from family to family and from one community to another. The types of gifts that are assembled will vary depending on the purpose of the event. Some gifts that are commissioned or made by the host family and community will have a theme that will be recognizable long after. Some gifts include decorative elements that will commemorate the event, including names and dates. Persons conducting an event often procure large quantities of some items in lots, creating a set of symbolic elements for the event. In this manner, gifts with a thematic focus can visually communicate to the people who participated in the system long after the event is past.

In addition to gifts assembled for specific guests and for honoring all attendees, gifts are prepared for persons who assist in the planning, preparation, and conduct of the event. Making arrangements and assembling the food to feed all guests and participants is a major task and is always honored. The persons who plan, prepare, and serve food for the event are always prominently thanked for preparing the table.

Because all families and communities are perpetually preparing for one event or another, some scheduled years in advance, it is possible to shift the resources gathered

for one event to another that is unplanned (such as a sudden death requiring a funeral in a matter of days, or a catastrophic natural event).

The event usually includes basic activities that may be scheduled over a period of several days:

- The host family spreads the table by welcoming guests to the community, by providing food, and by arranging housing for the duration of the event.
- All work begins and ends with prayer and a request for a spiritual blessing for the work being conducted.
- All work is announced and explained by Speakers selected by the host family to lead the work.
- The work concludes with gifts being given in thanks to the participants in the work, the assembled guests, and those who helped in supporting the event (the cooks).
- The event concludes with Witnesses who testify to the conduct of the event.

In the course of any community event, announcements about and invitations to other events are given. The host family always prepares breakfast, lunch, and dinner for all assembled. Families interact and make wide-ranging contacts and conduct other business. Families attending an event will compare notes on how they are related to the host family and to each other. Elaborate genealogies will be related and recorded, with individuals adding information from their own extended families.

At the conclusion of the event, participants are thanked for attending, helping, and witnessing. The extended host family distributes the gifts in a careful and organized manner. Speakers, Witnesses, and prominent guests receive blankets and other specially chosen items such as carvings, drums, baskets, and weavings that are commissioned from known artists. Participants who have come from a long distance, especially when they are persons of importance, will receive special gifts of thanks. Today, monetary gifts are also offered to Speakers and Witnesses for their support with specific tasks.

The items given away to the larger body of workers, relatives, and special friends attending the event fall under the category of household goods and tools. They include containers, towels, bags, pillows, dishes, glasses, and various utensils. Some items, such as knives, raw leather, canvas, and a variety of tools, are given to men; shawls and jewelry are given to women. Children also receive gifts of toys and coins.

After the guests and participants return home, some of the gifts will go into use in the household. The special gifts will be displayed and become family heirlooms or may be given away at another event, while others are stored for the time when the recipient will be part of a host family at another event. As people visit each other, these gifts serve as remembrances and are linked to the oral recollections of particular events. The four figures discussed here may have been such gifts and may have served as remembrances of a long-ago event.

Archaeological Context

The tradition of spreading the table is a long-term, stable cultural practice and deserves consideration in the interpretation of the distribution of material culture in archaeological sites. To track the kind of gift-giving that takes place at most Puget Sound tribal community gatherings in archaeological contexts would be challenging because it is difficult to separate commercial trading from that of exchanges through social networks. In the past, it may have been that most trade was conducted in support of community social events and functioned to create the volume of materials that would be given away at specific events. Distribution of the goods was done primarily in the context of very specific social obligations. The goods were collected and were stored or redistributed as daily living and social interactions occurred. At any one time, a single household would have stored a considerable quantity and variety of goods, goods that would be totally redistributed in a matter of days.

Special gifts may have entered the archaeological context as inadvertent discards, as stored items not recovered, or as deliberately buried items that have special cultural importance. Discarded items such as tools can serve to delineate trade networks as well as social networks. Deliberately stored and buried items may have been gifts with special qualities defining status and spiritual significance.

The Figures

One of the four figures (fig. 7.3) is crouching. This figure was found during construction monitoring at tʷi'wúc (archaeological site 45SK31), the main Swinomish settlement along the Swinomish Channel (see map, page xix). Three of the figures are standing; one (fig. 7.4) was recovered from ski'kikab, located at the mouth of the north fork of the Skagit River. The smallest and most fragmented of the standing figures (fig. 7.5) was recovered at site xceda'b at Conway, along an old slough channel that empties into the south fork of the Skagit River. The fourth and largest standing figure (fig. 7.6) is from Sucia Island, one of the San Juan Islands to the north of the Skagit River delta.

The two small standing figures were found in archaeological sites with datable contexts—associated with strata that are between 900 and 1,200 years old (Blukis Onat 1980: 84–87, plate 27; Munsell 1977: 4). The crouching figure was found in disturbed sediments during archaeological monitoring for the Swinomish Indian Tribal Community Dental Clinic and Senior Center. The larger standing figure was found on Sucia Island in the early 1950s; the exact location was not identified, although it was reportedly found in a cave. All figures could be radiocarbon dated, a process that would require taking a small sample from each, potentially damaging the object.

Design Elements of the Figures

The four figures are a unique grouping in that all display certain design elements. All of them were carved from antler. Each has the hair parted in the middle (this is assumed from the broken figure). They all have a representation of a garment on the lower body

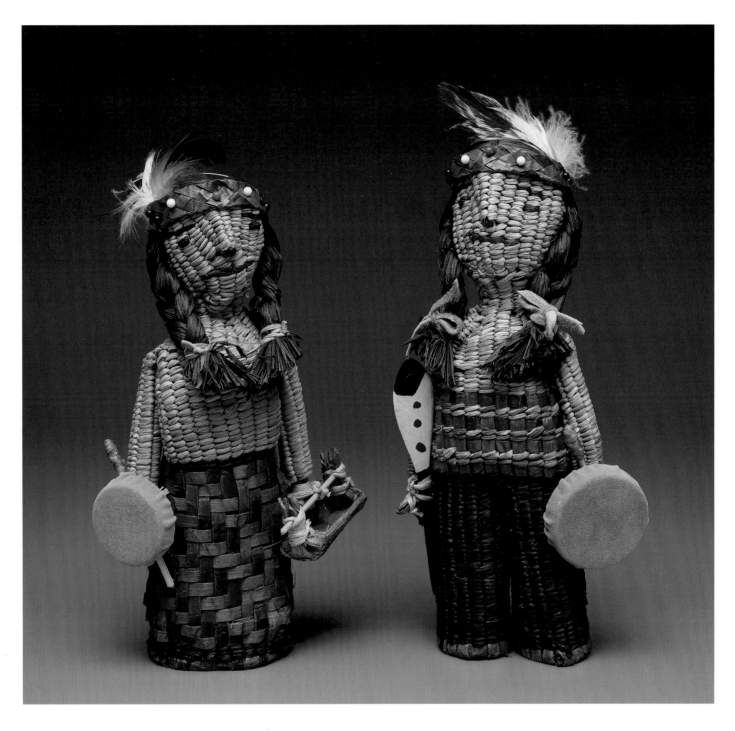

Figure 7.2
Dolls, attributed to Agnes James, Snohomish, ca. 1960, cattail fiber, raffia, beads, thread, 8 in. (20.3 cm) height. Gift of Vi Hilbert in honor of the 75th anniversary of the Seattle Art Museum, SC2005.15.

Gifts of basketry are given to special female guests and might indicate a special friendship or relationship between the maker and the recipient. Cattail leaves were used for soft, twined baskets, mats, and dolls. The leaves of the cattail (*Typha latifolia*) were cut near the base from the shallow fresh water where they grew. They were hung to drain, then gutted by running the thumb down the center of the leaf, thus separating it from the outside leaf that was used as the weaving material (Thompson and Marr 1983:22).

173

Figure 7.3
Crouching figure, antler, 3.5 × 2 in. (8.9 × 5.1 cm). Found by Jim Wilbur, recovered in the Swinomish Channel in 1966. Courtesy of the Swinomish Indian Tribal Community.

Figure 7.4
Standing figure, antler, 4.2 × 1.8 × 0.4 in. (10.7 × 4.5 × 1.1 cm). Collected by A. Blukis Onat at the mouth of the north fork of the Skagit River, 1973. Courtesy of the Swinomish Indian Tribal Community.

that may be a skirt and that is separated from a garment on the upper body by a waistband. The marks at the neck (not present in the crouching figure), wrists, and ankles may also represent decorated garments or marks on the body. All, therefore, are composed of the same set of elements.

None of the figures has a clearly indicated gender. They all show arms that are upraised in a traditional gesture of thanking and acknowledgment, which is still commonly used today by Salish peoples. Guests who attend community events to support the work being done may repeatedly raise their arms in gestures of support, similar to what is seen on the figures. Thus, this honorific gesture would be appropriate for figures given as gifts of thanks.

174 Remembrance

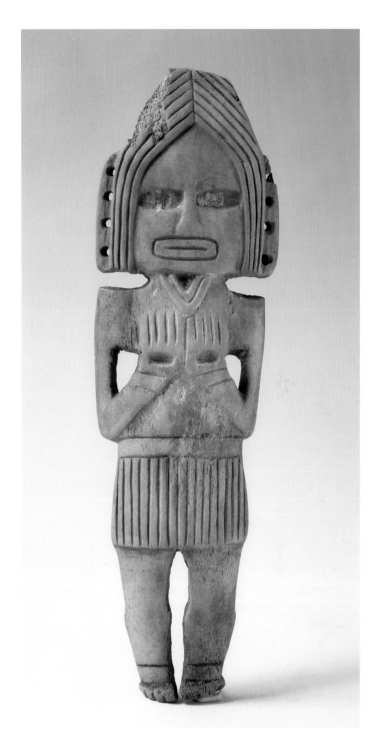

Figure 7.5
Figure, antler, 4³⁄₁₆ × 1¾ × ⁷⁄₁₆ in. (10.7 ×
4.5 × 1.1 cm); excavated by David A.
Munsell at Conway, Washington, 1969.
Courtesy of the Burke Museum of Natural
History and Culture, Seattle, 455K59A/00

Figure 7.6
Human figure, Sucia Island, AD pre-1200,
elk antler, 8¾ × 2¾ × ½ in. (22.5 × 7 ×
1.5 cm). Collected by E. Monk, ca. 1950.
Courtesy of the Burke Museum of Natural
History and Culture, Seattle, 2.5E603.

Differences among the figures are relative and include size, quality of carving, and degree of deterioration. The crouching figure is fully sculptural, having been carved on an antler tine rather than a flat piece of antler, as are the others. Evidence of paint, inlay, or other applied decoration is not present on the figure. All the standing figures are carved on flat pieces of antler. Of the two smaller standing figures, the one from xwceda'b is the most crudely carved and is the most fragmentary. The figure from skwkiwikwab appears to be more skillfully carved and has holes at the head for insertion of other decoration or for suspension. It is not as fine as the standing figure from Sucia Island. This figure stands out because of its much larger size and its finessed carving. It is unique in having ovoid elements carved at the wrists (reminiscent of northern Northwest Coast style) and has remnants of shell inlay in the eyes. Around the head are holes that once contained embellishments.

The Figures in Cultural Context

Because of their shared design, I have suggested that the four figures are remembrances of a specific event and were made to denote a particular theme. Based on information from oral history, I suggest that the event was held at tʷi'wúc or possibly at another location nearby. The tʷi'wúc settlement was the home of two treaty signers and the home of four brothers who founded the ancestral family of the Swinomish a long time ago (Snyder 1953–55: BD 36–37). The "real" Swinomish lived at xwiwuc (tʷi'wúc) as they had since the time of the mythic flood, a time that signifies the origin of the people and their land (Snyder 1953–55: AJ 41, 82–83). The tʷi'wúc settlement has deep roots as a location having important persons in residence.

The tʷi'wúc settlement included several residential houses as well as at least one large house (Waterman 1920s: 21). Such large houses (called longhouses or smokehouses) served as guest quarters for visitors, as well as being places where community events took place. The boundary of tʷi'wúc is the area that the residents of the Swinomish Reservation refer to as the "village." Most of the original tʷi'wúc structures were burned down after an epidemic in the mid-1800s. Archaeological deposits underlie the village area. These deposits have been altered in places because it continues to be a residential community. The Swinomish Indian Tribal Community Reservation continues to serve as one of the centers for traditional practices in the Skagit area. The present-day smokehouse is adjacent to the boundaries of the old tʷi'wúc village.

The crouching figure from tʷi'wúc was recovered from the central area of the old village. It is not possible to determine if it was inadvertently discarded or if it had been stored. In any case, it is in very good condition and was found adjacent to an area within the site where there is undisturbed evidence of house structures. The crouched position of the figure is suggestive of dance movements performed in winter smokehouse *siown* gatherings, and the item may have been given to a guest who was a *siown* spirit dancer.

The two smaller standing figures were found at archaeological sites within a ten-mile radius of tʷi'wúc and within a one-day canoe journey. Both figures were broken when

found, although the figure from skwikwikwab was recovered in its entirety. It was found in a shell midden that served as a shellfish and fish processing area on top of a hill above a settlement having established structures. The figure from xceda'b (fig. 7.4) is from a shell midden located well inland along a slough on the Skagit delta. This location also had evidence of structures. There is no specific evidence that the figures were stored or placed deliberately; however, the figures may have been discarded because they were broken. The largest of the standing figures was found in a sheltered location described as a cave. It is intact and may have been purposely placed, although the circumstances of the discovery are not known. It has been suggested that this figure may have been suspended on the chest and that such figures were used in shamanic practices (Carlson 1983a: 201). However, given its structure and decorative elements, the figure is better suited as a gift, no doubt for an important guest. Sucia Island is some distance from the Skagit delta but is well within the sphere of interaction among Salish-speaking groups.

The three standing figures may have been presented to individuals who were publicly acknowledged for their support—material and spiritual—at the event. The fact that the most elaborate of the figures was found some distance from the others corresponds to the practice of specially honoring guests who have come from far away. Ideally, more such figures will be found that could shed light on the conclusions put forth in this essay.

Finds of additional figures may support or negate the hypothesis presented here. Other figures that are superficially similar to the figures described here are a skeletalized figure from the Columbia River area (Holm 1983: 36, 1990: 622–23), an elaborately carved figure from the Yakima Valley of central Washington (Ames and Maschner 1990: 244–45), an obviously female figure found near Victoria, Vancouver Isla nd (Keddie 1987), and a much larger figure pendant from Kwatna on the central British Columbia coast (Carlson 1983: 124). These figures may have had a similar function to those described herein, however, they would more likely represent somewhat different regional expressions of the gifting tradition and may serve as remembrances of different events.

Additional assessment of other standing figures carved in antler and of other objects with decorative elements in collections from other archaeological sites is needed. It would be most useful if the assessment was done in the context of the gifting traditions of the Salish area.

Acknowledgment

It has been my fortune that several Swinomish Indian Tribal Community elders, as well as elders from other communities, invited me into their family and community gatherings. I especially want to acknowledge the following elders who taught me how to look: Laura Wilbur, Laura Edwards, Aurelia Stone, Maxine Williams, Edith Bedal, and Jean Bedal Fish. Four younger tribal members and friends helped me understand what the elders were teaching: Lona Wilbur, Norma Joseph, Nancy Decoteau, and Randy Lewis.

Note

1. The Swinomish Reservation was established as a place to which several tribal groups were moved in the late 1800s. The reservation is at a major settlement area of the aboriginal Swinomish; however, the Skwadabs, Lower Skagit, Kikiallus, and Samish people also were settled there as they were removed from their traditional homelands. These named groups comprise the people who lived in the Skagit River drainage. The Samish now have their own reservation, created after they were federally recognized as a separate entity in 1996.

WHEN WE LOOK AT AN OBJECT made by another culture, such as a basket, we look at it through the lens of our own culture. In that process, a basket might be seen only as a functional or utilitarian object because the viewers make an assumption about what they are seeing. In doing so, they close their eyes to another world of knowledge and experience. For many Coast Salish people, baskets are more than just containers for food, tools, and other types of belongings; they contain and carry forward memories and identities about who we are as people. They are not just functional objects, but are ones that carry everyday reminders of our grandparents and ancestors, their spiritual gifts and individual creativity.

Because coiled cedar-root baskets are abundant in many Salish collections in Canada and the United States, we might assume that traditionally all Salish women were basket

Symbols of Identity, Containers for Knowledge and Memories

Sharon Fortney

makers. In the case of coiled cedar-root basketry, however, this does not appear to be true. Early research on coiled basketry in British Columbia found that many Interior Salish women from the Lower Thompson area were basket makers, but in other areas of the province this was not the case (Haeberlin, Teit, and Roberts 1928: 143–45). These differences were initially attributed to diffusion—the gradual movement of coiled basketry, perhaps over thousands of years, from Interior Salish communities to their Coast Salish neighbors to the west and south. This hypothesis may hold some truth, but the reasons are likely much more complex.

Differing environments, and thereby resource bases, led to a level of cultural complexity on the coast that distinguished the lifeways of the Coast Salish from those of their relatives on the plateau. Ongoing trade, marriages, and other forms of social exchange between these two regions reflect the strength of long-standing relationships and the paths by which knowledge continues to be exchanged. Our shared identities as "Salish" peoples reflect the influence of linguists who traced the many constituent

Figure 8.1
Basket, Cowichan (Quw'utsun'), early twentieth century, red cedar, cherry bark, dye, grass, hide, 12 × 21 × 18 in. (30.5 × 53.3 × 45.7 cm). Vancouver Museum, Canada, AA1953.

This unique storage basket, collected early in the twentieth century, was made to fit into the bow of a canoe. The fitted lid would have protected the owner's belongings while they were traveling on the water. Bark from the western red cedar (*Thuja plicata*) was a mainstay of basket makers all over the coast. The weaver would select a young tree with few low branches and make a cut about three feet from the base and about one-fourth the circumference of the tree. The loosened bottom section is firmly pulled upward and outward, with care taken to get an even strip of up to thirty feet long (Turner 1998: 77). The outer bark is separated from the inner bark, which is leathery until dried and ready for weaving.

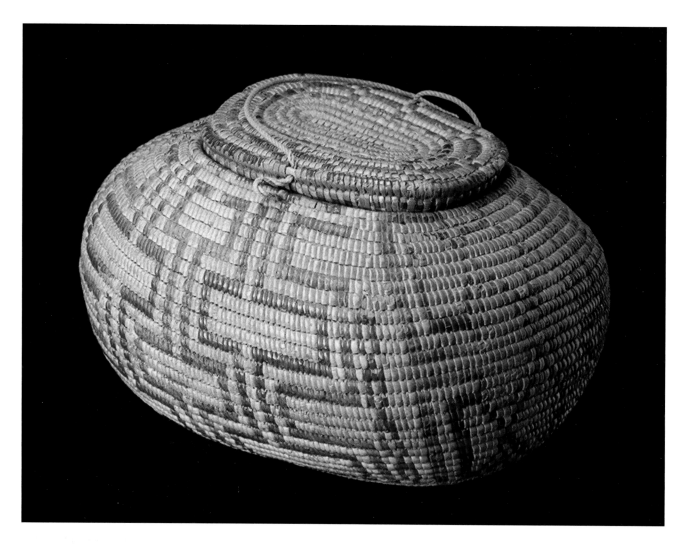

Figure 8.2
Basket, Saanich (?), late nineteenth century, cedar root, 4⁵⁄₁₆ × 6⁵⁄₁₆ × 7⁷⁄₈ in. (10.9 × 16 × 20.1 cm). Royal British Columbia Museum, 16242.

This older style of basket has been referred to as nut-shaped. It has a design that is known as "meander" and "mouth." Traditionally, this type of basket would have been used for berry picking or for carrying a woman's basketry awl or her other work tools. Stylistically, it appears to have a strong Interior Salish influence.

languages of our two regional communities back more than 8,000 years to a common source language, which is sometimes referred to as Proto-Salish. Early in the twentieth century, scholars like Franz Boas believed the Coast Salish to be recent arrivals to the coast, but subsequent archaeological evidence did not support this hypothesis. The "linguistic evidence suggests, if anything, a Salishan movement from Coast to Interior" (Suttles 1987: 257). The artistic traditions of the Coast Salish are no longer viewed as borrowed traditions but as ones with long lineages that influenced communities up and down the Northwest Coast.

In the past, each Coast Salish community was composed of people of different social status. What differentiated the highest ranking of these individuals from their slaves, the lowest ranking of individuals, was the ability to own property (Carlson 1997: 89–91). This was intellectual property in the form of advice, shared by older family members, combined with access to key resource sites and, for some people, privileged ceremonial knowledge and the accompanying regalia. Advice, a restricted form of traditional knowledge, continues to be shared along family lines today and remains an important dynamic for understanding how Coast Salish communities function. In the book *Be of Good Mind,* Bruce G. Miller provides several examples of this phenomenon, including a case in which "a tribal basket-making project floundered because elders were unwilling to teach members of other families. From this viewpoint, tribes and bands can be thought of as being composed of competing families, whose members' loyalties lie more with families than with the political units that contain them" (2007: 19).

Today, most communities have left behind the class system that was still functioning early in the contact period, but the restrictions placed on sharing family-owned knowledge, or "advice," remain intact.

The production of ceremonial and status goods, such as weavings, was the knowledge of specialists—most commonly from high-ranking families. By contrast, slaves assisted with the tasks of daily living, such as the procurement and preparation of food resources. This enabled higher-ranking women to devote themselves to the production of prestige items and other forms of material wealth that would later be redistributed during winter ceremonials that fulfilled the responsibilities of the high ranking, while reconfirming the status of their entire household within their regional social sphere (see Elmendorf 1971; Donald 1997). Coiled baskets, although not as prestigious as weavings made from mountain-goat wool, were still highly esteemed gifts at the "give-aways" that accompanied many of these events (Wells 1962: 664; Johnson and Bernick 1986: 8).

Strategic marriages brought new knowledge and prerogatives to families, and for this reason high-ranking individuals trace their genealogies not just through time but also across space (see McHalsie 2001: 32–33). In British Columbia the distribution of coiled basketry, and sometimes specific basketry designs, follows the same types of patterns since those who carry the knowledge of coiled basketry tend to share their skills only

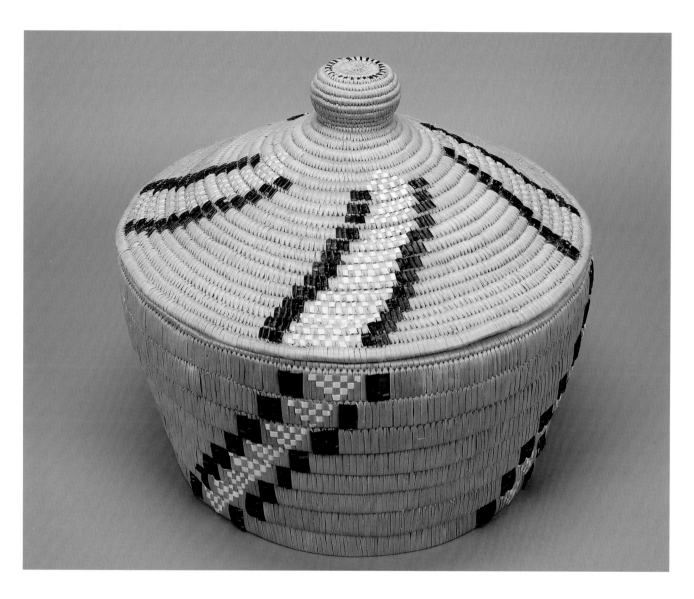

Figure 8.3
Basket, Rena Point Bolton, Skowkale (Stó:lō), 1993, cedar root, 12¹¹⁄₁₆ × 15⁵⁄₁₆ × 15⁵⁄₁₆ in. (32.3 × 38.9 × 38.9 cm). Museum of Anthropology, University of British Columbia, Nbz905 a-b.

Rena Point Bolton's contemporary coiled basket combines two distinctive types of coils. The lid was constructed on a cedar root foundation, producing rounded coils, while thin wooden slats were used for the body of the basket, creating coils with a wider and flatter appearance. Bolton is a highly regarded basket maker, weaver, and cultural activist.

with interested family members (Fortney 2001: 38). Rena Point Bolton, a Stó:lō basket maker from the community of Skowkale, explains:

> No, not everybody wants to make baskets. You know how it is. You can't force people to do something that they don't want to. It was the same in the old days. There were women who didn't particularly want to learn or there might be some women who would want to learn and then they were taught. But usually it was passed through women who already carried it and it was passed down to their daughters or their granddaughters. In our country here it was usually the hereditary carrier of the tribe who carried all the knowledge of these things, whether it was weaving or singing or dancing, or carrying the names. It came through her and then it was given to her family. Other families had their own means of carrying and if their parents didn't teach them then that's their problem. You can't force people to learn if they don't want to. (Fortney 2000: 21)

Just as different families have access to different types of advice, each basket-making family also has their own way of doing things. While cedar roots and decorative materials, such as wild cherry bark and cattail or canary grass, must be gathered in the spring and early summer months when the sap is running in the trees, each basket maker prepares their materials in a preferred way—usually the way they were taught by their relatives. Roots must be collected in areas without rocks that can cause kinks in them, but beyond that they may be split in different ways and are set aside to dry for different lengths of time.

Wendy Ritchie, daughter of Skowkale basket maker Rena Point Bolton, remarks upon the necessity of preparing your own materials:

> My mom told me that it's always best for you to get your own roots. Because you're the one that is going to put your sweat into it, you're the one that knows the type of roots that you like to work with. And if somebody else gets your roots for you, then it's not going to be the same as if you got them for yourself. And they're not going to be the quality that you like. And I totally understand where she's coming from because somebody gave me a bundle and they split them wrong, according to how I was taught, and I shouldn't even say wrong. They split them differently than how I was taught, so I have to use the whole bundle for filler. I couldn't use them for weaving. (Fortney 2000: 25)

However, beyond these practical constraints, individual creativity finds an outlet through the selection of designs, personal preferences for finishing touches, and the styles of baskets created.

Basket making flourished and many new styles of coiled basketry appeared between the years 1870 and 1920, with Coast Salish women from almost every household involved, even though the skill was not practiced by everyone previously (Gustafson 1980: 88). The gradual disappearance of internal class distinctions, combined with

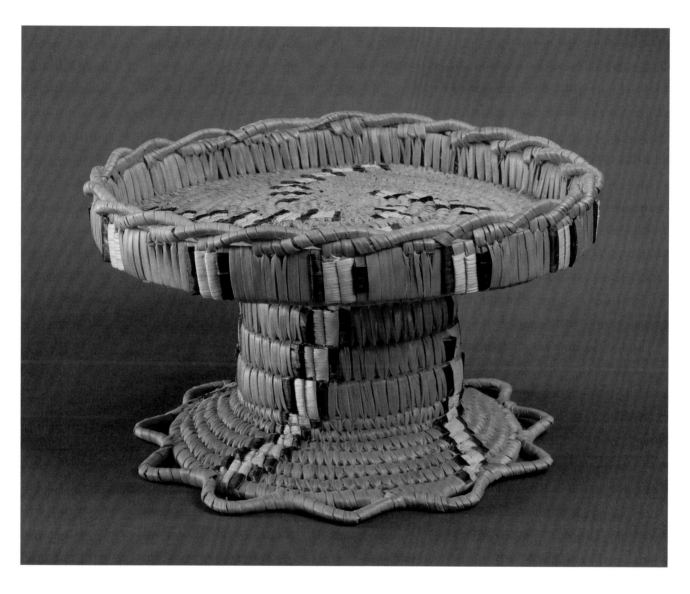

Figure 8.4
Pedestal basket, Mary-Jane Jackson, Sechelt (Shíshálh), mid-twentieth century, cedar root, cherry bark, corn husk, 9 × 6 in. (22.86 × 15.24 cm). Tems Swiya Museum, Sechelt Nation.

Baskets of unusual shapes and elaborate decoration allow basket makers to display their skills and creativity. Long popular with tourists, they also have a highly regarded place in aboriginal culture as favorite gifts between women on special occasions. Mary-Jane Jackson was a distinguished weaver of beautiful, but functional, baskets. Contrasting dark and light design elements create a vibrant pattern in her baskets: for the light material she used corn husks, a feature unique to Shíshálh basketry.

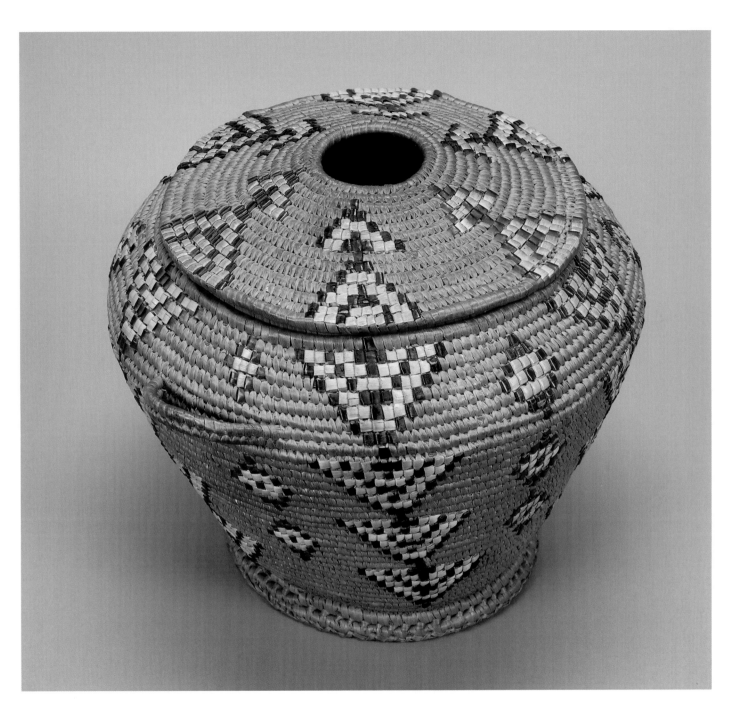

Figure 8.5
Knitting basket, Amy Cooper, Soowahlie (Stó:lō), before 1934, cedar root, cattail grass, cherry bark, 11¼ × 12½ × 12½ in. (28.6 × 31.8 × 31.8 cm). Museum of Anthropology, University of British Columbia, A1889 a-b.

This knitting basket, with an opening in the lid for yarn, was made by Amy Cooper of Soowahlie (Cultus Lake). It features a distinctive design—triangular motifs in contrasting light and dark colors—used by this basket maker on other documented examples of her work. It was collected by a missionary at the Coqualeetza Residential School in Sardis, British Columbia, and was made sometime in the early 1900s.

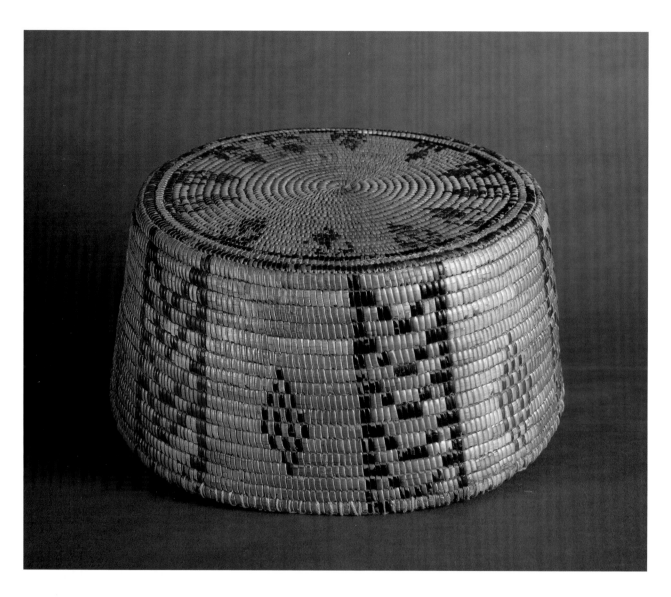

Figure 8.6
Basketry cake cover, Fraser River, early twentieth century, cedar root, bear grass, cherry bark, 12 × 6 × 6 in. (30.48 × 15.24 × 15.24 cm). Collection of Betty and Bob Stott.

This finely crafted piece is essentially an upside-down basket and would once have had a bottom to hold the cake or pastries. The vertical designs in alternating red and black colors—made by cherry bark and dyed cedar bark—are stately and provide a lovely counterpoint to the dynamic circular pattern on the basket's top. Cedar bark and bear grass would be submerged in mud for up to two weeks to produce a black-colored fiber (Thompson and Marr 1983: 25).

economic necessity and the influence of outside sources, such as missionaries and anthropologists (Hawthorne, Belshaw and Jamieson 1960; Johnson and Bernick 1986: 2), created an atmosphere where basket makers were encouraged to share their teachings more widely.

At this same time the Victorian Arts and Crafts movement provided an avid collector's market for American Indian basketry throughout North America. Steamship and railway tours capitalized on the trend by promoting Indian-made baskets as authentic souvenirs for tourists. Many collectors added to their collections as they journeyed by steamship along the coast from California on their way to Alaska (Ross 1994: 69–70; Lee 1999).

Throughout British Columbia, Coast Salish basket makers continued to support their families during the succeeding interwar years by using baskets as barter for much-needed items such as clothing and groceries. Nlaka'pamux / Stó:lō elder Minnie Peters recalls:

> I was about fifteen years old when my mother sent me to my great-grandmothers, great-great aunt I should say, and great-grandmother. And they took me up the mountain and I helped her dig the roots and she split them and she started me off on a basket. And she made me make a tray and then I had to take it to the store. This was in the thirties, you know, when there was no money. So she went and traded my basket for material and she cut it out and then I had to sew. She cut out my dress and I had to sew it by hand, and then if I didn't do it right she made me take it apart again. She made me just sit down until I got my basket made and that's the way I was taught how to get the materials for getting baskets. (Fortney 2000: 18)

Yamolot (Rosaleen George) of the Skwah Reserve, near Chilliwack, had a similar experience.

> That's why I had to learn to make baskets, because I had to earn my own clothes. Even I earned my own bed with basket weaving. A lady came to the house one day, and I said, "I'm busy picking up my blankets." She asked me what I was doing, and I told her, "I'm picking up my bed." "Oh, you don't have no bed," she says. "If you make me a shopping basket I'll let you have a bed," she says. I made her a shopping basket. (Fortney 2000: 18)

Yamolot was also one of half dozen girls at the Mission Residential School who were asked by nuns to demonstrate basketry to younger girls at the school. The baskets she made there were later picked up by her grandmother, who also supplied her materials. On several occasions, she remarked that this activity was encouraged by the nuns, who saw it as an economic opportunity for some of their students.

Economic opportunities also brought Coast Salish families from distant communities together at seasonal work sites such as canneries, hops yards, and cranberry bogs, where

trade in baskets would occur (Gunther 1927: 212–13). Travel to these locales also often included side trips to cities and towns, like Vancouver and New Westminster, where baskets could be sold or exchanged for much-needed items (Knight 1978: 156).

Whereas basket making became an economic necessity for many Coast Salish families during the early historic period, it went into a decline after the 1950s, when the situation once again reversed itself and fewer people continued to make baskets. Today, coiled basketry has been transformed from an economic activity into an artistic one. While most communities are home to one or more people who hold the knowledge and have the skill to make coiled baskets, few people do so on a regular basis.

There are a variety of reasons for this, ranging from lack of time due to the demands of modern life to the inability to access the required materials. Almost a decade ago, Stó:lō elders Ts'ats' elexwot (Elizabeth Herrling) and Yamolot (Rosaleen George) remarked that they seldom made baskets anymore because of the difficulty they had getting materials in the Chilliwack area. Since many of the larger cedar trees are located on private land, they feared the owners might charge them with trespassing (Fortney 2000: 19). My grandmother encountered the same problems on the Sunshine Coast at Powell River while visiting relatives in the late 1980s; in this instance, several elderly women from the community of Sliammon had resorted to buying their roots from local logging companies who salvaged them from uprooted trees. This solution was not ideal, however, as the quality of the roots varied and the expense associated with buying roots posed another difficulty for some elders. Today in British Columbia, it seems that the women who remain actively engaged in basket making tend to live in less urban areas and/or have younger family members nearby to assist with the gathering of materials.

Properties of Coiled Cedar-Root Basketry

Coiled basketry comes in a variety of shapes and sizes, ranging from small, tightly woven teacup shapes to large barrel- or hamper-shaped containers (see figs. 8.7, 8.8). The final appearance of a basket is also a reflection of the types of materials that go into its manufacture. Basket makers in British Columbia identify two or more varieties of coils. They are distinguished by the types of materials that are used as the foundation material and, in the Halkomelem language, by distinct names. Coiling, which involves the sewing of thin strips of cedar root by means of an awl, may be done over a foundation of cedar roots, usually pieces that did not split properly or are marred by flaws (such as "eyes"), or it may be done over thin strips of cedar sapling wood, which are sometimes referred to as slats. When the basket maker is skilled, the former practice results in small, tightly rounded coils, while the latter produces coils that have a flatter, more rectangular appearance.

Ts'ats' elexwot, who is from Seabird Island, differentiates between coiled-root baskets, called *ts'o'qw* or *susékw'*, and those made with cedar slats, which she identifies as *ts'emetel* (Fortney 2001: 16). Previous research on indigenous classification of coiled basketry among the Stó:lō demonstrated that specialized terminology was repeatedly

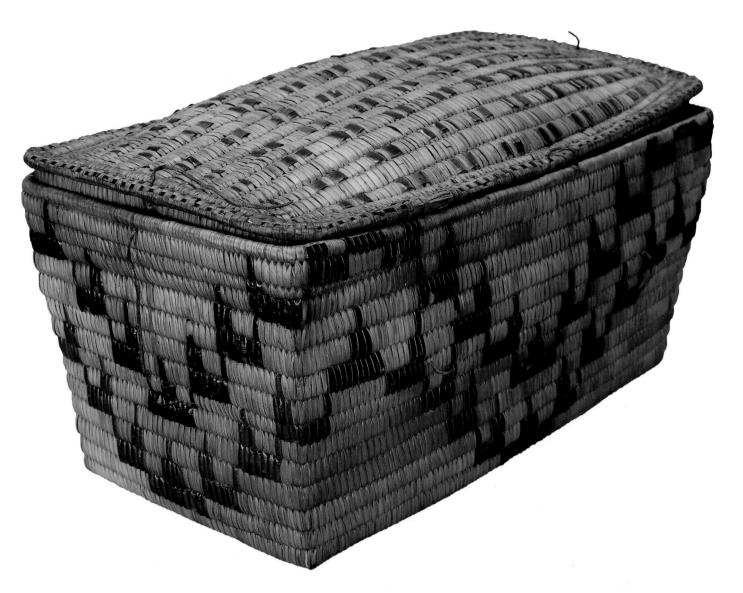

Figure 8.7
Lunch basket, Squamish, before 1885, cedar root, cherry bark, leather, dye, 9⅜ × 16½ × 9⅜ in. (24.4 × 41.9 × 23.9 cm). Museum of Anthropology, University of British Columbia, A3121 a–b.

The domed lid on this basket, collected at Squamish (Skxwúmish), British Columbia, suggests that it is an older style of basket. The collector's notes indicate that it was made prior to 1885.

used to describe components that could be manufactured using different methods, with different materials, or in separate stages, such as basket lids and bottoms (Fortney 2001: 20–21). An analysis of the Halkomelem terminology for basketry and its source materials suggested that the construction method, rather than function or appearance, is central to understanding the way Stó:lō basket makers classify their baskets. An apparent absence of terminology to describe decorative elements, such as imbrication or beading—done in conjunction with the coiling and without affecting the types of materials employed— seemed to support this assumption.

When we look at coiled basketry in a museum collection or a private home, we see that some Coast Salish basket makers combine techniques, by using one method of

Figure 8.8
Basket, Sliammon, early twentieth century, cedar root, cherry bark, straw, 10 × 20 in. (25.4 × 50.8 cm). Royal British Columbia Museum, 18328B.

The flat, fitted lid topping this storage basket, made during the early twentieth century at Sliammon, is more common to storage baskets made during the twentieth century. Styles in lid shape could change, and basket makers earlier in time typically chose inset and domed lids.

coiling for the bottom and another for the sides, or by using the smaller coils for finishing the rim and adding handles. Occasionally a basket maker will add pieces of root over the top of cedar slats before coiling, to create a softer, more rounded appearance in the former. These attributes, combined with preferences for different finishing techniques, such as the use of braided edges, loopwork, or overcast rims; the inclusion or absence of a foot on the base of the basket; different styles of handles and knobs; and preferences for certain shapes and designs are all hallmarks that speak to the signatures of specific basket makers and help to identify the work of specific individuals.

Just as each basket maker creates baskets that are uniquely their own, there are some styles of baskets that are distinctly Salish in origin. One traditional style of basket, not seen much today, is the water basket. Anthropologists Marian Smith and Dorothy Leadbeater once commented that "the Salish area is, so far as [we] know, the only one in which

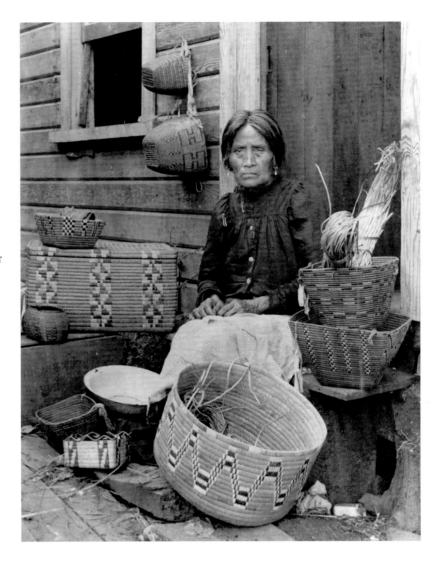

Figure 8.9
Sophie Frank, a member of the Squamish Nation and a resident of North Vancouver, with her coiled basketry. Vancouver Public Library, Special Collections, VPL 9414.

The fine, coiled baskets seen here, with rectangular bases and flaring sides, were the "work" baskets of aboriginal women, used for gathering and storing food and—in the case of the large "suitcase"—family possessions. Sophie Frank lived during a time when women greatly supported their households through the selling of basketry to outsiders: during the late nineteenth to the mid-twentieth century. Frank and Canadian artist and author Emily Carr had a lifelong friendship that was chronicled in Carr's writings.

water-tight baskets are manufactured. In other places, baskets are, almost by definition, objects incapable of holding water" (1949: 112). These tightly coiled baskets, made with cedar-root foundations, often achieved watertightness when soaked—although some basket makers also employed caulking materials such as mashed soapberries, heated cactus, or buds from the balsam poplar (Haeberlin, Teit, and Roberts 1928: 147). Ts'ats' elexwot also reports that interiors were sometimes treated with beeswax, collected from dormant beehives during winter months, to further enhance water retention (Fortney 2001: 18–19). These watertight baskets were used for cooking. Hot rocks from the fire would be placed inside the baskets to boil the water that was then used to prepare dried meats and other foods (Duff 1952: 74).

Basketry cradles are reported to be a recent addition to the repertoires of Salish basket makers, replacing the wooden cradleboards documented by early visitors such as artist Paul Kane, among others (Haeberlin, Teit, and Roberts 1928: 210; Hill-Tout 1978: 106) (see fig. 8.10). Anthropologists have reported that basketry cradles were virtually unknown in the adjacent areas of Vancouver Island and Puget Sound during the early portion of the twentieth century (Barnett 1955: 131–32; Haeberlin and Gunther 1930: 44), but today they are some of the most uniquely Salish basketry in many museum and private collections.

191

Figure 8.10
Basketry cradle, Fraser River, before 1950, cedar root, cedar slats, bear grass, cherry bark, leather, 22¾ × 10¾ × 5 in. (57.8 × 27.3 × 12.7 cm). Burke Museum of Natural History and Culture, Seattle, 1-907.

This basketry cradle was collected by anthropologist Erna Gunther along the Fraser River prior to 1950. Ornate decoration is common with cradles, where basket makers abandon their adherence to symmetry in favor of whimsy. In some communities the use of red decoration indicates a gift made for a beloved daughter or grand-daughter, while black is more commonly used for males.

While a sense of harmony or balance is desired in Coast Salish artistic expression, cradles are often an exception to the rule—the one place where a sense of whimsy may enter into the equation. In some communities, basket makers decorated cradles only on one side, since the other rested against the back of the mother and would not be seen. Pounded cedar bark was placed inside to keep infants dry, and some had urinals made from hollow wooden tubes that would drain out through an opening at the foot of the cradle. While some contemporary basket makers suggest that this was only common in cradles made for male children, the field notes of anthropologist Marian Smith suggest that these accessories may also have been employed for girls.

Coiled basketry is often part of a larger weaving skill-set for basket makers throughout the lower mainland of British Columbia. Many contemporary Stó:lō and Squamish basket makers also identify themselves as weavers of wool and cedar bark, or as practitioners of other textile arts such as knitting and crocheting (Fortney 2001: 27). Anthropologist June McCormick Collins has noted the same pairing of coiled basketry and weaving among the Upper Skagit of western Washington (1974: 71). Some basket makers employ the same designs and motifs on both their coiled baskets and their other textile works—an intrinsic signature to identify them as the artist.

Coming of Age: The Transmission of Knowledge

Traditionally, a girl's first coiled basket, as with any type of weaving in general, was given away or burned as a gift to the spirit world. This practice continues in many communities today, since it ensures that the basket maker will be productive and generous with her work, not stingy. It is also a means to show respect for a spiritual gift, since many women have spirit helpers that give them assistance with special skills, such as weaving and basketry (Barnett 1955: 150–51; Jenness 1955: 50; Snyder 1964: 282–83; Amoss 1978: 162; Bierwert 1999: 167).

Today, many women (and some men) learn the skill of coiled basketry as young adults or later in life. It has been suggested that, in the past, basket makers learned coiled basketry during their first menses when they went into seclusion (Jenness 1955: 80; Hill-Tout 1978: 104). Old Pierre of Katzie reported that once a girl began menstruating she underwent a four-day period of seclusion, followed by a ceremony on the fourth day at which two priests:

> danced and rubbed the girl, each time with a different bunch of ferns. They then offered her various kinds of food, from which she bit off morsels to throw away in the woods as offerings, just as was customary with boys. But when she carried her morsels of food to the woods, she carried also fragments of mats, baskets, blankets and other objects that she would make in later life, and she hung these fragments on trees, praying to Him Who Dwells Above to grant her skills in mat-making and in the weaving of baskets and blankets. (Jenness 1955: 80)

It seems unlikely that there was a definitive time when all girls learned the skills of basketry and weaving, since traditional methods of teaching involved learning through observation; as different families have their own way of doing things, there can be no standard account. Traditionally, those girls destined to be basket makers would have been exposed to the work of their mothers and other female relatives long before they underwent their period of seclusion.

My grandmother, the late Maryanne Pollner, a member of the Klahoose band, learned basket making from her mother before she went to school—when she was only five or six years old. Several elders from the areas of Upper Squamish and the Fraser Valley have reported learning prior to adolescence, many by age nine or ten; while their children and grandchildren were more commonly adults when they learned (Fortney 2000: 23). Contemporary basket makers indicate that a great deal of individual choice is now involved in the decision to begin learning this skill. Basket makers are taught when they demonstrate an interest.

In this essay I have frequently referred to basket makers as women, although I have tried to use more neutral language when possible. Today, not all basket makers are women, nor does this seem to have been the case in the past. While references to men weaving fish traps and other similar items are made in some of the ethnographic literature (Barnett 1955), several Stó:lō basket makers have recalled older male relatives and

spouses who were skilled basket makers in their own right. In these instances, the men either took up the skill after being afflicted with a work-related injury that prevented them from venturing far from home, or began making baskets in their retirement years as a hobby. Since the skill can require a lot of upper body strength, it is considered by some to be well suited to men.

How Basket Makers Judge a Well-Made Basket

Early investigations into coiled basketry in British Columbia found that basket makers from different regions had distinctive ideas as to what constituted a well-made basket (Haeberlin, Teit, and Roberts 1928) and that some designs and their variants had different names in different regions (Farrand 1900: 392–95). Basket making was, and continues to be, very individualistic, in that basket makers exercise personal preferences when it comes to size and shape. The final product, however, is also influenced by community standards and the techniques employed.

Another characteristic that coiled baskets share with other forms of Salish weaving, including the knitted Indian sweaters, is a sense of balance and symmetry (see the essay by Crisca Bierwert in this volume). While basket making can be a spontaneous and fluid event, it is also one in which the basket maker usually knows what the end product will be before she (or he) has even begun. Basket makers work from a mental template that is regulated by a cultural sense of aesthetics, further defined by family traditions, and then influenced by personal preference. Similar reports have been made about Pomo basket makers from California and other "Indian" artists (Boas 1927; Sarris 1993).

Although the final form of a basket is to some degree controlled by the materials used and the aforementioned cultural values pertaining to aesthetics, the basket maker must also be able to improvise to achieve the desired effect. Stó:lō weaver Rena Point Bolton notes:

> I just go by how I feel. I imagine the basket that I'm going to make and I make the bottom and then from there I decide what it is. If it's a round basket it's a little easier, but if it's a square basket or an oval basket then you have to figure it out. I have to put two designs on the sides, one on each end, so you're always mentally conjuring up what it's going to look like, and then if the design that you started out with doesn't quite fit, then you have to fill in with something else. If there's too much of a gap there, if it doesn't balance or something, then you have to fill in so that the basket looks balanced. You don't want to clutter it up much, but you don't want it to be too empty either. Everything must balance. This is the nature of Salish weaving: everything has to balance, even the rugs, the sweaters, everything. If you were taught properly, designs must always balance, and they must mirror each other no matter which way. So you have to be creative. You have to be able to improvise. (Fortney 2001: 31)

Bolton further suggests that this ability to "improvise" is especially important when working with the wider slat baskets, since the basket maker is required to build up the design using fewer rows of coils. She notes that Stó:lō basket makers often compensate by using several strips of bark or grass within one row to achieve the same complexity of design when decorating their cedar-slat baskets, a technique referred to as beading. Thus the basket maker must know ahead of time what the final product will be, and what type of space requirements are demanded to achieve it, yet must be able to compensate if they have judged incorrectly. An empty space will be corrected by the addition of balanced sets of smaller design elements or fillers. Similarly, a design that is too large or too small for a basket will be modified to fit the available space.

The balance and symmetry of designs are important attributes, but basket makers also judge the skill of a basket maker by the regularity of the coils and the appearance of the roots and decorative elements used in construction. Franz Boas discusses the former of these attributes in the opening pages of *Primitive Art,* where he states:

Figure 8.11
Basket, red cedar bark, cherry bark, 7 × 9 × 9 in. (17.8 × 22.9 × 22.9 cm); collected in 1928. Canadian Museum of Civilization, VII-G-217.

This cylindrical basket has a "beaded" design, a term that refers to a decorative method whereby strips of colored barks or grasses are threaded over and under the basketry coils, creating a flat, ribbonlike appearance. This is an alternative to the use of "imbrication," in which decorative materials are folded into the coils as they are sewn.

In the household of the natives we do not find slovenly work, except when a rapid makeshift has to be made. Patience and careful execution characterise most of their products. Direct questioning of natives and their own criticism of their own work shows also their appreciation of technical perfection. Virtuosity, complete control of technical processes, however, means an automatic regularity of movement. The basketmaker who manufactures a coiled basket, handles the fibers composing the coil in such a way that the greatest evenness of coil diameter results. (1927: 19–20)

Boas further suggests that this practiced skill produces aesthetic pleasure in the basket maker, and the viewer, and thus becomes the foundation of "art." His observations on the attributes of Native basketry remain valid for contemporary discussions on this topic. During visits to the Museum of Anthropology at the University of British Columbia in July 2000, Stó:lō and Squamish basket makers repeatedly identified baskets with uneven and irregular-shaped coils as being typical of the work of beginners.

A second element that determined the quality of the work was the roots that went into construction. An experienced basket maker knows that wood shrinks and so will dry the roots for six months, or even a year, to allow for maximum shrinkage before making a basket. The amount of time that roots are set aside to dry varies depending on the basket maker, since each family has its own ways of doing things and some individuals exercise personal preference as they become more experienced.

However, if the roots used for constructing a basket have not dried for a sufficient length of time, gaps will appear in the basket as it ages and the materials within the coils will become visible. Similarly, if a basket maker has not taken care in preparing the materials used for imbricating the surface and they are uneven in thickness, they will split and break. This can often be seen when one looks at baskets with improperly prepared canary grass, the material that is most commonly used for white design elements in the Fraser River area. Similarly, if the bitter cherry bark that is used for the red and black design elements is not scraped properly, the bark will be uneven in color and a grayish sheen will mar its surface. The surface will remain mottled with darker and lighter areas even if the bark has been dyed black.

Although what I am describing sounds very obvious, it takes an experienced basket maker to notice all of these fine details and qualities. To the inexperienced eye, such things might be attributed to age or to damage incurred during the life of the object. This attention to detail, which is characteristic of the work of Salish basket makers in general, has long been a source of wonder to researchers. In *Coiled Basketry in British Columbia and Surrounding Region*, it was suggested that:

It would not be surprising if something were temporarily overlooked and mistakes occurred which were observed only when it was too late to remedy them. In fact, it is amazing that the general character of the whole product is so perfect,

the stitches so even, the coils so uniform, the colors so well blended, and the designs so well adapted and spaced. (Haeberlin, Teit, and Roberts 1928: 258)

Thus Salish coiled baskets are distinctive not only for the care that is taken in executing the designs, but also for preparation of materials.

Experienced basket makers can also identify the materials used for the decorative elements on the baskets of others. Stó:lō weaver Wendy Ritchie reported that red cherry bark is differentiated from red cedar bark by the niches that mar the surface of the cherry bark. Anna Billy, a Lil'wat basket maker from Mount Currie who married into the Upper Squamish, with family connections to the Stó:lō community of Cheam, noted that canary grass can be differentiated from cattail grass since canary grass is shiny and cattail is not; while Stó:lō elder Yamolot differentiated between yellow and white canary grass, stating that "to keep it white it has to be dried in the shade, and [that] keeps it white and shiny" (Fortney 2001).

Conclusion

In this essay I have tried to avoid describing the stylistic attributes of coiled basketry in too much detail, since they are observable to those who look closely. Instead, I have tried to provide the reader with some of the cultural context from which this beautiful basketry derives. First and foremost, I have tried to situate it as a family tradition—one that crosses borders, reaching into many communities. Designs and techniques travel with people as they move between communities for reasons of marriage or economic advantage.

My discussion is largely informed by personal encounters with basket makers in a variety of settings—my grandmother's kitchen in Nanaimo, reservations throughout the Fraser River Valley, museum storage areas in the Vancouver area, and basketry work-shops and conferences. I have featured the specific words of a few of these basket makers in this chapter, but what appears is derived from all of these encounters. Thank you to everyone for sharing.

AMONG THE COAST SALISH PEOPLES, basket making is a well-respected activity and a vital form of artistic expression. In traditional times, most women learned the basic elements of how to construct a basket, but only a few became specialists in the art. These women sought training from mentors at an early age and devoted hours to learning the fine points of weaving techniques, materials preparation, and design composition. The creation of a basket also drew upon spiritual powers in a manner similar to male activities such as canoe carving or hunting (Haeberlin and Gunther 1930: 71). Those seeking spiritual powers went to a place far removed from other humans, such as an isolated lake or mountaintop, for this purpose. Women were the principal basket makers, although a few men did take up the art. The southern Puget Sound Salish associated basket making with Crow, who was thought to have been an expert in the myth

Objects of Function and Beauty
Basketry of the Southern Coast Salish

Carolyn J. Marr

period; when the world changed to its current state, Crow's baskets were turned into clamshells, which is why the shells have beautiful patterns (Waterman 1973: 18).

Early observers of the Coast Salish noted that their baskets showed both a mastery of design and a diversity of techniques. In 1904, Otis Tufton Mason published a report to the Smithsonian's United States National Museum that attempted to describe and classify the basket-making arts of over one thousand Native American groups. Within this seminal volume, Mason makes particular mention of the Salishan groups of the Pacific Northwest, remarking that their basketry is among the most diversified of any that he observed. Salish basketry shows a phenomenal variety of types and represents all the major techniques of twining, plaiting, and coiling (Mason 1904: 421). He attributes this diversity to the geographic spread of the Salish and also to their proximity to several other linguistic families.

While the Coast Salish division is not as extensive geographically as the entire Salishan Family, it does encompass a large area with distinctive environments. From the rugged coastline of the Pacific Ocean the land rises to mountains and then plunges into

198

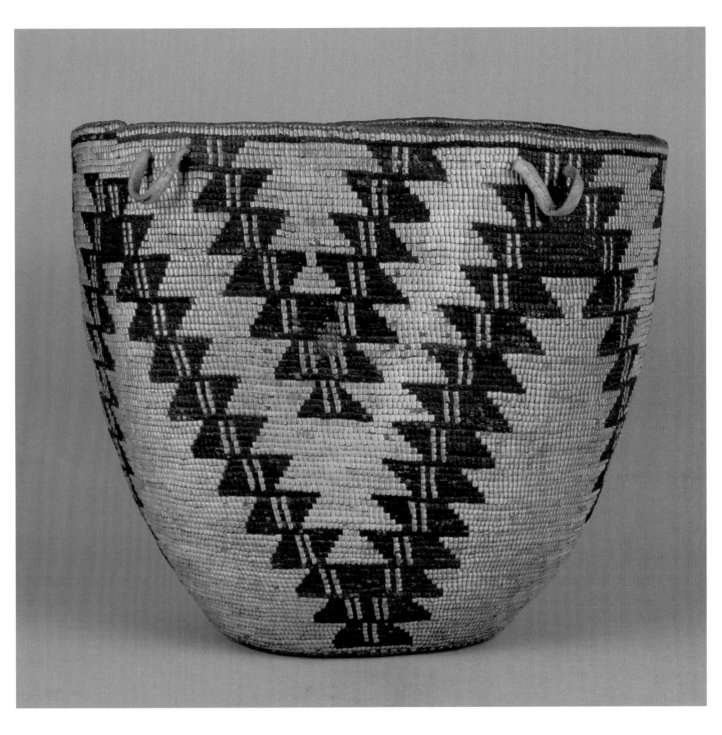

Figure 9.1
Kwalhiokwa basket, by the mother of Yuckton, before 1899, cedar root, bear grass, horsetail root, 14¾ × 17½ × 13¼ in. (37.46 × 44.45 × 33.52 cm). Burke Museum of Natural History and Culture, Seattle, 1998-30/1.

This basket was collected by Judge James Wickersham in 1899 on the Puyallup Reservation. It was made by the mother of Yuckton, an elder of the Kwalhiokwa (Qualhioqua) people of Pe Ell Prairie in western Washington (near Chehalis). Nothing is known of this artist except that her son was a knowledgeable linguist who provided data to George Gibbs and Wickersham. Judge Wickersham lived in Washington Territory from 1883 to 1898 and was a probate judge, city attorney for Tacoma, and a member of the state House of Representatives before moving to Alaska, where he had a successful political career. He was also an amateur ethnologist and collected and catalogued a sizable Native basket collection.

Figure 9.2
Basketry techniques:
twining and overlay.
Drawing by Kenneth
Greg Watson, 2008.

Figure 9.3
Basketry techniques:
plaiting. Drawing by
Kenneth Greg Watson,
2008.

Figure 9.4
Basketry techniques:
coiling and imbrication.
Drawing by Kenneth
Greg Watson, 2008.

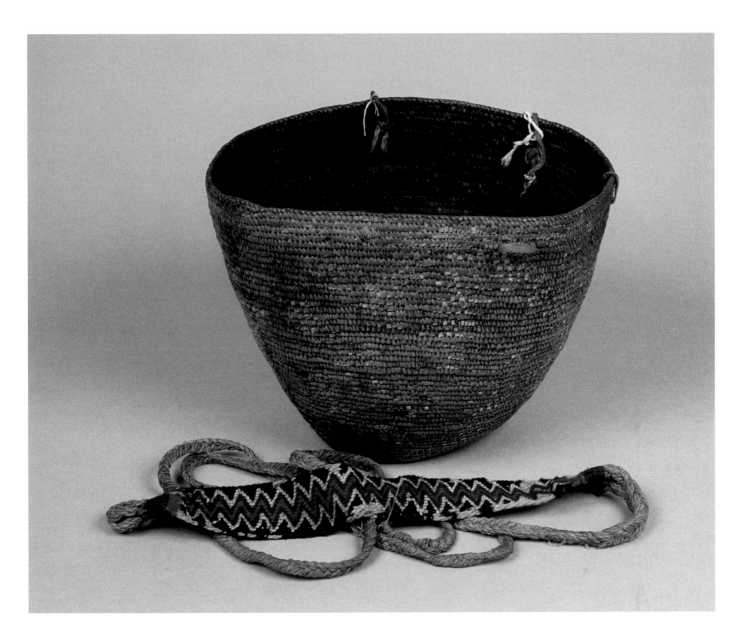

Figure 9.5
Basket and tumpline,
Cowlitz, 1904–28; tumpline:
wool, twine, 124 × 2½ in.
(304 × 1.5 cm); basket:
cedar root, bear grass, 11 ×
15 × 10 in. (27.94 × 38.1 ×
25.4 cm). Burke Museum of
Natural History and Culture,
Seattle, 1-11359.

sheltered water passages and lush river valleys. Farther eastward are steeper mountains with glaciers that feed countless freshwater lakes and streams.

Coast Salish groups living along the shores of saltwater and inland waterways relied on fishing and shellfish gathering for most of their food. In this environment, twined baskets were essential. Open twined containers provided drainage for clams, mussels, small fish, seaweed, and other saltwater resources. They also helped prevent mold and insect infestation when used for food storage. Tightly twined soft baskets were used to store household goods such as clothing and blankets. Since most travel was by canoe, baskets were used for carrying a variety of items during travels over the water (see fig. 8.1).

Coast Salish groups upriver in the foothills of the Cascade and Coastal ranges exploited a somewhat different environment. While fishing was still very important, there was more reliance on plant resources such as edible roots and berries. Tightly coiled baskets allowed them to transport berries over long distances, packing them on their backs by means of a tumpline (fig. 9.5). The sturdy cedar-root construction of these baskets helped to preserve the berries until they could be dried or eaten. Coiled baskets are also watertight, so they were used as both water carriers and cooking vessels.

The fact that twined and coiled baskets served different purposes does not mean that there was no overlap between these general types of baskets. In fact, by historic times nearly all groups made both twined and coiled baskets. Coastal peoples traveled to mountain areas to pick berries and thus had need of coiled baskets. Similarly, upriver peoples journeyed to the salt water for resources requiring twined baskets. Extensive trade networks existed throughout the Coast Salish area, and baskets were traded over long distances. Also, basket makers married outside of their own group and carried their particular skills with them.

Archaeological Evidence for Basketry in Coast Salish Territory

Archaeological evidence from the Columbia River area indicates that by 9,000 years ago, salmon had become the fundamental food resource for peoples of the Pacific Northwest (Kirk and Daugherty 1978: 45). A sophisticated fishing technology developed over time, with various kinds of nets, traps, and weirs constructed from cedar branches and roots with wrappings of bark. Twined basketry is closely related to the fishing economy, and the same techniques used to make an open-weave basket were used to fashion fish weirs, screens for fish traps, and drying racks (Smith 1940: 299). Fragments of twined baskets are commonly found at archaeological sites within the Coast Salish area (fig. 9.6). Because of the perishable nature of fibers, basketry is preserved mainly in waterlogged sites (Croes 1977; Bernick 1998). Excavation at these "wet sites" is executed with high-pressure hoses, which remove the fine sand and dirt particles. The plant fibers remain intact, and the color of these fibers is as bright as if they had just been removed from the plant. Deterioration takes place immediately, however; once removed from the wet medium that it has been buried in for hundreds or thousands of years, a basket must be stabilized in a solution of polyethylene glycol (Croes 1977).

Recent research at the southern Puget Sound site of Qʷuʔgʷəs (see map, page xix) at Mud Bay (near Olympia, Washington) links the basketry fragments found there to other wet sites such as Biederbost, Conway, Fishtown, and Musqueam NE. The time depth of this group of sites ranges from around 3,000 BP at Musqueam NE to the more recent Qʷuʔgʷəs, which has been dated to AD 200 to 500, with a probable end date of the later half of the seventeenth century (Croes, Kelly, and Collard 2005: 141–54). Archaeological evidence supports the theory that basketry of the twined variety has a long and continuous history in this area. Variations in technique, such as the direction of twining or the spacing of the wefts, exist just as they do in more modern examples. Kathryn Bernick has described in detail the weaving techniques and materials used by the ancient basket makers of southern British Columbia and northwestern Washington (Bernick 1998: 139–54). In wrapped twining, for example, the variety of techniques supports the theory that although Coast Salish basketry fits within a general Northwest Coast category, many details of construction and style did change over time.

The technique of constructing a coiled basket may have been introduced into the Coast Salish area through contact with Plateau peoples on the eastern side of the Cascade

Figure 9.6
Waterlogged basket excavated at
Qʷuʔgʷəs site at Mud Bay, near Olympia,
Washington, in 2007. Squaxin Island Tribe.

This image is a close-up of an ancient clam basket that was woven of split cedar boughs for the warp and split cedar root for the weft. This basket was found flat, in a three-foot-by-three-foot area, at the bottom of the Qʷuʔgʷəs site. It dates to 700 BP and is of a unique ancient Salish type. According to Squaxin elders, the contrasting dark and light decoration, made by using some splint boughs with bark left on for dark color, indicates which family owned the basket (see Gantenbein 2007–8).

Mountains. It is difficult to date the introduction of coiled basketry because so few examples are preserved in archaeological sites. One fragment of coiled basketry consisting of two stitches on a bundled coil was found at the Fishtown site on the Lower Skagit River (near Sedro-Woolley, Washington), dated at about seven hundred years ago (Croes 1977: 95–96). Coiling has not been found at older wet sites that contain many examples of twined work. A few ethnographic accounts mention that coiled basketry was learned from groups like the Cowlitz of southern Puget Sound, who had frequent interaction with groups in the Plateau areas. Native consultant Peter Heck related that the Chehalis learned coiled basket making from the Cowlitz (Adamson 1926: 9). The Straits Salish obtained coiled baskets through trade, according to a Lummi woman (Suttles 1950: 242). She said that baskets with a rectangular shape came from the Fraser River (see figs. 8.7 and 8.8), and those with a round form came from the Skagit. In both cases, when used for cooking or water carrying, the baskets substituted for locally made wooden vessels.

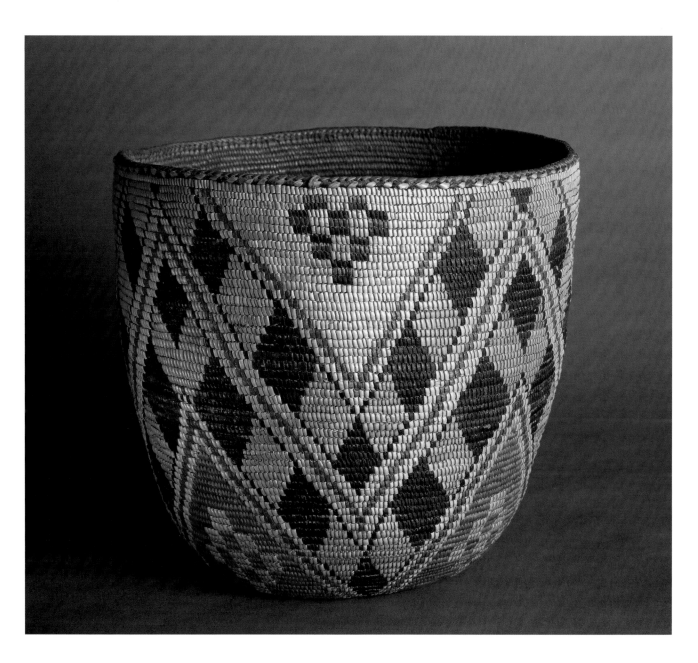

Figure 9.7
Basket, Cowlitz, ca. 1890, cedar root, bear grass, horsetail root, 12 × 13.5 in. (30.48 × 34.29 cm). Allan and Gloria Lobb Collection.

A masterpiece of form and surface decoration, this basket was collected by Judge James Wickersham at Mud Bay in 1899. The original collector's tag says that it was made at Silver Creek at Upper Cowlitz and was purchased from Louis Yowalich.

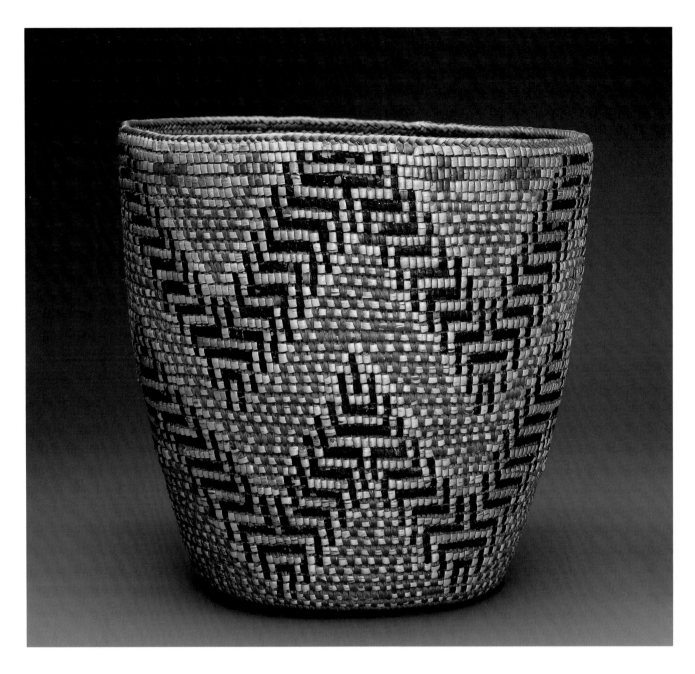

Figure 9.8
Basket, tsisdawš (Julia Anderson Meigs), Upper Skagit, late nineteenth or early twentieth century, cedar root, horsetail, bear grass, red huckleberry, 12 × 13 × 10 in. (30.5 × 33 × 25.4 cm). Gift of Vi Hilbert, in honor of the 75th anniversary of the Seattle Art Museum, 2005.176.

This sturdy cedar-root basket is a Vi Hilbert family heirloom and was made by her paternal aunt, tsisdawš, who was born in the 1860s or 1870s. Many generations of skilled weavers perfected this type of basket, which was a mainstay of domestic activities such as the collection and storage of food. With the advent of easily obtainable enamel and glass containers, coiled basketry continued to be made in diminutive sizes for the tourist market. Today, there are a small number of weavers working in the challenging form of coiled basketry.

Baskets from the U.S. Exploring Expedition

Some of the earliest dated examples of basketry from the Coast Salish area were collected in 1841 by the U.S. Exploring Expedition led by Lt. Charles Wilkes. By looking closely at these early pieces we can learn about regional specializations that existed at this early date (Marr 1984: 44–51). Although documentation regarding ethnographic materials is lacking, it is possible to draw some conclusions based on comparison with later examples and an understanding of the territory covered by the members of the party. The specimens collected on the expedition were transferred to the Patent Office in Washington, D.C., and one of the expedition members, Titian R. Peale, compiled an inventory of ethnographic items. In 1857, the collections became part of the newly established Smithsonian Institution.

The twenty-one baskets collected by the Wilkes expedition while in Coast Salish territory fall into four groups: (1) soft-twined baskets with overlay decoration, made by the Twana of Hood Canal; (2) stiff-twined baskets with overlay decoration, made by the Quinault; (3) coiled and imbricated baskets, made by the Cowlitz; and (4) wrapped twined baskets from the mouth of the Columbia River.

The largest specimen in the group is a Twana soft-twined basket (*tqayas*) that measures 15 inches high and 14 inches wide at the rim (fig. 9.9). This basket shows a mastery of technique and design that sets Twana basketry apart from other regional styles. The design, executed in overlay of cedar bark and bear grass (*Xerophyllum tenax*), shows dog figures in the rim design area and a design called starfish in the main field (Thompson and Marr 1983: 49). Twana baskets typically show this two-field arrangement, and the dogs or other animals along the rim are a hallmark of the style. The interior of the rim design on the Wilkes basket shows a reverse color pattern, which is done by using a full twist rather than a half twist with the overlay strand.

Only one Quinault basket was collected by the Wilkes expedition and it likely came from a group that traded with the Quinault, since the expedition ships did not stop along the Pacific coast north of Grays Harbor. This basket shows a distinctive style that continued until the 1930s. The warp and weft are of spruce root, finely twined to form a strong, waterproof container. This is in contrast to the Twana basket, where the warp and inner wefts are of flexible cattail. Decorative strands are, like those in the Twana pieces, made of bear grass that is overlaid on the foundation wefts. The Quinault basket shows a strong vertical design of light on dark.

An overland party led by Charles Wilkes journeyed from Fort Nisqually to Fort Vancouver on the Columbia River in June of 1841. They were accompanied by Plumondon, a French Canadian who founded Cowlitz Landing, an outpost of the Hudson's Bay Company. Plumondon was married to the daughter of a Cowlitz chief and he maintained friendly relations with the Native peoples in this area. It is likely that the three coiled baskets in the Wilkes collection were obtained from the Cowlitz on this trip.

Perhaps the most intriguing Cowlitz basket is a relatively small piece (7.4 inches long and 4.3 inches high) with a distinctive oval shape (fig. 9.10). It shows complete

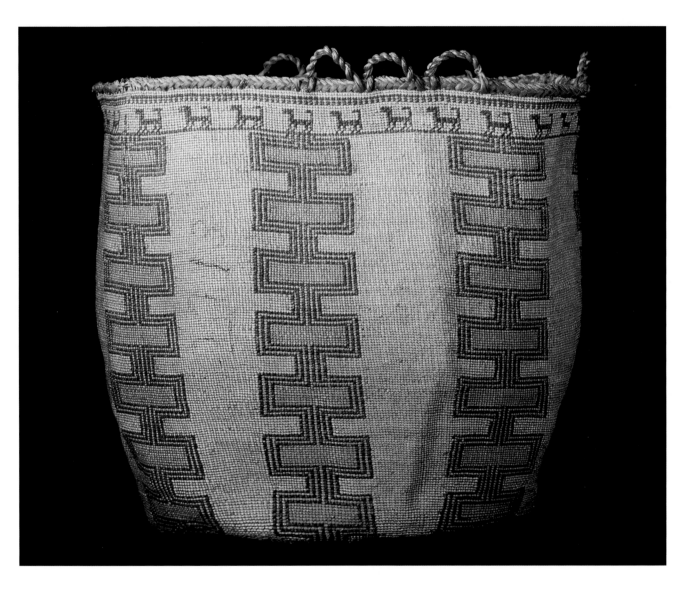

Figure 9.9
Basket, Twana, Skokomish, early nine-
teenth century, cattail leaves, bear grass
cedar bark, 15 × 14 in. (38.1 × 35.6 cm).
Collected by Lt. Charles Wilkes, U.S. Explor-
ing Expedition, 1841. Department of
Anthropology, Smithsonian Institution,
E2713-0.

This basket is extremely well preserved for its age and is exemplary
of Twana soft twined baskets. Creating an exquisite balance of
positive and negative space, the highly skilled weaver of this basket
decorated it with a starfish design in the form of geometric boxes
on the body of the basket, dogs with upturned tails on the rim, and
a small bird on the seam at the rim.

207

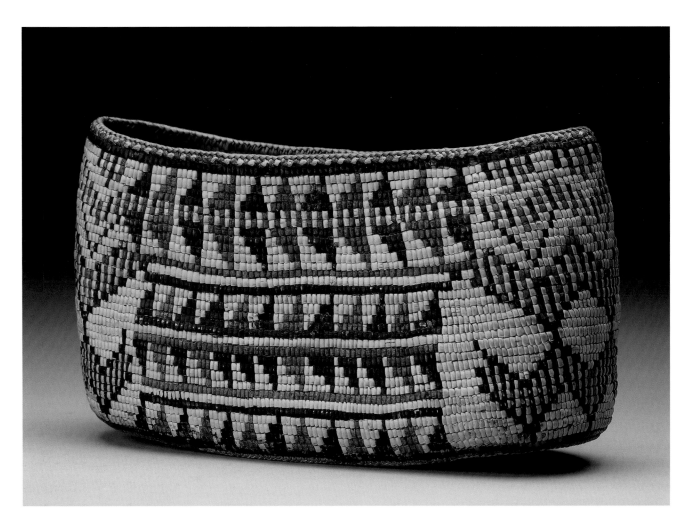

Figure 9.10
Basket, Cowlitz, cedar root, bear grass, horsetail root, 4⁵⁄₁₆ × 7½ × 1¾ in. (11 × 19 × 4.4 cm). Collected by Lt. Charles Wilkes, U.S. Exploring Expedition, 1841. Department of Anthropology, Smithsonian Institution, E2614-0.

This basket exemplifies the pinnacle of coiled and imbricated basketry. The shape and use of four design fields mark it as an early Cowlitz style. Catalogue records indicate that this basket had a lid at one time.

covering of the coils with imbrication, which creates a brilliant contrast between the red and black design elements on a background of light-colored bear grass. Even the base of the basket is imbricated. The design has a four-part field that fits neatly onto the oval shape. Catalogue records indicate that the basket once had a lid. Otis Mason thought that this specimen marked an early style of coiled basketry unsurpassed in its technical and artistic qualities (Mason 1904: 428). A second basket collected by the Wilkes expedition is more typical of the Cowlitz style that remained in use well into the twentieth century. It is a slightly flared piece with a round base, a typical berry-picking basket with total imbrication and a bold diagonal design.

The fourth subgroup of baskets from the Wilkes expedition was collected near the mouth of the Columbia River; these represent a style known to have been made by the Clatsop and Tillamook, and that is closely related to basketry made by the Lower Chehalis. In mid-July of 1841, a third ship of the expedition wrecked at the mouth of the river

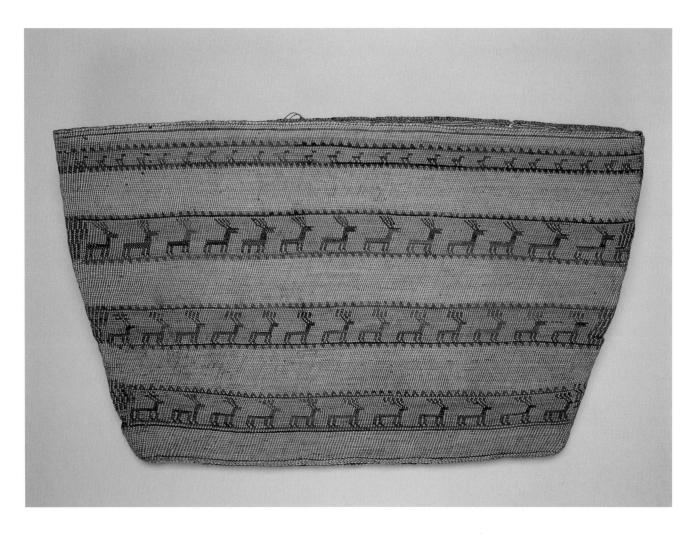

Figure 9.11

Flat bag, Clatsop or Tillamook, vegetal fiber, 12 × 15¾ in. (30.8 × 40 cm). Collected by Lt. Charles Wilkes, U.S. Exploring Expedition, 1841. Department of Anthropology, Smithsonian Institution, E251626-0.

From the mouth of the Columbia River but catalogued as Makah, this basketry wallet came into the Smithsonian Institution in 1908 but is likely to have originated at about the same time and have the same provenance as the Wilkes baskets (see fig. 9.10). The obverse side displays three bands of deer with one narrow band of birds near the rim; the reverse shows four horizontal bands of zigzags. The weave count shows a remarkably fine fourteen warps and fifteen wefts per inch.

and the crew made their way to Fort Clatsop. Here they were visited by both Clatsop and Tillamook Indians. Although these groups are from different language families, they maintained close relations and made similar types of baskets. All of the examples collected by the expedition are made with wrapped twining technique and have designs with horizontal bands of animal and geometric shapes. Several are deep cylinders, and a few show a distinctive flat bag shape. The designs on the bags are similar to the cylinders, although they have different patterns on front and back sides. One large bag is especially remarkable (fig. 9.11). It was not part of the original Wilkes inventory but came to the Smithsonian from a private collector who claimed it was from the expedition. This piece does match very convincingly in both design and technique the Wilkes baskets. It also bears a striking similarity to other bags collected by Russian and English explorers in the late 1840s, with bands of animals such as deer on the main field and a smaller row of designs beneath the rim.

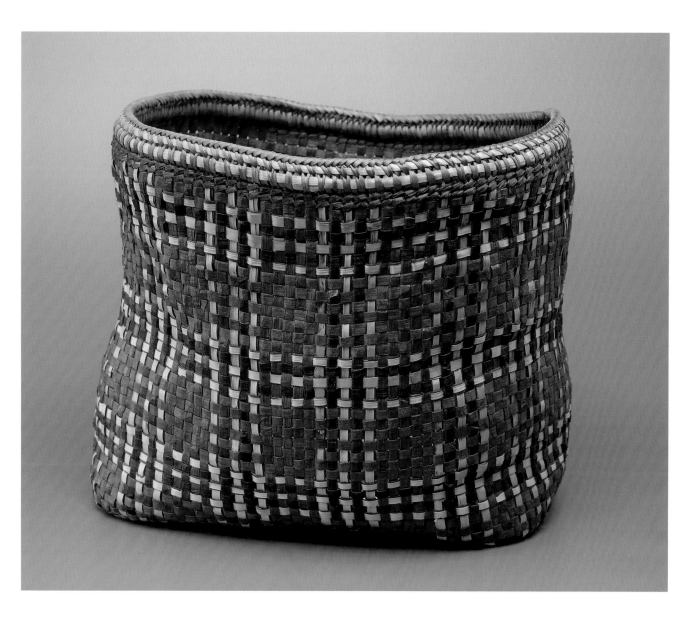

Figure 9.12
Plaited basket, Susan Wawetkin Bedal, Sauk, ca. 1900–30, cedar bark, bear grass, cedar root, 12 × 14 × 13½ in. (30.5 × 35.6 × 34.3 cm). Gift of Jean Bedal Fish and Edith Bedal, in honor of the 75th anniversary of the Seattle Art Museum, 2005.101.

Susan Bedal was an expert basket maker who carried the traditional knowledge of the harvesting, processing, and weaving of indigenous plants found in her Sauk homelands. Her life was a bridge that spanned the two worlds of the old ways and those brought by outsiders to her father's homestead near Darrington, Washington.

Figure 9.13
Basket, Chehalis, ca. 1900, cattail, bear grass, 7 × 4 in. (17.8 × 10.2 cm). Allan and Gloria Lobb Collection.

The weaving technique of wrapped twining is done by holding one of the two weft strands rigid on the inside of the basket and binding it to the warps by a flexible weft that wraps around it (Thompson and Marr 1983: 41). Decorated wrapped twined baskets were found at the Hoko River site near Neah Bay, Washington, that date to 2750 BP (Marr 1988: 56–57).

Diverse Types of Baskets

The Wilkes expedition baskets illustrate four major styles produced by different groups within the Coast Salish culture area. Other late-nineteenth-century collections, such as those made by James Swan and Myron Eells, provide an expanded picture of basketry production. As Otis T. Mason observed, the diversity of techniques and forms produced by the Salish basket makers is truly remarkable. In order to appreciate the full range of Coast Salish basketry, we can describe additional types found in museum collections, documented in historical photographs, or written up in ethnographic literature. Some of the utilitarian types are rare in collections because they were considered less valuable and received hard use during their lifetimes. But their practical qualities illustrate the importance of basketry in the economic and social fabric of the Coast Salish.

A large plaited basket (*QWayloolach* in Twana; *ləqʷa* in Lushootseed) was made from cedar bark split into strips one-third by one-half inch wide (fig. 9.12). It usually had a rectangular base and straight sides, and twining was sometimes used to bind the edges and strengthen the base. Minimal decoration on this type of basket consists of stripes made from black-dyed bark. It was used for storing household articles such as clothes or dried fish. In later years, this type was modified to become a shopping basket with handle.

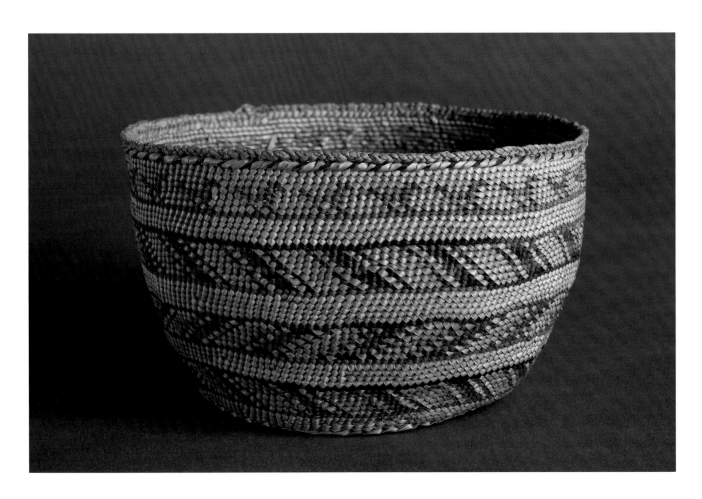

An open-weave basket with vertical warps (*sxWuluqWchee* in Twana; *xʷʔax̌ʷaʔəd* in Lushootseed) was made from cedar limbs or boughs and is often referred to as a "clam basket." It was used for gathering and rinsing clams and other shellfish, as well as for storing dried foods. The base is square and done in twill weave, the sides slope gently outward, and the wefts are spaced quite far apart. Sizes range from small for individual gathering to very large baskets into which people would place their shellfish. Some of the large open-weave baskets have wefts that alternate in the direction of their twist, increasing their overall strength. The Klallam made extremely sturdy baskets of this kind, some with woven loops on the sides just below the rim for attaching a tumpline.

Another type similar to the clam basket had cedar limbs placed diagonally and twined with cedar roots (*Xuhlaplach* in Twana; *sqʷəlulč* in Lushootseed). This technique produced a very strong basket capable of holding large and heavy loads. It was also used for gathering shellfish and for steaming fish or roots. The legend of Snail or Cannibal Woman tells of her kidnapping and carrying away young children in this type of basket to cook for her meal (Ballard 1929: 104). The name of the basket translates as "witch basket," after the ogress whose name is Sxuaiyekw. Because of the way she carried the basket on her back, it became a snail's shell.

A closely woven basket made from cattail leaves placed vertically and held in place with widely spaced rows of twisted fiber was made to store clothing (*Sheedeechee* in Twana; gʷəsubus in Lushootseed). It had a plaited base and was also referred to as a mat grass basket because of the cattails, most often used for making mats. Occasionally cedar bark was substituted for cattail.

A fairly common type of cedar bark basket was closely woven and sometimes decorated with designs just below the rim. Soft and pliable, with straight sides, the cedar bark warps were bound with two-strand twining. This basket was used for carrying and storing clothing, tools, weaving materials, and other personal items. It ranged in height from about 12 to 16 inches.

A wrapped twine basket was made by the Lower Chehalis using cattail warps and bear grass wefts. Other groups such as the Twana made a small wrapped twine basket using cedar bark and bear grass (*yubuTlach* in Twana).

In contrast to the utilitarian basket types, the coiled watertight basket (*spucho* in Twana; *syalt* in Lushootseed) was held in high esteem both for its inherent usefulness and for its artistic qualities. Among the Puyallup and Nisqually, all young girls learned the basics of how to construct a coiled basket, but only those who were good at it became specialists (Smith 1940: 305). This was the case among other Coast Salish groups as well, among whom the maker of a particular basket was remembered and its history recounted, including the names of its owners. The best examples of coiled baskets were kept within families; sometimes they were given away as gifts or exchanged for valued items. There are several examples of children's berry-picking baskets that were made by an older relative and then kept for years as heirlooms of the family.

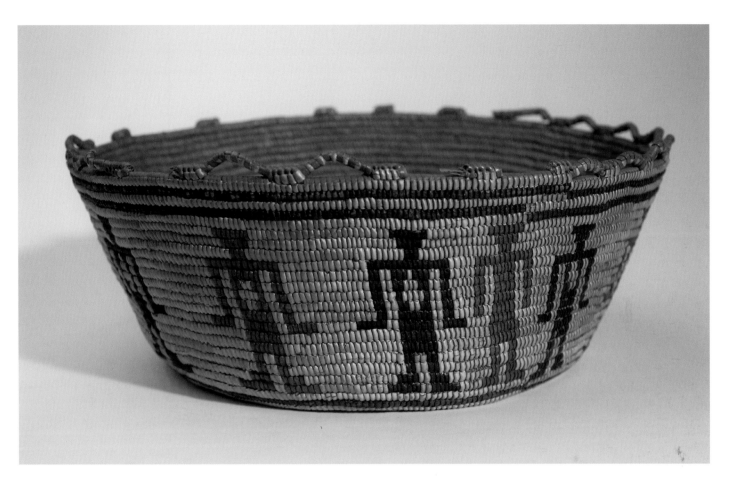

Figure 9.14
Basket, Puyallup, late nineteenth century, cedar root, bear grass, horsetail root, 5 × 13 in. (12.7 × 33 cm). American Museum of Natural History, 50/2480.

Human representations appear far less on baskets than do the myriad geometric motifs. Figures of women are indicated by the presence of skirts. Twana baskets depict humans without hands (Marr 1983: 48). According to Marian Smith (1949: 114–115), the Puyallup did not give names to their basketry designs. Smith concluded that no symbolic meaning was attached to the designs, yet contemporary basket makers dispute this. This basket was part of the Briggs/Peabody collection of more than 400 baskets that were purchased by George Peabody for the museum in 1901. The catalogue notes describe travel to Native communities to collect and meet with the basket makers.

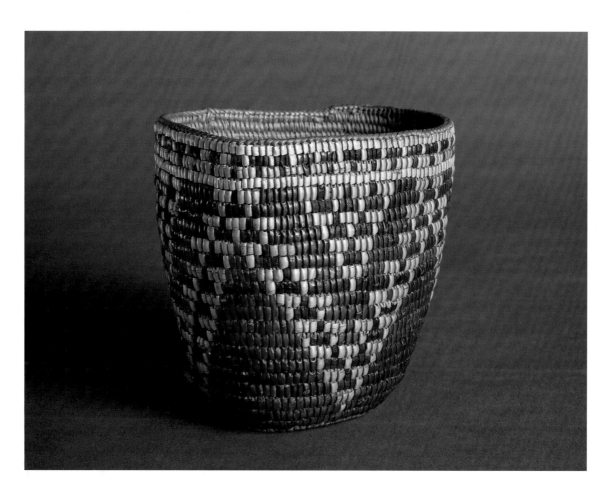

Figure 9.15
Child's berry basket, Siagut (Mrs. John Goody), Nisqually, ca. 1890, cedar root, cherry bark, bear grass, horsetail root, 6 × 5 in. (15.2 × 12.7 cm). Allan and Gloria Lobb Collection.

Judge James Wickersham recorded information about Siagut, a skilled weaver who provided him with information about her baskets (see fig. 9.21). This marvelous basket is completely imbricated with the decorative elements that are added during weaving, obscuring the cedar root underneath. Children helped their parents with seasonal tasks, such as berry picking, and had small baskets that would be tied to their waists, leaving their hands free to pick. When the little basket was full, the berries would be transferred into a larger basket.

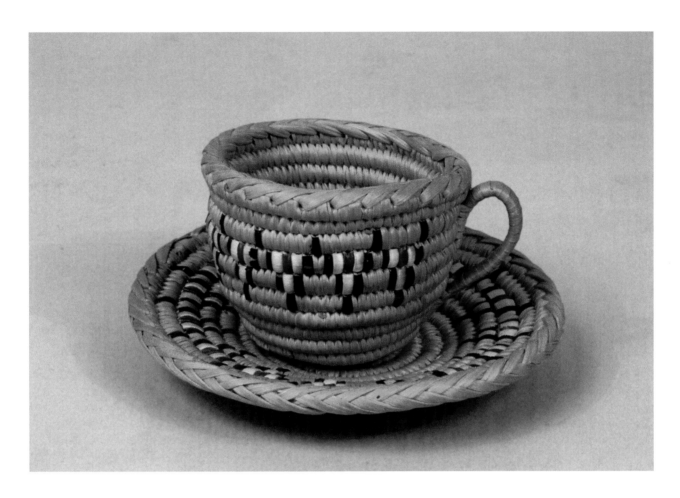

Figure 9.16
Basketry cup and saucer, Josephine George, Nooksack, ca. 1925, cedar root, bear grass, cherry bark, cup: height 3¾ in. (9.52 cm), saucer: diameter 5½ in. (13.97 cm). Burke Museum of Natural History and Culture, Seattle, 1-1004, 1-1005.

Whimsical baskets made in imitation of china attest to the resourcefulness of the weaver, who would have to puzzle out how to weave these new forms. This cup and saucer are part of an entire tea set that also includes a large tray with handles, a spouted creamer, and a double-handled and lidded sugar bowl. While Native men of this period went to work in commercial fishing, logging, and agriculture, Native women transferred their basketry skills to the making of clever souvenirs that would appeal to tourists.

Figure 9.17
Basket, Jennie Kanim, Snoqualmie, ca. 1916, cedar root, bear grass, horsetail root, 12¼ × 10 in. (31.1 × 25.4 cm). Burke Museum of Natural History and Culture, Seattle, 1-307.

Jennie Kanim (1878–1952), the wife of Chief Jerry Kanim of the Snoqualmie Tribe, was an accomplished maker of coiled cedar baskets. Chief Kanim was a traditionalist who created artworks for sale to pay for legal fees to secure compensation for land claims. He made and sold the Soul Recovery boards in figure 1.5.

Coiled baskets are usually ornamented with designs placed on the main body of the basket in a technique known as imbrication. The colors result from different materials and dyes used for the imbricated strands: bear grass bleached in sun for white, or dyed yellow with the inner bark of Oregon grape; wild cherry bark for deep shiny red; roots of horsetail or dyed inner cedar bark for black. The foundation and sewing strands are of cedar root (rarely spruce root) and form the background of the design. In placing a design on her basket, a maker could use a plain background or choose to imbricate the entire surface. Sometimes the background is beaded, meaning that a contrasting strand is run under and over a few coils to make a spotted backdrop for the main design. Many of the Coast Salish baskets demonstrate the height of artistic ability in their design composition. The basket makers selected their colors and placed their design on the basket row by row as it was being constructed from bottom to top. To attain proper symmetry, the design had to be conceptually mated to the basket shape. Basket designs could be passed down by relatives, learned by novices from their trainers, or borrowed from the work of other basket makers. New designs originated through dreams and pure artistic innovation.

The majority of Coast Salish coiled baskets have a similar shape, being oval in cross-section with slightly flared sides. There are differences within this general form, however, with some tending to be deeper and less flared and others widest closer to the rim. In size, coiled baskets fall into three main categories: large (10 to 12 inches high; 13 to 15 inches wide at rim); medium (6 to 8 inches high; 9 to 12 inches wide at rim); and small (4 to 6 inches high; 4 to 7 inches wide at rim). The largest served as cooking and carrying baskets, the medium sizes for berry picking, and the smallest for children's berry picking. Other less common shapes include a shallow bowl, perhaps for holding water, and a nut-shaped basket with a lid (fig. 8.2). Additional forms came about later when baskets were made for sale.

The Twana people of Hood Canal developed a distinctive style of soft-twined basket called ťaqayas that stands out from other Coast Salish types. As noted earlier, the Wilkes expedition collected two examples of Twana soft-twined baskets. Although dating the origins of these Twana baskets has proved problematic, we can assume that they must have existed for some time prior to the early nineteenth century. Twana weavers used a technique of half-twist overlay to create their designs, twisting cattail wefts overlaid with decorative strands of bear grass and cedar bark, both natural and dyed. The hallmark of the style is a row of animal figures placed just below the rim, with a variety of complex designs on the body of the basket (Nordquist and Nordquist 1983; Thompson and Marr 1983). The Twana basket did continue to be made in the twentieth century, and well-known weavers Louisa Pulsifer and Emily Miller of the Skokomish Reservation shared their knowledge of how materials are gathered and treated, as well as the fine points of weaving the baskets.

Basketry Artists

The names of some basket makers of the past are known to us today because their descendants preserved their work—or, in a few cases, the collectors of baskets recorded this information. For example, a maker of coiled baskets at Muckleshoot named Julia Siddle became known for creating some extraordinary large baskets in the 1920s and 1930s (Smith and Leadbeater 1949: 113). Julia John Siddle (Duwamish) was raised by Cheshiahud (Lake Union John). She was born in 1866 on the Black River near present-day Renton and later moved to the Muckleshoot Reservation (Thompson and Marr 1981). Anthropologist Erna Gunther collected some of her baskets, which were displayed at the Golden Gate International Exposition in San Francisco in 1939. One of her baskets was presented as a gift to President Franklin D. Roosevelt. Julia was a friend of Jennie Kanim, who lived at Tolt, Washington, and she is known to have woven baskets with her (fig. 9.17). Julia Siddle died in 1952 at the age of eighty-six. Two other skilled Puget Sound basket makers active in the early years of the twentieth century were Suquamish weaver Jennie Harmon (fig. 9.18) and Skokomish weaver Phoebe Charley (fig. 9.19). The legacy of Charley's elegant finger-work continues today in the baskets of Lynn Foster Wilbur (fig. 19.20).

Another renowned basket maker whose work is represented in this exhibition is Siagut, or Mrs. John Goody (see figs. 9.15, 9.21). Her name was recorded by Judge James Wickersham, an avid basket collector. Wickersham served as a judge in Tacoma and a Washington State legislator before moving to Juneau, Alaska, in 1900. He provided this information about the basket maker: "Si-A-Gut, a Nisqually basket maker, she originally came from the Cowlitz where her people lived, makes the finest baskets on Puget Sound. In July 1899 I bought several baskets from her[.] she sat on my floor and told me her history and about her baskets" (Burke Museum, 2000–2001). Another basket maker whose work was highly regarded at the turn of the twentieth century, Nancy Parsons, also had a Cowlitz background and lived at Nisqually (Thompson and Marr 1983: 33).

Susan Wawetkin Bedal (1865–1947) made several coiled and plaited baskets now in the collections of the Seattle Art Museum (fig. 9.22). Susan was the daughter of John Wawetkin, leader of the Sauk people. She lived for many years with her daughters, Jean and Edith, on the Sauk Prairie (Fish, Bedal, and Blukis Onat 2000: 148–49). Edith described how she sought the ever-valuable cedar roots and gathered wild cherry bark from the trees that grew near their home. In 1917, the Bedal family moved to Darrington, where the daughters attended public school. They continued to go every summer to their home on Sauk Prairie.

Modern-day basket maker Ed Carriere (fig. 9.23) carries on a tradition passed down from his Suquamish ancestors (Thompson 1984: 20–25). His great-grandmother, Julia Jacob, learned coiled-basket making from her parents, and Ed assisted with gathering materials when he was a child. These early experiences planted the seed for his development into a full-fledged basket maker specializing in the construction of clam and burden baskets, objects of function and beauty.

Figure 9.18
Basket, Jennie Harmon, Suquamish, early
twentieth century, cedar root, bear grass,
cherry bark, 5½ × 5½ × 4¼ in. (13.97 ×
13.97 × 10.79 cm). Collection of Betty
and Bob Stott.

Figure 9.19
Basket, Phoebe Charley, Skokomish,
1915, cattail leaves, bear grass, 4 × 4½ in.
(10.16 × 11.43 cm). Collection of Betty
and Bob Stott.

A collector's tag on the basket reads: "1915, Union City, 'Salmon gills'; weaver Mrs. Phoebe Charley, Skokomish Reservation, Twana. Beautiful rim weaver; design outside—false embroidery. She did our washing in old family home (Dalby)—Union City. Came in buggy with a girl to help her. Sold her baskets at McReavy General Store & Post Office. This is an exquisite basket—natural material—typical Skokomish design and Dogs. Very fine weaving and delicately finished edge."

The salmon gills design seems to refer to the light-colored linear segments on the dark field, yet this design is also called "hands" or "fingers." Phoebe Charley is known for her acute sense of creating bold surface patterns with geometric and figurative elements, especially in her preference for horizontal designs and groupings of three design elements (Thompson and Marr 1983: 12).

Figure 9.20
Sealroost with Dogs, Lynn Wilbur Foster,
Squaxin, 1999, yellow cedar bark, red
cedar bark, sweetgrass, 7¾ × 9 × 9 in.
(19.65 × 22.86 × 22.86 cm). Collection
of the artist.

This gifted young weaver tackled one of the most challenging
basketry patterns of the Twana and Squaxin Island Native people
even though she had been weaving just a short time. The design is
based on two adjacent sets of concentric squares with short marks
in the middle that refer to rocks. The triangles represent seals that
are lying on the rocks, while the fringe on the edge of the triangles
indicates seaweed (Thompson and Marr 1983: 50). A row of dogs
encircles the rim, which is tightly bound with yellow cedar bark.
The warp is red cedar bark, and the weft is sweetgrass. In the abbre-
viated shorthand of design elements, the myriad pulsating rhythms
of nature come alive.

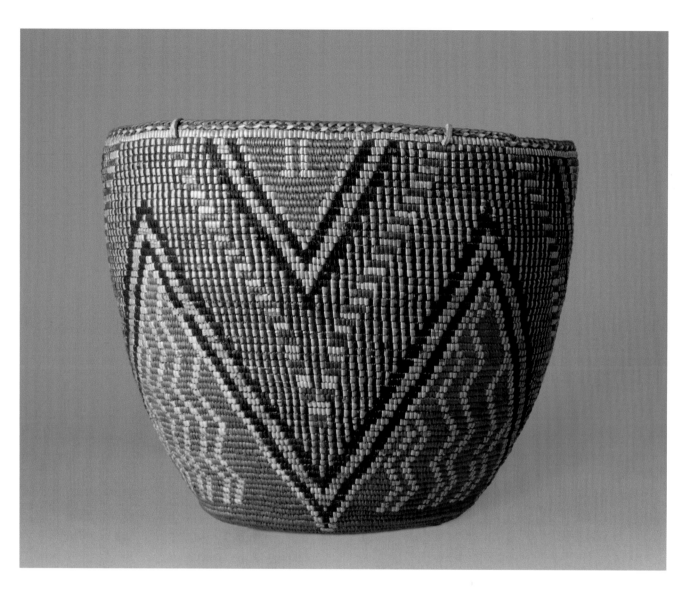

Figure 9.21
Basket, Siagut (Mrs. John Goody),
Nisqually, ca. 1899, cedar root, horsetail,
cedar bark, bear grass, 11½ × 14 × 11 in.
(29.2 × 35.6 × 27.9 cm). Burke Museum
of Natural History and Culture, Seattle,
2005-21/1.

Names of individual basket makers are rarely known, although
Judge James Wickersham—who collected this basket in 1899 just a
few years after it was made—noted the name of the weaver, Siagut
(see also fig. 9.15). Today, more scholars are turning their attention
toward uncovering the work of particular artists (see Thompson
and Marr 1983).

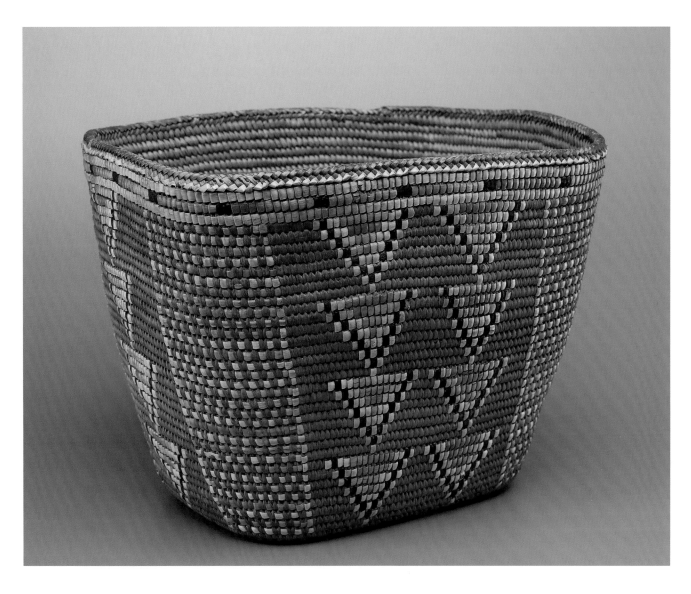

Figure 9.22
Basket, Susan Wawetkin Bedal, Sauk, ca. 1900–30, cedar root, horsetail root, cedar bark, cherry bark, 11½ × 15 × 13 in. (29.2 × 38.1 × 33 cm). Gift of Jean Bedal Fish and Edith Bedal, in honor of the 75th anniversary of the Seattle Art Museum, 2005.99.

Susan Bedal (1865–1947) possessed an intimate knowledge of the gathering and preparation of natural materials from the prairies, meadows, and forests of the Cascade Mountains, crafting these into masterful works. A dye created from huckleberries found in the Sauk homelands produces the unique rose color seen here in the triangular forms that represent butterflies. Bedal achieved visual balance through the placement and disposition of the designs on the surface of the basket using an additive technique called imbrication. Some coiled baskets served functional purposes, but this decorated basket was made as a special gift and considered a symbol of wealth.

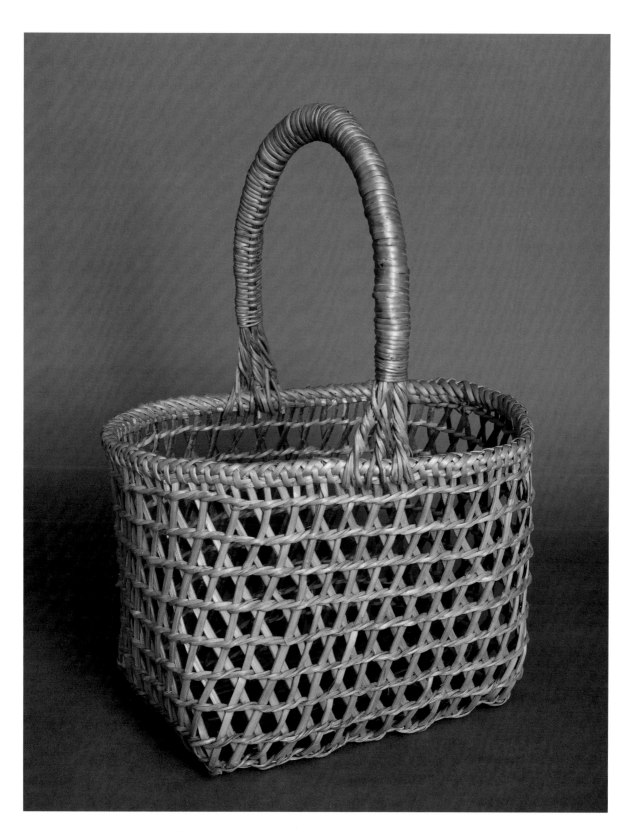

Figure 9.23
Clam basket, Ed Carriere, Suquamish, ca. 2003, cedar root, 12 × 9 in. (30.5 × 22.9 cm). Collection of the artist.

Ed Carriere was born and raised on the Port Madison Reservation and learned to make baskets from his great-grandmother, who was the daughter of a Suquamish chief. Carriere is an expert weaver of many styles of baskets, as well as a carver of canoes and canoe paddles.

The act of creating a basket unites the maker with his or her culture, continuing a tradition that has been passed on from countless generations. Although today's basket makers are few in number, they represent an art form with ancient roots, one that has survived decades of social change. Taking a close look at Coast Salish baskets from the past helps us to gain an appreciation for the incredible depth and breadth of this tradition. Today's basket makers may change some of the materials, they may create new designs or change the shapes of their baskets, but they nevertheless remain closely connected to the masters whose works are showcased in this publication.

IF, FROM A LONG TIME IN THE FUTURE, one were to look back at Salish weaving in the twentieth century, one would see a great similarity between the arts and uses of soft textiles at the beginning of the century compared to the end. And one might think that the cultural traditions continued in a strong and steady current throughout this time. But today we know that the cultural practices of First Nations people were suppressed and displaced during this same century, and that the history of the arts involves a variety of transformations, innovations, determination, visions, and—above all—love. In this essay, I offer a brief sketch of the threads of that twentieth-century history, providing some background on the significance of the weavings illustrated here, both as examples of a rich past and as elements of a moving force that underlies the weaving traditions of today.

Weaving in Beauty, Weaving in Time

Crisca Bierwert

National Dress

In 1906, a delegation of Salish chiefs gathered for a formal group portrait, prior to a political journey to London where leaders would meet with King Edward VII to advance the case for their land claims (fig. 10.2). They presented themselves as leaders of their Nations, not only in their persons but in their formal dress. Most wore woven blankets and ceremonial headgear, over suits. Photographs of the delegation provide a stunning documentation of the richness of Salish weavers' work available at that time. The photograph also shows how these delegates distinguished themselves from other First Nations leaders. Houdanausonee leaders from Ontario, for example, sometimes wore recognizably "Indian" headdresses for state occasions; these were the feathered headdresses of the Plains style, a "pan-Indian" signifier even then.

While wearing blankets created an immediate and lasting political statement to the rest of colonial British Columbia, and to the Queen and others in London, wearing these garments spoke to the Salish people in another register as well. Within the Coast Salish social network of political bands, tribes, webs of kinship, and religious practice,

226

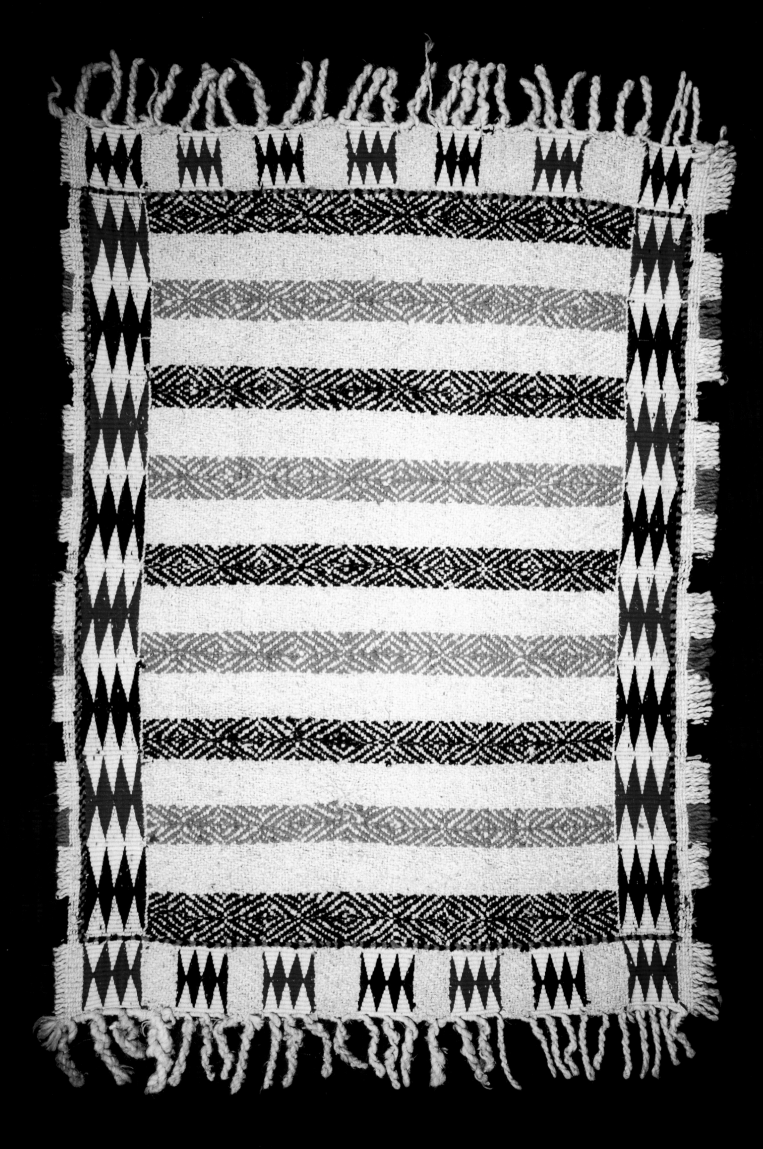

Figure 10.1 (preceding page)
Chief's blanket, Musqueam, before 1908,
mountain-goat wool, yarn, 46 × 72 in.
(116.84 × 182.88 cm). Collected by C. F.
Newcombe in 1908. Royal British Columbia
Museum, 1189.

The body of this colorful robe has a lozenge twill in natural white
wool, with black and orange knitting yarns. The borders are tightly
twined with black and maroon yarns (Gustafson 1980: 122, no. 9).

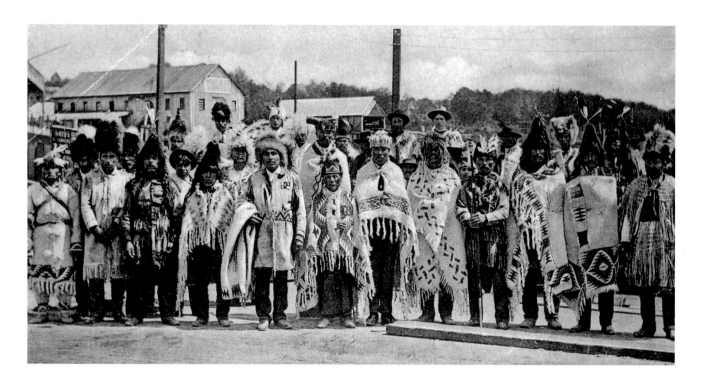

Figure 10.2
Indian leaders in Vancouver, British Colum-
bia, 1906. British Columbia Archives.

Chief Joe Capilano, third from right, is wearing his blanket, which
is in the collection of the Canadian Museum of Civilization (see
fig. 10.3). Ki-ap-a-la-no, anglicized to Capilano, was a high-ranking
name. Chief Capilano (1840–1910) was a renowned orator who
worked for the rights of First Nations people. In 1906, at the time
this photograph was taken, he and two other chiefs were preparing
to travel to London to discuss land claims with King Edward VII.

these blankets were markers of political leadership, civic prestige and responsibility, and
ceremonial distinction.

Oral traditions and archival documentation alike attest to the ceremonial use of
these blankets from the beginning of recorded time. In ceremonies marking major life
events—marriage, naming, memorials, and entrance into the Coast Salish longhouse
religious practice—a blanket is placed upon the individual being honored; the ritual
leaders and witnesses are also honored, each with a blanket pinned upon them. Thus,
these blankets have deep personal significance in addition to the public role they play.

Wearing the blanket matters in a way we might best realize from understanding the
way that one's name is spoken of in longhouse ceremonies. When a Coast Salish person
receives a traditional name, witnesses speak to him or her, noting the responsibilities
attached to the *wearing* of the name, as they say. This name "comes down to you," "is
given to you." "Take care of it. Don't drag it in the dirt." These evocations remind a

Figure 10.3
Robe of Chief Capilano Joe, Squamish, late nineteenth–early twentieth century, mountain-goat wool, yarn, 45 × 65 in. (114.3 × 165.1 cm). Collected by Harlan I. Smith, 1928. Canadian Museum of Civilization, VII-G-334.

The body of this robe is done in the twill technique, using the creamy white wool of the mountain goat (*Oreamnos americanus*); the borders are twined with goat wool and commercial yarn. Chief Capilano was photographed several times in his official capacity as chief wearing this robe, a testament to the premium placed on such elegant garments.

person that the name is "put on" them—much as the blanket is put on them during the ceremony. Such strong attachment to a name is something that is familiar to people from other cultures; what we can learn from this ceremonial language is that a Salish blanket has such significance too.

Blankets were once also objects that represented wealth, or the prestige that may be more familiar to a Western audience. People being honored were (and are today) seated on blankets, or stand on layers of blankets—to signify a high degree of prestige. And blankets were given away in large numbers at traditional ceremonies, called "potlatches"

by anthropologists, to redistribute wealth. This redistribution was carried to a symbolic extreme in the form of a "scramble," in which blankets were not handed to people but literally tossed out for others to run for—much as change might be tossed for children to scramble for at a party. Finally, in the nineteenth century, blankets were even torn apart for a scramble. Lucky recipients of pieces could then reweave the wool into a new, full piece. Blankets are still given away, but not, as far as I know, in pieces.

Finally, and again in a more nuanced way, blankets provide something that is very difficult to explain: protection. The protection afforded in a ritual context is parallel to, but quite different from, protection from rain or cold. As part of ceremonial regalia, blankets and other wool elements are said to give protection for those who are vulnerable, like the newly bereaved or those who have been newly initiated into religious practice. This protection comes from the attention with which they are made and the way they are used, and is not simply a quality of the object itself.

Ceremonial Regalia

During most of the first half of the twentieth century, production and use of Salish weavings fell away. First Nations religious practice was prohibited by a law enacted in 1884 and enforced for decades, explicitly to keep money and energy from going into these pursuits, and also as part of the "civilizing" process of forcing First Nations peoples into lifestyles that were recognizable to, and served, the mainly British colonizers. Although the regalia was infused with religious significance, longhouse dancers were able to keep their practices going in secret, even though the numbers involved dropped

Figure 10.4
Potlatch blanket scramble at Quamichan, Vancouver Island, c. 1905. British Columbia Archives.

Woven goat-wool blankets are stacked on the ground amid guests in Western dress and on the roof of the house. Trade blankets are also visible on the roof. Among the Coast Salish, one method of giving gifts to guests at potlatches was to throw blankets into the crowd or to cut blankets into pieces for distribution, to be unraveled and rewoven. Goat wool was a rare commodity, often requiring trade with other Native groups who had access to these mountain dwellers.

Figure 10.5
Sweater, Cowichan, twentieth century, sheep wool, yarn, 25 × 54 in. (63.5 × 137.2 cm). Royal British Columbia Museum, 17190.

Note the X-shaped design that was taken up by later weavers as the butterfly motif. Accustomed to the fine handwork required for weaving and basket making, First Nations women on Vancouver Island turned to knitting after the introduction of sheep in the 1850s and the instruction provided in the mission schools (Meikle 1987: 3–4). Like weaving, the process of taking the raw material to a finished garment is arduous: the wool must be washed, dried, carded, and spun, then hand-knitted into socks, mitts, hats, vests, or the warm, bulky garment called "Cowichan sweater." In the early 1900s, Cowichan knitters used Fair Isle patterns imported by Scottish immigrant women, from which they created geometric patterns taken from basketry and weaving and figurative designs like eagles, horses, and deer (Meikle 1987: 17).

to a very few between 1910 and 1965. In addition, the availability of high-quality wool blankets—especially through the Hudson's Bay Company—meant that blankets could be obtained for much less "cost" in terms of the time it took to purchase or exchange for a blanket. Many women with artistic talent focused on basketry making—an art that had recognized value both within and outside their communities—and they sold many of these baskets to collectors. Many also appropriated new technologies to produce garments. Intrigued by the spinning and knitting technologies used by settler neighbors, Coast Salish women created a regional style of knitting that was a commercial as well as practical success.

Now called "Cowichan" sweaters, because the first visible surge of Coast Salish knitting came from around this Vancouver Island community, these garments served many

of the purposes of the blankets. Women used sheep wool, available in abundance among the settlers, and spun bulky yarn that was similar to the weight used for older twill ceremonial blankets (see below for a discussion of the style). Instead of their former technology of using a spindle whorl and shaft, these women used the colonist-style treadle spinner, a technology still used today. While the form of the sweaters was adopted from European styles, the designs included both European motifs and motifs that the knitters created as "Indian" insignia, to use the language of the day. The knitters stitched whales in shapes like those on basketry of the West Coast, and they designed eagles, like those in emergent silversmithing and carving styles. The sweaters are snug and water-repellent, very functional in the wet chill of winter in the Northwest. They were also beautiful, individual, and handmade, and thus suitable for honoring close kin. They provided Coast Salish people with a way to signify pride in family and in their Indian-ness. They were not blankets and did not serve that ceremonial purpose. But vests and leggings that were knitted became part of ceremonial regalia, replacing those that had been woven before. In addition, other ritual elements, like belts and bands that have ritual purpose, were also knitted rather than being woven.

Traditional Archives

"Storing" the weaving tradition through a time when it was little used was the work of a few. Only a limited number of Salish textile artists continued to weave into the twentieth century. At Musqueam in the 1980s, Ed Sparrow remembered his grandmother and others weaving with mountain-goat wool on a two-bar loom in the early years of the century (Johnson and Bernick 1986: 26) (see figs. 10.6, 10.7). Upper Skagit elder Susie Sampson Peter, over ninety in the 1950s, recalled the weaving techniques to Leon Metcalf, who recorded her description.

But at Seabird Island in the Fraser River valley, Mary Peters was still actively weaving in the 1960s, when Oliver Wells, an amateur ethnographer and staunch advocate of First Nations cultural preservation, met her. This was on the eve of a cultural resurgence, supported by the motivation of First Nations peoples to reclaim their cultural identities and supported, too, by the Canadian federal government, which identified Native arts and crafts as an economic asset not only for the First Nations people but for local tourism.

Mary Peters had developed a weaving technology distinctively her own, creating strands for her weft not from wool at all but from strips of cloth, in the manner of frontier rag-rug weavers.[1] She used a traditional Salish loom, twining the cloth strips over a warp of cordage to make a solid weaving beautiful with the many colors of the cloth, but not patterned. Wells spread the idea that spinners might want to revive the weaving tradition, and Anabel Stewart and Martha James were among the first to begin. By the early 1970s, the women had organized a spinning and weaving cooperative and had a shop on the grounds of the Coqualeetza Cultural Education Centre, which was one of the first cultural organizations of the Stó:lō Nation, based in Sardis, British Columbia. Josephine Kelly was president of the group, and some of the most active weavers—

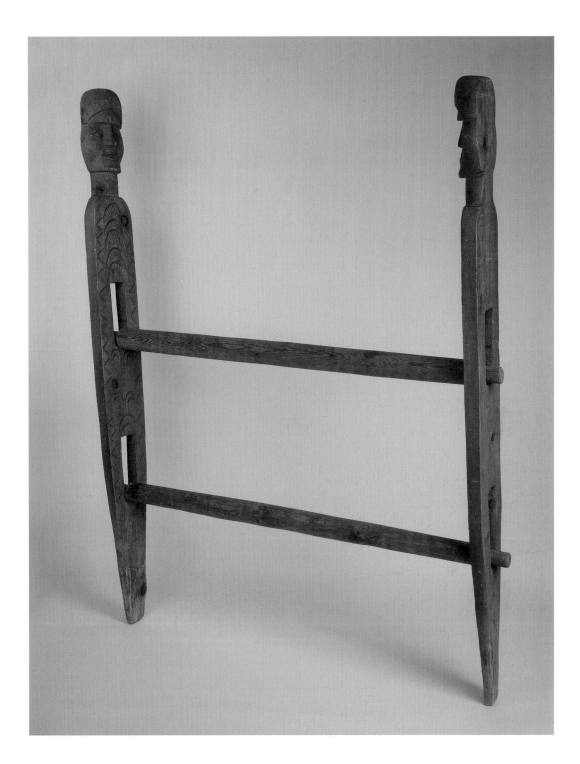

Figure 10.6
Loom posts and crossbars, Cowichan, wood; posts: 81 × 8½ × 4½ in. (205.74 × 21.59 × 10.79 cm), crossbars: 65 × 3 × 3½ in. (165.1 × 7.62 × 8.89 cm). Collected by George Emmons at Duncan, British Columbia, 1928. National Museum of the American Indian, Smithsonian Institution, 16/2071.

The Coast Salish loom has two round crossbars held in place by two posts that are secured in the ground about six feet apart. Sometimes the posts are decorated; in this case they are carved to represent stylized human figures. The posts have several slots cut at the top and bottom so that it is possible to weave different size blankets. The crossbars fit loosely in the slots, and wedges are added to keep the tension on the warp. Among the Salish, weaving is done from top to bottom or from bottom to top and, typically, from right to left. The earliest mountain-goat wool blanket has been dated to about AD 1550 and was found at the Ozette site near Neah Bay, Washington, along with loom uprights, roller bars, wool swords, and spindle whorls.

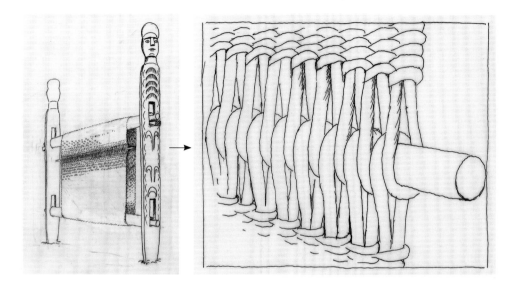

Figure 10.7 a and b
(a) Diagram of warping of the Salish loom.
(b) Close-up diagram of the loom's third
bar with warping. Drawings by Kenneth
Greg Watson, 2008.

The weaving technology includes two crossbars, set into holes or slots in upright posts. The warp is wrapped around these, but not in a continuous circle (see fig. 10.7a). The weaver ties a cord from one upright post to the other or, as seen here, inserts a third bar, as a place to reverse the warp winding (see fig. 10.7b). As in the illustration, the warp is placed over the upper crossbar, then down to the cord or third bar, making a "u" around it, then up again over the crossbar and then down the entire vertical length of the loom. Then the warp strand goes under the lower crossbar and up to the cord or third bar, making an "inverted u" around the cord, then down again under the crossbar and up the entire vertical length of the loom. When the entire warp is laid, the up-and-down tension keeps the cord or third bar in place, and it is untied from the upright posts. Weaving is done entirely by hand (no shuttles could be involved), as two strands of weft are laid, one over and one under each warp (or each two warps, depending on the texture desired) and twisting halfway around one another between warps, so that the two

strands alternate and secure one another. Salish twining goes straight across the warps. However, some weavers outline elements of the design with additional weft stitches. As the warp is filled in, the crossbars can roll the piece up, so the weaver can sit in a constant position. Also, as the warp is filled in, the tension changes, and the weaver moves pegs that she set in the slots holding the crossbars, so the tension can be adjusted. When the weaving is complete, the cord or third bar is removed, and the weaving comes away as one flat piece.

Twilling involves the same loom (except as noted in the text), but the weft strands are laid in one at a time, alternately under and over the warp threads across the loom. For the next row, weaving in the opposite direction, the strands go over the warps they went under in the previous row, creating a diagonal texture. By changing this alternation, the weaver can create patterns of diagonals, including diamond textures and other effects.

besides Anabel Stewart and Martha James—were my friends Georgina Malloway, Theresa Jimmie, Elizabeth Phillips, and Mary Sutherland.

The women used single-ply sheep-wool yarn for weaving, yarn that was about twice as thick as what they had been using to knit sweaters, and they wove on looms modeled after Mary Peters's loom. They created a large repertoire of designs, with each weaver originating some designs for herself, like Stewart's "Butterfly," and many of them using shared patterns, like diamonds or a band and chevron called "flying goose" (see fig. 10.9). They dyed spun wool with dyes made mostly from local materials (except for cochineal red, which they purchased) and used up to three or four colors against a white wool background. These weavings they called "rugs," and they were meant to be used as wall hangings. While many weavings were given as gifts to relatives, most of the work was for sale to a regional market.

Besides being drawn to creativity and self-expression, the weavers were bound in other ways. Monica Phillips, Elizabeth Phillips's daughter and the granddaughter of Mary Peters, told me that when she wove she sensed her grandmother very powerfully, "as if she was there." While some of this presence is personal and spiritual, some also comes from cultural practice: from learning through watching, and from being close to an elder, from sharing the unspoken tactility of art, and from the knowledge that one is continuing in a genealogy of knowledge.

Salish art was beginning to receive widespread notice. The University of British Columbia Museum of Anthropology hosted a major exhibit of Salish art in 1980, including historic spinning and weaving tools and weavings. One of the largest public audiences was Convergence '82, an international conference organized by the Hand Weavers' Guild of America in Seattle. The Burke Museum of the University of Washington created an exhibit of textile tools and arts from the Northwest Coast and asked Georgina Malloway of the Sardis weavers to demonstrate her spinning and display Salish weaving.

The Salish Weavers Guild, based in Sardis, flourished for more than a decade. During this time, the weavers had fully reestablished the concept and practice of Salish weaving, not only among themselves and their local market but among other Salish people. They had held classes for other First Nations women, and several weaving cooperatives sprang up—if briefly—in other reserve communities in British Columbia. By the mid-1980s, however, the Guild suffered from having saturated their local market, as well as from the changing demands of community and kin. A new wave of weaving was about to take place.

By that time, another weaving revival had been initiated by a Lummi mother and son, Fran and Bill James. Fran was a seasoned spinner when Bill decided to begin weaving as part of his repertoire of traditional cultural skills. Unlike the Salish Weavers Guild members, Bill decided to weave twill blankets, using a western-style loom. He used sheep wool that his mother spun, and he used naturally gray wool yarn to contrast with the white. Twill weaving is much lighter than twining, and the warp shows, so both the warp and the weft of his weaving include hand-spun yarn. He gave his early

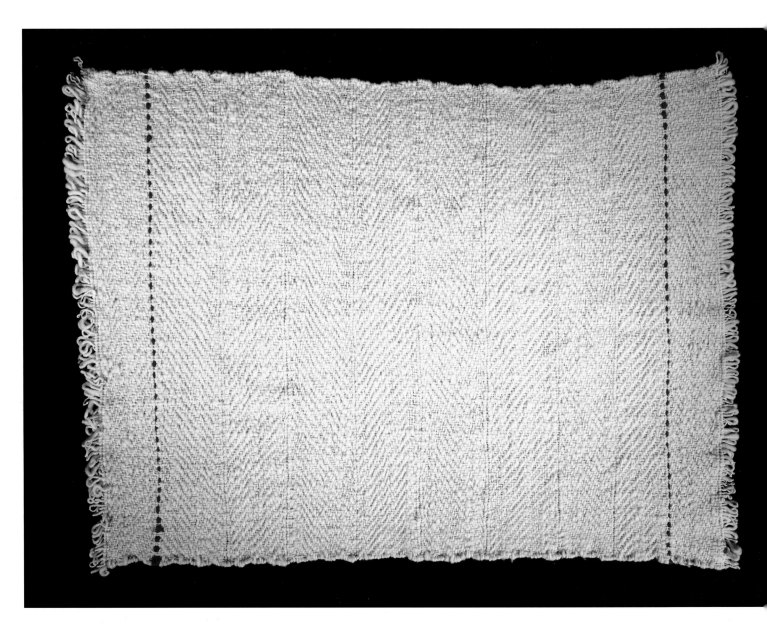

Figure 10.8
Blanket, Martha James, Skwah (Stó:lō), 1970s, sheep wool, 40 × 50 in. (101.6 × 127 cm). Royal British Columbia Museum, 18478.

Some of the weavers who became associated with Oliver Wells and the revival of Salish weaving examined old blankets that remained in the communities. This is an elegant older style, twilled blanket with red trade wool detail, but the Stó:lō weavers of the 1960s also created colorful and patterned twined weaves. Martha James (Mrs. Gordon James), from the Skwah Reserve, had been an accomplished knitter before she took up weaving in 1967. She wove rugs, saddle blankets, and wall hangings (Wells 1987: 212).

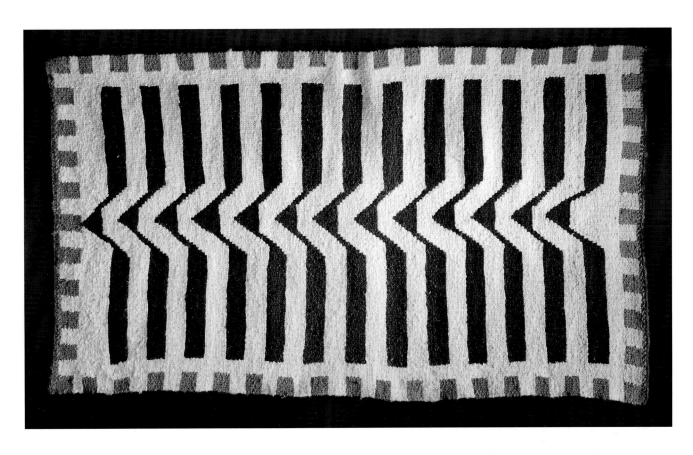

Figure 10.9
Blanket, Mary Peters, Seabird Island
(Stó:lō), 1971, sheep wool, about 60 in.
long (152.4 cm). Royal British Columbia
Museum, 13936.

Salish weaving designs are geometric—diamond, square, rectangle
—and can be oriented horizontally, vertically, and diagonally
in endless combinations of elements. Geometric elements are likely
conventionalized natural elements that refer to birds, butterflies,
snakes, water, and mountains, as is true for basketry designs; how-
ever, data about the designs are incomplete. Overall, designs are
symmetrical and the border areas are clearly demarcated with
a pattern on two or four sides. Mary Peters and her husband,
Edmund Joe Peters, lived on the Seabird Island Reserve in British
Columbia and provided valuable information about their culture
in a series of taped interviews recorded by Oliver Wells in 1964 (see
Wells 1987). Mary Peters was a skilled basket maker, rug maker, and
weaver whose dedication fueled the revival of Salish weaving.

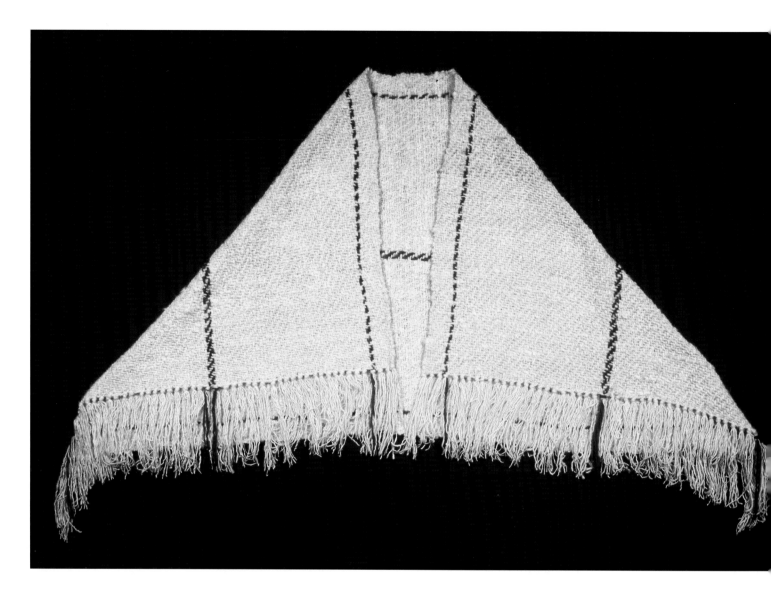

Figure 10.10
Robe, Fran James (Che top ie) and
Bill James (Tsi'li'xw) (b. 1944), Lummi,
mountain-goat wool, sheep wool, 38³/₁₆ ×
91¾ in. (97 × 233 cm). Burke Museum
of Natural History and Culture, Seattle,
988-84/1.

Fran and Bill James have been instrumental in the survival of the
Lummi language, as well as of the traditional arts of basketry and
wool weaving. Independent of the weaving revitalization on the
Fraser River, mother and son began creating traditional blankets in
the 1960s, with Fran making use of her considerable wool-spinning
and knitting skills learned as a child. This robe was the first twilled,
mountain-goat wool robe woven for many generations when it was
created for the Burke Museum's exhibition "A Time of Gathering:
Native Heritage in Washington State," in celebration of the centen-
nial of Washington statehood (Wright 1991: 140–41).

work to prominent elders, who wore the weavings as blankets at public and ceremonial
functions. One of those who made his work most visible was Skagit elder Vi taqʷšəblu
Hilbert, the storyteller, cultural leader, and Lushootseed language advocate, who makes
numerous appearances throughout Puget Sound and has spoken nationally and inter-
nationally (fig. 10.11). Bill and Fran have done so much work for cultural education that
the Northwest Indian College has named an endowment fund after them to support
future artists.

Figure 10.11

Treasure, Josef Scaylea, 2003. Vi taqʷšəblu
Hilbert wearing woven shawl by Bill and
Fran James and holding a basket by her
aunt tsisdawš.

Upper Skagit elder, linguist, storyteller, and author Vi taqʷšəblu
Hilbert has worked for fifty years to preserve the language and
literature of Lushootseed-speaking First Peoples. She was raised
traditionally in the Skagit River region, attended the Chemawa
boarding school (Oregon), graduated high school, married, and
owned a hair salon before meeting linguist Thom Hess in 1967.
Together they created two Lushootseed dictionaries and translated
recordings made in the 1950s and 1960s by fluent language speak-
ers, including Hilbert's mother and father, Louise and Charley
Anderson. (See basket, fig. 9.8.)

Figure 10.12

swo'qʷil: Gift of the Forest Robe, Heather
Johnson-Jock, Jamestown S'Klallam, 2007;
sheep wool, dyes, 72 × 48 in. (132.1 ×
114.3 cm). Collection of the artist.

Heather Johnson-Jock is a gifted emerg-
ing weaver who has studied with Fran
and Bill James. Each year she donates a
weaving to raise funds for the Bill and
Fran James Endowment. About the
recent weaving, the artist writes: "I chose
to represent our connection to the forest
in weaving this piece. So many of the
gifts we create as Salish artists come from
the bounty of the forest. I was inspired to
honor these gifts as well as the splendor
and beauty of the forest through weaving
patterns representing its complexity,
interconnectedness, and depth."

Figure 10.13
Robe, early nineteenth century, mountain-goat wool, dyes, 59¹³⁄₁₆ × 60⅝ in. (151.92 × 153.08 cm). Collected by Lt. Charles Wilkes, U.S. Exploring Expedition, 1841. Department of Anthropology, Smithsonian Institution, 2124-0.

In her study of Salish weaving, Paula Gustafson categorized robes by their designs as being classic, colonial, or hybrid. This robe fell within the classic category because of its emphasis on geometric patterns arranged in vertical bands. These robes were created between 1778 and 1850, when the indigenous traditions were not influenced by imported motifs and materials (Gustafson 1980: 37). Complex and sophisticated, this example consists of fifteen major and eighteen minor design units composed in vertical and horizontal sections. It is tightly twined without a border pattern and is fringed on three sides. Truly a masterpiece in its finished form, this piece tempts us to consider the knowledge the weaver had about the plant dyes that furnished the varied palette and the processing of wool and plant fiber needed to yield this lush textile.

Archives and Tradition

Weaving was revived at Musqueam in a different way. Elder Mabel Dan was still weaving with tumplines using the twining technique, and she helped some young weavers learn. A number of young women immersed in studying their cultural history wanted to learn everything there was to know about Salish weaving, from the knowledge of their elders who were still living, from the nearby Museum of Anthropology at the University of British Columbia, and from all the museums that had bought Salish weavings when traditional practices were being repressed. Wendy Grant, who would become a national figure in First Nations politics, as well as an extraordinary chief of the Musqueam people, was at the center of this movement. They went to Sardis to study with the weavers there. Then they traveled to museums in Europe, the United States, and elsewhere in Canada to take a close look at large and complex weavings that were more elaborate than anything that had been woven for nearly a century.

While many in this new group of weavers create wall hangings, like those that had earlier launched the revival, some of the women modeled their "new" weavings on those they had studied in museums, especially those that had been collected from their traditional homelands. The yarn used in most of these blankets was a finer, two-ply type, which added strength and texture and required more work and dexterity than the Salish weavings that had been modeled originally on Mary Peters's rugs. Barbara Cayou twined a blanket with bands of zigzags and bands of tiny checkered motifs, after a blanket now in Perth, Scotland. Rita Louis followed the lead of a former artist whose weaving is in the University of British Columbia Museum of Anthropology; this work has a large center of twilling and a broad twined border design, very much like some of those worn by the chiefs in figure 10.2. A number of these new creations were included in the *Hands of Our Ancestors* exhibition at the Museum of Anthropology in 1986.

These weavings took a tremendous amount of time to complete. They were not for sale; they were made out of love. These blankets began to follow those made by Bill and Fran James; that is, they began to cover those leaders and relatives who were honored in traditional ceremonies. The Salish longhouse practices had invigorated communities on both sides of the Canadian–U.S. border by the later 1980s, and public ceremonies also made increasing use of rhetorical traditions. It was fitting to bring the "old-time" weavings into both community and public settings. Now the new creations are for sale, finding their way into galleries, private collections, and public places, including museums.

With increased awareness and appreciation of these powerful works of art again spreading, the movement continued south. Barbara Marks, whose mother was Mabel Dan, and who participated in the Musqueam revival, is a member of the Swinomish Indian Tribal Community. She created a twine-and-twill blanket that was part of the 1986 Museum of Anthropology exhibit, and she began apprenticing a younger weaver at Swinomish.

Susan sa'hLa mitSa Pavel, a resident of the Skokomish Tribal Community, apprenticed with renowned weaver Gerald Bruce subiyay Miller beginning in 1996 (see fig. 3.10).

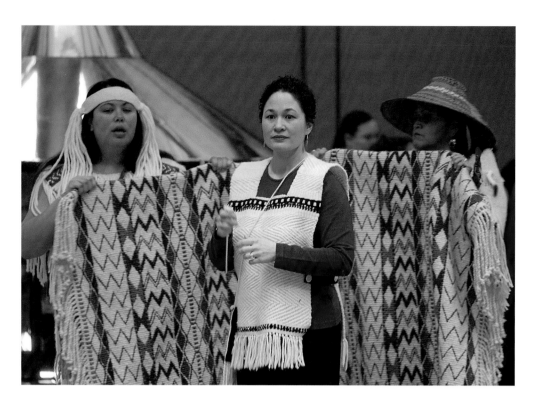

Figure 10.14
Susan sa'hLa mitSa Pavel, with weavers
Misty Kalama and Chief Janice George, at
a blanket dedication ceremony, January
2007. Evergreen State College Longhouse.

"Susan Pavel leads the unveiling and naming of *du'kWXaXa'ʔt3w3l*
(*Sacred Change for Each Other*), a fully twined, mountain-goat wool
robe, hand-dyed with native plants. This special robe is more than
a rare ceremonial robe: she is a feminine entity that came forth
into this world to bring a message of hope and inspiration to
Native and non-Native people alike through her teachings. Susan
is accompanied by her trusted friends, Misty Kalama on the left
and Chief Janice George on the right, to escort *du'kWXaXa'ʔt3w3l*
to be placed upon leaders of tribal communities in attendance so
that each could feel her message to respect the sacred change that
has been occurring in the last thirty years and will continue to
occur in our lifetime. That sacred change is the resurrection and
revitalization of Salish traditional culture that have come about so
that the aboriginal inhabitants of this land can once again experi-
ence the pleasure of living in honor of the Creator's teachings."
—D. Michael CHiXapkaid Pavel

After three months of full-time work, she finished her first weaving. She continued
weaving and in 2002 responded to a request from the Squamish Nation to teach weav-
ing there. In January 2007, she completed an elaborate, fully twined weaving made
entirely of mountain-goat wool, which was named *du'kWXaXa'ʔt3w3l* (*Sacred Change for
Each Other*) and ceremoniously brought out at a special gathering at the Evergreen State
College (see fig. 10.14).

The art in this weaving reveals that Pavel, too, has studied museum collections. And
the collections taught her something she had not expected. She went to study a large
collection of Skokomish weavings at the Field Museum in Chicago, expecting that the
high point would be looking at a dress worn by Skokomish Annie Williams at the 1893
Chicago World's Columbian Exposition. While there, she saw a plain white woven vest
and took pictures. It was "just a vest, a dingy white vest," she told me, "and then when

a

b

Figure 10.15 a and b
(a) Annie Williams in wool clothing collected by Rev. Myron Eells for the World's Columbian Exposition, 1893. Photograph by Myron Eells (?). Whitman College and Northwest Archives. (b) Shelby Pavel wearing mountain-goat wool dress and headdress and a glass-bead necklace made by Susan sa'hLa mitSa Pavel, 2002; now in the collection of the Heard Museum.

a

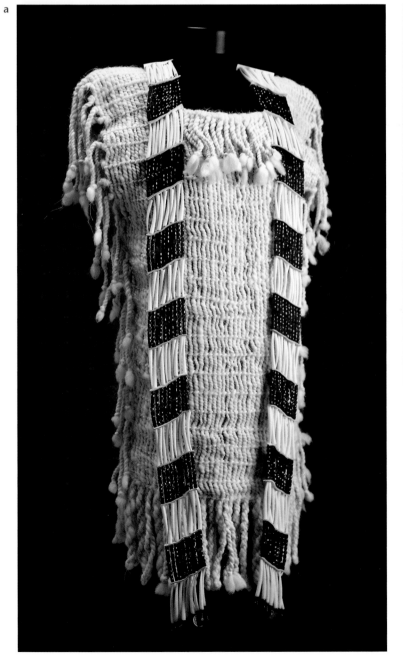

b

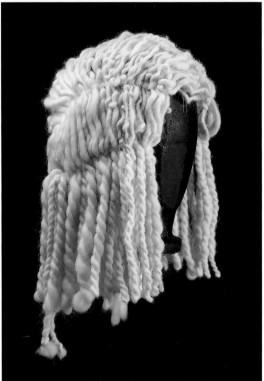

Figure 10.16 a and b
(a) **Dress and bead necklace,** by Susan sa'hLa mitSa Pavel, 2002; mountain-goat wool, glass beads, approx. 35 × 20 in. (88.9 × 50.8 cm); (b) **headdress,** by Susan sa'hLa mitSa Pavel, 2002, mountain-goat wool. Heard Museum, IL.1732.ALB-T-205.

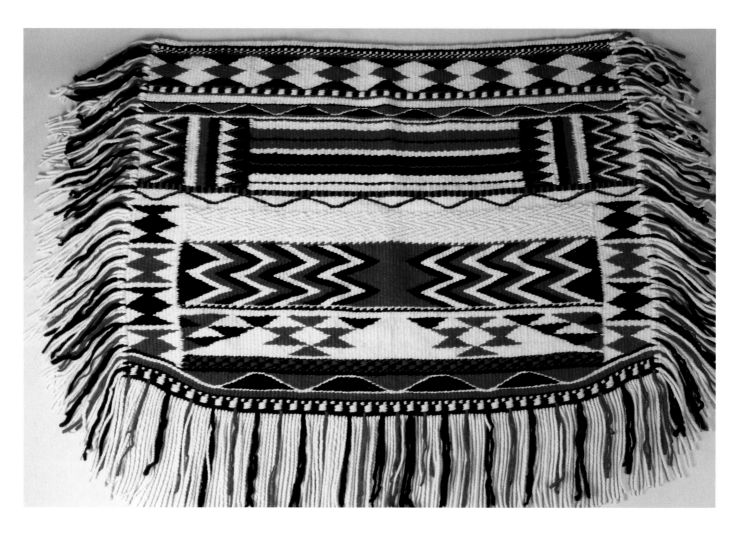

Figure 10.17
The Mourning Star Robe, Debra Sparrow and Robyn Sparrow, Musqueam, 2006; sheep wool, 62 × 84 in. (157.48 × 213.36 cm). Burke Museum of Natural History and Culture, Seattle, 2006-13/1.

"This blanket became an honouring of two special women. One was our Auntie Shirley who passed as we worked along on the weaving. In the early morning of the day she passed, I sat in my car at 6:00 AM and looked up at the stars. I thought of her and wondered if there was a new star that was for her. We also lost my sister's sister-in-law at a young age of forty. Robyn and I decided to create two stars at the end of the blanket for them. We were in mourning, thus *Mourning Star*."—Debra Sparrow, 2008

I came home—and here is spirit moving—that vest kept tapping me and I would think about it, dream about it." So she experimented with techniques to re-create the vest and she came to understand what it was intended for. Even a few years ago, she explained, the Skokomish people participating in the Tribal Canoe Journey (an annual convergence of more than seventy traditional canoes from British Columbia, Washington, and Alaska) were not wearing their own culture's traditional regalia. In the weeklong program, participants wore button blankets, beaded vests, and shawls from store-bought fabric—but not Skokomish garments. In 2007, the Skokomish were wearing their own woven regalia, inspired by Pavel's powerful encounter in the museum collection.

Others mention the spirit with which they weave garments. Lynn Dan of Musqueam said, "When you know the person, I think the weavings are lighter. Recently I showed this man from Chehalis some leggings I made for him last year, comparing them to

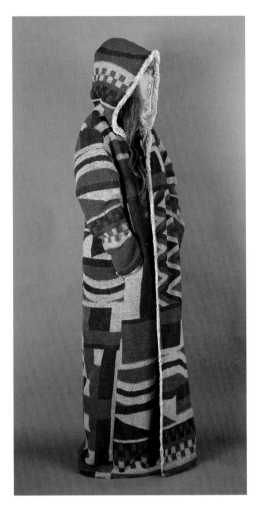

Figure 10.18
The Evolution of Salish Design Coat, Debra
Sparrow, Musqueam, and Frederick Fung,
2006; wool faux fur, 60 × 18 in. (152.4 ×
45.72 cm). Collection of the artist.

"For the design of the coat it only makes sense to take Salish design
to the place we are today—one foot in tradition and one in the
contemporary world. The old design elements speak to me and
guide me to take them in new directions. I am a facilitator of this
change. I merely assist the evolution because I respect the heritage.
As Salish people, we move, change, and evolve and new expres-
sions find their own time."—Debra Sparrow, 2008

leggings that someone else had done. Mine were really light compared to the other
ones" (Dan, pers. comm.).

Debra Sparrow said of Salish weaving that it "is really part of a larger whole that
can't be extracted. If you extract it, you take it out of its context, and you lose some
of its power and its meaning" (Sparrow, pers. comm.). Sparrow's statement reminds us
that much power and meaning had seemed to be lost during the twentieth century. The
movement of Salish weavers today, as well as what moves them, suggests that the power
was captive rather than lost. The recent history of Salish weaving is not continuous, but
it does connect, one episode to another, one generation to another. What was once held
apart and held back by collectors; what was waylaid and transformed by the pressing pri-
orities of colonialism and modernization; what was displaced by experiments with other
materials and other aesthetics—all this was remembered and capable of being recol-
lected. Perhaps the text to be written about Salish weaving in the twenty-first century
will be about a profusion of forms, during a time when the work of hands became ever
more precious.

Note
1. Weaving with strips is also a tradition developed in the Inte-
rior, where small mammal hides were woven on a warp.

245

WHEN MOST PEOPLE ENCOUNTER THE TERM "dugout canoe," they think of a crudely hollowed log with more or less pointed ends—a functional boat for simple purposes, but not much more. This sort of rough-and-ready vessel has in fact served people well in many places and times. Such simple craft enabled the Corps of Discovery, led by Lewis and Clark, to navigate the lower Snake and Columbia rivers to the Pacific Ocean and back again to the Rockies the following spring. At other times and in other parts of the world (notably Asia, the Pacific Islands, and northern California), the crude dugout was much further refined, reaching the level of an art form. These areas have produced beautiful vessels that exhibit smooth, fair lines and graceful curves and flare, which not only look good but also greatly enhance the serviceability and seaworthiness of the boats. In just a few areas of the globe, the basic idea of a hollowed log vessel was

More than Transportation
The Traditional Canoes of Puget Sound

Steven C. Brown

carried to an even greater degree of refinement and sophistication. In parts of South America, northeastern Europe, and the Northwest Coast of North America, the concept of altering the size as well as the shape of the log by the application of steam was incorporated into the construction process. The result was a canoe that was bigger than the log from which it was carved. The hull of such a canoe could be spread out until it was at least 50 percent wider than the original log, and in some cases even more.

This was accomplished by planning ahead for the dynamic changes that come about in the process of spreading open the sides of the canoe, and carving the wooden hull down until it was one inch in thickness on the sides and just an inch and a half on the bottom (fig. 11.1). Then, as the steaming process goes forward, the sides are bent outward and the ends of the canoe are drawn closer together, causing the bottom to bend upward from end to end, and radically altering the appearance of the vessel (fig. 11.2). Such were the canoes of the Northwest Coast and Puget Sound, where it can be said that these processes of sculptured canoe design and refinement reached their global peak.

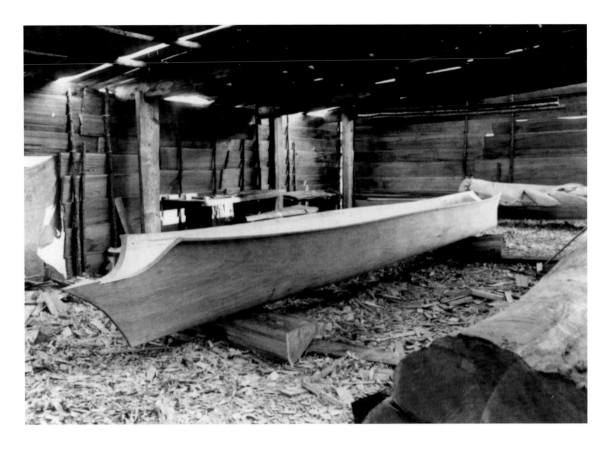

Figure 11.1
Canoe making in progress. Carved by Steve Brown and Lance Wilkie for the Makah Cultural and Research Center, 1978.

The canoe has been hollowed out and is ready for steaming. The hull is but an inch in thickness on the sides. Note that the bow and stern pieces, which are made separately, have not yet been added.

Puget Sound is a large inland body of water that opens indirectly to the Pacific Ocean via the long and often tempestuous Strait of Juan de Fuca, which joins with the mouth of the sound in an area known as Admiralty Inlet. Puget Sound is therefore a large region of comparatively protected and much less menacing waters than are found in many other parts of the Northwest Coast. These waters and the accompanying mild climatic conditions in the area from Puget Sound to the upper Strait of Georgia enabled the development of the most densely populated region of the aboriginal Northwest Coast. At least five families of Coast Salish languages and fourteen distinct tribal or cultural groups made their homes and their fortunes in the Puget Sound region. The lives and cultural traditions of all these groups were elevated to new levels of existence with the development of the functional and seaworthy sculpted cedar canoe. Western red cedar trees of very large and often remarkable size once grew in abundance in the region, and this resource was respectfully employed by Native peoples for many tasks, including constructing houses, sculpting large monuments, and building canoes. Unfortunately, most of these large trees are now gone, logged off by big corporations for quick profits over the course of the twentieth century.

These cedar vessels were perfectly adapted to the distances most often traversed and the types of water conditions commonly encountered in the sound as well as in the Gulf of Georgia region, which to a large extent incorporated the same types and designs of

Figure 11.2
Canoe making in progress: steaming. Carved by Steve Brown and Lance Wilkie for the Makah Cultural and Research Center, 1978.

Creating steam with water and hot rocks allows the wood to soften and the sides to be spread. This thirty-two-foot whaling canoe went from forty inches wide to fifty-eight inches after the steaming was complete.

aboriginal canoes with only minor variations in form. Specialized canoes were designed for either salt water or river travel, with characteristics that were particular to each environment. Canoes were employed in basic travel for social occasions, for fishing, for the hunting of both land and sea mammals, and for food gathering or processing journeys to and from traditional resource sites. Large and more or less permanent winter villages were surrounded by near and distant satellite areas rich in particular food or material resources. These ranged from the salmon runs of individual rivers or creeks, which might support any or all of the five species of anadromous Pacific salmon, to areas known and cultivated for the harvesting of abundant crops of berries, edible roots, shellfish, or craft materials. Viable canoes made this kind of regular seasonal travel possible, as people paddled the rounds from winter homes to the fish gathering and preserving sites of summer, to the hunting or resource gathering locations of the spring and fall. Without the seaworthy canoe, aboriginal existence on this coast would have been entirely different, as access to the freedom of movement afforded by waterborne transportation literally spawned the richness of material culture for which these cultures are recognized.

The process of such advanced canoe making as was practiced on the Northwest Coast came about through generations of inspiration, experimentation, and refinement, and was passed down from master to apprentice in a traditional line in village after village. This is what accounts for the vision so often seen in historical photographs that show large groups of canoes, where each is carved to the same precise standards of

workmanship that produced the seaworthy lines and characteristic forms established by the traditional masters. Inspirations, in the form of dreams or visions, provided the initial forms of the various canoe types, with further experimentation and refinement paring their shapes down to only the most essential elements. The demands of wind and water reduced various aspects of the canoe to their optimum size and shape. Just enough flare is carved in the ends to turn off the rising swells without adding unnecessary bulk and weight. The rise and width of the ends, if they are too high and too large in size, merely catch more wind and raise the center of gravity in the canoe, making it top-heavy and therefore less stable and more liable to tip radically. The traditional canoes are living examples of the idea that less is really more.

Canoe making, like weaving and other refined arts, was not undertaken by just anyone, but was the skilled work of trained artisans. These were specialists who had been taught the traditional shapes and the idiosyncrasies of canoe construction, such as the characteristic form that the canoes had to take prior to being steamed and drawn out

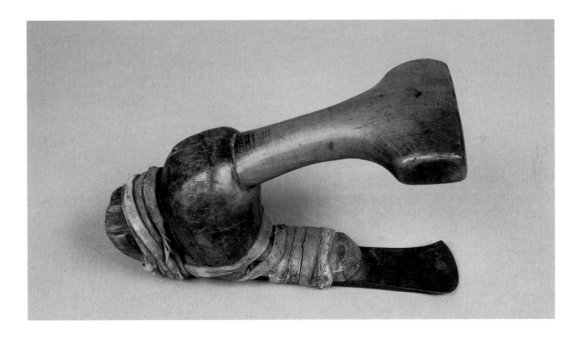

Figure 11.3
Elbow adze, Twana, late nineteenth century, yew, steel, hide, 8⅛ × 4¾ × 3⅓ in. (20.63 × 12.06 × 8.46 cm). Collected by Rev. Myron Eells for the World's Columbian Exposition in 1893. Burke Museum of Natural History and Culture, Seattle, 18.

In the manner of its use, the elbow adze of this type is closer to the D-adze than to the elbow adzes of the northern Northwest Coast. This style of adze, with many local variations, was used throughout the Puget Sound and Hood Canal areas. With the carver's hand positioned close over the top of the blade, the short handle added only a little leverage to the carving effort. With experience, however, a tool like this can accomplish a great deal of accurate wood removal. All kinds of hewing tasks were done with this tool, from the sculpting of canoes, models, bowls, and trays to the flattening and trueing of planks split from large cedar trees with wedges made of wood.

into their final width. The challenging tasks to which these vessels were put largely dictated certain aspects of their form. Canoes had to be made light enough so they could be drawn up the beach above the high tides and be paddled for miles on end in long journeys. They also had to be wide enough on the bottom to be as stable as possible, to preserve life in the rough waters and strong currents that are frequently encountered even in such comparatively sheltered waters as Puget Sound. If the hull is not carved thin enough, the dynamic changes of the steaming process are hindered and unsuccessful, causing splits in the hull. The canoes of the past were carved with sets of very rudimentary tools—adzes and axes of stone and steel,[1] two-handed scorps, wooden wedges, stone hammers, and carving knives for the finish details—but they all lived up to the traditional standards of form and finish. Canoe makers were always in demand, as over time the canoes would wear out and deteriorate in the wet marine environment, to be replaced by new vessels that were under construction on a more or less constant basis.

The skilled craftsmen that created the reliable and seaworthy vessels of the Northwest Coast left no visible record of their techniques or achievements except one—their work. The very small number of surviving, full-sized historical canoes that exist today and the numerous canoe models of varying sizes and designs are all that the old masters

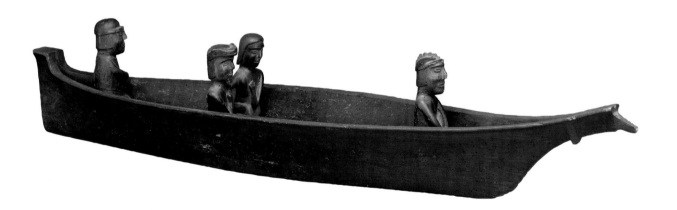

Figure 11.4
Model canoe, Nuu-chah-nulth, late eighteenth or early nineteenth century, alder, paint, nails, 7½ × 38 × 7½ in. (19.05 × 96.52 × 19.05 cm). The Margaret E. Fuller Purchase Fund and the General Acquisition Fund in honor of Jay and Susan Gates, Seattle Art Museum, 93.80.

This large model depicts the style of Nuu-chah-nulth canoe that was the standard of the early nineteenth century and before, with a bow piece that curves up from the level of the gunwales noticeably less than on the canoes of this type made after about 1880. The four figures that have been added into the canoe are said to represent a wedding party, among which several interesting styles of headgear can be seen.

left behind. Each one of these is an invaluable treasure. There are a fairly large number of finely made models from the Northwest Coast that were created for Native use as well as for sale to interested outsiders, who often admired the beauty and utility of traditional Native watercraft. Full-sized examples of historic Gulf of Georgia or Puget Sound style canoes are quite rare today, and so are the models of Coast Salish canoe styles, but the small numbers of these that survive tell us a great deal about their full-sized cousins from the past. They are the blueprints from which contemporary canoe makers can learn and refine their art, if they choose to study them.

Canoe models have probably been made for as long as the large canoes themselves. The oldest known Northwest Coast models survive only as fragments that were excavated in the 1970s from the Ozette village archaeological site in Makah territory on the Washington coast. These were found within the households that were engulfed by a massive mudslide between three hundred and five hundred years ago, and they illustrate the traditional family use of such objects. Models were made by carving them to form; they were not steamed out like their full-size counterparts, but the best ones contain all the characteristic forms and details of the large vessels. Some were made to illustrate various activities, such as a fine early Coast Salish model that includes a sturgeon fisherman

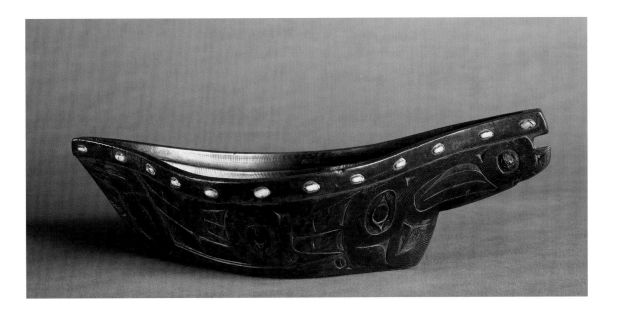

Figure 11.5
Canoe-shaped bowl, Coast Salish(?), late eighteenth or early nineteenth century, wood opercula shell, 6⅜ × 12½ × 4¼ in. (16.19 × 31.75 × 10.79 cm). Collection of Eugene and Martha Nester.

This wonderfully enigmatic bowl is carved in the form of a Salish canoe yet has surface designs that are diagnostic of the very old style of northern Northwest Coast cultures. Late eighteenth-century drawings from Capt. George Vancouver's voyage show typical Salish canoes as far north as the Kwakwa̲ka'wakw people, but the surface carving looks to be from northern British Columbia or coastal Alaska. The designs on the two ends are unusual (Bill Holm, pers. comm.).

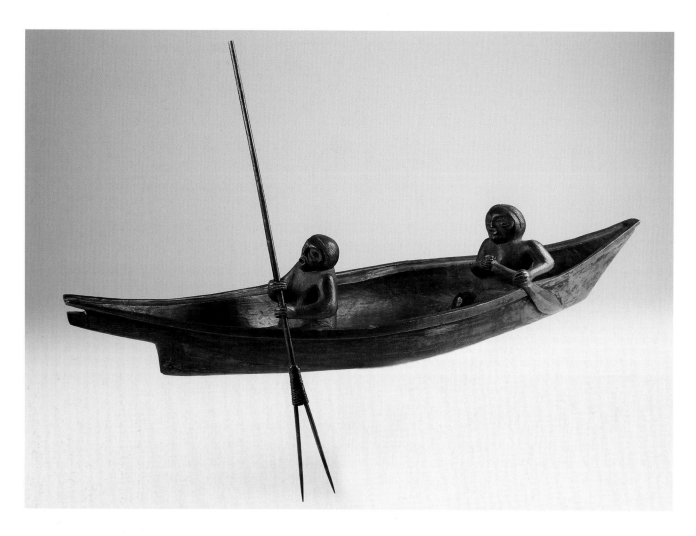

Figure 11.6
Model canoe, early nineteenth century, wood, leather, 7 × 22 × 4½ in. (17.8 × 55.9 × 11.4 cm). Acquired by Colin Robertson before 1833. Perth Museum and Art Gallery, Perth & Kinross Council, 1978.502.1.

Collected with two similar canoe models along the Fraser River, this remarkable piece is one of the few historic models of the indigenous Coast Salish canoe type and perhaps the only one showing sturgeon fishing. The paddlers appear to be singing, as one of them uses a special spear to impale the large, bottom-dwelling sturgeon. Sturgeon once grew to enormous sizes in area rivers, and ingenious methods were devised for their capture, including long pole sections that could be linked together to reach the deep river-bottom lairs of these prehistoric-looking but tasty fish.

with his characteristic long pole (fig. 11.6). Interior figures were frequently included in exceptional models, and the most remarkable of these have the figures carved from the same piece of wood as the canoe itself. Sometimes a canoe and its entire crew are carved from one block of wood, while in other cases the carved interior figures are added separately. Northwest Coast models were almost never made to scale, but were exaggerated in their proportions of height and width to emphasize the upward curves of the ends and the sweeping lines of the gunwales.

Puget Sound canoes were made in two main types. The first are river canoes, which are referred to in English as "shovel nose" canoes because the appearance of the ends of these long, narrow, and shallow canoes looks a bit like a square-ended shovel (fig. 11.8). The second major type is composed of seagoing or saltwater canoes. Of these, at least

Figure 11.7
Diagram showing canoe types used by
Salish people. Top: shovelnose canoe
(x̣ʷəlayʔ); center: Coast Salish canoe or
hunting canoe (sdəxʷiɫ); bottom: Nuu-chal-
nulth or Westcoast canoe (ʔəʔutx̌s). Draw-
ings by Kenneth Greg Watson, 2008.

Figure 11.8
On the Quinault River, Edward S. Curtis,
1912, photogravure. Gift of John H.
Hauberg, Seattle Art Museum, 86.154.

Curtis evocatively captures a small group of beautifully made
shovelnose river canoes drawn up on the bank of the Quinault
River, near the village of Taholah on the Quinault Reservation in
southwest Washington. This long and shallow canoe form was
perfectly adapted for navigating the region's rivers, from their
mouths to the beginning of their most serious rapids. Maneuver-
ability was accomplished mainly by the riders standing up and
using poles instead of paddles for upstream travel.

two different types were commonly in use in the Puget Sound region. The true indig-
enous Coast Salish–style canoe was known as *sdəxʷiɫ.* This canoe features narrow, drawn-
out forms in the bow and stern and a distinct flare from the hull outward that runs
slightly below the gunwale from end to end. The bow extends forward over a thin and
nearly vertical cutwater, which is sometimes squared off at the bottom and sometimes
rounded back. In profile, the stern is angled gently up, so that the peak of the stern flare
extends out over the water in a manner similar to the bow end. These hull characteristics
give the canoes the ability to ride up and over oncoming waves or following seas, and
the carved hull flares serve to turn outward any water that reaches their height at the
gunwale. The undersides of these vessels are keel-less and smooth, and the continuously
curving sides angle outward from the gently rounded bottoms. Except for the line of the

253

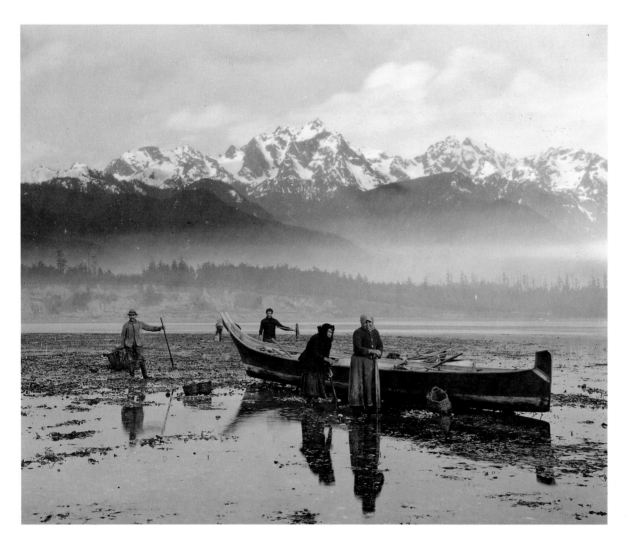

Figure 11.9
A Coast Salish family from the Port Townsend, Washington, area with their thirty-five-foot Nuu-chah-nulth–style canoe, digging for clams at low tide. Jefferson County Historical Society, Port Townsend, WA.

A S'Klallam family group stands proudly with their Nuu-chah-nulth–style canoe, digging clams at the far north end of Sequim Bay in the late nineteenth century. This large canoe has extremely fine lines and fair curves that denote a canoe maker of exceptional skill and experience. Having paddled in at a higher stage of the tide, the clam diggers will work through the low ebb until the rising of the next tide refloats their big canoe. Their net-woven gathering baskets, made of spruce or cedar roots, allow effective rinsing of the clams to rid them of sand and mud.

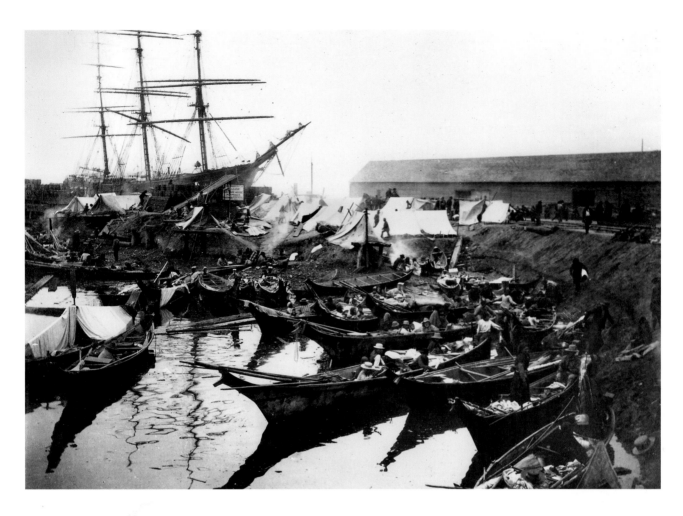

Figure 11.10
Canoes on the Seattle waterfront, c. 1909.
Special Collections Division, University of
Washington Libraries, NA680.

Coast Salish people from all over Puget Sound and First Nations
peoples from the British Columbia coast frequently journeyed to
Seattle for work or trade, or to sell basketry and other artworks on
the streets. Hops fields in the White River Valley and strawberry
fields were common employers of Native labor. The site in this
photo may be at the foot of Washington Street, where a welcome
portal from about 1920 still stands.

bottom from end to end, there are no straight lines on a traditional canoe. This shape
gives the canoe considerable stability for a narrow vessel of this kind, and because tradi-
tional Native people were literally raised in canoes, they learned to manage and handle
these vessels with great skill in all types of conditions.

A second traditional canoe type that was used extensively in Puget Sound waters
appears to have originated outside the immediate area. Known variously as the Makah,
Nuu-chah-nulth, or Chinook style, this canoe is made of three separate pieces, though
the majority of the canoe hull is hollowed from a single log (figs. 11.9 and 11.10). The
sections of the bow and stern that rise above the gunwales are carved from large added
pieces of wood and attached to the hull along specially shaped scarf joints. There is
a pronounced outward flare just below the gunwale from end to end similar to the
Coast Salish type, but otherwise the shape is completely different. The bow of this
canoe extends forward in a line curving upward from the water, which is punctuated
by a small, short protrusion about two-thirds of the way up its length. At the top of

this curve, at a point just forward of the end of the gunwale flare, a snoutlike protrusion reaches forward and slightly down, lending the canoe a lively zoomorphic appearance. The stern rises vertically from the water and is crowned by a slightly angled flat top, which is an upward extension of the gunwale flare. This canoe style most likely originated on the ocean coast, among the Makah/Nuu-chah-nulth people of Vancouver Island and the northwest tip of Washington State. Early fur traders saw them in use on the Washington coast as far south as the lands of the Chinook people at the mouth of the Columbia River and up the Lower Columbia as far as the site of the Cascade Rapids (now Bonneville Dam).

On the outer coast, these canoes varied in size from smaller fishing and seal-hunting vessels to thirty-five-foot whale-hunting canoes, and on up to much larger freight-carrying and traveling canoes. The largest existing example is fifty-three feet in length, and is now housed in the Smithsonian Institution in Washington, D.C. In 1901, a Captain Voss refitted a forty-foot canoe of this type by decking it over and adding three masts with gaff-rigged sails and a rudder hung on the vertical stern. He then sailed the canoe from Victoria, British Columbia, across the Pacific Ocean, into and across the Indian Ocean, around Cape Horn at the southern tip of Africa, and up the Atlantic to London, England—surely the longest single journey ever undertaken in such a craft. His restored canoe now resides in the Maritime Museum in Victoria.

Canoes from the outer coast have been traded into the Puget Sound region since at least the late nineteenth century, as indicated by their presence in historical photographs from that period and later (see fig. 11.10). As late as the middle nineteenth century, the Makah and Nuu-chah-nulth were often at war with Coast Salish peoples of the eastern Strait of Juan de Fuca and Puget Sound, although it is possible that canoe trading may have been carried out between these groups during that time as well as more recently. It is probably certain that, once this style of vessel had become well known in the Puget Sound area, Coast Salish canoe makers undertook the carving of this style as well as ones of their own indigenous types. Respected for their seaworthiness in the rougher, outer coast conditions, this style of canoe is chosen today by Coast Salish people to be made for their own use more often than the indigenous Coast Salish style.

The contemporary canoe journeys that have sprung up in the wake of the Paddle to Seattle in 1989 have expanded consistently over the years and now involve great numbers of Native people, young and old alike (see Qwalsius Shaun Peterson's essay in this volume). The rewards sought and fulfilled by the challenge and discipline that these journeys provide and require have been rich and varied, and are always recognized by those who speak of their experiences in these activities. It is unfortunate that this surge of interest in traditional canoe culture has come at a time when the old-growth trees upon which it was based have mostly been logged. Many of the canoes employed today for these journeys are made from whole logs, as were the traditional vessels, while others are made by the method known as strip-planking, which saves a tremendous amount of wood compared to the dugout versions. A fair number of strip-planked canoes could

ideally be made from the same log that would only produce one carved canoe and several hundred pounds of chips. Some carved canoes have served as the models from which copies have been made from fiberglass, and these have extended admission to canoe usage for those groups without access to large cedar trees.

Even today, the conditions encountered on the region's waters can be very rough and challenging and require the greatest service from the canoes and those who handle them. Museums can play an important role in making the models and full-size versions of historic canoes available for measurement, photography, and study by aspiring canoe makers, whether their goal is a carved and steamed vessel or a strip-planked one. By wedding the traditional standards of the past with the enthusiasm of the present, everyone involved can benefit, and the best examples of the indigenous canoe-carver's art can carry people over Puget Sound waters as they have for centuries past.

Note

1. Iron and steel tools have been found on both the southern and northern Northwest Coast that date to at least 500 BP (before present). Among the knife-sized tools recovered at the Ozette archaeological site on the Washington coast (dated to 300–500 years old) were thirty-seven ferrous metal–bladed tools and only one beaver-tooth knife, indicating the preponderance of iron and steel blades at that distant time. A lone Native hunter was recently found thawed from the ice near Dalton Pass, upriver from Haines, Alaska. His clothing and tools were dated to 500 years BP. He carried in his belt a steel-bladed knife. The metal of this and other early blades has been attributed primarily to Asian origin, most likely recovered from driftwood and/or shipwreck debris found on the outer coastal beaches. The first European explorers in the region arrived in the 1770s and found that Native peoples in the area already had iron and steel tools in common use. They knew iron's value and how to work it, though not how to smelt it from ore, and had names for such metals in their own languages, clearly indicating a longtime familiarity with the material. Access to more and varied forms of these metals through direct trade with Euro-Americans since the late eighteenth century further increased the use and sizes of steel tools in woodworking and warfare.

WHEN ONE THINKS OF THE NATIVE PEOPLES of the Northwest Coast, images of totem poles, cedar houses, and canoes on the waters come to mind. Today, however, a different reality exists. For the most part, Native languages have dwindled away, along with the stories and songs they interpreted. Traditional lifestyles of food gathering and ceremonial celebration face continual challenges. Such a loss of essential cultural identity has left a void that some have filled with alcohol, drugs, or family violence. Yet some countermeasures to balance negative incursions into traditional culture have, in recent decades, gained significant momentum in the pursuit of cultural reclamation. In particular, the Canoe Journeys, or Tribal Journeys, have been a catalyst in the resounding resurgence of aboriginal culture and values.

The Journey Has Just Begun

Qwalsius Shaun Peterson

The modern Canoe Journeys began in the 1980s, first with a single Bella Bella canoe paddling in the Vancouver Expo '86 opening ceremonies, and then in 1989, when seventeen tribes participated in the Indian Canoe Project during Washington State's centennial celebration. Quinault tribal member Emmett Oliver, a canoe "puller" in his youth, was the project coordinator and was instrumental in organizing the Paddle to Seattle, a moving event where more than twenty Native canoes landed at Golden Gardens beach in Seattle on July 21, 1989 (Oliver 1991: 248–49). The event was intended to honor the maritime traditions of Native people and to recognize Native contributions to the economic and cultural development of the region. The gathering further engendered dignity and self-respect for Native participants and guests as it harkened back to aboriginal times when the canoe was the primary means of transportation, food gathering, and preserving the strong spiritual connection to water. After more than a decade of annual journeys, its persistence and expansion are keys to continued cultural revitalization for indigenous peoples of the Northwest Coast.

258

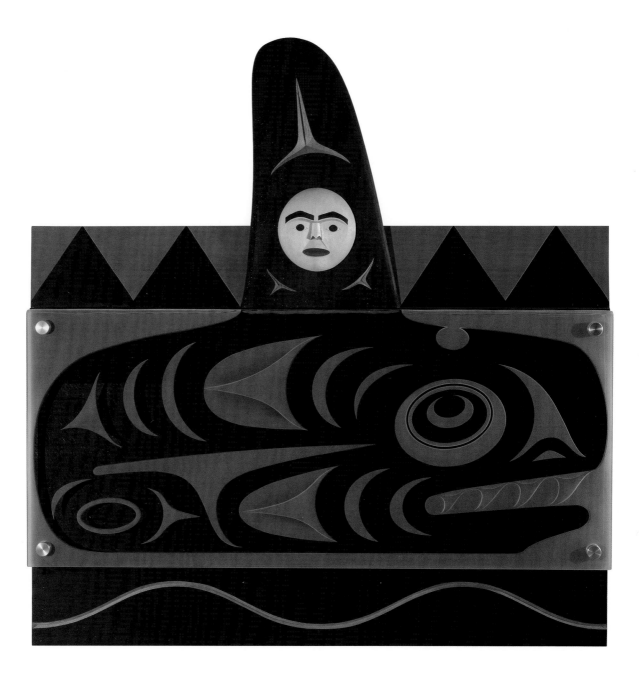

Figure 12.1
Journey by Moonlight, Qwalsius Shaun Peterson, Puyallup / Tulalip, 2007; wood, glass, paint, 43 × 42 × 3¼ in. (109.22 × 106.68 × 8.25 cm). Collection of the artist.

In Coast Salish society, children learn about their tribes' histories and family genealogies through legends recited by cultural historians over many hours. Stories also link living Native peoples to their mythic ancestors, such as Grandmother Cedar, Raven, and Bear, through tales of encounters and journeys and through the bestowal of names, dances, and songs upon their human relatives. Practical advice about health and hygiene is imparted through stories, as well as knowledge of the plant and animal world. Origin stories of basket making, weaving, and other human-centered endeavors also make up the repertoire of oral literature. Works of art "tell their own stories," about the experiences and motivations of the artist, about the transformation of group-held beliefs into patterns and designs, and about the journeys the artworks make from owner to owner, from generation to generation.

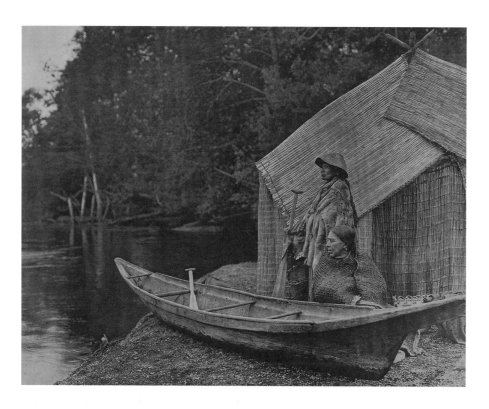

Figure 12.2
Fishing Camp—Skokomish, Edward S. Curtis, 1912; photogravure, 11⅞ × 15½ in. (30.2 × 39.3 cm). Gift of John H. Hauberg, Seattle Art Museum, 86.159.

The famed photographer and filmmaker Edward Sherriff Curtis (1868–1952) devoted his artistic career to documenting many Native and First Nations people at a transitional historic moment, between 1885 and 1935. Volume 9 of his monumental project *The North American Indian* focused on Coast Salish people and provided a wealth of information about traditional arts, clothing, and life-ways: this image shows the old-style canoe and paddles, hand-woven cedar-bark cape and hat, and the all-purpose cattail mats covering the temporary dwelling. In 1912, when this photograph was taken, Skokomish women were still working with cedar bark and cattails and the men were still using canoes for fishing and travel. Their homes and camps, however, would have necessitated a mix of traditional and modern tools and functional goods, as well as clothing. *The North American Indian* remains one of the most ethnographically important documents of Native culture, yet it is often cited as a romantic perpetuation of nineteenth-century stereotypes. Issued in a limited edition of twenty volumes from 1907 to 1930, the publication included 2,000 photogravure images bound with ethnographic text and accompanying portfolios of large plates.

Imagery and Reality

Even in the twenty-first century, we have trouble shaking off the "vanishing Indian" perception that was so well perpetrated in the photographs of Edward S. Curtis and others (see fig. 12.2). Available images of Northwest Coast Native peoples today seem to have a somewhat skewed perspective. Though traditional lifeways have been radically altered and some are in grave danger of disappearing altogether, the People are still here. In the late nineteenth century, traditional arts and practices, such as canoes, cedar houses, totem poles, and welcome figures, as well as the ceremonies associated with them, were repressed and our people were pressured to abandon what was unique and central to who they were. A huge void was created—one that led to self-deprecation and destructive behaviors—and the trauma of our grandparents is still felt today. The annual Canoe Journeys are a means of uprighting our culture from the capsizing of the cultural canoe. Sometimes it feels as though we are expected to be that Curtis-created Indian with all the visible trappings of tradition. At times we might wish for that, too, but the reality works against us. It is very complicated being a Native person—and a Native artist, as I am—in the contemporary world. I remember going to my great-uncle Jerry Jones (dx\u02b7squis) for advice about being a Salish artist. He told me that he could help me make tools and teach me some technical aspects of carving, but that I would have to learn the Salish style—which he had not learned—in place of other dominant styles like that of the Kwakwaka'wakw or Nuu-chah-nulth.

Figure 12.3

Jerry Jones (dx\u02b7squis) carving a canoe at the Tulalip carving shed.

The late Jerry Jones (1940–2003) was instrumental in the renewal of canoe carving and journeying that began in 1989. In that year he completed, with Joe Gobin, the canoe *Gift of Our Ancestors,* and in 2000 he carved the *Little Sister* canoe. He used the canoes as teaching tools and said, "We tell how the canoe was carved, how important it is to our culture and how we have to take care of it for future generations" (Tulalip, Master Carver brochure). Jones was a beloved teacher and master carver for Tulalip Cultural Resources.

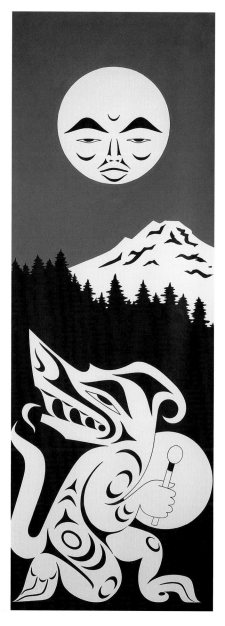

Figure 12.4
Song for the Moon, Qwalsius Shaun Peterson, Puyallup/Tulalip, 1975; acrylic on canvas, 101 × 42 × 1 in. (265.54 × 106.68 × 2.54 cm). Gift of the Seattle Art Museum Docents, in honor of the 75th anniversary of the Seattle Art Museum, SC2006.13.

One of the defining features of Shaun Peterson's work is the lyrical way in which he fuses cultural knowledge and personal experiences. With his visual storytelling, he places himself upon that age-old continuum of revisiting old teachings and giving them a new voice. His work has the feel of the monumental, from sculptural combs, rattles, and canoe paddles to large-scale public works. The epic legends (*sx̌ʷiʔab*) that inform many of his artworks recount the origin of living beings. These legends tell how the earth was prepared for living beings and how those beings should conduct themselves as they walked on earth. Often in these stories, every creation is personified as a living entity—rocks, the moon, trees, and animals. These accounts can be so vivid as to describe particular landforms that one is familiar with today, like Mount Rainier (pictured here) or the Puyallup River. For people without maps and addresses, stories connected them to the land.

When I was doing some teaching at Chief Leschi Elementary School, I was saddened that the students felt impoverished because they did not have a welcome song or examples of artwork that represented them. That was at a time when I was working traditional stories into my art and imagery. I would tell them, "This is a story that is generations old from our people." Knowing that, stories can create a sense of belonging when one is adrift. I still refer to these powerful teachings in my work but have moved toward capturing some of the energy and spirit of our art and our way of life, one that honors the present equally as the past.

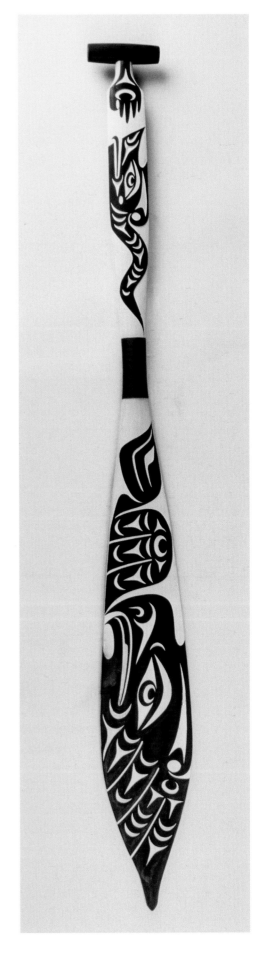

Figure 12.5
Thunderbird and Serpent, Qwalsius Shaun
Peterson, Puyallup / Tulalip, 2006; yellow
cedar, paint, twine, 52½ × 6 × 1½ in.
(132.03 × 15.24 × 3.81 cm). Burke
Museum of Natural History and Culture,
Seattle, 2006-158/1.

In the traditional repertoire of canoe paddles, there were several
styles of blades and handles that were determined by the type of
water travel intended and by whether the paddles were made for
men, women, or children. Today, artists replicate the function-
ality of canoe paddles but use the challenging vertical surfaces to
create innovative designs (see also fig. 5.41). Bird imagery is often
included on canoe journey paraphernalia and in the canoe songs
and dances, because birds are symbolic of strength and pride,
fitting symbols for these arduous but culture-affirming summer
events.

263

Figure 12.6

Transporter II / Spirit Board, Marvin Oliver, Quinault/Isleta Pueblo, 2005; glass, stainless steel, 47 × 14 × 6½ in. (119.38 × 35.56 × 16.51 cm). Stonington Gallery, Seattle.

Marvin Oliver has been a force in bringing public awareness of the lexicon of Coast Salish forms, albeit employing a syncretist approach crafted from knowledge of an array of coastal styles, his ancestral Quinault traditions, and a truly modern embrace of dynamic design and nontraditional materials. One of the leaders in the Native glass art movement, Oliver co-opts the unique shape of the shaman's board from the Soul Recovery Ceremony and overlays its luminous glass surface with quintessential imagery from the Northwest landscape—ravens and the snowcapped mountains. As an internationally respected artist and as professor of art at the University of Washington, Oliver has been one of the most influential teachers and mentors of Northwest Native art.

Counterbalancing

In a canoe, balance is everything. Your counter—the paddler or "puller" opposite you—is a similar weight to you. It is important when rough water swells hit the canoe. The collective balance must work together to take it safely through its course. The cultural devastation and the wake it left behind forced some to counterbalance against negative behaviors. Others rode the wave of Native arts revivals beginning in the 1960s, sometimes with government support, sometimes on their own. Carvers and weavers alike from small villages and the urban areas of Seattle and Vancouver began a momentum of creating works of art for sale. Legitimizing traditional styles through the art market had a positive effect in Native communities as well as with the public. In the southern Northwest Coast, several artists followed their determination to revitalize the old styles. Among these pioneers were Joe David (Nuu-chah-nulth), Bruce subiyay Miller (Skokomish), Marvin Oliver (Isleta/Quinault), Stan Greene (Semiahmoo), and others. The Canoe Journeys have helped to solidify and expand the efforts of those who reached back to authentic examples of our art styles.

A New Journey Begins

During the Paddle to Lummi in August 2007, I spoke with a number of people who have been involved with the annual event over the years. With themes like "Healing through Unity," it is clear that one of the goals of the Journeys is to promote spiritual and physical well-being among our youth. They are the most vulnerable and the ones who will continue the momentum of culture revival. The positive messages of the Journeys that are framed in the honorific speeches, dances, and songs are being witnessed by a new generation and have inspired them to take up active roles in the revitalization process. The traditional-style paddles that were once made merely as wall decorations are now being put to use in our waters and held high with pride by a new generation of Native people.

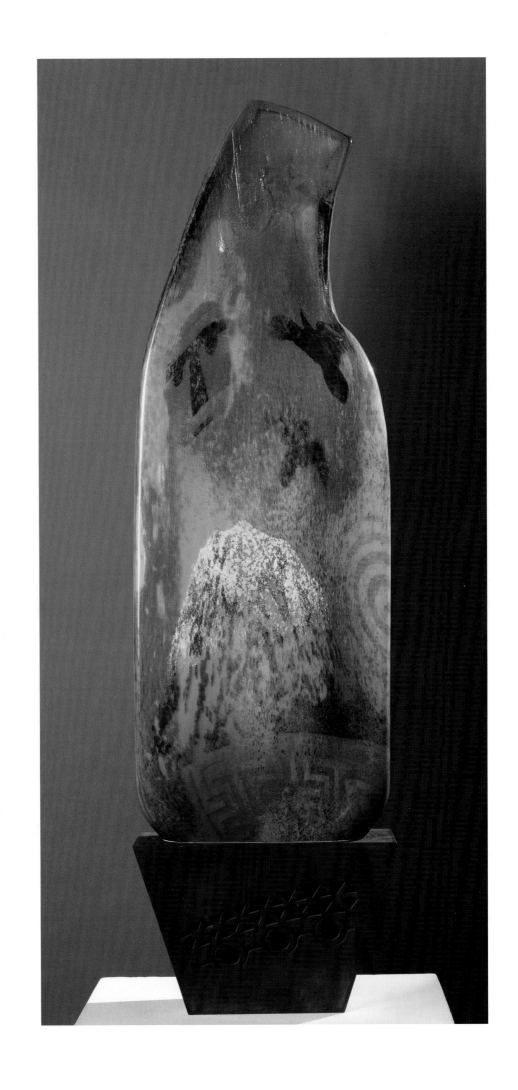

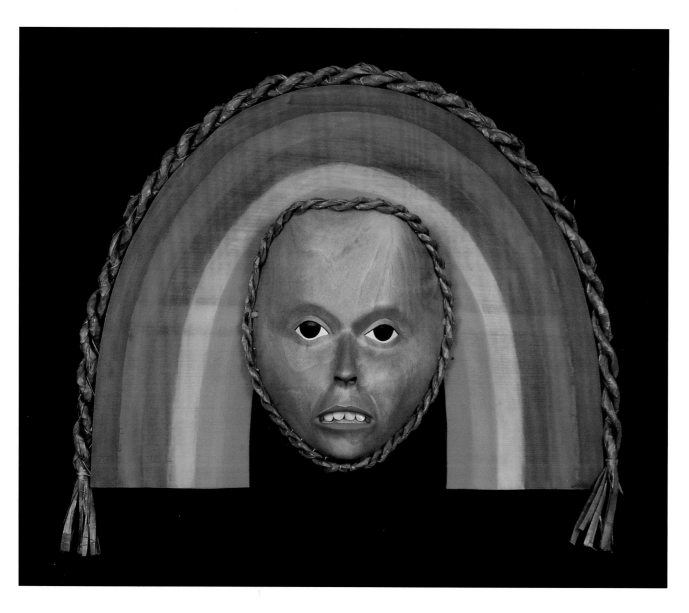

Figure 12.7
Rainbow Mask, Stan Greene (Eyi:ye), Semi-ahmoo / Chehalis / Nez Perce, 2007; wood, paint, cedar bark, 14 × 16 in. (35.56 × 40.64 cm). Collection of Paul Nicholson and Helen Carlson.

Although Stan Greene received training at the K'san School of Northwest Coast Art and practiced for some years in the Northern style, he is most known for steadfastly promoting the forms and meanings of traditional Central Coast Salish art. Many of his masks have personal significance: this one uses visual imagery seen in a dream about a medicine man with a rainbow aura. According to Salish beliefs, a man with medicine power had an aura around him, like a rainbow. These special individuals collected plants with which to make medicine. Once Raven tried to steal a medicine man's basket of plants, and as he flew with it, the plants were scattered in different places and that is the reason why certain plants are associated with the river, mountain, and valley landscapes.

The Journey Has Just Begun

Some people say you have to know your language or you don't know your culture, or that you have to live on the reservation to be Native. Why create such boundaries? Does that mean that when I am outside them I am less Native? Perhaps the most affirming thing to do is look at what we have and where we have come from and not at what we don't have.

Enduring the Storms Ahead

Although the Canoe Journey has grown in a short time, it faces obstacles. On the water, when the whitecaps hit, your captain may call for a "hard 50," which means you have to dig deep in the water with your paddle for fifty strokes to break through the rough waters. Often the call has to go out again, or go to a "hard 100," until the crew reaches more stable conditions. The fact remains that Native culture faces continual challenges, day by day. Even though preparation goes on throughout the year, the Journey is but one summer month. The challenge is to make it a lifestyle. I recall my first complete canoe journey as an adult, which was a paddle to Victoria, British Columbia, in 1999. It was amazing—singing, dancing, pulling, learning new songs and meeting new people. I was enthralled and felt so connected to something that had been missing. When it was over and I returned home, the old void became apparent once again.

At that point, I made a decision to seek out my heritage and incorporate it into my life. I wanted my art to belong to the momentum to reclaim Salish traditions. I wanted to make purposeful art, not just with proficient design or technique but with the spirit of what was behind the art, the ideas that are transferred when the old style is brought out. There are many young people who are content with their modern-day lives, and who don't feel the need to "be Indian." It is like having a full-time job, and the reality is that many are busy just getting by. Sometimes it is hard to keep tribal politics out of cultural endeavors like the Canoe Journey, and in that arena the youth cease to be the focus. All these challenges are growing pains that are part of the process.

Working with the Tide

At the crack of dawn, depending on the rise or fall of the tidal rotation, a crew must launch their canoe to "catch the tide" in order to ensure a journey with less resistance. It is about working with the thing we cannot change. In the big picture, there will never be a return to the old days as a tribal society. It is often noted that objects created by many Native artists today are made for the art collections, whereas their original purpose in pre-contact time was primarily for a specific use. They were there to do work. It is not likely that we will be able to peel back the layers of times past and resurrect that place in time. We have become citizens of the world. This being the case, it calls on our tribal community to "catch the tide" in the modern world.

I didn't have any formal art training, but I have observed individuals that I have considered to be the best; they have encouraged me to let my ideas flow, to fill my sketchbooks, because you never know when an idea will appear. It is like the old stories. At different times of your life you understand the different teachings in them. I work in many different, modern materials, including glass and metal. I have plans to try casting polymers and to use anodized steel. I am a contemporary artist and, like artists before me, I am drawn to new materials and new challenges. Teaching myself the intricacies of

Figure 12.8
Endurance, Qwalsius Shaun Peterson, Puyallup / Tulalip, 2008; computer-generated image of sculpture in progress. Courtesy of the artist.

This preliminary sketch of a work-in-progress invokes the age-old wisdom imparted to Peterson from an elder to tap one's inner core of resilience during times of upheaval, here symbolized by the bird's head within the eagle's wing. Buffeted by forces outside his control, even this mighty creature must call upon his inner strength. According to the artist, things that cannot be explained in words must be revealed in images born from the kinds of personal struggles that link us as humans.

the old Salish style gave me a foundation from which to strike out in different directions and to transcend any one perspective.

I think that the journey has only just begun and that part of our duty to honor our ancestors is to know that we are the ancestors to a future generation. We should be looking at our daily actions and asking ourselves if this is what we want our descendants to be proud of. The ancestral teachings that sustained people over the millennia are still valid: take care of the earth, respect the living things around you, share your knowledge, be kind to others, learn to listen and respect others' views, and work to resolve issues before they set you against another. These are elemental and don't require ceremony or public validation. Because I carry a Native name—Qwalsius—it is my daily responsibility to work toward those teachings the best I can. Above all, and what matters the most, is that we live and appreciate our own time, our own moment on this earth. Because things are always changing, our challenge is to be flexible and to always be able to "catch the tide."

Bibliography

Adamson, Thelma. 1926. "Sources of Chehalis Ethnology." Manuscript. Special Collections, University of Washington Libraries.

Ames, Kenneth M., and Herbert D. G. Maschner. 1999. *Peoples of the Northwest Coast: Their Archaeology and Prehistory*. London: Thames and Hudson, Ltd.

Amoss, Pamela. 1978. *Coast Salish Spirit Dancing: The Survival of an Ancestral Religion*. Seattle: University of Washington Press.

Ballard, Arthur. 1929. *Mythology of Southern Puget Sound*. University of Washington Publications in Anthropology 3. Seattle: University of Washington Press.

Barnett, Homer G. 1955. *The Coast Salish of British Columbia*. Eugene: University of Oregon Press.

Barrow, H. L., and Garland F. Grabert. 1968. *Arts of a Vanished Era: An Exhibition of the Whatcom Museum of History and Art*. Bellingham, WA: Whatcom Museum of History and Art.

Bates, Dawn, Thom Hess, and Vi Hilbert. 1994. *Lushootseed Dictionary*. Seattle: University of Washington Press.

Berlo, Janet Catherine. 1992. *The Early Years of Native American Art History*. Seattle: University of Washington Press; Vancouver, B.C.: UBC Press.

Bernick, Kathryn, ed. 1998. "Stylistic Characteristics of Basketry from Coast Salish Area Wet Sites." In *Hidden Dimensions: The Cultural Significance of Wetland Archaeology*. Vancouver, B.C.: UBC Press.

Bierwert, Crisca. 1999. *Brushed by Cedar, Living by the River: Coast Salish Figures of Power*. Tucson: University of Arizona Press.

Blackman, Margaret, Edwin S. Hall, Jr., and Vincent Rickard. 1981. *Northwest Coast Indian Graphics: An Introduction to Silk Screen Prints*. Seattle: University of Washington Press; Vancouver, B.C.: Douglas & McIntyre.

Blanchard, Rebecca, and Nancy Davenport. 2005. *Contemporary Coast Salish Art*. Seattle: University of Washington Press and Stonington Gallery.

Blukis Onat, Astrida R., and David Munsell. 1970. "Skagit Art: Descriptions of Two Similarly Carved Antler Figurines." *The Washington Archaeologist* 14(3).

Boas, Franz. 1890. *The Shuswap*. Sixth Report on the Northwestern Tribes of Canada, British Association for the Advancement of Science.

———. 1897. "The Decorative Art of the Indians of the North Pacific Coast." *Bulletin of the American Museum of Natural History* 9: 123–76. (Reprinted in Jonaitis 1995, pp. 58–106.)

———. 1900. "Art and Conclusion." In James Teit, *The Thompson Indians of British Columbia*, pp. 376–90. (Reprinted in Jonaitis 1995, pp. 127–54.)

———. 1905. "The Jesup North Pacific Expedition." *International Congress of Americanists* 13: 91–100. New York.

———. 1910. "Die Resultäte der Jesup-Expedition." *International Congress of Americanists* 16: 3–16. Vienna.

———. 1927. *Primitive Art*. Oslo: Institutet for Sammenlignende Kulturforskning. (Reprinted in 1955 by Dover Publications, New York.)

———. 1938. "Methods of Research." In *General Anthropology*, ed. Franz Boas, pp. 666–86. Washington, D.C.: Heath and Co.

Borden, Charles E. 1982. "Prehistoric Art of the Lower Fraser Region." In *Indian Art Traditions of the Northwest Coast*, ed. Roy L. Carlson, pp. 133–65. Burnaby, B.C.: Archaeology Press, Simon Fraser University.

Boyd, Robert T. 1999. *The Coming of the Spirit of Pestilence: Introduced Infectious Diseases and Population Decline among Northwest Coast Indians, 1774–1874*. Seattle: University of Washington Press; Vancouver: UBC Press.

Brotherton, Barbara. 2007. "Coast Salish Fiber Weaving." In *SQ3Tsya'yay: Weaver's Spirit Power*. Pullman: Washington State University Press.

Brown, Steven C. 1998. *Native Visions: Evolution of Northwest Coast Art from the Eighteenth through the Twentieth Century*. Seattle: University of Washington Press and Seattle Art Museum.

———. 2005. "The Coast Salish Two-Dimensional Art Style: An Examination." In Rebecca Blanchard and Nancy Davenport, *Contemporary Coast Salish Art*, pp. 7–20. Seattle: University of Washington Press and Stonington Gallery.

Bruseth, Nels. 1950. *Indian Stories and Legends of the Stillaguamish, Sauks and Allied Tribes*. Arlington, WA: Arlington Times Press.

Bunn-Marcuse, Katie. 2007. "Precious Metals: Silver and Gold Bracelets from the Northwest Coast." PhD diss., University of Washington.

Burke Museum. "Entwined with Life, Native American Basketry." Burke Museum of Natural History and Culture online exhibition: http://www.washington.edu/burkemuseum/baskets/index.html (accessed August 18, 2007).

Cabello, Pax. 1989. "Materiales etnográficos de la Costa Noroeste recogidos en el siglo XVIII por viajeros espanoles." In *Cultural de la Costa Noroeste de América*, ed. José Luis Peset. Madrid: Sociedad Estatal Quinto Centenario.

Carlson, Keith, ed. 1997. *You Are Asked to Witness: The Stó:lō in Canada's Pacific Coast History*. Chilliwack: Stó:lō Heritage Trust.

———. 2001. *A Stó:lō–Coast Salish Historical Atlas*. Vancouver, B.C.: Douglas & McIntyre; Seattle: University of Washington Press.

Carlson, Roy L. 1983a. "Change and Continuity in Northwest Coast Art." In *Indian Art Traditions of the Northwest Coast*, ed. Roy L. Carlson, pp. 190–205. Burnaby, B.C.: Archaeology Press, Simon Fraser University.

———. 1983b. "Prehistory of the Northwest Coast." In *Indian Art Traditions of the Northwest Coast*, ed. Roy L. Carlson, pp. 13–32. Burnaby, B.C.: Archaeology Press, Simon Fraser University.

———. 1990. "History of Research in Archaeology." In *Handbook of North American Indians*, vol. 7: *Northwest Coast*, pp. 107–15. Washington, D.C.: Smithsonian Institution.

Castile, George Pierre. 1985. *The Indians of Puget Sound: The Notebooks of Myron Eells*. Seattle: University of Washington Press.

Cole, Douglas. 1985. *Captured Heritage: The Scramble for Northwest Coast Artifacts*. Seattle: University of Washington Press.

Collins, June McCormick. 1974. *The Upper Skagit Indians of Western Washington*. Seattle: University of Washington Press.

Croes, Dale R. 1977. "Basketry from the Ozette Village Site: A Technological, Functional and Comparative Study." Ph.D. diss., Washington State University.

Croes, Dale, Katherine M. Kelly, and Mark Collard. 2005. "Cultural Historical Context of Qʷuʔgʷes (Puget Sound, USA): A Preliminary Investigation." *Journal of Wetland Archaeology* 5: 141–54.

Curtis, Edward Sherriff. 1913. *The North American Indian; being a series of volumes picturing and describing the Indians of the United States, and Alaska*, vol. 9: *The Salishan Tribes of the Coast: The Chimakum and the Quilliute*. Seattle: E. S. Curtis.

Dan, Lynn. n.d. "Resource Site on Weavers at Musqueam, Canadian National Archives." http://epe.lac-bac.gc.ca/100/205/301/ic/dcd/musqueam/default.htm (accessed May 30, 2007).

Donald, Leland. 1997. *Aboriginal Slavery on the Northwest Coast of North America*. Berkeley: University of California Press.

Douglas, Frederic H., and René d'Harnoncourt. 1941. *Indian Art of the United States*. New York: Museum of Modern Art.

Drucker, Philip. 1955a. *Indians of the Northwest Coast*. Anthropological Handbook No. 10. New York: McGraw-Hill for the American Museum of Natural History.

———. 1955b. "Sources of Northwest Coast Culture." In *New Interpretations of Aboriginal American Culture History,* pp. 59–81. Washington, D.C.: Anthropological Society of Washington.

———. 1965. *Cultures of the North Pacific Coast.* San Francisco: Chandler Publishing Company.

Duff, Wilson. 1952. *The Upper Stalo Indians of the Fraser Valley, British Columbia.* Anthropology in British Columbia Memoir No. 1. Victoria: British Columbia Provincial Museum.

———. 1956a. *Prehistoric Stone Sculpture of the Fraser River and Gulf of Georgia.* Anthropology in British Columbia Memoir No. 5, pp. 15–151. Victoria: British Columbia Provincial Museum.

———. 1956b. *Unique Stone Artifacts from the Gulf Islands.* Provincial Museum Annual Report 1955, pp. 45–55. Victoria: British Columbia Provincial Museum.

———. 1967. *Arts of the Raven, Masterworks by the Northwest Coast Indian.* Vancouver, B.C.: Vancouver Art Gallery.

———. 1975. *Images Stone B.C.: Thirty Centuries of Northwest Coast Indian Sculpture.* Seattle: University of Washington Press.

Duncan, Kate C. 2000. *1001 Curious Things: Ye Olde Curiosity Shop and Native American Art.* Seattle: University of Washington Press.

Eells, Myron. 1889. *Twana, Clallum, and Chemakum Indians of Washington Territory.* Washington, D.C.: Government Printing Office.

Elmendorf, William W. 1960. *The Structure of Twana Culture.* Research Studies Monographic Supplement No. 2. Washington State University, Pullman.

———. 1971. "Coast Salish Status Ranking and Intergroup Ties." *Southwestern Journal of Anthropology* 27(4): 353–80.

Emmons, George Thornton. 1991. *The Tlingit Indians.* Edited and annotated by Frederica de Laguna. Seattle: University of Washington Press.

Fane, Diana. 1991. *Objects of Myth and Memory: American Indian Art at the Brooklyn Museum.* Seattle: University of Washington Press.

Farrand, Livingston. 1900. *Basketry Designs of the Salish Indians.* Memoirs of the American Museum of Natural History, vol. 2, pt. 5. New York: American Museum of Natural History.

Feder, Norman. 1983. "Incised Relief Carving of the Halkomelem and Straits Salish." *American Indian Art Magazine* 8(2): 46–53.

Fish, Jean Bedal, Edith Bedal, and Astrida R. Blukis Onat. 2000. *Two Voices: History of the Sauk and Suiattle People and Sauk Country Experience.* Seattle: Astrida R. Blukis Onat.

Fladmark, K. R., D. E. Nelson, T. A. Brown, J. S. Vogel, and J. R. Southon. 1987. "AMS Dating of Two Wooden Artifacts from the Northwest Coast." *Canadian Journal of Archaeology* 11: 1–12.

Fortney, Sharon. 2000. "Changing Perspectives on Stó:lō Coiled Cedar Root Basketry." Manuscript prepared for the Stó:lō Nation.

———. 2001. "Identifying Stó:lō Basketry: Exploring Different Ways of Knowing Material Culture." Master's thesis, University of British Columbia.

Fritzsche, Ulrich. 2001. *Helmi Dagmar Juvonen, Her Life and Work: A Chronicle.* Privately printed.

Ganternbein, Douglas. 2007–8. "Working at the Mud Bay Wet Site: Waterlogged Wonders." *American Archaeology* 11(4): 12–19.

Garfield, Viola. 1996. *Seattle's Totem Poles.* Bellevue, WA: Thistle Press.

Goddard, Pliny Earle. 1934. *Indians of the Northwest Coast.* Handbook Series No. 10, 2d ed. New York: American Museum of Natural History.

Gunther, Erna. 1927. *Klallam Ethnography.* University of Washington Publications in Anthropology 1(5): 171–314. Seattle.

———. 1951. *Indians of the Northwest Coast.* Colorado Springs: Taylor Museum of the Colorado Springs Fine Art Center; Seattle: Seattle Art Museum.

———. 1962. *Northwest Coast Indian Art: An Exhibit at the Seattle World's Fair Fine Arts Pavilion,* April 21–October 21, 1962. Seattle.

———. 1966. *Art in the Life of the Northwest Coast Indians, with a Catalog of the Rasmussen Collection of Northwest Coast Indian Art at the Portland Art Museum.* Portland, OR: Portland Art Museum.

———. 1972. *Indian Life on the Northwest Coast of North America, as Seen by the Early Explorers and Fur Traders During the Last Decades of the Eighteenth Century.* Chicago: University of Chicago Press.

Gustafson, Paula. 1980. *Salish Weaving.* Vancouver, B.C.: Douglas & McIntyre.

Haeberlin, Herman, and Erna Gunther. 1930. *The Indians of Puget Sound.* University of Washington Publications in Anthropology 4. Seattle: University of Washington Press.

Haeberlin, H. K., James A. Teit, and Helen H. Roberts. 1928. *Coiled Basketry in British Columbia and Surrounding Region.* Forty-first Annual Report of the Bureau of American Ethnology, 1919–24. Washington, D.C.: Government Printing Office.

Halpin, Marjorie. 1994. "A Critique of the Boasian Paradigm for Northwest Coast Art." *Culture* 14(1): 5–16.

Harmon, Alexandra. 1998. *Indians in the Making: Ethnic Relations and Indian Identities around Puget Sound.* Berkeley: University of California Press.

Harper, J. Russell. 1971. *Paul Kane's Frontier, Including Wanderings of an Artist among the Indians of North America by Paul Kane.* Austin: University of Texas Press and the Amon Carter Museum of Western Art.

Harris, George. 2005. *A Bad Colonial Day, Lawrence Paul Yuxweluptun.* Prince George, B.C.: Three Rivers Gallery.

Hawker, Ronald W. 2003. *Tales of Ghosts: First Nations Art in British Columbia, 1922–61.* Vancouver, B.C.: UBC Press.

Hawthorn, Audrey. 1956. *People of the Potlatch, Native Art and Culture of the Pacific Northwest Coast.* Vancouver, B.C.: Vancouver Art Gallery.

Hawthorn, Harry B., C. S. Belshaw, and S. M. Jamieson. 1960. *The Indians of British Columbia: A Study in Social Adjustment.* Toronto and Vancouver: University of Toronto Press and UBC Press.

Hewett, George. n.d. "Catalogue of the Vancouver Collection from the List of George Goodman Hewett, Surgeon's Mate on the *Discovery.*" British Museum Ethnological Document No. 1126.

Hilbert, Vi. 1985. *Haboo: Native American Stories from Puget Sound.* Seattle: University of Washington Press.

———. 1991. "When Chief Seattle (siʔaɬ) Spoke." In *A Time of Gathering, Native Heritage in Washington State,* ed. Robin Wright, pp. 259–66.

———. 1995a. *Aunt Susie Sampson Peter, gʷəqʷulcəʔ: The Wisdom of a Skagit Elder.* Seattle: Lushootseed Press.

———. 1995b. *Gram Ruth Sehome Shelton, x̌əčusədəʔ Siastenu: The Wisdom of a Tulalip Elder.* Seattle: Lushootseed Press.

Hilbert, Vi, Jay Miller, and Zalmai Zahir, eds. 2001. *Puget Sound Geography: Original Manuscript from T. T. Waterman.* Seattle: Lushootseed Press.

Hill, Beth, and Ray Hill. 1974. *Indian Petroglyphs of the Pacific Northwest.* Saanichton, B.C.: Hancock House Publishers.

Hill-Tout, Charles. 1902. "Ethnological Studies of the Mainland Halkomelem, a Division of the Salish of British Columbia." Report of the 72nd Meeting of the British Association for the Advancement of Science, pp. 353–445.

———. 1978. *Salish People,* vol. 3: *The Mainland Halkomelem.* Edited by Ralph Maud. Vancouver, B.C.: Talon Books.

Holm, Bill. 1965. *Northwest Coast Indian Art: An Analysis of Form.* Seattle: University of Washington Press.

———. 1983. "Form in Northwest Coast Art." In *Indian Art Traditions of the Northwest Coast*, ed. Roy L. Carlson, pp. 33–45. Burnaby, B.C.: Archaeology Press, Simon Fraser University.

———. 1987. *Spirit and Ancestor: A Century of Northwest Coast Art in the Burke Museum.* Seattle: University of Washington Press.

———. 1990. "Art." In *Handbook of North American Indians,* vol. 7: *Northwest Coast,* pp. 602–32. Washington, D.C.: Smithsonian Institution.

———. 1991. "Historic Salish Canoes." In *A Time of Gathering: Native Heritage in Washington State,* ed. Robin Wright, pp. 238–47. Seattle: University of Washington Press and Burke Museum.

Hyde, Louis. 1979. *The Gift: Imagination and the Erotic Life of Property.* New York: Vintage Books.

Idiens, Dale. 1983. *Catalogue of the Ethnographic Collection: Oceania, America, Africa.* Perth, Scotland: Perth Museum and Art Gallery.

———. 1987. "Northwest Coast Artifacts in the Perth Museum and Art Gallery: The Colin Robertson Collection." *American Indian Art Magazine* 13(1): 46–53.

Inverarity, Robert Bruce. 1950. *Art of the Northwest Coast Indians.* Berkeley: University of California Press.

Jenness, Diamond. 1932. *The Indians of Canada.* National Museum of Canada Bulletin 65. Ottawa: F. A. Acland.

———. 1955. *Faith of a Coast Salish Indian.* Anthropology in British Columbia Memoir 3. Victoria: British Columbia Provincial Museum.

Johnson, Elizabeth, and Kathryn Bernick. 1986. *Hands of Our Ancestors: The Revival of Salish Weaving at Musqueam.* Museum Note No. 16, Museum of Anthropology, University of British Columbia.

Jonaitis, Aldona. 1981. "Creations of Mystics and Philosophers: The White Man's Perceptions of Northwest Coast Indian Art from the 1930s to the Present." *American Indian Culture and Research Journal* 5(1): 1–45.

———. 1988. *From the Land of the Totem Poles: The Northwest Coast Indian Art Collection at the American Museum of Natural History.* Seattle: University of Washington Press and the American Museum of Natural History.

———. 1995. *A Wealth of Thought: Franz Boas on Native American Art.* Seattle: University of Washington; Vancouver, B.C.: Douglas & McIntyre.

Kaeppler, Adrienne L. 1978. *"Artificial Curiosities": An Exposition of Native Manufactures Collected on the Three Pacific Voyages of Captain James Cook, R.N.* Honolulu: Bishop Museum Press.

Kew, Della, and P. E. Goddard. 1974. *Indian Art and Culture of the Northwest Coast.* Saanichton, B.C.: Hancock House.

Kew, J. E. Michael. 1980. *Sculpture and Engraving of the Central Coast Salish Indians.* Museum Note No. 9, Museum of Anthropology, University of British Columbia.

King, J.C.H. 1994. "Vancouver's Ethnography." *Journal of the History of Collections* 6(1): 33–58.

———. 1999. *First Peoples, First Contacts: Native Peoples of North America.* Cambridge, MA: Harvard University Press.

Kirk, Ruth, and Richard D. Daugherty. 1978. *Exploring Washington Archaeology.* Seattle: University of Washington Press.

———. 2007. *Archaeology in Washington.* Seattle: University of Washington Press.

Knight, Rolf. 1978. *Indians at Work: An Informal History of Native Labour in British Columbia 1858–1930.* Vancouver, B.C.: New Start Books.

Kroeber, A.L. 1939. *Cultural and Natural Areas in Native North America.* Publications in American Archaeology and Ethnology No. 38, University of California, Berkeley.

Krohn, Elise. 2007. *Wild Rose and Western Red Cedar: The Gifts of the Northwest Plants.* Bellingham, WA: Northwest Indian College.

Lee, Molly. 1999. "Tourism and Taste Cultures: Collecting Native Art in Alaska at the Turn of the Twentieth Century." In *Unpacking Culture: Art and Commodity in Colonial and Postcolonial Worlds,* ed. Ruth Phillips and Christopher Steiner. Berkeley: University of California Press.

Lévi-Strauss, Claude. 1975. *The Way of the Masks.* Trans. Sylvia Modelski. Seattle: University of Washington Press.

Lincoln, Leslie. ca. 1991. *Coast Salish Canoes.* Seattle: Center for Wooden Boats.

Lobb, Allan. 1990. *Indian Baskets of the Pacific Northwest and Alaska.* Portland, OR: Graphic Arts Center Publishing Co.

Macnair, Peter L. 1993. "Trends in Northwest Coast Indian Art 1880–1950: Decline and Expansion." In *In the Shadow of the Sun: Perspectives on Contemporary Native Art,* ed. Gerald McMaster. Canadian Museum of Civilization, pp. 47–70. Canadian Ethnology Service Mercury Series Paper 124. Hull, Quebec.

Macnair, Peter L., Alan L. Hoover, and Kevin Neary. 1984. *The Legacy: Tradition and Innovation in Northwest Coast Indian Art.* Vancouver, B.C.: Douglas & McIntyre; Seattle: University of Washington Press.

Malin, Edward, and Norman Feder. 1962. *Indian Art of the Northwest Coast.* Denver: Denver Art Museum.

Marr, Carolyn J. 1984. "Salish Baskets from the Wilkes Expedition." *American Indian Art Magazine* 9(3): 44–51.

———. 1988. "Wrapped Twined Baskets of the Southern Northwest Coast: A New Form with an Ancient Past." *American Indian Art Magazine* 13(3): 54–63.

———. 1990a. "Continuity and Change in the Basketry of Western Washington." In *The Art of Native American Basketry: A Living Legacy,* ed. Frank W. Porter III, pp. 267–80. Westport, CT: Greenwood Press.

———. 1990b. "Basketry Regions of Washington State." *American Indian Art Magazine* 16(2): 40–49.

———. n.d. "Assimilation through Education: Indian Boarding Schools in the Pacific Northwest." University of Washington Libraries Digital Collection. http://content.lib.washington.edu/aipnw/marr.html (accessed July 10, 2007).

Mason, Otis Tufton. 1904. *Aboriginal American Indian Basketry: Studies in a Textile Art without Machinery.* Report to United States National Museum. Reprint ed. published 1976. Santa Barbara, CA: Peregrine Smith.

Mayr, Ernst. 1959. "Darwin and the Evolutionary Theory in Biology." In *Evolution and Anthropology: A Centennial Appraisal,* ed. Betty Meggers, pp. 1–10. Washington, D.C.: The Anthropological Society of Washington.

———. 1982. *The Growth of Biological Thought: Diversity, Evolution, and Inheritance.* Cambridge, MA: Harvard University Press.

———. 1988. *Toward a New Philosophy of Biology: Observations of an Evolutionist.* Cambridge, MA: Harvard University Press.

McHalsie, Sonny. 2001. "Intergenerational Ties and Movement: Family as a Basis of Nation." In *A Stó:lō–Coast Salish Historical Atlas,* ed. Keith Thor Carlson. Vancouver, B.C.: Douglas & McIntyre.

McMaster, Gerald, and Lee-Ann Martin, eds. 1992. *Indigena: Contemporary Perspective in Native Canadian Art.* New York: Craftsman House.

McNutt, Nan. 1997. *The Spindle Whorl: A Northwest Coast Indian Art Activity Book.* Seattle: Sasquatch Books.

Meikle, Margaret. 1987. *Cowichan Indian Knitting.* Museum Note No. 21, Museum of Anthropology, University of British Columbia.

Miller, Bruce G. 2007. "Introduction." In *Be of Good Mind: Essays on the Coast Salish,* ed. Bruce Granville Miller, pp. 1–29. Vancouver, B.C.: UBC Press.

Miller, Bruce subiyay. 1999. "Seeds of Our Ancestors: Growing Up in the Skokomish Song Tradition." In *Spirit of the First People: Native American Music Traditions,* ed. Willie Smyth and Esmé Ryan, pp. 25–43.

Miller, Jay. 1999. *Lushootseed Culture and the Shamanic Odyssey: An Anchored Radiance.* Lincoln: University of Nebraska Press.

———. 2005. *Regaining Dr. Herman Haeberlin: Early Anthropology and Museology in Puget Sound, 1916–17.* Seattle: 4Culture and Lushootseed Press. See also https://kb.osu.edu/dspace/handle/1811/29277.

Nemiroff, Diana. 1992. *Land, Spirit, Power: First Nations at the National Gallery of Canada.* Ottawa: National Gallery of Canada.

Newcombe, Charles F. 1909. *Guide to Anthropological Collection in the Provincial Museum.* Victoria, B.C.: King's Printer.

Nordquist, D.L., and G.E. Nordquist. 1983. *Twana Twined Basketry.* Ramona, CA: Acoma Books.

Oliver, Emmett. 1991. "Reminiscences of a Canoe Puller." In *A Time of Gathering, Native Heritage in Washington State,* ed. Robin Wright, pp. 248–49.

Olson, Ronald L. 1967. *The Quinault Indians and Adze, Canoe and House Types of the Northwest Coast*. University of Washington Publications in Anthropology 6(1) and 2(1). Seattle: University of Washington Press.

Popper, Karl R. 1950. *The Open Society and Its Enemies*. Princeton, NJ: Princeton University Press.

Ross, Alison S. 1994. "The Art of Northwest Coast Tourist Basketry: 1890–1910." Master's thesis, University of Victoria.

Sarris, Greg. 1993. *Mabel McKay: Weaving the Dream*. Berkeley: University of California Press.

Sampson, Martin. 1938. *Swinomish Totem Pole: Tribal Legends as Told to Rosalie M. Whitney*. Bellingham, WA: Union Printing Co.

———. 1972. *Indians of Skagit County*. Skagit County Historical Society.

75 Years of Collecting: First Nations: Myths and Realities. Vancouver Art Gallery web publication; http://projects.vanartgallery.bc.ca/publications/75years (accessed Feb. 20, 2008).

Shelton, William. 1913. "Sklaletuts of Tribal Elders." (Originally published as "Indian Totem Legends of the Northwest Coast Country.") Revised and annotated by David Dilgard. Northwest Room, Everett [WA] Public Library, 1996.97.

Simon Fraser University Gallery. 1992. *Simon Charlie: Salish Carver, From the Todd Collection*. Exhibition at Simon Fraser University Gallery, with an essay by Norman Todd. Edited by Ralph Maud. Burnaby, B.C.: Simon Fraser Gallery Press.

Smith, Marian W. 1940. *The Puyallup–Nisqually*. Contributions to Anthropology 32, Columbia University, New York.

———. 1941. "The Coast Salish of Puget Sound." *American Anthropologist* 43: 197–211.

———, ed. 1949. *Indians of the Urban Northwest*. New York: Columbia University Press.

Smith, Marian, and Dorothy Leadbeater. 1949. "Salish Coiled Baskets." In *Indians of the Urban Northwest*, ed. Marian W. Smith, pp. 111–32. New York: Columbia University Press.

Snyder, Sally. 1953–55. Field Notes. Documents on file at Swinomish Indian Tribal Community, La Conner, Washington, and Special Collections, University of Washington Library, Seattle.

———. 1964. "Skagit Society and Its Existential Basis: An Ethnofolkloristic Reconstruction." PhD diss., University of Washington.

Sparrow, Debra. n.d. Resource site on Weavers at Musqueam, Canadian National Archives, ac.gc.ca/100/205/301/ic/dcd/musqueam/default.htm (accessed May 30, 2007).

———. Pers. comm., 2008.

Stein, Julie K., and Laura S. Phillips, eds. 2002. *Vashon Island Archaeology: A View from Burton Acres Shell Midden*. Burke Museum of Natural History and Culture Research Report No. 8. Seattle: Burke Museum.

Street, Eloise. 1957. *Sepass Poems: Songs of Y-Ail-Mihth*. Sardis, B.C.: Eliose Street Harries.

Sturtevant, William C., general editor. 1978–2004. *Handbook of North American Indians*. Washington, D.C.: Smithsonian Institution.

Suttles, Wayne P. 1950. "Economic Life of the Coast Salish, Indians of Haro and Rosario Straits." PhD diss., University of Washington.

———. 1982. "The Halkomelem Sxwayxwey." *American Indian Art Magazine* 8(1): 56–65.

———. 1983. "Productivity and Its Constraints." In *Indian Art Traditions of the Northwest Coast*, ed. Roy L. Carlson, pp. 67–88. Burnaby, B.C.: Archaeology Press, Simon Fraser University.

———. 1987. *Coast Salish Essays*. Vancouver, B.C.: Talonbooks.

Teit, James. 1900. *The Thompson Indians of British Columbia*. Memoirs of the American Museum of Natural History, vol. 2, pt. 4. New York.

———. 1928. *The Middle Columbia Salish*. University of Washington Publications in Anthropology 4: 83–128.

Thom, Brian. 2001. "Harlan I. Smith & the Jesup North Pacific Expedition." In *Gateways to Jesup II: Franz Boas and the Jesup North Pacific Expedition*, ed. William Fitzhugh and Igor Krupnik. Contributions to Circumpolar Anthropology No. 1. Washington, D.C.: Smithsonian Institution.

Thompson, Laurence C., and M. Dale Kinkade. 1990. "Languages." In *Handbook of North American Indians*, vol. 7: *Northwest Coast*, pp. 30–51. Washington, D.C.: Smithsonian Institution.

Thompson, Nile. 1984. "Ed Carriere Continues a Suquamish Tradition." *American Indian Basketry Magazine* 4(15): 20–25.

Thompson, Nile, and Carolyn Marr. 1981. Interview with Donna Brownfield, Muckleshoot Reservation.

———. 1983. *Crow's Shells: Artistic Basketry of Puget Sound*. Seattle: Dushuyay Publications.

Thrush, Coll. 2007. *Native Seattle: Histories from the Crossing-Over Place*. Seattle: University of Washington Press.

Thrush, Coll-Peter. "The Lushootseed Peoples of Puget Sound Country." University of Washington Digital Collections. http://content.lib.washington.edu/aipnw/thrush.html (accessed July 19, 2007).

"Tulalip Master Carver Brochure." The Tulalip Tribes Cultural Resources Department. http://www.tttculturalresources.org/rediscovery/master_carver_1.asp (accessed Nov. 16, 2007).

Turner, Nancy J. 1998. *Plant Technology of First Peoples in British Columbia*. British Columbia Museum Handbook. Vancouver, B.C.: UBC Press.

United States Exploring Expedition 1838–1842. Smithsonian Institution Library. http://www.sil.si.edu/DigitalCollections/usexes/ (accessed Oct. 19, 2007).

Vodden, Christy, and Ian Dyck. 2006. *A World Inside: A 150 Year History of the Canadian Museum of Civilization*. Hull, Quebec: Canadian Museum of Civilization.

Waterfield, Hermione, and J.C.H. King. 2006. *Provenance: Twelve Collectors of Ethnographic Art in England, 1760–1990*. Geneva: Barbier-Muller Museum.

Waterman, T.T. 1920s. "Puget Sound Geography" [microform]. Original ms. handwritten and typed interspersed with ports., maps, illus., in Smithsonian Office of Anthropology, Bureau of American Ethnology, Manuscript Collection No. 1864. Microfilm 1 reel (part), 35mm, Smithsonian Institution, 1968. Microfilm available at Special Collections Microform, University of Washington Libraries, Seattle.

———. 1973. *Notes on the Ethnology of the Indians of Puget Sound*. Indian Notes and Monographs, Misc. Series No. 59. New York: Museum of the American Indian, Heye Foundation.

Wells, Oliver. 1962. Interview with Mrs. Albert Cooper, February 8. Edenbank Farm Collection (4-3). Stó:lō Nation Archives.

———. 1969. *Salish Weaving, Primitive and Modern, As Practiced by the Salish Indians of South West British Columbia*. Rev. ed. Vancouver, B.C.: Frank T. Coan Ltd.

———. 1987. *The Chilliwacks and Their Neighbors*. Edited by Ralph Maud, Brent Galloway, and Marie Weeden. Vancouver, B.C.: Talonbooks.

Whatcom Museum of History and Art. 1971. *Master Carvers of the Lummi and Their Apprentices*. Bellingham, WA: Whatcom Museum of History and Art.

White, Ellen Kwulasulwut. 1992. *Kwulasulwut: Stories from the Coast Salish*. Penticton, B.C.: Theytus Books, Ltd.

———. 1995. *Kwulasulwut II: More Stories from the Coast Salish*. Penticton, B.C.: Theytus Books, Ltd.

———. 2006. *Legends and Teachings of Xeel's, the Creator*. Vancouver, B.C.: Pacific Educational Press, University of British Columbia.

Wingert, Paul S. 1949a. *American Indian Sculpture: A Study of the Northwest Coast*. New York: J.J. Augustin Pub.

———. 1949b. "Coast Salish Painting." In *Indians of the Urban Northwest*, ed. Marian W. Smith, pp. 77–91. New York: Columbia University Press.

Wise, Jonathan. Audiovisual Department, Canadian Museum of Civilization, pers. comm., 2007.

Wissler, Clark. 1950. *The American Indian: An Introduction to the Anthropology of the New World*. 3rd ed. New York: Peter Smith.

Wright, Robin K., ed. 1991. *A Time of Gathering: Native Heritage in Washington State*. Seattle: University of Washington Press and Burke Museum.

Wyatt, Gary, ed. 2000. *Susan Point, Coast Salish Artist*. Vancouver, B.C.: Douglas & McIntyre; Seattle: University of Washington Press.

Contributors

Crisca Bierwert obtained her Ph.D. in cultural anthropology from the University of Washington. She worked in the Native educational programs of the Coqualeetza Centre (Sardis, British Columbia), and taught at Green River Community College (Auburn, Washington) and at the University of Michigan. Her major publications in anthropology and Native American studies, which focus on text analysis, cultural politics, and environmental issues, include *Lushootseed Texts: An Introduction to Puget Salish Narrative Aesthetics* (1996) and *Brushed by Cedar, Living by the River: Coast Salish Figures of Power* (1999). Dr. Bierwert is the associate director at the Center of Research on Learning and Teaching at the University of Michigan.

Barbara Brotherton is curator of Native American art at the Seattle Art Museum and former associate professor of art history at Western Michigan University. She received her Ph.D. in art history under Bill Holm and Robin Wright, and studies Lushootseed language and literature with Upper Skagit elder Vi Hilbert. She is a board member of Lushootseed Research, an organization dedicated to the preservation of Puget Salish culture and literature. She is the author of a book chapter and several articles on Native art and art history.

Steve Brown has been appreciating and creating Northwest Coast art since 1967; he has made thirteen dugout canoes and numerous large sculptures, many of which have been replications of historic monuments for their Native owners. Brown specializes in teaching carving and tool-making skills with Native and non-Native groups and has written several books and numerous articles on the history and style characteristics of Northwest Coast art, including *Spirit Within: Northwest Coast Native Art from the John H. Hauberg Collection* (1995) and *Native Visions: Evolution in Northwest Coast Art from the Eighteenth through the Twentieth Century* (1998).

Sharon Fortney has a B.A. in archaeology from the University of Calgary and an M.A. in anthropology from the University of British Columbia, where she is currently a Ph.D. candidate. She has Klahoose ancestry and enjoys working on cultural projects that promote sharing knowledge and cross-cultural understanding. She has worked with, and for, several Coast Salish communities as a museum professional and contract researcher for several years. She is currently working on her dissertation, "Forging New Partnerships: Coast Salish Communities and Museums."

Vi taqʷšəblu Hilbert is a fluent speaker of Lushootseed and shares her long life and knowledge as scholar-elder-teacher, storyteller, and director of Lushootseed Research. Her substantial contributions, media efforts, and publications have earned her many national awards, including an honorary doctorate from Seattle University, a National Endowment for the Arts National Heritage Fellowship, and a Living Treasure of Washington State award. She taught the Lushootseed language and literature at the University of Washington. Her publications include two Lushootseed dictionaries, two books of stories, biographies of three Salish elder-historians, and republication of and commentary on T. T. Waterman's place names and George Gibbs's dictionary of southern Lushootseed.

J. E. Michael Kew was assistant curator of anthropology at the Provincial Museum of British Columbia (now the Royal British Columbia Museum) in Victoria, and served for several years as a research assistant for the Center for Community Studies in Saskatchewan. He received his Ph.D. in 1970 from the University of Washington, writing his dissertation on modern Coast Salish ceremonials and establishing himself as a renowned expert on the Coast Salish. Kew had a distinguished teaching career in the Department of Anthropology and Sociology at the University of British Columbia until his retirement in 1997. He was the curator of the first major exhibition of Central Coast Salish art, "Visions of Power, Symbols of Wealth," held at the Museum of Anthropology, University of British Columbia, in 1980.

Carolyn J. Marr is the librarian at the Museum of History and Industry in Seattle. She received a B.A. in anthropology from Stanford University, an M.A. in anthropology from the University of Denver, and an M.S. in librarianship from the University of Washington. She is co-author (with Nile Thompson) of *Crow's Shells: Artistic Basketry of Puget Sound* (1983) and has published a number of articles about Native American basketry and historical photography. She is currently working on a photography cataloging and digitization project and is contributing to a book on basketry of the Olympic National Park.

Jay Miller, Ph.D., has devoted his long career to the "saving and sharing" of Native traditions across the Americas, including three decades with Lushootseed Research and a series of books and drafts about the peoples of Puget Sound. He has taught throughout the United States and British Columbia and published both scholarly and children's books on the Delaware, Tsimshian, Pueblo, and Salishan Indians. Two of his Salishan publications include *Mourning Dove: A Salishan Autobiography* (1990) and *Lushootseed Culture and the Shamanic Odyssey: An Anchored Radiance* (1999).

Gerald Bruce subiyay Miller (Skokomish / Yakama) (1944–2005) dedicated his life to preserving and disseminating the knowledge and artistic skills of his elders, including his aunt Emily Miller. He was widely regarded as a spiritual leader,

healer, artist, ethnobotanist, and master of oral traditions, songs and dances related to Salish ceremonies and rituals. He was central to the revival of the southern Puget Sound Salish language and teachings, including first foods and winter ceremonies. A gifted artist, subiyay wove baskets and wool robes, created traditional regalia, and carved house posts, traditional implements, ceremonial masks, and poles. In 1993 he received the Washington State Governor's Heritage Award; in 1999 he was named a Living Treasure by the Washington State Superintendent of Public Instruction for his lifetime of teaching youth; and in 2004 he received a National Endowment for the Arts National Heritage Fellowship.

Astrida R. Blukis Onat received her Ph.D. in anthropology and archaeology from Washington State University. She taught anthropology at Seattle Central Community College for nearly thirty years and is the principal of BOAS, Inc., an archaeological consultation firm. She is the author of numerous reports and papers on Puget Sound archaeological site excavations and initiated the Swinomish Indian Tribal Community on-reservation archaeology program. Blukis Onat has been a Fulbright Scholar and has received grants from the National Academy of Sciences and the National Endowment for the Humanities. She is currently researching Puget Sound Native historic narratives, mythology, and ethno-archaeology.

D. Michael CHiXapkaid Pavel is a member of the tuwuduq Skokomish Nation and a traditional bearer of southern Puget Salish culture. He received an apprenticeship in carving from his late uncle, subiyay Gerald Bruce Miller. Pavel holds a Ph.D. in higher education from Arizona State University and is professor of education at Washington State University. He has received the Inaugural Faculty Diversity Award at Washington State University; was an honored Buffett Award finalist for indigenous leadership from EcoTrust; and was named the Washington State Indian Education Association Indian Educator of the Year. He is currently working on two books—*Increasing American Indian Postsecondary Success* and *The Art, Science, and Spirit of Salish Weaving*—and a carving commission of Salish house posts for the Suquamish Community House.

Qwalsius Shaun Peterson is an enrolled member of the Puyallup Tribe and has Native heritage from the Tulalip, Skokomish, and Yakama peoples. He received his traditional name from his maternal great-grandfather, Lawrence Williams. Peterson was mentored in carving by Steve Brown and Greg Colfax and has established himself as one of the few artists practicing Coast Salish design and aesthetics. He began by working in wood, creating traditional drums, rattles, and masks, and has since evolved a personal style that includes the modern media of metal, glass, and serigraphy. Peterson has completed several large-scale art commissions from the cities of Tacoma and Seattle, and from the Puyallup Tribe.

Susan Point has played a pivotal role in the revitalization of Coast Salish design. She was mentored in the traditions of the Musqueam people by her mother Edna Grant Point and her uncle Dominic Point. From her first foray into silver engraving in 1981, followed by a prolific period of producing innovative works in wood sculpture and printmaking, to major international monumental commissions, Point's work bears the ethos of the unique principles of Coast Salish design. She has created large-scale works for the National Museum of the American Indian, Washington, D.C.; Vancouver International Airport; and the Victoria (B.C.) Conference Centre. She also contributed artwork to the Richmond (B.C.) Skating Oval built for the 2010 Winter Olympic Games. In June 2008, three fully carved monumental gateways (titled *People Amongst the People*) were installed at Stanley Park, Vancouver. Point has been elected to the Royal Canadian Academy of Arts, is an Officer of the Order of Canada, has been the recipient of the National Aboriginal Achievement Award and the B.C. Creative Achievement Award, and has received honorary doctorate degrees from Simon Fraser University and Emily Carr College of Art + Design. She lives and works on the Musqueam First Nations Reservation in Vancouver.

Cameron Suttles, son of the late Wayne Suttles, is a designer and writer with marketing communications agency Alling Henning Associates. He is working on research and writing for the Confluence Project, Maya Lin's seven-site art installation that commemorates the Lewis and Clark expedition while honoring Native culture and history. Beyond client work, he pursues personal creative writing projects and is also literary trustee for his father's unpublished manuscripts.

Wayne Suttles (1918–2005) was the first to be awarded a Ph.D. in anthropology from the University of Washington. His publications on the Coast Salish, including his interpretation of the relationship between culture and environment and the nature of the social network, have had a significant influence on ethnographic work in the region. He was editor of the Northwest Coast volume of the *Handbook of North American Indians* (1990) and author of the pivotal volume *Coast Salish Essays* (1987). His 2004 grammar of the Musqueam language was a milestone in Salish studies.

Dr. Ellen White Kwulasulwut ("Many Stars") is an esteemed elder from the Snuneymuxw Nation of Nanaimo on Vancouver Island, well known for her decades of dedication to education, social change, and community building. She has touched many lives in her roles as teacher, storyteller, dancer, drummer, healer, midwife, political activist, and bearer of her aboriginal language. She is a resident elder at Malaspina University-College, where she received an Honorary Doctorate of Laws, and she acts as a mentor in both spiritual and practical matters for students and educators in the First Nations Studies program there. White has been honored at Malaspina College with a garden in her name—Kwulasulwut Garden—because of her many teachings about native plants.

In 2007 she received the British Columbia Achievement Award for her community work. She is the author of *Kwulasulwut: Stories from the Coast Salish* (1981), *Kwulasulwut II: More Stores from the Coast Salish* (1997), and *Legends and Teachings of Xeel's, the Creator* (2006).

Index

Credits

Exhibition itinerary:

Seattle Art Museum
Seattle, Washington: October 24, 2008–
January 11, 2009

Heard Museum
Phoenix, Arizona: February 21, 2009–
August 16, 2009

Royal British Columbia Museum
Victoria, Canada: November 20, 2009–
March 8, 2010

Seattle Art Museum
1300 First Avenue, Seattle, WA 98101 U.S.A.
www.seattleartmuseum.org

University of Washington Press
P.O. Box 50096, Seattle, WA 98145 U.S.A.
www.washington.edu/uwpress

Editorial coordination by Marilyn Trueblood
Copyedited by Sigrid Asmus
Proofread by Sherri Schultz
Designed by John Hubbard
Typeset by Brynn Warriner
Indexed by Barbara Cohen
Color management by iocolor, Seattle
Produced by Marquand Books, Inc., Seattle
 www.marquand.com
Printed and bound in Singapore by
 CS Graphics Pte., Ltd.

Library of Congress Cataloging-in-Publication Data
 S'abadeb = The gifts : Pacific Coast Salish arts and
artists/edited by Barbara Brotherton.
 p. cm.
 Includes bibliographical references and index.
 ISBN 978-0-295-98863-4 (pbk. : alk. paper)
 1. Coast Salish Indians—Material culture—
Washington (State)—Puget Sound Watershed—
Exhibitions. 2. Coast Salish art—Washington
(State)—Puget Sound Watershed—Exhibitions.
3. Coast Salish artists—Washington (State)—Puget
Sound Watershed—Exhibitions. 4. Seattle Art
Museum—Exhibitions. I. Brotherton, Barbara.
II. Seattle Art Museum. III. Title: Gifts.
E99.S21S34 2008
979.7—dc22 2008024421

Front cover: Detail of *Four Salmon Heads,* Maynard
Johnny Jr., Penelakut/Kwakwaka'wakw, 2008
(fig. 5.46, p. 134)
Back cover: Detail of Quamichan potlach, about 1913
(fig. 3.9, p. 35)
p. i: Native family and canoe, courtesy Jefferson
County Historical Society
p. ii: Detail of *du'kWXaXa'ʔt3w3l (Sacred Change
for Each Other),* Susan sa'hLa mitSa Pavel, 2007
(fig. 3.10, p. 37)
p. iii: Kimberly Miller stripping cedar bark on
the Skokomish Reservation (fig. 3.17, p. 48)
p. vii: *Killer Whale,* Charles Elliott, Tsartlip, 1980
(fig. 5.35, p. 121)
p. xii: *The Legend of Octopus Point,* John Marston,
Chemainus, 2007 (fig. 4.7, p. 67)
p. xiv: Carved figure, Suquamish(?), eighteenth
century (fig. 5.7, p. 76)
p. xx: Basket, Twana (Skokomish), nineteenth century
(fig. 3.5, p. 30)
p. 5: Coast Salish family from the Port Townsend,
Washington, area (fig. 11.9, p. 254)